D0849574

Paris *Africain*

PARIS AFRICAIN

RHYTHMS OF THE AFRICAN DIASPORA

James A. Winders

PARIS *AFRICAIN*
© James A. Winders, 2006.

All rights reserved. No part of this book may be used or reproduced in any manner whatsoever without written permission except in the case of brief quotations embodied in critical articles or reviews.

First published in 2006 by
PALGRAVE MACMILLAN™
175 Fifth Avenue, New York, N.Y. 10010 and
Houndmills, Basingstoke, Hampshire, England RG21 6XS
Companies and representatives throughout the world.

PALGRAVE MACMILLAN is the global academic imprint of the Palgrave Macmillan division of St. Martin's Press, LLC and of Palgrave Macmillan Ltd. Macmillan® is a registered trademark in the United States, United Kingdom and other countries. Palgrave is a registered trademark in the European Union and other countries.

Portions of the text appeared as "Mobility and Cultural Identity," in French Historical studies. Copyright 2006, The Society of French Historical Studies. All rights reserved. Used by permission of the publisher.

ISBN-13: 978–1–4039–6004–7
ISBN-10: 1–4039–6004–6

Library of Congress Cataloging-in-Publication Data is available from the Library of Congress.

A catalogue record for this book is available from the British Library.

Design by Newgen Imaging Systems (P) Ltd., Chennai, India.

First edition: December 2006

10 9 8 7 6 5 4 3 2 1

Printed in the United States of America.

To my sister,
Jane Winders Frank

Contents

Foreword

"I want to know more about this," you tell yourself, having encountered something that gets your attention in a new way. That's how a topic of historical research can begin—yet another example of life happening to you while you happened to be making other plans. The topic of this book began in my ears. As a devoted listener who grew up with rock 'n' roll, I, like many music buffs during the 1970s, had developed a taste for reggae music. The distinctive music of Jamaica opened my ears for the first time to an example of a hybrid produced through the encounter of a postcolonial country's music with Western pop (as I write these lines, I am listening to Bob Marley's "Lively Up Yourself"). Eventually, I was to realize that I wanted to experience styles of contemporary popular music from as many countries and cultures as possible. By the late 1970s I was delving happily into music from South Africa, having been made aware of it through the anti-apartheid struggle I followed with great interest and sympathy. Friends who knew of my musical interests, including some who worked in record stores where I shopped regularly, were prone to call my attention to recordings they thought would appeal to me. By the mid-1980s, I was beginning to explore music from all parts of Africa.

I found that some of my favorite new records were those of musicians from Central and West African countries, many of them French-speaking. I began to notice that quite a number of the recordings I admired had been produced in Paris. As a French historian, I sat up and took notice. As my collection of African recordings grew larger, I realized that Paris truly had established itself as a major center of African music, and I wanted to find out why and how this had happened. At this point (early 1990s), I wore two somewhat different hats. I was a French cultural/intellectual historian preoccupied especially with twentieth-century topics, and also operated as a freelance music journalist, covering whatever genres or artists interested me. As I began to explore the topic that led to this book, my two roles merged into one.

I decided that I needed to try to meet and interview the African musicians of Paris and those associated with their music. I envisioned a kind of oral history project, and hoped to make contact with as many interview subjects as possible. From music journalism, I had learned how to contact musicians and music business people to set up interviews and had become more or less comfortable with my tape recorder. Thus, my project began, and I embarked on a long series of journeys to Paris, where each door that opened to me seemed to lead to a succession of other doors. As one person after another granted me an interview, almost invariably they generously supplied me

with suggestions of a host of other people with whom, they said, I should speak. I still remember the excitement and gratitude I felt many years ago as Jocelyne Béroard, singer with the hugely popular band Kassav', booted up her laptop computer and pulled up a long list of fellow musicians and others for me to contact, along with their most up-to-date *coordonnées*.

As I proceeded with this work, which introduced me more thoroughly than ever to the Paris region, I was operating in territory that the theoretical discussions and debates I had been immersed in for many years had designated as post-something or other (modern, colonial, etc.). Like many of my generation of scholars in the humanities, I found linguistic, literary, and cultural theory exhilarating, and believed it challenged the usual ways of doing things in such a discipline as history. And certainly the themes of difference and identity at work in so much of recent cultural theory have shaped my thinking in ways that helped lead me to this book's topic. However, as soon as I began to consider African musicians making their way in contemporary Paris, I realized that the postmodern theoretical emphasis on visual representation and signification could not account adequately for those I wished to study. Their individual stories could not be reduced to the familiar postmodernist categories.

The people I had the privilege to interview were quite remarkable. The musicians among them exuded the kind of spiritual sense of music's power to overcome differences that I had come to expect from other musicians I had known. The views they expressed befitted the cosmopolitanism of their lives. Embracing their adopted country of France and determined to continue with the lives they had fashioned there, they nevertheless remained proud of their African cultural roots. As I came to realize after further study, I had come into contact through my interview subjects with new models of citizenship and cultural identity. For me, this has become the most fascinating aspect of the contemporary currents of global migration. I will remain grateful to the people whose stories I have tried to weave into my narrative for leading me into fields of study (such as the history of immigration) I may otherwise never have explored.

After completing this book, I returned to Paris in May 2006 wondering if I would find evidence of continued interest in African music. I did—at least an evidence of interest in the established stars of the heyday of Paris-based "world music." Ads announced an upcoming Salif Keïta concert, for one thing. Also, although the concert was not announced in *Libération*—as once it might have been—I was alerted by the weekly *Pariscope* to a performance by Touré Kunda at New Morning. As discussed in chapter two, they were the first African band to "make it big" in Paris (*ca.* 1982–1983). Ismael and Sixu, the two original members (and twin brothers), formed the core of the group, augmented by seven other musicians. I arrived at the popular club hidden away in the back streets of the Tenth Arrondissement to find an overflowing crowd. The band ran through their familiar hits from two decades ago, but the mostly young crowd did not seem to regard it as an exercise in nostalgia. They were happy to express their enjoyment of the music by dancing. I noticed a sprinkling of fellow geezers in the audience, probably the ones singing along with the choruses. But by far the crowd was composed of hip young people, multi-ethnic and taking for granted the new face of Paris. I stood next to a young man sporting a Kobe Bryant #8 Los Angeles Lakers jersey, its bright yellow lighting up the room. However difficult it

may have become for new African musicians to break into the Paris scene, clearly the music fans of the city still held the prominent musicians of the 1980s in high esteem.

New African restaurants were in evidence in several areas of Paris, including the lower Ninth Arrondissement, just north of the Grands Boulevards Métro stop on the Number 8 (Balard–Créteil) line. There, on the small rue de Montyon, Mamadou Coumdoul (profiled in chapter seven) moved his Paris–Dakar restaurant late in 2004. The new restaurant, renamed Le Nouveau Paris–Dakar, is bright and festive, decorated with Senegalese art and fabrics. The day I visited, Monsieur Coumdoul was busily attending the lunchtime customers. Even though the place was far from full, he was kept hopping since he was by himself. "The children are in school," he reminded me. As in the previous location on the rue du Faubourg Saint-Martin (Tenth Arrondissement), a very large supply of concert videos stood next to a large television set and DVD player. I sat close by, enjoying a Youssou N'Dour concert that had been filmed at the Bercy auditorium.

By moving into such a different neighborhood, Coumdoul had acquired a new clientele—although he assured me that he had retained his "regulars" from the old location. Near where I sat, a large table of young professionals received elaborate attention from the proprietor, as he explained his dishes to them. After things had calmed down a bit, Coumdoul spoke of his enthusiasm for the new version of his restaurant. He expressed satisfaction that he was now bringing a bit of African culture to a part of Paris where it had not previously been in evidence. In a similar way, my modest hope for this book is that it will help to illuminate aspects of the recent history of Paris that may not have been obvious to many, but that will, after close examination, leave us with a new sense of Paris—perhaps even a Paris *africain*.

Note on Sources:
All interviews were conducted in French, and translations are my own. I take responsibility for any and all mistakes. In most cases, page numbers indicated for press sources refer to the *ADRI-Presse* volumes archived by ADRI (Agence pour la Développement des Relations Interculturelles).

Acknowledgments

I owe a very large debt of gratitude to the many people whose kindness, good humor, knowledge, and creativity made this book possible. First and foremost I must thank the persons whose interviews are featured herein. In the first place, they granted me their time and attention and, quite often, their domestic hospitality. Moreover, in nearly all cases, they took the trouble to make suggestions for my continued research, supplying me with names and information about additional persons to be contacted. In a very real sense they facilitated my passage through a growing network of actors in the story I wished to tell. They are some of the most extraordinary people I have ever met—courageous, resourceful, and inspiring. Also, quite a number of people gave me advice and in myriad ways assisted me in my research, from providing helpful information to posing challenging questions about my approach to the topic.

In addition to my actual interview subjects, the following persons assisted my research in Paris or elsewhere in France: Elliott Murphy, Françoise Viallon-Murphy, André Gnimagnon, Suzanne Koc, Michel Darmau, Catherine Coquery-Vidrovitch, Christine Pelloquin, Isabelle Lemann, Jean-François Dutertre, Valérie Coudert, Katherine Poinsen, Samba Yatèra, Corinne Serres, Pascale Robert, Suzelle Anstett, Didier Gondola, Gérard Noiriel, Alice Conklin, Vera Mark, David Prochaska, Fanny Pigeaud, Moustapha Diop, Michelle Robert, Christian Genevier, Michelle Kilbourne, Gary Stewart, Brooke Wentz, Andrew Seidenfeld, Babacar Sal, Jacob Winders, Michel Fabre, Emmanuel Diop, Christophe Meyer, Patrice Coulon, Richard Derderian, Jean-Jacques Petit, Alec Hargreaves, and the late Philippe Dewitte. My warm thanks to all of them.

Bouna Ndiaye, Thomas Rome, Jimi Mbaye, Chérif Cissé, Oumar Thiam, Babacar Ndiaye, and Tami Hultman, all helped me with my research in Dakar. Chérif Cissé and his family, as well as Jimi Mbaye, graciously welcomed me into their homes and made my stay in Dakar much more enjoyable. Larry Birnbaum, Jacob Edgar, and Carla Sacks assisted me with interviews in New York City. Thanks to Elizabeth Thompson and Frank Heath for arranging the two interviews in North Carolina.

In Paris I benefited from the considerable resources of CIEMI (Centre d'Études et d'Information sur les Migrations Internationales), where Christine Pelloquin has sustained me with her abundant help and interest in my research. I also express my thanks to the staff (especially Moutapha Diop) of ADRI (Association de la Développement des Relations Interculturelles), now part of the Cité Nationale de l'Histoire de l'Immigration. My thanks as well to the helpful staffs of the Bibliothèque Nationale de France (Tolbiac and Louvois sites), the Bibliothèque de

Documentation Internationale Contemporaine (Nanterre), and the Bibliothèque du Musée de l'Homme.

At the very outset of my research, conversations with Becky Winders and Susan Keefe provided valuable suggestions that helped me to formulate the project. I owe them thanks for sharing their expertise in social science methodology. Scott Haine, Lloyd Kramer, Matt Matsuda, Carl Pletsch, Janine Lanza, Martin Jay, and Linda Orr, all read and critiqued papers and drafts of research proposals, and have encouraged me with their steadfast interest in my work. I am indebted to them. This is true as well of Patrick Ambrose, for whose friendship, encouragement, and admirable writing I am most grateful. Members of the Triangle Area French Studies Seminar (including Alice Kaplan, Mi Gyung Kim, Lloyd Kramer, Michèle Longino, Keith Luria, Linda Orr, Donald Reid, Jay Smith, Philip Stewart, and Steven Vincent) commented critically on my research as it progressed, and made extremely useful suggestions. They provide models of collegiality and scholarly dedication that are beyond compare. I express my thanks to the many conference organizers both in the United States and in Europe for the opportunity to present my work, and to those colleagues who provided valuable critical commentary. These include Tyler Stovall, Charles Rearick, Erica Peters, Samba Diop, Vicki Hamblin, Robin Walz, Leslie Page Moch, Dennis Cordell, Carolyn Sargent, Annemarie Cotaar, and Dirk Hoerder. I am grateful to John Cassini, Robert Weiner, and Jonathan York for inviting me to lecture at their campuses and for their unfailing hospitality.

A full-year research fellowship from the National Endowment for the Humanities enabled me to complete the book. I also must thank the Department of History, the College of Arts and Sciences, the Office of Academic Affairs, and the Graduate School of Appalachian State University for their substantial support of my research. Most gratefully I must single out Marvin Williamsen of the Office of International Programs at Appalachian State. Time and again he assisted me with support for international travel. Colleagues in my own department and elsewhere in the university have been gracious with their encouragement and good conversation. Among the many deserving of mention I certainly want to thank Michael Moore, Michael Krenn, Jeffrey Bortz, Bruce Dick, and Tom McLaughlin. I also warmly thank William Dubin for the gift of several decades of treasured friendship.

Kathryn Goforth transcribed or indexed the majority of the interviews. Her assistance has been of enormous value in the completion of this book. I am grateful for her intelligence and enthusiasm. I certainly have been fortunate in the good counsel and guidance I have received from my editors at Palgrave Macmillan, including Gabriella Pearce and Michael Flamini, who first supported this project.

I express my gratitude to Duke University Press for permission to include material from "Mobility and Cultural Identity: African Music and Musicians in Late Twentieth-Century Paris," *French Historical Studies* 29:3 (June 2006), and to Palgrave Macmillan for permission to republish portions of "*Le Français dans la rue:* Caribbean Language, Music, and the African Diaspora," from *Musical Migrations: Transnationalism and Cultural Hybridity in Latin/o America*, edited by Frances R. Aparicio and Cándida F. Jáquez (2003).

Finally, and most importantly, the love and steadfast support of my family have been the greatest and most sustaining gifts of all. My father, Jack Winders, is ever a

positive force in my life. Benjamin Winders, my son, helped to see me through a very difficult period as this book neared completion, as did my sister Jane and my brother-in-law John Frank. Jacob Winders, also my son, was present in Paris for some of the most important episodes I describe. I can never begin to repay them for all they have done for me. I can only offer my love and gratitude. Throughout my life one person especially has given me abiding love, exceptionally entertaining conversation, and the inspiration of her own work. That person is my sister, Jane Winders Frank. To her I dedicate this book.

Part I

Apparent Embrace:
Les Années Quatre-Vingt

Chapter 1

Sub-Saharan African Musicians in Paris and the Recent History of French Immigration

Paris long has served as a haven for artists from all over the world. Often throughout modern French history, writers, painters, and musicians have joined political refugees fleeing oppressive governments or escaping bloody conflicts. But whether in times of war or peace, creative souls have been drawn to the city long considered a zone of tolerance and interest in the contributions of artistic immigrants. Lloyd Kramer, in a passage that seems perfectly applicable to more recent history, vividly described the sense of possibility the city appeared to embody for early nineteenth-century expatriates:

> The city offered something for everybody: elegance and privilege for aristocrats, a market for merchants, intrigue for diplomats, contacts and ideology for revolutionaries, an audience for writers and artists, jobs for laborers.[1]

If, for the nineteenth century, we think of such artistic foreigners in Paris as Heinrich Heine, Frédéric Chopin, or Rainer Maria Rilke, for the twentieth century our minds turn to Pablo Picasso, Igor Stravinsky, Josephine Baker, Samuel Beckett, or Milan Kundera. In most cases, the creative exiles embraced all that Paris was for them, and Paris returned the favor.

The musicians from sub-Saharan former French African colonies who, rather unexpectedly, made Paris the capital of African pop music during the 1980s and well into the 1990s may be understood as occupying a very recent chapter in the modern history of Paris as artistic host to foreign arrivals. Theirs is a somewhat contradictory story, for their time in the spotlight coincided with an often painful evolving national debate over immigration, national identity, and citizenship. This debate in turn has been framed all around by French anxieties about the nation's place and stature in the world, as well as the encroachments of the products and influence of the American market and the global advance of English-language usage. A peculiar feature of the

French fretting over immigration during the last two decades or so has been the sense conveyed by much of the discussion that immigration is a recent phenomenon. This perception has not been unrelated to the greater visibility of African immigrants since the early 1980s, and the growth of the anti-immigrant politics epitomized by Jean-Marie Le Pen's National Front.

A Neglected History

The persistent but mistaken popular notion that the level of immigration has increased dramatically in recent times, so much so that its presence in French life is unprecedented, depends on the long-standing neglect of the history of immigration to which historian Gérard Noiriel first called attention with his groundbreaking book *Le Creuset français: Histoire de l'immigration XIXe–XXe siècle* (1988; translated and published in English in 1996 as *The French Melting Pot: Immigration, Citizen, and National Identity*). Noiriel, who went on to produce a number of works on the history of immigration in France, eventually became director of research at the École des Hautes Études en Sciences Sociales and has influenced an entire generation of scholars on the subject of immigration in modern France.[2] In *Le Creuset français*, Noiriel called for a new awareness of the central role immigration had played in modern French history and argued that the topic had been ignored in part because historians themselves had internalized enduring myths about the formation of the French national character.

Noiriel attacked the stubborn concept of a French national essence, and went so far as to argue that what we call "France" has consistently been an evolving process. Perhaps one-third of all present-day French people have at least one foreign-born parent or grandparent, he asserted,[3] and for that matter even the supposedly original inhabitants of France can be shown to have migrated from other locales, like most Europeans. In subsequent works, Noiriel even argued against the notion of a native French population—*les français de souche*—pointing out that the earliest inhabitants of what is now France, some two million years ago, migrated originally from the African savannah.[4] The implication of this argument, echoed by other contemporary authors, is that migration is the essence of human activity.[5]

Also in his writings Noiriel has demonstrated that French concepts of nationality have been steeped in contradiction, as is evident in Ernest Renan's influential 1882 lecture at the Sorbonne, "Qu'est-ce qu'une nation?" ("What is a Nation?"). Renan explained that the idea of "nation" contains both an ethnic definition, one dear to philosophers of the Romantic era, and a contractual one, wherein citizens agree to participate in something larger than themselves.[6] As many others have pointed out, the first concept provides the basis for "nationality," whereas the second is the foundation of "citizenship."[7] Much of the confusion at the heart of contemporary debates over questions of national identity and immigration derives from a slipping back and forth between these two very different ideas. Additional confusion and distortion stems from the habit of referring to all persons of foreign ancestry in France as immigrants, even when they have been born in France and have acquired citizenship.

This is one of many tendencies that lead regularly to the overestimation of the number of immigrants residing in France.[8]

Following Noiriel's lead, researchers on the topic of immigration have demonstrated not only that immigration has played a substantial role in French history, but also that France has been the European country most marked by immigration—and indeed the country whose immigrant population has become most thoroughly integrated into the life of the nation.[9] The phrase "French people" therefore designates a multifaceted reality, something composed of varied elements in an ongoing process of historical development. But in times of national crisis (examples include the Dreyfus Affair, the Vichy regime, and the Algerian war), strident voices with the Hexagon have promoted forcefully the idea of an originally pure and true France that has come to be threatened by foreign elements. French anti-Semitism has consistently articulated this view over many decades, making it the most sinister example of what historian Herman Lebovics has described as the ideologically driven concept of a true France defined in ethnic terms as well as in terms of a way of life that has become threatened, according to its champions.[10] Jean-Marie Le Pen's "France for the French" message appeals to those who find themselves fearful or uncomprehending of the movements of people that constitute a major feature of the age of globalization, and the belief in a true France that is in danger of eclipse is found well beyond his hardcore following.

Noiriel and his fellow students of immigration in France have charted the stages and flows of modern migrations that have shaped the country. France, with its declining birthrate already underway in the late nineteenth century, had long needed immigrants to serve as industrial workers. In the early part of the twentieth century, Italians overtook Belgians as the largest immigrant group. They worked unskilled jobs in southern France,[11] and made up much of the workforce that built the Paris Métro. Spanish immigrants, many of whom began arriving during the Spanish Civil War,[12] eventually became the largest group (by the late 1960s). The period between the two world wars also saw a large influx of Polish immigrants.[13]

First Stages of African Immigration

Beginning in 1945 and extending almost thirty years (*les trentes glorieuses*, in the phrase that characterizes a period nostalgically celebrated as one of steady economic growth), France eagerly sought immigration, especially to encourage manual laborers. It was during this time that almost exclusively male African immigrants came to France. Also during the 1960s and 1970s large numbers of Portugese immigrants, many fleeing political circumstances under the Salazar dictatorship, entered France. By 1975 they constituted the largest group from any one nation (some 758,000).[14] The year 1974 marked a profound turning point, as the global energy crisis threatened industrial economies. The presidential regime of Giscard d'Estaing officially put an end to immigration except for those seeking political asylum (in practice, foreign workers continued to arrive, although at a reduced rate).[15] In the short run, the 1974 ban made life difficult indeed for many African workers in France, especially those

caught in the midst of return visits to their countries of origin, forbidden to return once the ban was in effect.[16] In actual practice, the 1974 ban proved impossible to enforce in absolute terms. For example, the first official announcement suspending immigration was followed by a circular designed to put en end to immigration for the purpose of family immigration. In May 1975 the Conseil d'État ruled that this circular was unconstitutional, and so it had to be reversed.

The Giscard d'Estaing presidency was marked by initial rhetoric in favor of humane treatment for immigrants and the announcement of programs meant to improve housing and other conditions and to achieve integration of immigrants into French society. But the rhetoric was not matched by necessary funding, and when it became clear that foreign workers did not intend to leave France, efforts were put in place to bring about their repatriation. In 1977 the secretary of state for migrant workers (a position Giscard created) Lionel Stoléru announced a new program that would pay ten thousand francs to any worker who surrendered his residence permit and returned to his country of origin. The primary target of this effort was the Algerian community, but most who accepted the offer were immigrants from the Iberian Peninsula whose return to their countries had much to do with the improved post-dictatorship political climate there.[17] The ban on immigration was lifted in 1981 when François Mitterrand took office as president, and spouses and children arrived at a significantly higher rate to join the African workers who had arrived years earlier.

The 1980s was the decade in which anti-immigration opinion would most aggressively promote the view that the percentage of immigrants in France had reached an unprecedented level. However, census figures and many demographic studies suggest otherwise. INSEE (Institut National de la Statistique et des Études Économiques), the official French census agency, has published figures that show that the percentage of foreigners in France in the 1980s and 1990s (between 6 and 7 percent of the country's total population) was by no means unprecedented in the twentieth century, comparable in fact to the level recorded during the 1920s.[18] The belief that immigration was increasing like never before clearly was related to the rise in the number of African immigrants. The population originating from the Maghreb (Morocco, Algeria, Tuinisia) had been the traditional focus of what was meant by "African," but during the 1980s the unprecedented level of sub-Saharan African immigration began to have an impact. Still, the numbers were never staggering compared to other immigrant groups. By 1990 the estimated African immigrant population in France, excluding North Africans, was some 240,000,[19] a negligible figure compared to such large groups as Portuguese (650,000), Algerians (615,000), and Moroccans (573,000).[20]

African laborers, recruited by French consulates and other government agencies, began to arrive in France almost immediately after their countries had gained their independence (most between 1960 and 1962). Many came from the Senegal River Valley (which includes parts of Mali, Mauritania, and Senegal),[21] and included such populations as the Toucouleurs, the Sarakolé, and the Soninké. In 1966 recruitment of laborers by the French expanded to include residents of Côte d'Ivoire, Bénin, Burkina Faso, and Cameroon. From just a few thousand sub-Saharan workers in France by the mid-1960s, the number would grow to approximately one hundred

thousand by 1975.[22] Once in France, the exclusively male immigrants were housed in workers' hostels called *foyers*. These were administered by a state agency originally created in 1956 to lodge Algerian workers, but renamed in 1963 as the Société Nationale de Construction de Logements pour les Travailleurs (SONACOTRA), with its mission expanded to accommodate foreign laborers of all nationalities.[23]

While intended to provide better housing for immigrant workers than they could secure otherwise, the *foyers* had the effect of ghettoizing immigrants,[24] much like the public housing developments known as HLMs (Habitations à Loyer Modérés).[25] SONACOTRA, whose official reports later bore the slogan *"Nous logeons ceux qui bougent"* ("We lodge those who are on the go."),[26] over the years has often been the object of complaints by African and other immigrants. Manu Dibango, the very well-known French musician from Cameroon, devoted a section of his autobiography— "Sonacotra Blues"[27]—to it. Within the *foyers*, residents typically sought to reproduce as much as possible the structures and patterns of the villages they had left behind (temporarily, they assumed in the manner of most immigrants). Those from the Sahel region formed numerous associations to address the needs of their home countries, and regularly sent home a portion of their pay, so that the villages from which they had come increasingly became dependent on such support.[28] The Soninké immigrants were known especially for their strong social organization and for the economic support they supplied to their original communities.

Most African immigrant workers in France were unskilled, and many were illiterate. In Paris, the municipal sanitation department—the Propreté de Paris—became known for its employment of black African workers. After 1974 those sub-Saharan immigrants who were able to enter France brought with them a notably higher level of education than that of most other immigrants.[29] Like some of their predecessors from the late 1940s and 1950s, a number of them had come to France to continue their education. For those African families able to afford it, sending their children (especially sons) to France to pursue their studies was desirable as a boost for career prospects and as a means of advancement that could benefit the entire family. Several of the most influential African musicians who settled in France well before the 1980s fit this pattern. The two most prominent examples, both from Cameroon, were Francis Bebey and Manu Dibango. They arrived in Paris during the postwar period associated with the intellectual ferment of the Left Bank, Saint-German-des-Prés in particular. This heyday of Existentialism was not as noted for the reception accorded African and African American immigrants as the 1920s and 1930s had been, but the African presence was nevertheless recognized and jazz clubs flourished.

During the last years of the French colonial empire in Africa and on into the first years of independence, some in France had begun to develop an interest in and appreciation of African music, at least in an ethnomusicological or folkloric sense. The Musée de l'Homme sponsored a number or research trips during the 1950s and 1960s to African countries that resulted in a rich store of field recordings.[30] These provided the basis for what would become the African or "World" (*Musiques du monde*) category for several French record companies, from which some of them would later branch out into contemporary African popular music. The African musician in Paris who perhaps most exemplified the "folkloric" aspect of African music during the period before the 1980s was the versatile performer Francis Bebey.

Francis Bebey

Francis Bebey (1929–2001) came to France in 1951 for the purpose of passing his *baccalauréat* examination.[31] Although he traveled frequently during his long musical career, touring much of the globe and returning often to his native Cameroon, he called Paris home for most of a half-century. Despite his long residence there, Bebey never took French citizenship. This was a deliberate choice, which he explained by saying, "I want to see to what extent a foreigner can live well in France, especially when he comes from black Africa."[32] He was a poet, novelist, musician, and diplomat who authored more than a dozen books and produced a prolific body of recorded work. His performances on vocals, guitar, mouth bow, and *sanza* (also known as *mbira* or "thumb piano") were exercises in ethnomusicology, although the joyousness of the presentation always outweighed the academic component. He was a major cultural ambassador for sub-Saharan Africa, but he deeply loved and identified as well with French culture and received many honors from his host country's cultural institutions.

Francis Bebey grew up the son of a Baptist minister in Douala, Cameroon. The father attempted to discourage his son's interest in the music of his own country, exposing him instead to Bach and Beethoven. However, Bebey was fascinated by the music he was able to hear in the village around him. When he was a very young child, his family brought in a traditional folk healer for his sister who was very ill, and Francis was quite taken with the musicians who accompanied him.[33] As he grew older, he would steal away from home at night with friends to listen to players of such traditional instruments as the mouth bow (*l'arc à bouche*).[34] One result of Bebey's early life between two opposing musical models was that he became a person who loved both and sought to bridge the gulf between them. He became a passionate advocate of African music, both as a multi-instrumentalist performer (especially the guitar and the *sanza*) and as an author. His *Musique de l'Afrique* (in English translation as *African Music: A People's Art*), published in 1969, was one of the very first books devoted to traditional African music.

In addition to being a performer, Bebey worked as a radio journalist in both France and Ghana, and from 1961 until 1974 for UNESCO in Paris[35] as director of its musical division. Truly a Renaissance man, he published more than a dozen novels and collections of poetry, directed films, and composed and recorded a prolific amount of music. He was a master of classical guitar, having been inspired by Segovia, and also featured traditional African instruments in his repertoire. He received many honors over the years, including the literary award *Le Prix Saint-Exupéry* in 1994[36] and also represented Francophone Africa on the Haut Conseil de la francophonie created by President Mitterrand 1984. Francis Bebey always remained a man at home in two cultures—that of the Cameroon to which he remained proudly attached, and that of his beloved adopted city of Paris. He was at once an African cultural ambassador and one who embraced all aspects of Francophone culture.

During his last years, Francis Bebey suffered declining health. I was not sure if it was all right to bother him for an interview, but I decided to try and called his number. Happily, he readily agreed to be interviewed and invited me to his apartment in

a quiet staid neighborhood in the Thirteenth arrondissement. On a drearily cold, damp Paris December day, the apartment seemed especially inviting, filled with books, art, and comfortable furniture. Clad in a warm sweater, Bebey introduced me to his wife, led me into his living room, and invited me to take a seat. In view of the bitter weather, he suggested that I try a glass of a cordial he said was called *Monte au ciel*. He said he would have one too, and that we would "climb up to heaven together." I was soon to have more examples of his famous playful sense of humor: I was seated next to a small stand that held a telephone, and there was just enough space for me to set the glass next to the phone while I sought to balance my tape recorder, pen, and notebook. As he watched me awkwardly arranging myself this way, with eyes twinkling he said that I shouldn't place my glass there because, "My telephone doesn't drink, *monsieur*."

After setting up my tape recorder, I held on to my little glass and we settled into conversation. I said something about his having been called the "father" of world music in Paris, and he dismissed this by saying, "I have no idea who made that up. I am certainly the father of my children, so why not the father of music too? I'm not afraid of anything!" I then explained that I had been researching especially the period of the 1980s and was very interested in talking to him since he had settled in Paris long before that period. He cautioned me that he believed one needed more chronological distance than a mere twenty years or so for a real historical perspective, but that he did not want to prevent me from the perspective of the "instant present," which, after all, could be very interesting too. He was much the man of letters as well as an artist, and clearly wary of historians.

Even though, as he admitted, the audience for African music and performance had been small during the 1950s (when he had first arrived in Paris), he felt drawn to that period and wanted to remind people of the figures who had brought African art to France then. He discussed the musical and dance troupe led by Keita Fodeba of Guinea, who performed in France and throughout Europe during the late 1950s.[37] Bebey pointed out that the group included members from several African countries. We discussed the more recent history of African musicians in Paris, including the popularity by the late 1990s of more traditional kinds of performance, somewhat in reaction to the hybrid pop music of the 1980s and early 1990s. He became very animated about this subject, declaring "it is time that Europeans begin to get to know the real African music," which is played on instruments such as the *kora* (large West African harp-lute of twenty-one strings) and the *n'goni* (small four-or five-string lute) instead of "synthesizers."

In other interviews, Bebey has made it clear that by "real" African music, he does not mean music frozen in time and clinging to tradition. This passage, worth quoting in full, is characteristically passionate and forceful:

I see myself as an authentic African, but as an African of the twentieth century. And I have no intention at all of changing my behavior in order to do a favor to some Germans, Russians, Americans, Englishmen, or Frenchmen. I don't want to be an African according to their opinion. I want to be the African I am: somebody who can think and turn out intellectual and artistic products suitable to the African of the present, and to what his ancestors might have been. To expect me, an African musician of

the twentieth century, to produce ancestral music is an insult to me, to my art, and to my audience, which I would have to deceive. I mistrust organizations that, perhaps, believe that African musicians should play tom-toms on stage. Nothing against tom-toms, I use it myself if it corresponds to something in my present life. But I never use it to do a favor to my audience.[38]

When I asked him about the impact he believed he and other African musicians had made on French culture, Bebey was guarded, saying,

I think attitudes (*mentalités*) are in the process of changing, but not as rapidly as I would wish. But the French are people like everyone else, and people do not like to change.

Then he added, meaningfully, "French people do not change as fast as me, as I would want." He clarified this somewhat enigmatic remark by explaining that there remained a great majority of the French population who were still unexposed to the "truth" of African culture. This moment was typical of the interview—of the way Bebey would alternate between modest disavowal of his impact and strong advocacy of the culture he sought to promote.[39]

In the course of the interview, Francis Bebey spoke at length about his approach to his music and the way his love of music developed during his formative years. He described the contradictory responses he has come across, including occasional resistance encountered to his performance of, for example, the music of Bach. Those who reacted negatively did so, in his opinion, out of the conviction that Africans should play strictly African music. Yet he viewed himself as someone seeking to encourage love of African music, so that his resentment of European audiences insisting that he confine himself to it put him in a highly paradoxical position. His love of playing "very African music" itself derived from an early prohibition, for as a child he was "forbidden to get to know African musics." To express the complex aims of his music, Bebey had coined a term composed of elements from key words in English, as it happened. This "umbrella" term, he said, was "amaya," standing for "African, modern, and yet authentic."

Bebey spoke forcefully about the opposition he experienced in his childhood between the music heard in church and that he experienced within the deeper recesses of the village that made up his part of Douala. While the first music to which he was exposed was that within his father's church, the alternative was available in the form of

pagan musics that were marvelous. To my way of thinking, ten times more beautiful than the canticles in the churches . . . My father did not succeed in turning me away from that music.

"That music" turned out to be the music performed by the village "sorcerer" Bebey and his friends sneaked out of their homes to hear late at night. He was

a man who played his music very late at night, because, people said in the village, it allowed him to communicate with the devil . . . and me, I would go like other village children to listen to his music, very late, I think it was around midnight, perhaps.

We would go out of the house, out of the house that was never locked, children went out to go to the home of the neighbor who played music for the devil. And it was beautiful, it was marvelous! And that permitted me to decolonize myself.

"Decolonize your mind?" I asked. "Oh yes, my head," he replied, then went on to say "I was decolonized well before the decolonization of my country."

Bebey spoke as well about the relationship between music and daily life in Cameroon, for example, that women near his home milked cows or prepared rice or corn to music. He declared,

[The village] was full of music, music that had nothing to do with canticles. Thank God! And that music formed me. It even permits me to live in an apartment in the Thirteenth Arrondissement of Paris.

Although he began to play guitar during his teenage years, it was only much later in life (When he was forty-five) that he became a musician, professionally speaking. As he explained it,

I started my life as a radio man, first, and next I became a so-called specialist in educational radio in countries under development by UNESCO. And one day I slammed the door on UNESCO, saying "I want to earn my living as a composer of music and a writer."

My meeting with Francis Bebey was nearing its end, and he wanted to play the *sanza* for me. He went into another room to get the instrument, and came back with it and sat on a sofa to play. His face was a picture of sheer delight as he played the thumb piano, showering us with what seemed like enough sound to have emanated from an entire orchestra. I expressed my surprise at the amount of sound he could get from the instrument, and he responded by insisting that I take copies of two of his recent CDs featuring the instrument. I thanked him and took my leave regretfully, promising myself that I would visit again someday. Less than six months later, I learned of his death from a heart attack at the age of seventy-two. His passing away was met with an outpouring of grief in the French media, who acknowledged him as a major African cultural ambassador for the Francophone world and beyond.[40]

Manu Dibango

Another immigrant from Cameroon who arrived in Paris during the same era as that in which Bebey made his appearance was tenor saxophonist and bandleader Manu Dibango (1933–). Like his counterpart Francis Bebey, Dibango has played an important role in representing African culture and in introducing the French to African music, and he has been more consistently in the spotlight. With his deep, booming voice and shaved head and mirrored sunglasses, he has become a much more widely recognized and iconic presence in French culture today, something already well-established even before the appearance in 1989 of his best-selling autobiography

Trois kilos de café. During the 1990s he was featured in a memorable pose used for an Air Afrique ad, and also in the cover photo for his 1994 CD *Wakafrika*.[41] In the image, Manu Dibango's body, standing and photographed at an angle from above, becomes the representation of the African continent. His elbow juts out to the side and his hand cradles his slightly bowed head, so as to suggest the Northwest of Africa. His jacket, torso, and hips suggest the center of the continent, and his legs and feet trail off to the bottom, as a free-floating Madagascar lines up with his lower left leg. Dibango has received many honors in France, including being named Chevalier des Arts et des Lettres.

The title of his autobiography refers to the actual payment he brought from Cameroon for his first term in a French boarding school to where he traveled after arriving in Marseilles in 1949.[42] After completing his schooling in 1957, Dibango moved on to Brussels, both to enroll in university and to work in a jazz club. Soon after arriving in Belgium he met the model and actress "Coco," who would later become his wife, musical collaborator, and business associate. Manu's educational aims soon gave way to his musical career, which received a significant boost when he joined Joseph Kabasele's legendary band from Zaïre, African Jazz. From Brussels Dibango made several trips to play music in African countries, first in 1960 to Abidjan—the capital city of Côte d'Ivoire, which was becoming an important center of African music. He accompanied African Jazz on a month-long tour of the newly independent country of Zaïre in 1961. With Coco, he also spent a great deal of time back in Cameroon, but by 1965 they had moved back to Paris, which would remain their base.[43]

Trips back to Cameroon as well as to much of the rest of the world continued over the succeeding decades. Côte d'Ivoire was a country he visited often, including extended stays for recording and performing. In 1975 he received an official government invitation to organize a national orchestra there.[44] In 1973 Manu Dibango recorded his very successful record "Soul Makossa," a dance hit on the American Motown label that sold more than two million copies worldwide. It was the first international "hit record" for an African musician, and it catapulted him into a position of great prominence—certainly the best-known African musician in Paris for many years. The success of "Soul Makossa" also brought about a U.S. tour that included a memorable concert at Harlem's Apollo Theater.[45] For African musicians in Paris, especially the significant number that had begun to arrive during the 1980s, Manu Dibango became an indispensable resource and inspiration.

Late in 2000, I interviewed Manu Dibango in Le Bar des Ondes, a location he suggested since it sits just next to the imposing landmark La Maison de la Radio-France in a bustling area of the Sixteenth Arrondissement. This was convenient for Dibango since he was to tape a television show that day (La Maison de la Radio-France is also used for this purpose). Our rendezvous site turned out to be a particularly crowded, noisy café, certainly not the ideal spot for an interview. We sat at a small table—he, a colleague from the television studio, my son Jacob, and me. Cigarette smoke, a significant share of which Manu Dibango was generating, enveloped us as we leaned into the conversation. Interruptions were rather frequent, invariably because a young admirer wanted to pay respects to the instantly recognizable star. In one case, an aspiring singer asked if she could send him a demo tape.

He consented. As new patrons entered the establishment, there were successive waves of recognition, often in response to his booming laugh. You could sense people saying to themselves, "Look—that's Manu Dibango!"

Dibango began the interview by talking about the inseparability of the topic of immigration from that of African music in France. "The immigration of people is the immigration of music," as he put it.[46] Perhaps understandably, he wanted to emphasize the importance of the period just after World War II. Describing in general terms the patterns that matched his own experience of coming to France, he said,

> There were accords between France and its colonies to send the best—in principle— African children to continue their studies in France . . . but you had to have the luck of having parents who had the means, or the government might give you grants because you were the son of "someone," in short. Then, all the Africans coming from Côte d'Ivoire, from Senegal, from Cameroon, from Congo, from Gabon, etc. would meet again in France in *lycées* and in French families. And in summer, they would meet again in summer camps.

As well as being from all over Africa, the students who came to France were a diverse lot in terms of interests. Some, Manu said, were musicians, some dancers, and "there were those who loved football." The first experience that "brought the blacks together in France was the Guinean named Keita Fodeba," referring to the same dance artist Francis Bebey had emphasized. This, Manu said, "was the beginning of something"—of a sense of African cultural identity in Paris. From this point, he said, "artists began to emerge little by little."

To be a student in Paris at the beginning of the 1950s was to experience a time of enormous cultural ferment, Manu remarked, for it was the time of Sartre and Beauvoir, Saint-Germain-des-Prés, and jazz clubs. This was the era known for the presence in Paris of celebrated African American writers such as Richard Wright and James Baldwin, and of course such jazz greats as Dizzy Gillespie and Charlie Parker. Dibango spoke of the influences he was absorbing from these and other musicians, including Louis Armstrong, Duke Ellington, and "Be-Bop with Miles Davis." He referred especially to the Miles Davis album *The Birth of the Cool.* "We were deeply in that culture," he said, "and we didn't drink Coca-Cola. We drink Beaujolais here."

Within the circle of African students in Paris during the early 1950s, the person who really stood out, Dibango said, was Francis Bebey. He called him a "Cameroonian musicologist" and "a very great musician," whose children had also become musicians. Manu said,

> [Bebey] was one of the first to make known American musical technique. In fact, it was Francis Bebey who taught me the blues; the blues measure. What is more, he married my cousin from Cameroon . . . He has been one of the men who has influenced me enormously. At home in Cameroon, there was also as you know since you read the book (*Trois kilos de café*), a choir leader who equally influenced me.

Dibango emphasized as well the importance of what he learned musically through interaction with his fellow African students in Paris. During the 1950s, they, whether Cameroonian, Senegalese, Ivoirean, and so on, were able to move about as they

pleased in France, because "we weren't immigrants; we were French." Together they formed a "small nucleus of African musicians, but I should say Afro-Europeans after all, shouldn't I? Because we learned the music here and not in Africa." He went on to clarify the point that his "small nucleus" of musicians was made up of Cameroonians and those from the two Congos (some of whom, in the 1950s, were technically Belgian).

The African identity, he explained, was secondary in that period to being simply "musicians." "There was not yet the question of African music," Manu stated. He went on to argue that, even after Paris became identified much later as a center of African music, the most prominent African musicians were those who, like himself, had begun their careers in Europe.

> When I came back to Paris in the years 1965–1966, I started to work in a big record company here, and it was Polygram. I was somewhat the house arranger. So I arranged for all of the Africans who came, whether from Senegal or Cameroon. I did that then for five seasons, from the time a new generation began to arrive, things like that. That permitted me to get to know the urban music of Côte d'Ivoire, the music of Gabon, the music through the singers.

It was not yet, he explained, the period of "the African stars." However, singers who wanted to record in Paris but were unable to afford the expense of bringing band members with them could benefit from the musicians Dibango could assemble for recording sessions. "I accompanied everybody," he said. The network of musicians around Manu Dibango, which had formed by the late 1960s and early 1970s, would grow larger and more significant after 1981, when sub-Saharan Africans moved more freely across French borders.

The 1970s

The 1980s is the decade usually associated with African music in Paris, but already during the 1970s some well-known Francophone African musicians were coming there to perform. Lamine Konté (1945–) of Senegal even moved there in 1971. He was a player of the *kora*, associated with the traditional combination performer–storyteller–ceremonial figures known as *griots*. Later, he would become involved in pop music, especially through his work with Stevie Wonder.[47] African musicians who relocated to Paris during these years were driven by economic necessity and by the lack of a sufficiently developed structure for the music business in their countries.[48] In December 1970 the influential singer Tabu Ley Rochereau (1940–) from Zaïre became the first African singer to headline at one of the *grandes salles* of Paris, the Olympia. There had been some concern about how the music would be received,[49] but the concert was a great success and boosted his international career significantly.[50] The success of Tabu Ley's Olympia appearance led the theater to book other acts from Zaïre. For example, the singer Abeti Masikini (1956–) had a breakthrough concert there the following year that much enhanced her status back in Zaïre.[51]

Musicians from Zaïre gradually began to make their way to Paris during the late 1970s, some for brief stays to record, and others to base themselves there. A guitarist and singer named Péla Nsimba (1955–), who performed as Péla Simba and had been successful in Zaïre in a late-1960s/early-1970s band called Thu Zaina, was an example of the latter.[52] He arrived in 1977.[53] The first record shops specializing in African music began to appear during the mid-1970s, one of the first being Afric Music in Montparnasse.[54] In 1976 Eddy Gustave, a jazz musician from Martinique, opened a record shop near Père Lachaise Cemetery, where he sold Caribbean and African music. In 1978 he moved into production and began inviting musicians from Zaïre to come to Paris to record.[55] By the late 1970s touring Zairean performers such as Tabu Ley Rochereau, Franco, or Papa Wemba passing through Paris found a small but significant community of musicians from their country living there.[56]

Word of the excellent quality of Parisian recording studios began to circulate, and more and more African musicians began to seek out the advantages they had to offer. Sensing an opportunity to draw more attention to the growth of African music in an international context, Manu Dibango, someone routinely sought out by African musicians soon after their arrival in Paris, established the magazine *Afromusic*, although it ceased publication in 1978 after twenty-two months.[57] In 1979 the Senegalese group Touré Kunda, who would become very prominent in Paris just three or four years later, moved there.[58] Generally speaking, there was as yet little visibility of the communities of African musicians in Paris. One of the people who did the most to change that was Mamadou Konté.

Mamadou Konté

In 1978, by which time Paris was beginning to emerge as a destination for African musicians, a remarkable and enterprising immigrant named Mamadou Konté (1948–) announced the formation of "Africa Fête," an organization that would sponsor concerts featuring African musicians and related cultural events, as well as an annual festival bringing together a large number or participants. Africa Fête grew out of earlier associations formed by Konté and his political allies that were aimed at improving conditions for African immigrants in the Paris region. Konté expressed the hope that his new organization would encourage cross-cultural understanding by exposing French people to African music and art. "If they listen to us, they will understand us," he declared.[59] Later, speaking on the role of Africans in Europe, he remarked memorably, "The Europeans colonized us. Now we've come to Europe. Not to colonize but to civilize."[60] Tall, lean, bearded, and especially distinguished by dreadlocks peeking out from underneath his trademark fedora, Konté was to become a most recognizable figure on the Parisian music scene.

Mamadou Konté is a member of the generation of laborers who migrated to France during the economic boom years—in his case, in 1965. His story is fascinating, as I learned first-hand when I interviewed him in 1998. By that time he had spent almost thirty years in Paris, moving himself and his organization to Dakar in 1994. From his base there, Konté organized the first Africa Fête tour of the United

States for the summer of 1995.[61] The year 1998 marked the second such tour, which began with a concert in New York City. I interviewed him the following day at a record company office in the Empire State Building.

He was born in Mali among the Soninké people, and later migrated to Senegal and became naturalized as Senegalese. Seventeen years old and illiterate, he sailed for France in 1965, landing in Marseilles and then making his way to Paris.[62] In describing his path to becoming an immigrant, Konté spoke of his village Tambacounda,[63] estimating that there were at least eight fellow villagers who preceded him in that status. Speaking thoughtfully and deliberately in his deep voice, he explained more about the generation that preceded his:

> In the first place, the history of immigration for me begins with the army. Yes, with the men who came to fight the war in France. Then after the war, these people returned to the village. Some had begun to speak French. And then also there were missionaries who passed through our villages to look for immigrants.[64]

He pointed out that Paris was not the immediate destination at that time, since one traveled by ship. People went to Marseilles or Bordeaux, for example. While he was preceded by the others who had emigrated from his village, "I was the first of my family to come to France," Konté said.

When he arrived in France, he carried the address of a hotel in Saint-Denis, north of Paris, where some of the men from his village resided.[65] He found work in a metallurgical factory in the northern Paris suburban town of Aulnay-sous-Bois, where he worked for four years. After that, said Konté, "I worked in construction, because I realized that after four years I wasn't making enough money, and I quit. In those days it was very easy to find work." He stayed with the construction work for two years, and then moved on to a textile factory in Saint-Denis. Then he returned to metallurgy "to learn how to be a skilled worker."

Mamadou became radicalized through his experiences and through his interaction with coworkers, some of whom played a decisive role in his education. This was particularly true of the Algerian comrades who taught him to read so that, he explained, he could explore the works of Marx, Engels, and Lenin. His political activism was heightened by the events of May 1968, and he was in frequent contact with the student revolutionaries. Many such persons would become Mamadou Konté's allies in the cultural politics of the following decades. A prime example is Jean-François Bizot, editor of the early 1970s countercultural magazine *Actuel* who went on to found Radio Nova, the FM station closely identified with African and other world music.[66] For his part, Konté was moving more and more to agitate on behalf of foreign workers in France. He knew from his immediate experience the plight of immigrant workers:

> We worked in very bad conditions. We lived in dormitories that made conditions worse. For example, if one of the men was sick, everyone was at risk of becoming ill. We took part in strikes to fight against bad conditions. Between 1970 and 1978, then, I was in the factory, but at the same time I lived in the *foyer*, but also engaged in syndicalist struggles to help immigrants to improve their living conditions. In 1978, I started to make "militantism" through music, that is to say, to get artists to come to the *foyers* to put on cultural performances.

Such performances, he said,

> Enabled me to win over the audience of Saint-Denis who came to our *foyer* for the performances. Because that permitted us at the same time to show our living conditions, to ask that they unite with us to have a French force by our side to fight against bad living conditions.

These conditions certainly were deplorable, matched with the extremely low wages many workers earned. "For example," said Konté, "when I started to work I earned two francs an hour, less than half a dollar." In response to one of my questions, he said he had lived in several different *foyers*. The first was called "L'Accueil Promotion," and had been established by French missionaries who had been active in West Africa. Their intent was to create beneficial conditions for immigrant workers, but, said Konté, "I think they did not have the means to make conditions better." He spoke of SONACOTRA, pointing out that this organization had been established in response to the agitation by immigrant workers. It did lead to some improvements, for "you could find two people in a room, with a toilet outside, whereas in the old system twenty people had the same toilet. Twenty people had two showers." Still, SONACOTRA, mocked as "sleep merchants,"[67] would remain a target for mobilization by groups agitating on behalf of immigrants.

The *foyer* was comparable to life in a prison, Konté said:

> You could come back after Eight O'Clock at night except for those who worked at night. When you worked nights, you had a card that permitted you to come back at whatever hour of the night you needed. It was a little like the army, because there were guards.

By calling attention to the living conditions immigrant workers endured, Konté's activism helped to break down the ghetto-like (he compared it to *apartheid* South Africa) existence in neighborhoods people came to see as slums. By the late 1960s the demand to clean up such places had reached a significant level. "Blacks have the right to live wherever they want," Konté said.

In 1973 Konté founded "Révolution Afrique," which he described as an organization in solidarity with revolutionary movements in Africa that would address Africans and their concerns in France, including the continuing problem of conditions in the *foyers*. To do this, Konté's organization, allied with parties of the left such as La Ligue Communiste Révolutionnaire would organize both political meetings and cultural events. It was out of this mix of efforts that the impetus for Africa Fête was formed. "Africa Fête for me was a continuation of la Révolution Afrique," Konté declared. The musical connection came about through the donated services of singers sympathetic to the cause. One of these was François Béranger (1937–2003), a musician and political activist who had played a leading role in the uprising of May 1968.[68] He gave a series of benefit concerts for Mamadou Konté's organization in 1976, even paying for the posters that publicized the events.[69] In 1979 Béranger commemorated his encounter with Mamadou Konté through a song that became a radio hit: "Mamadou m'a dit" ("Mamadou told me").[70] Another well-known musician who performed in the same concert series was Pierre Akendengué (1942–), a politically outspoken blind singer

from Gabon who, much like Francis Bebey and Manu Dibango, had come to France originally to complete his studies.[71] Akendengué arrived in 1964, and came to prominence for his recordings and performances especially during the 1970s.[72] Thus, he was something of a precursor figure for African musicians in Paris.

Konté continued to enlist musicians to aid his efforts, and began to organize efforts for African workers who were being urged to return to Africa through a government incentive program that offered them ten thousand francs apiece. His reaction was to create an association for the "creative return" of African workers. Relatedly, he sought to support development projects in Senegal, including agricultural apprenticeships and the opening of a library in Thiès. These activities led directly to his founding of Africa Fête in 1978.[73] For the next two years, Konté continued with both of the organizations he had started, with Révolution Afrique for more explicitly political aims, and with Africa Fête for the cultural realm. As African musicians had begun to gather in Paris by the late 1970s, and then a dramatic change in immigration policy that brought many more was introduced after President Mitterrand took office in 1981, Africa Fête was well-positioned to play a major role in placing a spotlight on the new Paris-based musical phenomenon.

Notes

1. Lloyd Kramer, *Threshold of a New World: Intellectuals and the Exile Experience in Paris, 1830–1848* (Ithaca, 1988).
2. Studies of immigration in modern French history include Gary S. Cross, *Immigrant Workers in Industrial France: The Making of a New Laboring Class* (Philadelphia, 1983); Michèle Tribalat, *Cent ans d'immigration: Étrangers d'hier, Français d'aujourd'hui* (Paris, 1991); and *De l'immigration à l'assimilation: Enquête sur les populations d'origine étrangère en France* (Paris, 1996); Patrick Weil, *La France et ses étrangers* (Paris, 1991); Philip E. Ogden, "Immigration to France Since 1945: Myth and Reality," *Ethnic and Racial Studies* 14:3 (July 1991): 294–318; Yves Lequin, *Histoire des étrangers et de l'immigration en France* (Paris, 1992); Maxim Silverman, *Deconstructing the Nation: Immigration, Racism and Citizenship in Modern France* (London, 1992); Alec G. Hargreaves, *Immigration, "Race" and Ethnicity in Contemporary France* (London, 1995); Ralph Schor, *Histoire de l'immigration en France de la fin du XIXe siècle à nos jours* (Paris, 1996); Laurent Gervereau, Pierre Milza, and Émile Termine, eds., *Toute la France: histoire de l'immigration en France au XXe siècle* (Paris, 1998); Marie-Claude Blanc-Choléard, *Histoire de l'immigration* (Paris, 2001); and Jane Freedman, *Immigration and Insecurity in France* (Aldershot, 2004).
3. Gérard Noiriel, "Preface to the English-Language Edition," *The French Melting Pot: Immigration, Citizenship, and National Identity*, trans. Geoffroy de Laforcade (Minneapolis, 1996): xii. Among his many other works, see *Population, immigration et identité nationale en France (19e–20e siècles)* (Paris, 1992) and *État, nation, et immigration; vers une histoire de pouvoir* (Paris, 2001).
4. Noiriel, *Population, immigration et identité nationale en France*: 44.
5. See, e.g., Bruce Chatwin, *The Songlines* (New York, 1987).
6. Noiriel, *État, nation, et immigration; vers une histoire de pouvoir*: 222.
7. Isabelle Taboada-Leonetti, "Citoyenneté, nationalité, et stratégies d'appartenance," in *Pluralité des cultures et dynamiques identitaires: Hommage à Carmel Camilleri*, ed.

Jacqueline Costa-Lascoux, Marue-Antoinette Hily, and Geneviève Vermes (Paris, 2000): 97–98.

8. Jane Freedman cites as an example of this syndrome a 1991 article by former president Giscard d'Estaing in *Le Figaro*. Freedman, *Immigration and Insecurity*: 17.

9. Miriam Feldblum, *Reconstructing Citizenship: The Politics of Nationality Reform and Immigration in Contemporary France* (Albany, 1999): 13. See also Silverman, *Deconstructing the Nation*: 10.

10. Herman Lebovics, *True France: The Wars Over Cultural Identity, 1900–1945* (Ithaca, 1992).

11. Hargreaves, *Immigration, "Race" and Ethnicity in Contemporary France*: 9.

12. "L'immigration en France," *l'Humanité* (June 11, 1996): 16.

13. Hargreaves, *Immigration, "Race" and Ethnicity in Contemporary France*: 9.

14. Ibid.: 13–14.

15. "L'immigration en France": 16.

16. Jacques Barou, "Espaces migratoires pluriels des africains en France," *Annales de la recherche urbaine* 49 (December 1990): 101.

17. Freedman, *Immigration and Insecurity*: 34–36.

18. Hargreaves, *Immigration, "Race" and Ethnicity in Contemporary France*: 8.

19. Ibid.: 79.

20. "L'immigration en France": 16.

21. Christophe Daum, "Quand les immigrés du fleuve Sénégal construisent leur pays," in Institut PANOS, *Quand les immigrés du fleuve Sénégal construisent leur pays*, Actes du colloque Immigration et développement de la vallée du fleuve Sénégal (Paris, 1993): 17.

22. Pascal Blanchard, Éric Deroo, and Gilles Manceron, *Le Paris noir* (Paris, 2001): 158.

23. Hargreaves, *Immigration, "Race" and Ethnicity in Contemporary France*: 69.

24. Ibid.: 70–71.

25. Abundant detail about life in the HLMs can be found in Guy Boudimbou, *Habitat et modes de vie des immigrés en France* (Paris, 1991).

26. SONACOTRA, *Les Bilans sociaux, les bilans d'activité et les états financiers, 1983–1994*: Carton 1 of 7: Archives of the Bibliothèque de Documentation Internationale Contemporaine, Nanterre.

27. Manu Dibango *en collaboration avec* Danielle Rouard, *Trois kilos de café* (Paris, 1989): 203–208.

28. Daum, "Quand les immigrés du fleuve Sénégal construisent leur pays": 17.

29. Michèle Tribalat, *De l'immigration à l'assimilation: Enquête sur les populations d'origine étrangère en France*, avec la participation de Patrick Simon et Benoît Rianley: 259.

30. Elizabeth J. Miles, "Immigrant Music in Europe," in *The Garland Encyclopedia of World Music, Volume 8: Europe*, ed. Timothy Rice, James Porter, and Chris Goertzen (New York, 2000): 233.

31. Nago Seck and Sylvie Clerfeuille, *Les Musiciens du beat africain* (Paris, 1993): 66.

32. Francis Bebey, author interview, Paris, December 2, 2000.

33. Nidam Abdi, "Francis Bebey, l'homme de la sanza," *Libération* (July 13, 2000).

34. Seck and Clerfeuille, *Les Musiciens du beat africain*: 66.

35. D.R., "Biographie résumée de Francis Bebey," *Africultures* 49 (June 2002; dossier "Francis Bebey: l'homme-orchestre"): 57.

36. Boniface Mongo-Mboussa, "L'humanisme discret de Francis Bebey," *Africultures* 49 (June 2002): 39–40.

37. François Bensignor, "Africains en France: la compile," *Hommes & migrations* 1191 (October 1995): 31.

38. Quoted in Wolfgang Bender, *Sweet Mother: Modern African Music*, trans. Wolfgang Freis (Chicago, 1991): 70.

39. Francis Bebey, author interview, Paris, December 2, 2002. Unless otherwise indicated, all information on Francis Bebey is based on this interview.

40. The article by Bouziane Daoudi, "Francis Bebey rejoint l'eau et le vent," *Libération* (May 29, 2001) provides an affectionate example.

41. Manu Dibango, *Wakafrika* (Giant Records, 1994).

42. Manu Dibango *en collaboration avec* Danielle Rouard, *Trois kilos de café* (Paris, 1989): 24; translated as *Three Kilos of Coffee: An Autobiography by Manu Dibango in Collaboration With Danielle Rouard*, trans. Beth G. Raps (Chicago, 1994).

43. Dibango, *Trois kilos de café*: 56–97.

44. Graeme Ewens, *Africa O-Ye!: A Celebration of African Music* (New York, 1992): 77.

45. Dibango, *Trois kilos de café*: 139–154.

46. Manu Dibango, author interview, Paris, December 7, 2000. Unless otherwise indicated, all information on Manu Dibango comes from this interview.

47. Seck and Clerfeuille, *Les Musiciens du beat africain*: 148; Blanchard et al., *Le Paris noir*: 161.

48. Christian Mousset, "La Musique africaine et la France," in *Étudiants africains en France 1951–2001: cinquante ans de relations France–Afrique: Quel avenir?*, ed. Michel Sot (Paris, 2002): 165.

49. Gary Stewart, *Rumba on the River: A History of the Popular Music of the Two Congos* (London, 2000): 167–168.

50. Seck and Clerfeuille, *Les Musiciens du beat africain*: 204.

51. Stewart, *Rumba on the River*: 191–192.

52. Ibid.: 244.

53. Péla Simba, author interview, Paris, July 16, 1997.

54. François Bensignor, "Africains en France: la compile," *Hommes & migrations* 1191 (October 1995): 32.

55. Stewart, *Rumba on the River*: 256.

56. Ibid.: 243–244.

57. Bensignor, "Africains en France: la compile": 34.

58. Blanchard et al., *Le Paris noir*: 161.

59. Michel Raffoul, "Dix ans de fêtes en noir et blanc," *Jeune Afrique* (June 1–6, 1988): 42.

60. Eric Charry, *Mande Music: Traditional and Modern Music of the Maninka and Mandinka of Western Africa* (Chicago, 2000): 307.

61. Dan Rosenberg, "Fest Western: Afro-Pop's Best-Known Touring Festival Returns to America," *Rhythm Music* VII:6 (June 1998): 28.

62. Frank Tenaille, *Le Swing du caméléon: musiques et chansons africaines 1950–2000* (Arles, 2000): 182.

63. Ibid.: 182.

64. Mamadou Konté, author interview, New York City, July 6, 1998. Unless otherwise indicated, all information on Mamadou Konté is based on this interview.

65. "Mamadou Konté," *Afromix:* http://www.afromix.org/html/musique/labels/Africa_fete/mamadou.fr.html.

66. Bintou Simporé (Radio Nova), author interview, Paris, June 26, 1995.

67. Tenaille, *Le Swing du caméléon*: 182.

68. "François Béranger," Radio France Internationale: http://www.rfimusique.com/siteFr/biographie/biographie_14852.asp.

69. Bensignor, "Africains en France: la compile": 33.

70. Ibid.

71. Tenaille, *Le Swing du caméléon*: 55, 183.

72. Blanchard et al., *Le Paris noir*: 188–189.

73. Tenaille, *Le Swing du caméléon*: 183.

Chapter 2

New Immigrants, New Music, 1981–1985

It is clear that a small but critical mass of African musicians had gathered in Paris by the late 1970s, just as it is clear that the 1974 ban on further immigration was never absolute in practice. When the presidential election of May 1981 brought the Socialist Party candidate François Mitterrand to office, the subsequent changes introduced by a government of the left significantly accelerated the flow of African immigration and, in the cultural sphere, boosted the emerging Paris-based African music network. The ban on new immigration was lifted, which resulted in significant numbers of women and children entering France to join the men who had preceded them.[1] By the early years of the new decade, the number of sub-Saharan immigrants rose to over five thousand per year, with women and new male arrivals almost evenly matched.[2]

One of the most far-reaching changes in French law was inaugurated by the law of October 9, 1981 that granted the right of association for foreigners (*étrangers*) residing in France—an expansion of the original 1901 law for French citizens.[3] For African immigrants living in the *foyers*, the new law simply legitimated the village-based associations they had brought with them from Senegal, Mali, or other countries.[4] But the law also helped make possible the formation of new cultural associations, some of which musicians would organize, and served as a means for the French government to communicate its policies to newer immigrants.[5] From another viewpoint, some have argued that the October 9 law encouraged the kind of separation into ethnic communities—what one scholar of immigration has called the "politicization of identities"—that has been known to offend French republican sensibilities.[6]

The government of Prime Minister Pierre Mauroy came to an end in July 1984,[7] but did so as the National Assembly passed dramatic legislation granting ten-year residency permits for immigrants regardless of employment status. They were to be automatically renewable. This very significant step brought an end to the long-standing definition of the immigrant as a foreign worker, or as Catherine Wihtol de

Wenden, a widely recognized researcher on the topic, expressed it, the legislation shifted the emphasis from "foreign worker" to "foreign resident."[8] The legislation meant that the immigrant population was now to be seen as a component of French society rather than as a source of temporary labor.[9] This also was a high point of support for recent immigrants from which subsequent governments would retreat, as Jean-Marie Le Pen's *Front National* gained strength and an increasingly sensationalist media fanned the flames of xenophobic resentment. Still, for much of the 1980s, the French political establishment enjoyed a reputation, deserved or not, for extending a welcome to immigrants. Much of this reputation stemmed from government sponsorship of cultural events and activities that placed a spotlight on musicians (including those recently arrived from Africa) and other artists.

The government that took office under President Mitterrand featured a beefed-up Ministry of Culture (the post created in 1957 by André Malraux) with a very high-profile minister, Jack Lang (1939–). He had the vision and the inclination to put into practice policies that embraced the cultures of France's newest immigrants, and he presided over a ministry with a newly doubled budget.[10] Lang reached out to African musicians and gave them, so to speak, the stages on which to perform in France. He frequently provided legal and financial assistance to individual musicians.[11] Lang's ministry greatly increased government support for the annual music festivals in Angoulême ("Musiques métisses," founded in 1976) and Bourges ("Le Printemps de Bourges," founded in 1977), and helped steer them much more in the direction of what would come to be called "World Music." He launched the annual national music festival known as "Fête de la Musique," which was held first in Paris in 1982. Intended originally as an opportunity strictly for musical amateurs to perform, it spread to the rest of France and throughout much of the world eventually. Over the years this June 21 event has exposed French people to a wide range of African musicians. Later Lang himself would write, in a preface to a book profiling African musicians, that, "Little by little, France becomes mixed, colors (*se métisse, se colore*)."[12]

According to government statistics published in 1992, between 1975 and 1982 the African population in France practically had doubled from 80,000 to 160,000, with especially sizeable increases in numbers of women and children. This was true particularly of the Senegalese and Malians.[13] By 1990 the number of sub-Saharan African immigrants in France would rise to approximately 240,000.[14] That figure was the one reported by INSEE (Institut National de la Statistique et des Études Économiques), and some have argued that it sharply underestimated the true number, which could have been as high as 300,000, perhaps even 400,000, especially taking into account the heavy concentration of African immigrants in the Île-de-France, where their numbers overwhelmed the government agencies set up to deal with them. The Senegalese and Malians were largest in number.[15] The true total number of African immigrants no doubt was and remains unknowable. In a study published in 1999, Catherine Quiminal included a table showing the numbers of sub-Saharan African immigrants (again from the 1990 census) separated out by nationality. The four largest groups were from Senegal (43,692), Mali (37,693), Cameroon (18,037), and Côte d'Ivoire (16,711).[16] Although the sub-Saharan immigrant population increased steadily throughout the 1980s, it remained small in comparison to the overall immigrant population of France, led by the Portuguese (more than 600,000)

and Algerians (some 540,000), again according to the figures reported by INSEE based on the 1990 census.[17]

The new immigrants were comprised of students, asylum seekers (of which those from Zaïre were notable examples), and family members joining immigrants who had arrived years earlier.[18] From the earliest years of the Mitterrand presidency it was clear that the African immigrants arriving from sub-Saharan countries were typically better educated, often skilled at a trade, and generally of more diverse backgrounds than their counterparts of earlier postwar decades. Michèle Tribalat, a prolific analyst of French immigration, would estimate by 1996 that only around 20 percent of black African immigrants in France were uneducated, and argued that one needed to distinguish between immigrants coming largely from rural areas and those relatively more urbanized who were much more likely to have been educated.[19] Tribalat also pointed out that African immigrants were typically much more fluent in French than other immigrants, and that they benefited from a level of sociability that could be attributed to membership in associations.[20]

African Musicians and the New Immigration

Among the African immigrants who arrived during the early 1980s (some having arrived during the late 1970s) were musicians. As with their predecessors a few years earlier, they were compelled by the harsh economic conditions that prevailed in Africa, which suffered the global economic crisis more acutely than did Europe. In many cases, they were attracted by the career opportunities they had good reason to believe Paris could offer, with its technologically more advanced recording studios and record companies beginning to specialize in African music. Also, as musicians, they sought to escape the ravages of the piracy of recordings, especially in the cassette market (cassettes being the medium through which most listeners in African countries had access to music), which robbed them of the lion's share of their earnings.[21]

In other cases, musicians arrived to complete their studies, only later turning to music as a profession. A number of significant musicians had established themselves well in African locations, but now wished to penetrate an international market. The choice of Paris as a destination is explained as well by language and the results of having been educated in a French-style system, where the capital city was upheld as the true center of civilization. What Tribalat observed about the relatively high educational level of many sub-Saharan immigrants applies even more to musicians, much as has been observed about African writers in Paris.[22] Wally Badarou (1955–), the musician from Bénin who became one of the most prominent African music stars in Paris during the 1980s, was the son of physicians.[23] Both Ray Lema (1946–) and Lokua Kanza (1958–) were conservatory-trained musicians originally from Zaïre.[24] Many other examples can be cited. Once this new generation of musicians settled into life in Paris, the music they made came to be identified as a distinctive hybrid produced by applying traditional African performance to advanced studio technology. However, in nearly every case the new musical styles of these immigrants had been emerging for many years in various Western and Central African centers.

Despite the fact that musical roots remained the foundation for this generation of musicians, they, like twentieth-century African musicians before them, practiced a kind of *bricolage* that should make it impossible to imagine their music developing in some pure, isolated state, irrevocably wedded to tradition. And this should not be surprising, since, according to one musicologist, African cultures were never isolated, but always encountering other cultures through travel, trade, or military invasion.[25]

The concept of "professional musician" is enshrined almost exclusively within modern Western culture. The role is a relatively recent one for African cultures, where, as Francis Bebey (see chapter one) and others have argued, music is not an activity separate from the dynamics of everyday life and social interaction. Instead, it has been a cultural, communicative force that permeates the lived environment.[26] As Ray Lema, a highly regarded musician from the former Zaïre who has been in Paris since 1982, expressed in a videotaped interview from 2003, "In Africa, we live beside music. Everything is music."[27] In traditional African cultures, music is woven into the fabric of everyday life, including ritual occasions. Throughout West Africa, a particular type of performer would provide music for such events.

Many of the musicians who made their way to Paris by the early 1980s were from Senegal, Mali, and Guinea, precisely the area defined by Mande culture and associated with the empire established centuries ago by Sunjata Keita and his allies, an empire that lasted from the early thirteenth through the late fifteenth centuries.[28] A distinctive feature of traditional Mande society (which includes the Maninka and Mandinka peoples of West Africa) was the existence of a hereditary artisanal caste of *jelis*,[29] elsewhere commonly referred to as *griots*. Since the latter term is much more widely used, including by those within this category, it seems unavoidable to adopt it. Mindful of the warnings of those scholars who caution us that there is more than one type of *griot*,[30] it may still be possible to offer a general characterization. The *griot* is someone born into a family succession of artisans who groom their sons (for it is inherently a patriarchal notion) for the ceremonial role the origins of which were found in ancient monarchies. The *griot*, therefore, was someone whose job it was to honor the monarch in lyrical tribute to his great deeds. Praise songs are still the most common examples of a *griot*'s performance. Typically, an African restaurant in Paris today will employ a *griot* to perform during the evening meal, and as he moves among the diners, receiving their tips as well as their attention, he improvises praise songs in response. In traditional West African societies, expanding beyond the royal circle to the larger community, the *griot* was available to lend his talents to such ceremonial occasions as births, circumcisions, weddings, and funerals. *Griots* traditionally have been masters of certain kinds of instruments, including the *xalam* and *kora* of West Africa (stringed lute-like instruments).[31]

The oral culture of the *griots* began to receive more widespread attention in colonial West Africa through radio and recordings during the late 1940s and early 1950s, and remained the foundation for the evolution of popular music in the region in the postcolonial period.[32] Although Lamine Konté of Senegal preceded him in Paris, Mory Kanté (1950–) of Guinea who arrived in 1984[33] was the first true *griot* to become a genuine star in Parisian music circles, with his amalgam of the traditional West African harp-lute known as the *kora* and heavily amplified instrumental accompaniment. Despite his embrace of urban pop sounds, in interviews he has insisted

firmly on the centrality for him of the *griot* as the repository of memory for the people for whom he has performed his duties. As he has pointed out, *jeli*, the *mandingue* term for which "*griot*" is often substituted, means "blood." The *griot*, then, is the lifeblood of the ethnic group he represents. Traditionally, persons who inherited this role were exempt from work in the usual sense, and others were obliged to offer him food, as in the case of mendicant monks in a Buddhist land.[34] Transplanted to late-twentieth-century Paris, the figure of the *jeli* or *griot* would become at once an avatar of the player of an ancient role and something more closely akin to what we in the West would call a "pop star."

When a non-African listener first encounters such a performer, dressed in a flowing *boubou* and playing a *kora*, it is natural to assume that one is in the presence of some age-old musical essence. But appearances can be deceptive. Closer study reveals that even the seemingly "purest" forms of African music are themselves products of decades of articulation with European genres brought to the African continent and Western styles returning across the Atlantic. The *griots* of Senegal traditionally have been players of the stringed lute-like instrument known as the *xalam*, which became the inspiration for the distinctively Senegalese genre of pop music known as *mbalax*.[35] But to say "Senegalese" is already to indicate a complicated mixture of styles and influences, including some of surprising provenance. The capital city Dakar, a major port city, had long been a crossroads for diverse musical influences, including those migrating back across the Atlantic in newer permutations of the African diaspora. Caribbean genres of popular music, especially Cuban *rumba*, were especially popular with Senegalese listeners during the 1950s and 1960s. Many singers even performed in Spanish, although Orchestra Baobab (formed in 1971),[36] one of the most influential of all Dakar groups inspired by Cuban music, became the first to sing in Wolof, the language spoken by a majority of the Senegalese people.

For Senegalese musicians as well as for their counterparts throughout West Africa, the atmosphere in which they operated was composed of everything from traditional music to jazz to American rhythm 'n' blues to Caribbean genres. In the 1960s this meant especially that artists such as James Brown, Otis Redding, and Aretha Franklin became influential. By the early 1970s the influence of the guitar playing of Jimi Hendrix could be heard throughout West Africa, often in combination with attempts to simulate sounds of traditional instruments such as *xalam* using the electric guitar. The emergence of *mbalax* by the mid-1970s was a resulting synthesis of the diverse styles mentioned, and would reach its first wide acclaim in the success of the Senegalese trio Touré Kunda, who moved to Paris in 1979.[37] The group was composed of three brothers: Amadou (1943–1983), Ismael Touré (1950–), and Sixu (1950–). After Amadou died, another brother Ousmane (1955–) replaced him in the band.[38] They were *Soninké* from Casamance, the southernmost province of Senegal. The name "Touré Kunda" means "elephant family" in the Soninké language.[39] Some years later, Youssou N'Dour (see chapter six) would become the Dakar-based international star most associated with *mbalax*.

A similar mix of musical genres provided the basis for some of the most successful musicians of the late 1970s, some of the most prominent of whom would relocate to Paris during the following decade, in other parts of the Sahel region. Bamako, Mali, became the launching pad for some very successful musicians who would make their

mark in African countries before achieving celebrated stature in Paris. Salif Keïta (1949–), one of the most internationally successful of all African singers, got his start as a member of the Rail Band of Bamako (often referred to as the Rail Band du Buffet de la Gare de Bamako, since they were hired by the national rail company to entertain travelers dining at the railway station), as did Kanté Manfila (1947–), a guitarist and singer. Keïta and Manfila performed with the Rail Band from 1970 until 1973, then departed to form their own group called Les Ambassadeurs de Mali. In 1977 they relocated to Guinea, where Keïta received support from President Sékou Touré,[40] and then to Abidjan, Côte d'Ivoire.

Salif Keïta provoked controversy by becoming a singer, for he was descended from royalty and by traditional definition should not have been in the position of addressing the public directly. Moreover, as an albino, he bore a stigma that is widespread in many African cultures.[41] He also, of course, suffered physical consequences, most notably severely impaired eyesight.[42] As he became highly successful, he began to support efforts to aid victims of albinism. Singing in the Bambara language, Keïta evolved a dramatic style that features his stunning falsetto vocals against a combination of traditional instruments and heavily electronic instrumentation, also employing backup singers who create a call-and-response pattern with him. In performance he is in constant motion, exhorting and interacting happily with his fellow musicians. His singing style was inspired somewhat by the calls to prayer of the *muezzins*, appropriately for someone who found solace for his albinism in Islam.[43] At times Keïta's bands have featured horn sections that create an even more imposing sound. Songs typically begin with prolonged instrumental overtures, building dramatically to the point where Salif's soaring voice makes its entrance. Keïta's widely emulated style would come to define for many the new internationally successful African pop music that has been assigned various labels, including "Afropop" and "World Beat."

The *makossa* music of Cameroon, in which Manu Dibango had led the way, continued to develop during the 1970s, influenced by a variety of other genres from African regions as well as from the United States and Latin America. One of the most influential bands of the day was *Les Tigres noirs* ("The Black Tigers"), led by André-Marie Tala (1950–) and Sam Fan Thomas (1955–) both of whom would go on to have successful solo careers.[44] Tala's story is especially interesting. From Bandjoun in West Cameroon (the area of the Bamiléké) and orphaned at an early age, he tragically lost his sight at the age of fifteen,[45] and by age seventeen was playing guitar in bands in his hometown.[46] His first group, Les Rock Boys, became *Les Tigres noirs*. In 1970 he met Manu Dibango and signed a contract with Philips/Polygram. His first recordings sold very well in Cameroon, where he was especially well-established by 1973, when his album *Hot Koki* was released.[47] Tala's music at this point, strongly influenced by American rhythm 'n' blues as well as by *makossa* and the *zouk* music of the Antilles, was adapted from a form of dance music known as *tchamassi*. He called his version "Soul *tchamassi*."[48]

Tala moved to France in 1978. In 1998 I visited him in his comfortable apartment in the suburban town of Asnières, just northwest of Paris. It was the time of the round of play leading up to the World Cup in soccer, and the national team of Cameroon was one of the top contenders. I arrived to find Tala seated on his living room sofa next to his young son. He was smartly dressed and wearing his trademark dark

glasses. The television was on, and the Cameroon team was playing. When I asked about his interest in the team, he said, "I am a great fan of the Cameroon team," breaking into a broad smile. Although I am sure he would rather have been concentrating on the game, he had beers brought out for us and encouraged me to be comfortable. The television volume was muted.

He spoke at length of his early years in Bandjoun, which he described as a "village" of nearly one hundred thousand people. When he began as a musician, he said, he educated himself by listening to a wide variety of music, having no access to a conservatory. American music influenced him very much. "With my first band," he said, "I interpreted rhythm 'n' blues songs of American artists like Otis Redding, James Brown, Wilson Pickett, and," he added, "several songs of Clarence Carter." He was also inspired by the French pop singer Johnny Hallyday, and certainly by such African musicians as Manu Dibango, Miriam Makeba, and Franco, he explained. Then, his voice rising sharply, he declared, "James Brown plagiarized one of my songs."

The song in question was the title track of the successful 1973 album *Hot Koki*, which James Brown heard when he came to Cameroon that same year. Four months after the cassette release, James Brown used the tune as the basis for his song "The Hustle." "I brought suit in 1975," Tala said, "and won the suit in 1979." The reason the process took four years was twofold: that Brown contested the suit and that Tala's attorney was killed in an automobile accident in the United States. By the time the lawsuit was decided, Tala was living in Paris. First of his family to become an immigrant, he said he came because of his music, "because Paris was the crossroads for African music and the U.S., and for the good studios."

Musicians of the two Congos were conspicuously active and influential well before they began to make their way to Paris. Kinshasha had been a dynamic center of musical performance even before independence, and became especially so during the 1960s and on into the 1970s. It attracted musicians from the neighboring French colony as well. Electric guitars began to make their appearance by the late 1950s,[49] by which time Latin musical influences had led to the evolution of Congolese *rumba*.[50] Musicians from across the Congo River in Brazzaville had been migrating into Kinshasha (then called Léopoldville) by that time.[51] In Kinshasha they plunged into a thriving musical culture that depended heavily on the nightlife provided by "bars-dancing,"[52] where the music was a blend of African genres, Latin American importations, and French *chanson*.[53] The importance of the local language *lingala* has also been emphasized as one especially well-suited to musical performance.[54] Many of the most important Congolese musicians got their start with the groundbreaking band African Jazz, led by Joseph Kabasele (1930–1983) a.k.a. "Le Grand Kalle"[55] who founded the group in 1953. Just three years later the very talented guitarist François Makiadi (1938–1989), known simply as "Franco,"[56] formed a rival band called O.K. Jazz.[57] Together, these two bands presided over the development of Congolese *rumba*, which by the 1970s evolved especially through Franco's influence into a much more guitar-driven, fast-paced music known as *soukous*.

The evolution of the latter music owed much to the influence of American so-called soul music, the version of rhythm 'n' blues rising to dominance during the late 1960s and becoming a force in African countries then and during the following decade, especially through the enormous popularity of James Brown. Angélique

Kidjo (1960–), the African-born French singer who became a star in the 1990s, recalled in an interview that she was dancing to James Brown songs as a ten-year-old child in Bénin in 1970.[58] American artists such as headline act Brown and B.B. King, Etta James, The Pointer Sisters, and The Spinners shared the stage with Zaïrean artists such as O.K. Jazz, Abeti, and Zaïko Langa Langa at the mega-concert organized for the so-called Rumble in the Jungle, the heavyweight boxing match between Muhammed Ali and George Foreman promoted by Don King in Kinshasha, which took place after long delays on October 30, 1974. The much-hyped contest was exploited shamelessly by the Zaïrean dictator Mobutu, and was very much an international event. Other musicians who performed included the great salsa star Célia Cruz, among other Latin American singers, and also African musicians from other countries. These included Miriam Makeba of South Africa and Manu Dibango of Cameroon (and France),[59] who recalls being introduced to the Zaïrean virtuoso musician Ray Lema—with whom he later would collaborate in France—in Kinshasha on this occasion. Lema accompanied Dibango in the concert.[60] Prominent journalists and writers from throughout the world also graced the match that proved a great comeback for Muhammed Ali.

The three-day music festival, known as "Zaïre '74," helped bring many of the Zaïrean groups to greater prominence, and was marked by a triumphant set performed by Tabu Ley Rochereau.[61] It also demonstrated the link between such American genres as soul music and Zaïrean *rumba* and *soukous*, which continued to evolve in articulation with rock and jazz. Bands such as Zaiko Langa Langa (which included for a time the singer who went on to great fame as "Papa Wemba") and Thu Zaina, with whom Péla Simba played before he moved on to Paris in 1977,[62] were examples. By the late 1970s musicians from Zaïre who wanted to be in Europe began to select Paris rather than Brussels as their destination, especially as a tight community of immigrants formed there and word of the superiority of Paris recording studios spread. During the early 1980s they were joined by a number of already successful musicians from Zaïre, for example, Ray Lema, who arrived in 1982, and Kanda Bongo Man, who followed in 1984.[63]

Certainly one of the most breathtakingly talented musicians to come out of Zaïre in the 1970s was Ray Lema, whose nomadic life, both in terms of physical travel and in terms of musical adventures, seemed to have been signaled by the often-repeated legend that he was born on a train.[64] In a 2004 interview Lema set the record straight, explaining that his mother actually gave birth in the station waiting room.[65] At age eleven he entered a Roman Catholic seminary where his musical gifts became apparent for the first time. He exhibited particular ability on the piano, learning much of the classical Western repertoire for the instrument. He also regularly played organ accompaniment for masses. He left the seminary in 1962[66] and eventually studied chemistry at l'Université Lovanium in Kinshasha. But he abandoned his studies to begin his musical career, first playing with a rock group called the Yss Boys. At this point Lema was experimenting with guitar, much influenced by the popularity of Jimi Hendrix and Eric Clapton.

In 1972 the government of Zaïre asked Ray Lema to put together a national ballet, and he embarked on a lengthy and difficult journey throughout the huge country with its some 250 ethnic groups, searching for musicians and dancers. He managed to recruit more than 100 of them. This life-transforming experience opened

his ears to the richness of the musical traditions all around him.[67] Lema left his position as ballet director in 1976, frustrated by lack of adequate funding. He formed a new band called Ya Tupas, playing music much influenced by his field research of 1972–1973.[68] Also during the 1970s he had played at various times in the bands led by Joseph Kabasele, Tabu Ley Rochereau, and Franco.[69] In 1979 Lema received a fellowship from the Rockefeller Foundation, which took him to Washington D.C., where he composed music[70] and met and married a woman from the area. He traveled to New Orleans, where he recorded his first solo album *Koteja*. In 1981 he moved to Brussels, then to Paris the following year,[71] where he embarked on his ambitious project of adapting African roots rhythms to electronic instrumentation. He became one of the best-known African musicians in Paris during the early 1980s, much sought after both as a performer and as a producer.

In June 1995 I interviewed Ray Lema at his home in Villiers-sur-Marne, a quiet town east of Paris, easily accessible by regional rail. It was a short walk from the train station to his street, and I passed a group of middle-aged men energetically involved in a game of *pétanque*, the French lawn bowling game. Once I arrived and talked for a while with both Ray and his wife, he and I settled down to talk in his large basement, filled with musical instruments and a mixing board for home recording. Tall and bearded, Ray was dressed casually in a t-shirt, jeans, and baseball cap. He played me some recent recordings he had been producing in London for the Jamaican artists Sly & Robbie. I admired one of his guitars, and he asked me if I played. I ended up showing him an open tuning I use.

As we talked about his music and his career, it became clear that the time he spent traveling about Zaïre in search of musicians for the ballet remained one of the truly formative experiences of his life. It was, as well, something of a personal revolution,

> Because me, I started with classical music as a child. Then, that was a problem for me, because to play African music in Zaïre, that was impossible, now. I had a lot of problems already in Zaïre. Next I started searching for my traditional music, and I swung over to the other side when I had the experience as director of the National Ballet. There, I discovered so many of the things behind what we call Zaïrean music. That is to say *soukous* and *rumba*.[72]

Becoming ever more earnest as he warmed to his topic, Lema added,

> I tell you it is very difficult to discover Zaïre because there is no highway infrastructure. There are no good roads where you travel like in the United States, where you go out in your car and you go anywhere. It's not like that in Zaïre. To travel through Zaïre is really an expedition! There are no musicians. I am the only musician I know who has had the chance there to be paid by my government to go all around the country.

He discovered through his travels around the country that it was impossible to generalize about some "Zaïrean" music, for he encountered many styles of playing, and "very sophisticated" rhythms. Needless to say, the experience left him profoundly "impressed" intellectually, and led to a new level of appreciation for the music of his country. "I told myself," Lema related, "that I want to try to bring [to my music] little by little what I encountered there."

Eventually Ray Lema became frustrated with the lack of reliable economic support for musicians in Zaïre, and left for good in 1979, ending up in Paris by 1982. He rejected the idea that he was some kind of founding member of the African music scene there, crediting such figures as Manu Dibango, Francis Bebey, and Pierre Akendengué—"all musicians I admire very much"—instead. Having spent time in a variety of locations internationally, he said that Paris made sense as his current location:

> I feel myself to be halfway from Africa, halfway from the Orient, and halfway from the Anglo-Saxon bloc, you see? It's a place that is almost central for me.

Explaining this point further, he said,

> When I lived in the United States, I felt myself really to be off the track, off the main road. I work a lot in London now where I produce some reggae. Even in London already, you feel that you're a little off the track. In Paris, one hears everybody. One hears also the Orient, and one hears the Nordic countries. One hears everyone in the same manner.

He spoke to me as well about the music he saw emerging during the mid-1990s, but that will be a subject for a later chapter.

Radio Nova

Having absorbed influences from a broad range of musical genres from around the globe so that the "African" music they played was already part of an international mix of styles, the African musicians who arrived in Paris during the early 1980s were able to take advantage of new laws and new developments in the music business that encouraged them. One of the most significant changes introduced by the first French government under President Mitterrand was the end of the state radio monopoly, with private stations being legalized for the first time. The announcement by Communications Minister Georges Fillioud on August 6, 1981, was met with a stampede of new stations popping up on the FM dial, some four hundred by September of that year. By 1985 there would be more than fifteen hundred private radio stations.[73] Several of the new stations set out to broaden the range of musical offerings available to French listeners, emphasizing especially the music of new immigrants. Such stations in Paris included Radio Nova, Tropic FM, Oui, and Tabala FM.[74] Radio Nova, Tropic, and Oui especially were known for providing a wide range of African and other international music, Francophone and otherwise.[75] Radio France Internationale also increasingly began to feature such music.

Over many years, Radio Nova has been a force for cultural variety and for what has come to be known as world music in Paris. Jean-François Bizot (1944–) founded the station in 1981. He is the best-known example of the generation of the 1960s who would become the defenders of new ethnic minorities in France during the 1980s and beyond, championing their cultural contributions. Heir to a wealthy Lyon

family,[76] in 1970 he started a countercultural magazine, covering music among other topics, called *Actuel*. It folded in 1974, but resumed publication in 1979. Then in 1997 *Actuel* came to an end and Bizot launched *Nova Magazine*, linked to his by-then very successful radio station. Bizot has written a number of books, both fiction and non-fiction, and in 2001 published a history of twentieth-century "underground" culture.[77] He has also been a translator of the American cult author Charles Bukowski.

Bizot had been encouraged to start Radio Nova by friends who had been part of the *Radio libre* movement during the years prior to the 1981 law that made a station like Radio Nova possible.[78] *Radios libres* were pirate radio stations often operating out of (and limited in range to) specific neighborhoods. The musician Péla Simba remembered friends living in Belleville whose apartment the police raided, searching for such a broadcast source.[79] Such underground stations played music not otherwise accessible to the listening public, and Bizot wanted Radio Nova to do the same on a much larger scale. He and his staff were able to make it work. Mamadou Konté emphatically credits the new FM stations, and Bizot's in particular, with having made possible "the success of African music" in France.[80] Over the years, Radio Nova has done much to profile African and other international music, and hip-hop, always embracing what Bintou Simporé, perhaps the station's best-known on-air host, calls "plurality of expression."[81] Wary of the all-too-familiar phrase world music, she says she prefers the label *sono mondiale*,[82] one that Bizot liked to use during the station's early years.[83] He had introduced it in the pages of *Actuel*, as the magazine began to cover such topics as African music and hip-hop.[84]

Simporé, in recent years the voice of the popular weekly program "Neo Geo," came to music and radio simply from the background of a fan and a knowledgeable music consumer. Born to a French mother and father from Burkino Faso, she studied sociology and economics, first in Tours and then in Paris. She formed an academic interest in problems of underdevelopment, a subject that helped lead her to her great interest in African music.[85] In 1985 she began work for Radio Nova. She described her experience and some of the history of the station for me when we met in her office where the station is still headquartered, in the rue du Faubourg Saint-Antoine, just east of the Place de la Bastille. One entered the building after gaining access to what seemed like an ancient courtyard. Inside, people came and went constantly, telephones rang every few minutes—in short, it seemed just like a radio station. In her office filled with CDs, books, papers, and much else, Bintou Simporé sat comfortably behind her desk and spoke with ease and evident pride about the radio station for which she had been working—then—for more than a decade.

She began by saying that Radio Nova was the station that had popularized what she called *musiques métisses* for "white" listeners, going on to say that the station had consistently profiled black music, both through broadcasts and by organizing concerts called *les nuits noires*. She said there was a relationship during the early 1980s between the founder of Radio Nova and the production of African music in Paris. For example, Martin Meissonier, who produced such artists as Fela Kuti and King Sunny Ade of Nigeria, was a friend of Jean-François Bizot's, who himself produced Ray Lema just after the latter arrived in Paris. "He (Bizot) also contributed to the creation of Celluloïd, in distribution with Mélodie," she added. Celluloïd, founded by Gilbert Castro[86] (who remains CEO of Mélodie) with help from Bizot, was one of the most

important independent record companies based in Paris, and Mélodie remains a major distributor of African and other international music.

Simporé emphasized the important relationship between the politics of the day and the music broadcast by Radio Nova. The 1980s was the climactic decade of the antiapartheid movement, and South African musicians were very much at the forefront of it. Many of them, including Miriam Makeba, Hugh Masekela, Lucky Dube, and the Mahotella Queens, were played on the station. One singer, Johnny Clegg, the so-called white Zulu, became very popular in France. Simporé stated that the first article on Clegg to be published in France was in Bizot's *Actuel*. Selecting music by such artists was a means for the station to combat racism, just as they sought to counter the rise of racist politics in France. The combination of "new wave, funky, African" tunes, as she expressed it, was an attempt to "mélanger des musiques pour mélanger des gens ('blend musics in order to blend people')." This pattern has continued in the station's programming, as Simporé explained:

> Until now, it's mixed. The flow of the radio is a bit of acid jazz, a bit of African, a bit of Latino, a bit of house, a bit of rap—it's like that. This is the way for us to affirm racial mixing (*métissage*).

She mentioned other examples of politically minded black musicians the station had been known to play, such as the Jamaican/English singer/poet Linton Kwesi Johnson and the influential American group The Last Poets. More "concretely," Simporé stated, Radio Nova has supported concerts organized by SOS-Racisme, the antiracist organization that flourished in Paris after 1985. The radio station's work is necessarily educational, even as it seeks to entertain, because, as Bintou Simporé explained, "A lot of French people are taking a lot of time to understand that ours is a multicultural society." Unfortunately, often young immigrants have received the angry message that "they should go back where they came from," but in fact, she noted, "they have grown up here." It is too easy to blame immigrants for France's economic problems, and, she pointed out sadly, "the extreme right is helped by the media."

Celluloïd Records and Touré Kunda

The new radio stations were able to have the kind of impact they did in France during the 1980s because of the independent record companies who signed and promoted African artists. The 1980s was the real heyday of independent companies, and when the decade came to a close the large multinational music companied had consolidated their position. Celluloïd was the label many identified most with the newly popular African music, especially since Touré Kunda recorded for them. In addition to independent labels, Paris-based subsidiaries of major record companies, at least for much of the decade, were very committed to African music. This was true of Barclay, under the corporate umbrella of Virgin Records,[87] directed from 1979 to 1990 by Philippe Constantin (1941–1996), who had been a founding member of the

influential music magazine *Rock et Folk* before working for record companies. After Island Records was sold to Polygram, Constantin was named head of its subsidiary Mango Records in Paris, which he would steer toward major African and other "world" music.[88]

When Celluloïd and another independent company, Pathé-Marconi, hired long-time Senegalese producer Ibrahim Sylla to record African musicians for European distribution,[89] this marked a major step for the Paris-based music. Sylla first came to Paris from Senegal in 1974 to study management and law. He returned to Senegal and began music production,[90] working with such important musicians as Youssou N'Dour and Orchestra Baobab. The latter group was a perfect match for Ibrahim Sylla, who was devoted to Cuban music and had amassed a very large collection of salsa records.[91] In 1983 he returned to Paris and began producing recordings in studios there.[92] In 1997, when I interviewed Sylla very briefly at his office very near the Marx Dormoy Métro stop on the eastern edge of the Eighteenth Arrondissement, I mentioned to him that the journalist Hélène Lee (1947–) had told me that he had produced at least half of all the African recordings in Paris.[93] He said this was true.[94] He also said the studio he had used most in Paris was Harry Son, just northeast of Paris in the suburban location of Pantin.

Although he has produced music in Abidjan, Dakar, and in the United States, he remains best known for his work in Paris. He spoke of the reasons to be based in Paris for African musicians and people like himself involved in the business. For the 1980s, convenience was an overriding factor. As he put it,

> Paris became the center for African music because it is easier to communicate from Paris than within the African countries. It is expensive to travel and to move equipment between African countries. It takes eight hours to travel from Congo to Dakar, but you can leave Paris at eight o'clock in the morning and be in Dakar by noon.

Celluloïd Records was very much at the heart of African musical developments in Paris during the early 1980s. Gilbert Castro and Jean-François Bizot brought into the company assistants who would go on to prominent positions with later record companies closely identified with world music in Paris. Two such persons were François Post and Gilles Fruchaux. Post described the boom period for African music in Paris when I spoke with him in his office at the record company Lusafrica, where he has worked since 1993. As the name indicates, this company is focused primarily on music from former Portuguese African colonies. It first took shape around the great success of the Cape Verdean singer Cesaria Evora.

The offices of Lusafrica were located in a building situated on a busy (and very noisy) corner on the Quai de la Charente in the Nineteenth Arrondissement, not very far from the Parc de la Villette. Speaking of the interests that led to his beginning to work for Celluloïd/Mélodie in 1980, François Post said he had always been interested in "all sorts of music." He remembered listening to the classic French pop singer Charles Trenet as a child. As he grew older, he became partial to black American music, especially rhythm 'n' blues, and became a fan of The Rolling Stones (*Les Stones*, as he put it). By the 1970s his love was reggae music, especially the music of Bob Marley. "I began buying reggae records very early," he informed me.[95] For a

while he worked as a disc jockey in a club. Also during the 1970s his interest in African music began to develop. At the time he was recruited by Celluloïd, the label was concentrating on "new wave" rock and reggae. Then, at the end of the year 1980, in what represented a new direction, "we signed the group Touré Kunda," Post said. This would lead him to put together an African music catalogue for Celluloïd.

Almost immediately Touré Kunda's album *É'mma Africa* was released, and the eponymous *Touré Kunda* followed later in 1981.[96] Explaining that Touré Kunda had the kind of impact not made by previous African musicians promoted in Paris, Post said,

> I started to work on Touré Kunda and certainly the manner in which I began to work on this group was something completely new for African groups. There was an African music market in Paris, and there were record companies, for example Éditions Espérance and Sonodisc. But these labels worked uniquely for the African publics— Zaïrean music for the Zaïreans, Senegalese music for the Senegalese, etc. Everything was very *communautaire*. These musics did not circulate among each other.

Touré Kunda, then, was the first African band whose popularity crossed the boundaries of the separate African immigrant groups in France. This had to do with a combination of factors, including the convergence of political changes and new musical fashions. As Post saw it,

> The beginning of the 1980s was an epoch of change. Everyone knew that, with the Left, there was a kind of change in the air. The newspaper *Libération* was recreated and assumed a position of enormous importance for culture in general and for music in particular.

The attention *Libération* began to pay to new forms of pop music was unprecedented for French newspapers, except for occasional coverage of "the big stars," in Post's opinion. But *Libé* began to regularly profile rock groups and reggae artists. Jean-François Bizot's magazine *Actuel*, revived in 1979, played a similar role, only with even more extensive emphasis on alternative cultural currents, from the paintings of Jean-Michel Basquiat to new wave rock music. *Actuel* also called attention to African music as performed in bars and clubs in Paris. Furthermore, according to Post, it had been Bizot, involved in the initial stages of Celluloïd's establishment, who had come up with the idea of creating an independent record label modeled on the examples found across the channel in England.

Left politics and African music converged in the case of Touré Kunda. Their music began to receive notice in Paris as the left came to power, Post argued, saying that "Jack Lang helped Touré Kunda a lot," as he later would such celebrated musicians as Salif Keïta. "It's true," Post said, "It's undeniable." Soon after Touré Kunda's first album was released on Celluloïd, Jean-François Bizot's magazine (along with help from *Libération*) and Gilbert Castro of Celluloïd began to organize weekly *soirées* at the Rex-disco, a dance club in the basement of the huge Rex Cinema on the Boulevard Poissonnière at the corner of the rue Poissonnière. These occasions, especially during the winter of 1982, featured both rock and African groups.[97] Touré Kunda played regularly at the Rex, and other musicians were involved, including the

American hip-hop innovator Afrika Bambaataa. The weekly event took place for much of 1982 and 1983. Further explaining the left political connections for these occasions, Post said that Castro was the former treasurer of La Gauche Prolétarienne, the organization founded by Jean-Paul Sartre.

If one stops to reflect on twentieth-century Parisian history in terms of particular urban spaces or landmarks, these concert-dances underneath the Rex Cinema might be contrasted, in terms of the politics of immigration, with the murderous events of October 17, 1961, when the large peaceful demonstration organized by Algerian immigrant opponents of the continued French presence in Algeria marched down the Boulevard Bonne Nouvelle and were fired upon by police, including by those stationed on the roof of the Rex Cinema. This massacre of at least two hundred persons (whose bodies were dumped in the Canal Saint-Martin and the Seine) received very belated attention during the 1999 trial of former Vichy official Maurice Papon, who in 1961 was police prefect of Paris.

Thanks to the coverage provided by *Libération*, among other boosts Touré Kunda received, they went in a relatively short period of time from real anonymity to great acclaim. "In 1981," Post said, "they played in a small club in the Thirteenth Arrondissement in front of four paying customers!"[98] He was referring to the Dunois, named for the rue Dunois in which it was located. In any case, they had other dates there over a period of one month and the audience grew larger. The group's popularity began to soar after they moved on the Chapelle des Lombards,[99] formerly a jazz club on the rue de Lappe near Bastille. Four years after their inauspicious debut, Post said, they were regularly playing around France for three to seven thousand people per concert. Touré Kunda was by no means the only African group on the Celluloïd label (e.g., the first two albums of Les Ambassadeurs de Mali featuring Salif Keïta and Kanté Manfila were part of the catalogue), but, in François Post's opinion, their success had the most to do with the African music scene taking off in Paris. "Touré Kunda was the most popular group in France," he claimed.

Their success, Post said, then spurred other musicians from such countries as Senegal, Mali, and Guinea who, like Touré Kunda, did not enjoy large market success in their own countries. When Touré Kunda sold one hundred thousand copies of their first Celluloïd release, these other musicians took notice and made their way to Paris. The African music boom was underway. As a result Celluloïd and other independent companies began to sign more and more African musicians. Post said he tried to have a "global vision" for his label's roster. He recognized that, as he put it, "African music does not exist. There are *musics*." Contrasting the period of the early 1980s with the African music based in Paris by the late 1990s, François Post remarked that the musicians of the initial phase had come directly from African contexts, whereas the later generation was comprised more of musicians playing music "transformed through contact with urbanism here."

Gilles Fruchaux also worked with François Post at Celluloïd/Mélodie, before leaving in 1987 to found the world music record company Buda Musique with Dominique Buscail, who died in 1990.[100] Fruchaux offered additional insights into the Touré Kunda phenomenon. He argued that they played a decisive role by making music aimed at a much wider audience, just as Celluloïd, with the distribution of Mélodie, aimed beyond the "strictly ghettoized music" that had been the norm for

African immigrants in Paris. Not only was the music Touré Kunda made meant to cross boundaries that separated one African community from another, but it was also meant "for the ears of white French people." Since the group was "somewhat well structured, had no problems with papers, and was able to tour a great deal," Fruchaux said, they succeeded in opening up the market in a decisive way. Speaking to me in his office at Buda Musique on the Boulevard Voltaire, Fruchaux contrasted the early 1980s when he worked for Celluloïd with the following decade when, although he was able to put together a large catalogue of *Musique du Monde* (the name of a series of folk recordings marketed by Buda), he did not have the resources to promote artists in the fashion of major labels or the independent labels that were able to flourish during the earlier period.

Music Journalists

Music journalists who became enthusiastic about the music of new African immigrants in Paris helped significantly through their writings and related activities to increase interest in the emerging world beat (on its way to being called world music) scene. Some of the most influential ones have been Hélène Lee, François Bensignor, and Philippe Conrath. Hélène Lee has long written for *Libération*, and has especially been responsible through her extensive research in Jamaica and her books on Rastafarian culture and reggae music for promoting the spread of that music in France. This also has meant an intersection with West African music, Côte d'Ivoire having been known for singers who performed reggae with African musicians, often singing in African languages as well as in French. Alpha Blondy, about whom Lee has written extensively, became very popular as an Ivoirean reggae singer during the 1980s.

Describing herself as part of a generation known for living its life in relation to music, Lee began to explore Jamaican culture during a first visit to the country in 1979. As for African music in Paris, about which she began to write during the 1980s, in a conversation with me in 1997 she stated that during a period of ten years after 1981, "the quantity of African discs recorded in Paris was absolutely phenomenal, from productions destined for Africa, for France and a number of productions destined for the world."[101] However, she insisted that this heady period had come to an end—"Paris is not the passionate place it was four or five years ago, ten years even." Our talk turned to the reasons for the appeal of African music to the French public during the 1980s.

Her take on this was informed in interesting ways by her research on reggae and Jamaican culture. Music is a way to get to know people and to understand them across boundaries, she said. "It's true that when a musician plays, he touches you," she argued, "You have no need to speak the same language, to have the same culture to know that you are the same." From this general observation, a truth all lovers of music from around the world easily could acknowledge, Lee focused more closely on the French "new generation confronted with the failures of old systems," who embraced both African music and reggae. What they recognized as the inadequacies

of the past by no means made them insist only on new styles, however. For whether the singer was Bob Marley or Salif Keïta, they brought to their youthful listeners "the texts of proverbs, of ancient wisdom," she stated. Such a search for a so-called roots culture, a search for something more grounded and basic to life was reflected, Lee said, in the way people began to move differently when they danced. The change she noticed evolved during the 1980s, she said, with their feet much more planted on the ground, "with movements that come from the ground. They were much more physical and sensual. Formerly they were trying especially to cut figures." The sense I got from listening to Hélène Lee was that the world music that caught fire in Paris during the decade of the 1980s supplied some element for which a significant number of people had been hungering. By the 1990s, lack of money to support immigrant musicians and a more negative political climate had created severe obstacles.

François Bensignor, whose sense of the continued vitality of African music in Paris seemed much more optimistic (when I spoke with him at his home in 1997 and 1998) than Hélène Lee's, is someone who came to music journalism first from the background of musical performer. Born in Versailles but a Parisian from the age of nine, his formative musical tastes were African American, especially rhythm 'n' blues and free jazz. He performed in rock bands as a singer from an early age. He even met the Zaïrean star Tabu Ley Rochereau, who lent his services to "the last group in which I sang," Bensignor related.[102] Bensignor began to write on popular music in the late 1970s, and published widely, especially in such music magazines as *Paroles et musiques* during the 1980s. More and more his topic was African music, and he became known for his comprehensive study of the music region by region. During the 1990s he had the idea for the guide *Sans-Visa*, which collected material on all types of music being made in the Francophone world, and served as editor of *Visa permanent*, a newsletter for similar topics.[103] More recently he has worked a great deal on internet sites devoted to African music and to Francophone music generally.

He explained that he did not begin with "a special relation to Africa." Instead, he said, "It was because of my interest in music that I began to meet African musicians." For Bensignor, then, first came the "aesthetic appeal" of the African music he heard, and then an interest in the "sociological" dimension—"in the problems immigrants experience in French society." Referring especially to the anti-immigrant politics of the 1990s, he said that he was attuned to this topic because of his Jewish family background. He spoke about the early 1980s when he and other French journalists were beginning to write eagerly about the music of African immigrants in France, but pointed out that not all music publications rallied to the Africans. *Rock et Folk*, which he called the "Bible" of rock music in France, was notable, he said, for the consistent absence of black faces on its covers (the only exceptions, *ca.* 1984–1985, being Tina Turner, Michael Jackson, and Prince). Bensignor also felt it was important to recognize that "the musicians supported by Jack Lang already had very important careers in African countries before arriving in France." Those African musicians trying to establish careers in Paris without such a preliminary stage faced many more difficulties. In our conversation the following year, Bensignor argued that the African music era in Paris was far from over, but that it lacked the explicit sponsorship of a powerful figure such as Jack Lang.[104]

At around the time Radio Nova was beginning to operate, Philippe Conrath and Rémi Kolpa-Kopoul, both writing for *Libération*, began to devote regular attention to African music. Kolpa-Kopoul would later join the management of Radio Nova.[105] Like Lee and Bensignor, Conrath has long been identified with promoting African music in Paris, beginning with journalism and then moving into related fields. He was one of three journalists with *Libération* who, in 1979, founded Cobalt Records. Artists on Cobalt included such jazz musicians as James Newton and Claude Barthelémy and Marquis de Sade, a band Conrath called the "first new wave group in France."[106] Cobalt began to languish as Philippe Conrath plunged more and more into writing about the new African music in Paris, producing many articles and interviews as well as books and documentary films. Finally, in 1989 he quit journalism and founded an organization called Africolor to promote African musicians. He also relaunched the Cobalt label, which in its second version was, in his words, "very open to the musics of the world (*les musiques du monde*)." Africolor's most visible activity has been the annual festival bearing its name in Saint-Denis, known especially for performances of traditional, acoustic music by Malians, although other African countries have also been represented.

In July 1997 I interviewed Conrath at the Africolor office in the rue de Ménilmontant. Like both Lee and Bensignor, his knowledge of and enthusiasm for African music was extensive. Reflecting from the perspective of the harsher political climate of the latter decade, which among other things had made it increasingly difficult for him to help musicians enter France to perform at his festival, he saw the early 1980s as a heady period. "I grew up with African music," he said of his career as a journalist at the beginning of the 1980s. Conrath had been exposed to African music during a trip through West Africa in 1975, and first became interested then.[107] Traveling there again in 1977, he was surprised to discover that many of the most celebrated musicians from the region often played in Paris, yet no one there seemed to acknowledge the fact.[108] The African music that captured his attention in Paris during the early 1980s followed on the heels of the new genres he had come to appreciate during the late 1970s, including rap music, to which he was introduced during a stay in New York City. The response to Touré Kunda's first Celluloïd release seemed a real watershed event for him, and very quickly it seemed that "all kinds of African musicians were passing through Paris—known and unknown, or at least known in their own countries."

His work at *Libération* took shape around the new phenomenon:

> I agreed to do the first regular column (*chronique*) on African discs in a daily newspaper— that was completely crazy! Little by little, I found myself doing interviews. I did the first interview in France with Mory Kanté in 1982. He came to France in 1985. I interviewed Salif Keïta in 1982. He came to France in 1984. Et cetera, et cetera. I began the column in 1981. In 1984 I interviewed Touré Kunda; in 1986 Alpha Blondy, Mory Kanté, Salif Keïta, and Youssou N'Dour. It was a reality of sales, of fashion. We believed in that reality, but it was much in fashion.

It was also a question of political "fashion," for, in his opinion, the political motivations were more important than the artistic ones during the 1980s. At the time we spoke, "whites," he judged, were no longer looking for "exoticism" in African music.

In addition to doing his column for *Libération*, Conrath was asked to write about the Paris-based Antillean group Kassav' and the South African singer Johnny Clegg (whose popularity in France owed a great deal to Radio Nova). He also made documentary films for French television. "Professionally," Conrath said, "I was recognized as someone of importance in that milieu. There were some others, but not many, perhaps a dozen." Even a handful of people can, of course, have a large impact, and the story of African music coming to prominence in Paris has much to do with certain individuals, such as the "great producer" (in Conrath's words) Ibrahim Sylla. He also emphasized the importance and influence of Bintou Simporé on Radio Nova. Meanwhile, the attention paid African music not just by *Actuel* and *Libération*, but also by *Le Matin, Le Monde*, and *Le Nouvel observateur* certainly contributed to the success of many of the musicians.[109]

SOS-Racisme

The policies of the Mitterrand years and the immigration they encouraged, the vitality of independent record companies, the proliferation of excellent recording studios, and the attention given new African music in Paris by newspapers and magazines, all were significant elements in the mix that made Paris the center of what a few years later would be called the world music phenomenon. What was the appeal of African diaspora music to French listeners? This is a question that appears to defy an easy answer. The early 1980s was a period of the continued popularity of Jamaican reggae music (still very strong in France), which certainly prepared many ears for hybrid African rock sounds. Discussions with several music journalists, radio and record company personnel, and just plain music fans yield the impression that they came to African music from various directions, including jazz, blues, rhythm 'n' blues, classic rock, and punk rock. Each person seemed to find in the new African music (understood as plural) something not previously heard in other genres, and they took to it immediately and passionately. Often the receptiveness to African musical styles was related to a political sensibility that favored immigration and opposed racism. The 1980s was the climactic period for the antiapartheid struggle, which provided a strong emphasis for African music. Radio Nova and such festivals as Le Printemps de Bourges regularly featured antiapartheid artists such as Miriam Makeba, Hugh Masekela, or Johnny Clegg.[110] Politics, specifically the debates over immigration and the mobilized opposition to racism that occurred after 1984, would converge with music in very interesting ways. Antiracist political movements were to be found in several European countries by 1980 or so, for example, in England where punk rockers and West Indian immigrants often spoke out against police violence and the racist violence of neo-Nazi "skinheads."

In France, where a number of antiracist groups had been active during the twentieth century, much of the energy behind antiracist politics after 1980 came from young people born to immigrant parents, such as the so-called *beurs*, those of North African origin typically residing in the *banlieues*, where unemployment and desperation were high, and where police routinely victimized them. The word *beur* comes

from the form of slang known as *verlan*, a "back-slang" in which the order of syllables is reversed (*verlan* itself coming from *l'envers*). *Beur* evolved from reversing the syllables of *arabe*. As such young people watched the growing strength of Jean-Marie Le Pen's National Front, with its message of virulent hostility toward immigrants, especially immigrants of African origin, they were increasingly dismayed by the obvious unwillingness of establishment politicians to denounce the movement or, more importantly, to take any real steps to counter it. In 1983, the growing frustration turned to real alarm, for this was the first year in which the *Front National*, founded in 1972, performed impressively in regional elections. In October 1983 ten young people of North African origin marched from Marseilles to Paris in order to call attention to the growing menace of racist politics. Once in Paris, joined by a crowd of one hundred thousand supporters, they marched to the Élysée Palace where President Mitterrand received them. He promised to push for new antidiscrimination legislation, but nothing was done, even after a series of marches directed toward Paris from several French cities in 1984.

That was the year that two new antiracist organizations—SOS-Racisme and France-Plus—were founded. Of the two, SOS-Racisme had the greater impact, in part because of the skill its president Harlem Désir displayed in getting the group's message out through the media.[111] Désir, born to a mother from Alsace and a father from Martinique, became very much the public face of the organization during the years (1984–1992) he served as its president, but it was in fact composed of young representatives of many ethnic groups in France.[112] Even though it was clear that SOS-Racisme was the result of several years of mobilizing around issues of antiracism and police mistreatment of minorities, a kind of popular myth of its spontaneous creation took hold. According to this legend, the idea for the organization came about when a group of young friends enjoying a get-together at a Paris pizza restaurant were worried about a Senegalese friend who arrived very late. When he finally showed up, he described being detained by police in the Métro who took him for a thief, singling him out because of his skin color. The collective outrage of this group of friends supposedly led them to form the group that became SOS-Racisme.[113] In his own account of the founding of his organization, Harlem Désir described a scenario something like this, but many political observers believed it was more likely that the origins of SOS-Racisme owed more to planning than to spontaneity.[114]

SOS-Racisme rose to prominence in part through direct assistance from the Socialist Party,[115] large successful rallies and concerts organized in Paris in 1985, and the success of Désir's manifesto published later that year. The central idea promoted by the movement was that of banding together to protect against racist violence, including violent acts coming from the police. The motto of SOS-Racisme encapsulated that concept: *Touche pas à mon pote* ("Hands off my buddy"). The organization's very recognizable logo was a large upraised hand, palm outward, emblazoned with those words. Harlem Désir used this slogan as the title of his book published by Grasset in 1985. The back cover bore a glowing endorsement of the movement's significance by novelist Marek Halter. Early pages of *Touche pas à mon pote* describe the large concert organized by SOS-Racisme in the Place de la Concorde on June 15, 1985.[116] Some three hundred thousand people attended[117] and heard performances by musicians including Salif Keïta and Mory Kanté.[118] This event, known as the

"Nuit des potes," enjoyed the support of the government through Jack Lang's Ministry of Culture, and was promoted energetically by Radio Nova and other stations. At least on this occasion, it appeared that the Mitterrand era would be known for its embrace of a newly heterogeneous French culture.[119]

"Tam-Tam pour l'Éthiopie"

The year 1985 was also when a collaborative recording featuring a large number of African musicians then based in Paris received widespread play and publicity and helped serve notice internationally that Paris truly had become the center of contemporary African music. The idea for the project came in response to similar musical collaborations done in England and the United States to raise money for famine relief in Africa. In addition to recordings, the "Live Aid" concerts organized by English rock singer Bob Geldof in 1985 were very successful examples of musicians contributing their services to a humanitarian cause. Late in 1984 musicians in Paris began to join forces to mount a similar project to generate aid for famine relief in the Horn of Africa. It is clear in retrospect that the growing awareness of the importance of Paris as a center for African musicians played a major role in giving rise to the collaboration. Manu Dibango, in his autobiography, credits a number of individuals who helped to bring about such awareness, and the passage is worth quoting at length as one very significant observer's personal summary:

> Like an explorer, Martin Meissonier was on the lookout for seeds that would germinate. Gilbert Castro and François Post helped them grow at Celluloid, their production house. Rémy Kolpa-Kopoul and Philippe Conrath at *Libération*, Jean-François Bizot at *Actuel*, and Jean-Jacques and Sylvie Coma at Radio France Internationale realized which way the African wind was blowing. They were inseparable from this newly expatriate generation of African individualists.

Dibango then discusses the contributions of Ray Lema, Mory Kanté, Salif Keïta, Touré Kunda, Alpha Blondy, and Xalam, and adds,

> The ground had been planted for a growth of a real cultural current that was no longer exotic in the least. Mamadou (Konté) was its catalyst; I was very likely its precursor. Ultimately, this generation's arrival reassured me: people like me were not doomed to be "accidents." My success had proven that an African could get by without compromising.[120]

Within this milieu that Dibango described in such lyrical terms, the idea for a gathering of Paris-based African musicians to produce a recording that could raise money for famine relief came, Dibango remembered, from Philippe Constantin, whom he called "a first-class talent scout."[121] Dibango greeted the idea enthusiastically, having just returned in the fall of 1984 from a concert in Holland whose purpose was to raise money for Ethiopia.[122] Constantin arranged for the record, which eventually bore the title "Tam-Tam pour l'Éthiopie," to be released by Phonogram-Philips in France,[123] and Virgin in the United Kingdom. Manu Dibango agreed to

produce the recording, and began to assemble the musicians who would participate. At first Alpha Blondy lent a hand, but the reggae singer withdrew because of a long-standing personal conflict he had with Salif Keïta.[124] Alpha Blondy did receive thanks on the printed record sleeve for his help.

Dibango soon enlisted Keïta and Mory Kanté, and other musicians began to come aboard. Initially, they agreed to donate all proceeds to Médecins Sans Frontières (Doctors Without Borders).[125] The recording took place on December 21–23, 1984, and made use of several Paris studios, especially Davout and Accousti. The record, released early in 1985, was a twelve-inch 45 RPM single, one side of which contained the song "Starvation," performed by a collection of English musicians including members of the bands UB 40, The Specials, and Madness and joined by many others such as the Nigerian musician Gaspar Lawal on talking drums. "Tam-Tam pour l'Éthiopie" bore a very long list of credits, since some thirty-five musicians were involved.[126] Manu Dibango was the lone musical producer, but four different people and one recording studio (Clouseau Musique) shared credit for "executive" production: Philippe Constantin, Clouseau Musique, Philippe Conrath, Rémey Kolpa-Kopoul, and Martin Meissonier. Above the list of credits was an announcement that all proceeds from the sale of the record would be distributed "in the famine areas of Ethiopia, Eritrea and Sudan," through Oxfam (based in Oxford, England), War On Want (based in London), and Médecins Sans Frontières (based in Paris).

Musicians included Ray Lema on piano and synthesizer, Mory Kanté on *kora*, Souzy Kasseya (like Lema, an immigrant from Zaïre)[127] on guitar, Ismael Touré on congas, Salif Keïta, Youssou N'Dour, and André-Marie Tala on vocals, and a large chorus that included Touré Kunda, a member of the Nigerian group Ghetto Blaster, and Georgia Dibango (Manu's daughter). Other African musicians not from the Francophone world included the Nigerian star of *juju* music, King Sunny Ade, on talking drums, as well as Hugh Masekela and the group Malopoets from South Africa. Lyrics were sung in five different African tongues: Douala, Lingala, Malinke, Wolof, and Swahili.

"Tam-Tam pour l'Éthiopie" was recorded in two parts, the second serving as a kind of coda to the first. Part one begins with lively conversation, as if at a crowded party, then the talking drums announce themselves. Very quickly Mory Kanté's *kora* takes up a strident insistent riff that threads its way throughout the song, which unfolds through the entrance of synthesizer and then a sequence of vocal performances built around a repeated chorus of what sounds like "Nous pour la faim, Africa!" (It appears that lyrics have never been published due to failure to agree on rights). After the first lyrics sung in Douala, Manu Dibango (appropriately, since he came from Cameroon) blows tenor sax, lending a swinging, jazzy flavor that adds a nice dimension to the track. After the segment sung in Lingala, the piercingly commanding voice of Salif Keïta contributes the only unaccompanied vocal performance (in Malinke). His singing plays off forcefully against the *kora* and a female chorus. After the vocals in Wolof (performed by Touré Kunda) and then the Swahili (Ray Lema among others), the song goes into fadeout, but a faint voice can be heard to say in English, "Let us wake up and put our hands together."

Part two begins once more with talking drums, then introduces a series of spoken vocals. The first speaker is the Zaïrean singer M'Pongo Love, and others include

Hugh Masekela, Youssou N'Dour, King Sunny Ade, and Ousmane Touré (switching between French and English). Their statements explain their support for the effort they are engaged in, but the vocals are semi-buried in the mix, so that the effect is like brief bits of radio transmission heard just before the signal fades away. The eerie figure played by the synthesizer adds to the air of mystery. In some ways, this makes part two an odd counterpart to the first. The overall significance of the record remains that of the musicians having been assembled and donating their talents in this way, and it also stands as a testimony to the great energy and commitment of Manu Dibango, who was able to bring the project to completion in the studio.

The record, with its impressive lineup of musicians, did not have the same impact as the Quincy Jones American counterpart "We Are the World" or Bob Geldof's "Do They Know It's Christmas?" from roughly the same period, but it nevertheless sold well enough for Mory Kanté and Dibango to be able to travel to Addis Ababa to present the funds they had raised.[128] And in terms of the heightened awareness of the African music in Paris, the response to "Tam-Tam pour l'Éthiopie" was part of the cultural and political atmosphere in the early months of 1985 that culminated in the impressive SOS-Racisme concert in the Place de la Concorde on June 15.[129] For the remaining years of the decade, Paris would enjoy a reputation as the center of a remarkably expressive African immigrant culture that France appeared to celebrate even as efforts to discourage its presence gained momentum.

Notes

1. Christian Poiret, "L'immigration familiale d'Afrique noire en region Île-de-France," *Migrations études: Synthèse de travaux sur l'immigration et la présence étrangère en France* 57 (May 1995): 1–2.

2. Michèle Tribalat, "Enquête mobilité géographique et insertion social," Rapport Final de l'Institut National d'Études Démographiques, Volume II (Paris, 1995): 31.

3. Catherine Wihtol de Wenden, "France: les mirages de l'immigration zéro," in *L'Europe et toutes ses migrations*, ed. Wihtol de Wenden and Anne de Tinguy (Bruxelles, 1995): 64.

4. A. Moustapha Diop, "Le Mouvement associatif négro-africain en France," *Hommes & migrations* 1132 (May 1990): 20. Among other sources on the associations, see Samba Yatèra, "Immigration, dynamiques associatives et transformations socio-économiques," *Sociétés africaines et diaspora* 4 (1996): 27–51.

5. Jacques Barou, ed., "L'immigration en France des ressortissants des pays d'Afrique noire," Rapport du groupe de travail interministériel (Paris, 1992): 88.

6. Riva Kastoryano, *Negotiating Identities: States and Immigrants in France and Germany*, trans. Barbara Harshav (Princeton, NJ, 2002): 99.

7. Alec G. Hargreaves, *Immigration, "Race" and Ethnicity in Contemporary France* (London, 1995): 221.

8. Wihtol de Wenden, "France: les mirages de l'immigration zéro": 64–65.

9. Danièle Lochak, "La Politique d'immigration en France et l'évolution de la législation," in *Les Nouvelles migrations: un enjeu européen*, ed. Emmanuelle Bribosia and Andrea Rea (Bruxelles, 2002): 211.

10. Philippe Urfalino, *L'invention de la politique culturelle*, Comité d'histoire du ministère de la Culture (Paris, 1996): 343.

11. Elizabeth J. Miles, "Immigrant Music in Europe," in *The Garland Encyclopedia of World Music, Volume 8: Europe*, ed. Timothy Rice, James Porter, and Chris Goertzen (New York, 2000): 238.

12. Jack Lang, "Préface," in Nago Seck and Sylvie Clerfeuille, *Les Musiciens du beat africain* (Paris, 1993): 9.

13. Barou et al., "L'immigration en France des ressortissants des pays d'Afrique noire": 14.

14. Hargreaves, *Immigration, "Race" and Ethnicity in Contemporary France*: 79. See also Leslie Page Moch, *Moving Europeans: Migration in Western Europe since 1650* (Bloomington, 1992): 175.

15. Jacques Barou, "Des chiffres en général et de ceux de L'INSEE en particulier," *Migrants-Formation* 91 (December 1992): 7–8.

16. Catherine Quiminal, "Les Africains, divers et dynamiques," in *Immigration et intégration: l'état des saviors*, ed. Philippe Dewitte (Paris, 1999): 113.

17. Hargreaves, *Immigration, "Race" and Ethnicity in Contemporary France*: 14.

18. Barou et al., "L'immigration en France des ressortissants des pays d'Afrique noire": 13.

19. Michèle Tribalat, *De l'immigration à l'assimilation: Enquête sur les populations d'origine étrangère en France* avec la participation de Patrick Simon et Benoît Rianley (Paris, 1996): 41.

20. Ibid.: 250, 253.

21. Gilles Anquétil and Philippe Conrath, "La Fièvre des samedis soirs: Paris, capitale mondiale des rythmes africains," *Le Nouvel observateur* (July 22–28, 1988): 77, 79.

22. Bennetta Jules-Rosette, *Black Paris: The African Writers' Landscape* (Urbana, IL, 1998): 149.

23. Philippe Martinat, "La Roue de chance de Wally Badarou," *La Croix* (August 13–14, 1989): 100.

24. Lokua Kanza, author interview, Paris, June 26, 1995. Ray Lema, author interview, Villers-sur-Marne, June 23, 1995.

25. Artur Simon, "Islam und Musik in Afrika," in *Musik in Afrika: Mit 20 Beiträgen zur Kenntnis traditionelle Afrikanischer Musikkulturen*, ed. Artur Simon (Berlin, 1983): 297.

26. Louise M. Bourgault, *Mass Media in Sub-Saharan Africa* (Bloomington, 1995): 252.

27. "Ray Lema: Composer/Musician (Zaïre/France)." Interview by Barbro Scultz, Paris, April 2003: http://www.freemuse.org/sw3920.asp.

28. Lucy Duran, "Mali/Guinea—Mande Sounds," in *World Music, Volume 1: Africa, Europe and the Middle East: The Rough Guide*, ed. Simon Broughton, Mark Ellingham, and Richard Trillo (London, 1999): 540.

29. Eric Charry, *Mande Music: Traditional and Modern Music of the Maninka and Mandinka of Western Africa* (Chicago, 2000): 1.

30. Wolfgang Bender, *Sweet Mother: Modern African Music*, trans. Wolfgang Freis (Chicago, 1991): 16–17.

31. Thomas A. Hale, *Griots and Griottes: Masters of Words and Music* (Bloomington, 1998).

32. Mamadou Diawara, "Mande Oral Popular Culture Revisited by the Electronic Media," in *Readings in African Popular Culture*, ed. Karin Barber (Bloomington, IN, 1997): 41.

33. Seck and Clerfeuille, *Les Musiciens du beat africain*: 135.

34. Hélène Lee, *Rockers d'afrique: Stars et légendes du rock mandingues* (Paris, 1988): 40.

35. Angela Impey, "Popular Music in Africa," in *The Garland Encyclopedia of World Music, Volume 1: Africa*, ed. Ruth M. Stone (New York, 1988): 421.

36. Chris Stapleton and Chris May, *African All-Stars: The Pop Music of a Continent* (London, 1989): 116–117.

37. Graeme Ewens, *Africa O-Ye!: A Celebration of African Music* (New York, 1992): 71.

38. "The Touré Kunda Discography": http://user.va.net/smith/toure/.
39. Frank Tenaille, *Le Swing du caméléon: Musiques et chansons africaines 1950–2000* (Arles, 2000): 136.
40. Christian Mousset, "La Musique africaine et la France," in *Étudiants africains en France 1951–2001: Cinquante ans de relations France–Afrique: Quel avenir?*, ed. Michel Sot (Paris, 2002): 164.
41. Impey, "Popular Music in Africa": 421.
42. Tenaille, *Le Swing du caméléon*: 145–149.
43. Impey, "Popular Music in Africa": 421.
44. Ewens, *Africa O-Ye!*: 119–120.
45. "Biographie": http://andremarietala.com.
46. André-Marie Tala, author interview, Asnières, France, May 31, 1998.
47. "Biographie."
48. Seck and Clerfeuille, *Les Musiciens du beat africain*: 217.
49. Gary Stewart, *Breakout: Profiles in African Rhythm* (Chicago, 1992): 147.
50. Phyllis M. Martin, *Leisure and Society in Colonial Brazzaville* (Cambridge, 1995): 143.
51. Stewart, *Breakout*: 147.
52. Charles Didier Gondola, *Villes miroirs: Migrations et identities urbaines à Kinshasha et Brazzaville 1930–1970* (Paris, 1996): 216–219.
53. Ibid.: 200–208.
54. Ibid.: 221.
55. Gary Stewart, *Rumba on the River: A History of the Popular Music of the Two Congos* (London, 2000): 36–38.
56. Seck and Clerfeuille, *Les Musiciens du beat africain*: 120.
57. Ewens, *Africa O-Ye!*: 130–132.
58. Angélique Kidjo, author interview, Sucy-Bonneuil, France, June 22, 1995.
59. Stewart, *Rumba on the River*: 207.
60. Patrick Labesse, "Manu Dibango, musique de fête et dossiers chauds," *Le Monde* (July 28, 2004): 3: http://www.lemonde.fr.
61. Stewart, *Rumba on the River*: 207–208.
62. Péla Simba, author interview, Paris, July 16, 1997.
63. Pascal Blanchard, Éric Deroo, and Gilles Manceron, *Le Paris noir* (Paris, 2001): 161.
64. Tenaille, *Le Swing du caméléon*: 257.
65. Patrick Labesse, "Ray Lema Solo: All About My Mother," *rfimusique.com.* (March 29, 2004): http://194.117.210.41/steeen/article_7261.asp.
66. "Ray Lema," *Yahoo! Musique France* (December 2000):http://fr.music.yahoo.com/biographies/ray_lema.html.
67. Tenaille, *Le Swing du caméléon*: 258.
68. "Ray Lema," *Yahoo! Musique France.*
69. "Ray Lema," *African Music Profiles:* http://africanmusicprofiles.com/RayLema.htm.
70. Tenaille, *Le Swing du caméléon*: 259.
71. "Ray Lema," *Yahoo! Musique France.*
72. Ray Lema, author interview, Villiers-sur-Marne, June 23, 1995. Unless otherwise indicated, all information about Ray Lema comes from this interview.
73. Richard L. Derderian, "Broadcasting From the Margins: Minority Ethnic Radio in Contemporary France," in *Post-Colonial Cultures in France*, ed. Alec G. Hargreaves and Mark McKinney (London, 1997): 101.
74. Hane Djeynab and Francis Kpatindé, "Comment ils ont conquis le monde," *Jeune Afrique* 1485 (June 21, 1989): 4.
75. Miles, "Immigrant Music in Europe": 238–239.

76. Dorothee Tromparent, "Le Chef de la tribu Nova," *Le Monde: Télévision/Radio/ Multimédia* (June 16–17, 1996): 33.
77. Pascale Nivelle, "Tu vois ce que je veux dire," (November 23, 2001): http://paris70. free.fr/bizot.htm.
78. Tromparent, "Le Chef de la tribu Nova": 33.
79. Péla Simba, author interview, Paris, July 16, 1997.
80. Mamadou Konté, author interview, New York City, July 6, 1998.
81. Bintou Simporé, "Des Radios et des musiques du monde," in *Les Musiques du monde en question*, ed. Sabine Wespieser and Hubert Nyssen (Paris, 1999): 243.
82. Bintou Simporé, author interview, Paris, June 26, 1995.
83. Tromparent, "Le Chef de la tribu Nova": 33.
84. Bernard Loupias, "La Planète des sons: L'explosion des musiques du monde," *Le Nouvel observateur* (February 25—March 3, 1989): 20.
85. Bintou Simporé, author interview, Paris, June 26, 1995. Unless otherwise indicated, all information about Bintou Simporé is based on this interview.
86. François Bensignor, "Africains en France: la compile," *Hommes & migrations* 1191 (October 1995): 36.
87. Chris Warne, "The Impact of World Music in France," in *Post–Colonial Cultures in France*, ed. Alec G. Hargreaves and Mark McKinney (London, 1997): 140.
88. "Décès de Philippe Constantin," *Le Web de l'Humanité* (Jnauary 5, 1996): http:// www.humanite.fr/id_article=742384.
89. Miles, "Immigrant Music in Europe": 239.
90. Patrick Labesse, "Cuban Salsa Gets an African Flavour," trans. Julie Street (rfimusique.com): http://194.117.210.41/steeen/cd_semaine/cd_semaine_6559.asp.
91. Charlie Gillett, "Record of the Month October 2004: The Very Best of Syllart Productions," *The Sound of the World:* http://www.charliegillett.com/rotm.php?/date= october04.
92. Labesse, "Cuban Salsa."
93. Hélène Lee, author interview, Clichy, France, June 29, 1997.
94. Ibrahim Sylla, author interview, Paris, July 2, 1997. Unless otherwise indicated, information about Ibrahim Sylla is derived from this interview.
95. François Post, author interview, Paris, July 9, 1997. All information on François Post derives from this interview.
96. "The Touré Kunda Discography": http://user.va.net/smith/toure/.
97. Anquétil and Conrath, "La Fièvre des samedis soirs: Paris, capitale mondiale des rythmes africains": 21.
98. Mar Fall writes that the crowd was "scarcely one hundred people," but perhaps no more than four of them paid their admission (assuming he was referring to that debut concert). He contrasts this with a two-day period in March 1985 when Touré Kunda played before more than twenty thousand people. See Mar Fall, *Des Africains noirs en France: Des tirailleurs sénégalais aux . . . Blacks* (Paris, 1986): 75.
99. Tenaille, *Le Swing du caméléon*: 140.
100. Gilles Fruchaux, author interview, Paris, June 1, 1998. All information about Gilles Fruchaux is based on this interview.
101. Hélène Lee, author interview, Clichy, France, June 29, 1997. All information on Hélène Lee is based on this interview.
102. François Bensignor, author interview, Paris, July 1, 1997. Unless otherwise indicated, all information on François Bensignor is based on this interview.
103. François Bensignor, "Préambule/Preamble," *An Introduction to African Music in 100 CDs/Pour connaître les musiques africaines, Afrique en scenes: supplément au no. 6* (December 1996): 1.

104. François Bensignor, author interview, Paris, May 21, 1998.
105. Loupias, "La Planète des sons": 20.
106. Philippe Conrath, author interview, Paris, July 11, 1997. Unless otherwise indicated, all information on Conrath comes from this interview.
107. Michel Doussot, "Le Monde selon . . . Philippe Conrath," *Routard mag* (December 17, 2001): http://www.routard.com/mag_invite/id_inv/39.htm.
108. Loupias, "La Planète des sons": 20.
109. Blanchard et al., *Le Paris noir*: 161.
110. Bintou Simporé, author interview; Fara C., "Voix de tête et de fête: L'affiche noire du 10 avril," *l'Humanité* (April 1, 1988): 83.
111. Jane Freedman, *Immigration and Insecurity in France* (Aldershot, 2004): 155–159.
112. Hargreaves, *Immigration, "Race" and Ethnicity in Contemporary France*: 128.
113. Evelyne Fallot, "L'histoire secréte de la génération Désir," *l'Express* (October 2–8, 1987): 42.
114. Freedman, *Immigration and Insecurity*: 158–159.
115. Ibid.: 159.
116. François Bensignor, "Africains en France: la compile": 38.
117. Maxim Silverman, *Deconstructing the Nation: Immigration, Racism and Citizenship in Modern France* (London, 1992): 63.
118. Harlem Désir, *Touche pas à mon pote* (Paris, 1985): 14.
119. Danielle Tartakowsky, "La Construction sociale de l'espace politique: Les usages politiques de la place de la Concorde des années 1880 à nos jours," *French Historical Studies* 27:1 (winter 2004): 167.
120. Manu Dibango, *Three Kilos of Coffee: An Autobiography by Manu Dibango in Collaboration with Danielle Rouard*, trans. Beth G. Raps (Chicago, 1994): 114.
121. Manu Dibango, author interview, Paris, December 7, 2000.
122. Dibango, *Three Kilos of Coffee*: 115.
123. Bensignor, "Africains en France: la compile": 37–38.
124. Dibango, *Three Kilos of Coffee*: 115.
125. Ibid.: 115–116.
126. Tenaille, *Le Swing du caméléon*: 232.
127. Seck and Clerfeuille, *Les Musiciens du beat africain*: 137.
128. Dibango, *Three Kilos of Coffee*: 190–191.
129. Bensignor, "Africains en France: la compile": 38.

Chapter 3

"La World Music" in Paris, 1985–1989

Throughout the remainder of the 1980s awareness increased that Paris had become truly a center—or perhaps a crossroads—for African music. This awareness was linked as well to political life and the immigration question. Large rock concerts staged by SOS-Racisme became a regular feature of Parisian life, and it became unthinkable for the organization to put together an event that was part rally and part festival without booking some prominent African musicians.[1] The period from 1985 to 1989 saw support stronger than ever from Jack Lang's Ministry of Culture.[2] But it was also during these years that the anti-immigration sentiment expressed on the margins of French political culture found its way into the corridors of power, particularly from 1986 to 1988, when the right-wing government of Prime Minister Jacques Chirac "cohabited" with the presidency of François Mitterrand.

The parties of the center-right won a narrow legislative victory in the March 1986 elections, but the margin was sufficient to allow the appointment of Jacques Chirac as prime minister. His RPR ("Rassemblement Pour la République") party had been trying to siphon away the growing support Le Pen's National Front party was getting, and soon showed that its method would be to borrow from the far right's anti-immigrant platform. Upon assuming the post of prime minister, Chirac announced that his government would introduce legislation that would end the practice of granting citizenship automatically to certain residents, such as children born in France to immigrant parents who would no longer gain French nationality without formally requesting it.[3] Where African immigration was concerned, France now seemed to be running on two separate tracks. Momentum clearly was building behind anti-immigrant politics, but at the same time the cultural spotlight shone more brightly than ever on African musicians, with regular media coverage and the increasingly bustling activity of the Parisian record companies and studios associated with their music. With Jack Lang's Ministry of culture providing much of the support, annual music festivals booked African musicians more than ever, and the annual national celebration of Fête de la Musique provided another important occasion for audiences to hear the music of the recent immigrants.

Antillean Paris

One of the highlights of the Fête de la Musique of June 21, 1986, in Paris was the first-ever *Carnaval antillais* at which Kassav', the pop group composed largely of immigrants from Martinique and Guadeloupe, performed before a throng of some 250,000 on the lawn of Reuilly, to the immediate southeast of Paris between the Porte de Charenton and the Bois de Vincennes. The concert followed a joyous parade,[4] and served both as a landmark event in the band's history and as an occasion of self-discovery for the large Antillean population of Paris. Immigrants from the Caribbean overseas territories had begun heading to France during the 1960s, a time of severe economic downturn and job loss due especially to the closing of sugarcane factories.[5] While they have not always fared well in France, since the 1960s the overall Antillean population has been transformed from one assumed to be in France just long enough to improve their fortunes to another of the more or less permanent ethnic "communities" of the *métropole*. By 1990 this population, including those born in France to immigrant parents, numbered about 337,000.[6] Ever since the early 1960s, the Antillean population in the Paris region had, when not suffering unemployment, performed low-level jobs. Many had suffered the same kinds of social ills faced by other immigrant families inhabiting the *banlieues*, including juvenile delinquency and poor scholastic performance.[7] For these reasons, the success of Antillean musicians and writers in France brought pride and validation to the whole community.

When Patrick Chamoiseau of Martinique won the *Prix Goncourt* for his 1992 novel *Texaco*, written in both French and Creole, it shook the French literary world, and remains a marker of the gradual cultural expansion of the Francophone world in recent decades. Chamoiseau's novel vividly captures the lure Paris and its local stand-in Fort-de-France had for residents of Martinique. Going there was more than a rite of passage, as it remained the center of the French civilization in whose language they had been instructed and whose values and achievements they had been taught to revere, often at the expense of pride in their indigenous culture. But even though they held French citizenship, Antillean immigrants in Paris encountered disapproval for their use of Creole and, as blacks, had their citizenship questioned on a regular basis—especially once African immigration began to increase significantly by the 1980s. And as with the new African immigrants, it was through music and the *grands bals* and carnivals presided over by such groups as Kassav' that the Antillean community in Paris gained visibility.[8]

Musicians from Guadeloupe and Martinique founded the influential band Kassav' in Paris in 1977. The majority of the group's members over the years have been from Guadeloupe, but they have also come from Martinique (most notably singer Jocelyne Béroard), France, Belgium, Algeria, and Cameroon. The music they would play came to be called *zouk*, a Creole term for a raucous party filled with dancing and celebration.[9] The music built on the traditional music of Guadeloupe known as *gwo ka*, first performed by slaves in the early seventeenth century.[10] This "roots" style of the island was blended with carnival rhythms (including seventeenth-century European influences),

contemporary African styles, and electronic dance music to produce *zouk*.[11] It owes a debt to the popular traditions of both Guadeloupe and Martinique.[12] The sound is structured around the *ti-bois*, a stick that serves as the principal percussion instrument. While Kassav' uses the actual instrument in its performances, they simulate it electronically when recording. The listener is confronted with a dense, layered quality in the powerful sound the band achieves, and one hears at times a "Latin" flavor. The source, in fact, is from the music of the former Zaïre, where Congolese *rumba* was in direct response to Cuban influences. Jean-Claude Naimro, keyboardist and another of the Martinican members of Kassav', has credited the band Rico Jazz, who came to Martinique from Zaïre in 1967, with this influence.[13]

While recognized in Paris before making its big splash there, Kassav' especially had been making a name for itself internationally. In 1983 the band scored its first big worldwide hit with "Zouk la Se Sel Medikamen Nou Ni" ("Zouk is the Only Medicine We Have"). The sense of the song's title and lyrics, which provoked much debate and comment in Guadeloupe, was that the music held a healing power for the cultural differences and divisions among Antillean peoples.[14] The following year, Kassav' held a series of warmly received concerts in Guadeloupe and Martinique during the carnival season of February and March. By this point the band had released a string of albums, and individual members had released solo projects. In 1985 Kassav' toured for the first time beyond the Antilles, giving concerts from Dakar to Yaoundé and meeting with especially notable success in Abidjan, Côte d'Ivoire, in March.[15] Finally, they made their triumphal stand in Paris in June 1985, with a series of concerts—completely sold out one month in advance—at the Zénith concert hall. The response to their music was coming both from the Antillean community in Paris and from African music enthusiasts.

After 1985 the band's place in the Paris music arena was very well-established, and was reinforced by the June 21, 1986, "carnival" performance as well as by their now-regular annual series of concerts at the Zénith. In 1987 they made the leap to a major-label recording contract, signing with CBS/Sony.[16] Jocelyne Béroard has explained they decided on the label because they were able to demand successfully that they would retain complete control of their own music.[17] In November their first album on the label, *Vini pou*, went "gold" just two weeks after its release. In 1988 and 1989 Kassav' was awarded artistic prizes in France and in Québec, and continued to enjoy great commercial success. They closed out the year 1989 with another series of concerts at the Zénith.[18]

Jocelyne Béroard has been the member of Kassav' who has granted interviews and commented in the media most frequently on behalf of the band.[19] In June 1997 I interviewed her at the studio in Saint-Ouen, outside Paris, where Kassav' has recorded most frequently over the years. Not only did she submit to an interview, but searched through her laptop computer to find me names of musicians and others with whom I could speak. Studio Zorrino clearly was a state-of-the-art sophisticated recording facility and a bustling center of activity. Several projects seemed to be underway at once: work on the music of Kassav', solo efforts by Béroard and guitarist Jacob Désvarieux, and recording sessions involving a number of other musicians more or less in the Kassav' orbit. Interestingly, Jocelyne Bérorard was not someone

whose early life seemed to point toward a career in music. She described her early life this way:

> When I was a little girl in Martinique, I loved sciences and I loved arts. But then, it was art, art in all its forms. I loved painting. I painted and I drew a lot. I made fashion designs. I sang because I loved that. I loved to sew. I loved do it yourself, to make all sorts of things with my hands. And I loved sciences—mathematics and science. But at that time in Martinique, it was unthinkable that a woman could make a career as a singer, especially a girl of a "good family."

She explained further,

> My mother was an English teacher, and my father was a dental surgeon, so I couldn't say to them, "I am going to be a singer." They would have said, "You're crazy!" and so on. So, I was educated to prepare for a serious career. Then, since I loved science but did not want to be a doctor, I started to study pharmacy instead.

So she arrived in Normandy in 1972 to prepare for a career in pharmacy. But at the end of two years, she was injured in a major automobile accident after which, she explained, she "did not feel like" starting her third year. "I decided to drop it," said Béroard of her pharmacy program. Instead, she relocated to Paris, where she enrolled in the École Nationale Supérieure des Beaux-Arts.[20] Her choice of Paris enabled her to rejoin her brother Michel, a musician who introduced her to his musician friends.[21] She also began to get work as a singer, primarily working in studios as a backup vocalist for various Antillean musicians,[22] and she sang at Antillean "soirées," virtually the only way in those days one could hear the music, absent as it was from the airwaves before 1981. These, she explained, were "prestigious" gatherings of "all sorts of Antillean personalities, where I sang traditional songs of our homeland." After this, she tried her hand at "piano bars," performing with jazz musicians.[23] Then, in 1980, after spending six months in Jamaica working with famed producer Lee Perry,[24] she returned to Paris where she met Jacob Désvarieux and the other members of Kassav', joining the band as one of its singers.[25] Once Radio Nova took to the air in 1981, the station played a vital role in supporting Kassav', something Béroard acknowledged readily.

One of the most important considerations in the music of Kassav' has been their use of Creole, giving validation to the language in a way similar to that of Chamoiseau and other Antillean writers. The embrace and affirmation of Creole also became a source of pride for the Antillean residents of the Paris region who made up the band's most loyal fan base. I asked Béroard if it was very important for her to use Creole in her music, and she answered this way:

> Yes, because it is the language that lends itself best to this music . . . the language gets mixed up in the rhythms, I believe. Anyway, it is the language of my childhood and it is equally a combat because, well, Creole has been considered exemplary of Kassav' and then perhaps some writers, etc. have restored Creole to a position of honor. But in the Antilles, when I was little people did not play in French. They only played in Creole, yet Creole was considered as vulgar. Why? Because if you wanted to be a good French

person, you had to know to handle the French language properly. Then the point was to be able to take Creole and to be able to show people that Creole could be completely political, that Creole finally has some colors, some smells, and some taste. That in fact allows this language to grow and gives it back its position of honor. In families when I was little, we were forbidden to speak Creole. I didn't have the right to speak Creole at home.

By the mid-1980s Antillean music in France was beginning to reach an ever-wider audience, the audience that was responding to music by sub-Saharan African musicians. To lovers of "La World Music," *zouk* fit in comfortably with *mbalax, bikutsi, soukous,* and other African genres. Bridging the cultures of two different hemispheres was not always a sign of a positive response, however. Unfortunately, those in France who were hostile to immigrants, especially those of color, likewise did not distinguish between French citizens from the West Indies and African residents of France. All were unwelcome.

Attacks on Immigrants and the Campaign Against Racism

In 1986 it seemed in many ways that French culture was going through another of its phases of fascination with African culture, increasingly referred to as "black"—using the English word. That September Radio France Internationale, already helping to promote African music, introduced a new program called *Taxi Brousse* ("Bush Taxi," named for the vans and small buses that transport passengers in many African countries), anchored by a journalist named Sylvie Coma. Well-known artists such as Salif Keïta, Papa Wemba, and Touré Kunda made regular appearances, as did lesser-known performers.[26] The seeming vogue for black culture made a surprising hit out of the film *Black mic-mac* by Thomas Gilou, which played to over one million viewers in cinemas in 1986.[27] The film depicted the plight and misadventures of black African immigrants in France. Mar Fall's book *Des Africains noirs en France: Des tirailleurs sénégalais aux . . . Blacks* (1986), tracing the changing place of black Africans in the Francophone world during the twentieth century, was very much of the moment.

At the same time, the new government of Prime Minister Chirac was busy during the spring and summer of 1986 readying its sharply hostile legislative approach to immigration and citizenship. Charles Pasqua was appointed as interior minister, and he set about reversing some of the fundamental positions established by his Socialist predecessors. Not that the left in power had been uniformly lenient toward immigrants. They had demanded that residents applying for permanent status (being "regularized") prove they had arrived in France before 1981 and that they were employed. The Mauroy government also imposed stiff penalties on employers who knowingly hired illegal immigrants. Then, in December 1984, the new government of Laurent Fabius with Pierre Joxe as interior minister successfully sponsored legislation to make family reunification more restrictive. Generally speaking, however, the Mauroy and Fabius governments of 1981–1986 had eased the path of African and other immigrants.

An important policy in this regard was the refusal to use executive powers to deport immigrants judged illegal. Instead, court orders had to be obtained.[28] One of the laws passed in September 1986 that would bear Charles Pasqua's name restored executive control over deportations, specifically granting authority to the prefects to order that foreigners judged to be "irregular" be taken our of the country.[29] Other "Pasqua laws" passed between September and November broadened the categories for persons who could face expulsion and restricted access to the ten-year residency permit.

One of Pasqua's most ambitious proposals—to "reform" the Code of Nationality—provoked so much controversy that it had to be set aside while a special study commission was appointed. Pasqua had argued for doing away with the long-standing principle of *jus soli*, whereby all children born to foreign parents living in France and themselves living in France for at least five years prior to the age of eight-een be granted citizenship automatically upon reaching that age. Pasqua argued that such persons would need to make formal applications subject to refusal on certain grounds (such as a criminal record). Legislative hearings on this reform received television coverage and elicited an energetic national debate.[30] In January 1988 the Commission de la Nationalité published its recommendations, which included the reaffirmation of *jus soli*. When the Chirac government, and Pasqua with it, left office in May this issue had not been resolved, but Pasqua was able to get his pro-posed law passed when he became interior minister for the second time in 1993.

Meanwhile, in the same month (October 1986) in which Pasqua had introduced his proposed change to the Code of Nationality, he began a process of deportations of illegal immigrants that lasted for several months, beginning with 101 Malians. His draconian actions were matched by shocking rhetoric, as in May 1987 when he vowed to fill trains with illegal immigrants and convey them out of the country. Since this occurred at the time that the trial of Klaus Barbie for crimes against humanity was getting underway, many in the country were horrified to be reminded of Vichy-era deportations.[31] To many, Pasqua had assumed the role of Jean-Marie Le Pen in the Chirac government. It appeared that the center-right politicians were eager to steal the National Front's thunder without officially allying themselves with it.

The continued strength of Le Pen's movement and the new laws and policies (especially the deportations) of Interior Minister Pasqua elicited a vigorous response and sustained activity from Harlem Désir and SOS-Racisme. The organization's lead-ership had a sense of urgency as well due to evidence of racist violence whose flames Le Pen's rhetoric certainly helped to fan. In early August 1987 a group of racist "skin-heads" attacked some Senegalese vendors in Perpignan. One of them, when arrested by police, announced simply that he "did not like blacks."[32] That same month, Harlem Désir's appearance on French television (France 2),[33] where he delivered a stirring denunciation of intolerance and the hateful politics of anti-immigration, received wide comment in the media. Le Pen's National Front party, quite pre-dictably, denounced his comments, but an instant poll on the night of the broadcast found that 70 percent of respondents had a "good opinion" of him.[34] One headline proclaimed "Bad Night for Le Pen."[35] Désir covered a wide range of topics, making clear his opposition to the Pasqua laws and endorsing the antiapartheid movement in South Africa. These stances made some prominent commentators uncomfortable, even as they professed to admire the way SOS-Racisme had, as Louis Pauwels of

Le Figaro put it, "exalted in young people the taste for fraternity" and "offered a more generous image of our country." Like some of his counterparts on the left, Pauwels revealed his suspicion of Désir's pluralistic approach to culture and to "French" identity.[36]

Harlem Désir, born in 1959, was himself young when he gained prominence in French political life, and the theme of the appeal his movement had for young people was echoed often in press accounts during the late 1980s. For example, Étienne Gau, writing in *La Croix* in August 1987, offered the view that SOS-Racisme, which he dubbed "le mouvement des potes," "expresses the aspirations of a large part of the young generation."[37] The themes of youth and immigration were linked frequently in the flood of commentary on the latter topic, especially in reference to the youthfulness of the recent immigration population. In 1992 a study supervised by CNRS (Centre National de la Recherche Scientifique) would show that roughly one-third of the African immigrant population was made up of children under the age of fourteen.[38] This continues to have relevance for an aging French population and workforce. Of course, young people also were the ones most likely to consume recordings of popular music, especially the newly available African music that found its way onto the stages of rallies organized by SOS-Racisme. It was a similar convergence of politics and music that had marked the generation of 1968, and it seems significant that Jean-François Bizot's magazine and radio station continued that spirit, one result being that many aging veterans of May 1968 joined the youthful supporters of Désir's organization in both political convictions and musical tastes. In later years, as political demonstrations were organized in support of immigrants seeking regularization, many of Bizot's contemporaries typically joined forces with the youthful followers of SOS-Racisme.

Paris *Soukous*

Paris continued to attract African musicians as its reputation as a vital center of African music grew. One prominent example was Sam Mangwana (1945–), a singer originally from Angola who had moved when young with his family to Kinshasha. In 1963 Mangwana left school to begin singing in Tabu Ley's l'Orchestre de Rochereau. Later he would broaden his experience with Zaïrean musicians by playing with Franco and O.K. Jazz. By the late 1970s he was based in Abidjan. He arrived in Paris in 1987 to have his album *Aladji* produced by Ibrahim Sylla.[39] He had been preceded by a number of fellow musicians from Zaïre, many of them Paris residents since the late 1970s. One such person, guitarist and singer Péla Simba, years later expressed pride in the fact that he had been on hand to "welcome" Sam Mangwana to Paris.[40] Mangwana rapidly became a sought-after musical talent, but for every successful Congolese musician in Paris (examples included Ray Lema, Kanda Bongo Man, and Papa Wemba), many more struggled to gain recognition and faced a host of other difficulties. One good example was Lokassa Mbongo, rhythm guitarist for the well-regarded band Soukous Stars.

The band, a sextet, formed in Paris in 1989, after Lokassa Mbongo (1951–) and singer Ballou Canta (1954–; real name Hyacinthe Ballou) had worked together

during a session produced by Ibrahim Sylla.[41] Most members of the band had spent time playing in other *soukous* groups or as session musicians. Ballou Canta, from Congo-Brazzaville, was in demand as a singer and guitarist,[42] much like the admired Zaïrean guitarist Diblo Dibala. The latter, an avowed jazz lover best known for his playing with the group Loketo,[43] was described by one African music expert as "one of this era's best *soukous* lead guitarists." He had played with the charismatic singer Kanda Bongo Man (1955–), who arrived in Paris in 1979.[44] Like Dibala, who first settled in Belgium before moving to Paris,[45] he experienced his ups and downs.[46] Life in Paris was more often difficult than not for musicians from Zaïre, but the appeal of the city remained its value as a base for one's musical career.

Soukous Stars reached its peak of popularity in Paris during the early-to-mid-1990s before relocating to the United States during the next decade. Lokassa had arrived in Paris in 1984, but struggled to survive due to the fact that he lacked papers. He spent eight years as someone *sans-papiers*.[47] When I met him in 1996, he and the band were working at Harry Son Studio in Pantin, on the verge of departing for an American concert tour. In fact I took my leave just before a doctor was to arrive to administer some inoculations the musicians needed ("Dans mon cul," Lokassa said, patting his butt).

The rendezvous point for our interview was in front of the McDonalds at the Porte de Clignancourt Métro stop. Lokassa ya Mbongo picked me up and drove us to the studio, his band's music playing on the stereo. We arrived and sat down, and he immediately began talking about his early life, and the fact that he had always wanted to play music but had encountered resistance from his family. He held his guitar and strummed it nearly the whole time we talked, explaining that he had always experimented with different tunings. The one he used most often produced a seventh chord with the strings played open—an extraordinary sound he used as a rhythm guitarist to punctuate the layered *soukous* textures around which Dally Kimoko's lead guitar spiraled.

Before coming to France, Lokassa had put in many years playing with top musicians of Zaïre, including ten years (1968–1978) with Tabu Ley Rochereau. After that time, he played with Sam Mangwana, staying with him for a while in Abidjan. That city was one of the locations favored by Ibrahim Sylla; thus Lokassa had experience working with the influential producer before coming to Paris. Once in Paris, he took part in recording sessions with a number of African and Antillean musicians, never limited to fellow Zaïreans. But unlike many of them who possessed *cartes de séjour*, Lokassa was unable to tour or make recording dates outside the country, since he was in France without papers. "I was stuck in Paris," he explained, "It was really very, very difficult. People needed for me to come to the United States, other continents, even to other countries in Africa. But people couldn't see me because I didn't have papers." Lokassa had been in France all those years without his family, and he told me he had not seen his own children for more than a dozen years. Leaving aside the subject of his own personal hardships, Lokassa suggested that, even at the height of the popularity of African music in Paris, the public had made room for only a few selected big "stars." He frequently cited Ray Lema and Papa Wemba as success stories.

Later that same bright June day when I interviewed Dally Kimoko (1955–), the lead guitarist of Soukous Stars, I was fascinated to learn that the same band could

contain members with very contradictory histories as immigrants in Paris. Like Lokassa Mbongo, Kimoko had settled in Paris in 1984, having been there two years earlier to record.[48] Having acquired French citizenship (in 1989) through his wife, Kimoko had escaped the worries that had dogged his bandmate's steps. In the process, he appeared to have settled more comfortably into Parisian life, an impression confirmed by the fact that he later quit the band Soukous Stars before they left for the United States. He has pursued a solo career since the late 1990s. He and I even met in what could be described as a more quintessentially modern Parisian manner. He came to the neighborhood where I was living and met me in a café before we walked to the apartment nearby that I had rented.

An exceptionally agreeable and thoughtful person, Dally Kimoko exhibited none of the self-importance one sometimes encounters in successful performers. He described his years in Paris as busy ones, saying he recorded and played with "lots of great musicians." And while he professed to be no expert on contemporary politics, it was clear that he remained interested equally in both African and French developments. He was passionate about his cultural roots, and bitter over the colonial legacy. "The whites came to colonize us, to give us *their* education." But, he added, "We had our own education." He regretted not being able to visit his relatives in Zaïre due to the political situation there, but seemed pleased with the life he led in Paris with his wife and two children. He commented also on the strength of Le Pen's National Front movement, speculating on the support it enjoyed in class terms.

Like the other members of Soukous Stars, Kimoko had ranged widely as a musician, playing not only with fellow Zaïreans but also with Youssou N'Dour of Senegal, for example, on one of his U.S. tours. He had also worked with the Japanese pop musician Ryuichi Sakamoto, someone who enjoyed international popularity during the late 1980s. Meanwhile, even if Paris by the mid-1990s was no longer in its heyday as far as African music was concerned, Kimoko had remained in demand and still saw Paris as an essential center for the music as it had been during the previous decade. "I think African music in Paris is progressing," he stated emphatically. At the time he uttered those words, Paris had been associated with the so-called world music for more than a decade.

The Invention of "World Music"

As for that now overly familiar phrase, it was the invention of a group of independent record company representatives, concert promoters, broadcasters, and others meeting in an upstairs room over a North London pub called the Empress of Russia[49] in July 1987.[50] This group of twenty-five (roughly) felt some urgency in devising a category that could direct consumers to the widening range of music becoming available from many parts of the world not already represented in familiar headings such as "rock" or "jazz." They were responding to the African music phenomenon in Paris, where Radio Nova had been using the phrase *sono mondiale* for several years to refer to the new international music.[51] Also, being residents of the United Kingdom, they were mindful of the great success being enjoyed by Peter Gabriel's annual WOMAD

("World of Music Art and Dance") concerts, which featured everything from West African *kora* music to Pakistani *qawwali* vocal performances.[52] Before long the designation world music would be entrenched in the music industry, with its own separate sales chart. The leading Anglo-American trade publication *Billboard* began publishing such a chart in 1990.[53]

French aficionados of African music, interestingly, had for some time been using the phrase "les musiques du monde" as a folkloric category influenced by the African ethnomusicological expeditions of the Musée de l'Homme in the 1950s and 1960s.[54] The use of the phrase concocted by the group meeting in England in the summer of 1987, which would catch on in France in the *franglais* of "La World Music," has come in for its share of criticism. Some have accused it of creating a new kind of ghetto, while many others have commented on its Western bias, pointing out that, depending on the vantage point, any music that comes from outside the local sphere is world music for someone. Gérald Arnaud, a prolific French writer on African music, calls world music a "neo-colonial" label, and argues that the singular "music" is highly reductive, as well as aggressively "globalizing" toward the very cultures it seeks to appropriate.[55] Meanwhile, the success of world music as a category that directs consumer choices owes much to leading record store chains, who embraced it and devoted increasing amounts of their inventory to it as the rubric expanded well beyond its African emphasis. In France the two largest retail chains, La FNAC and Virgin Megastore, led the way.[56]

It is important to emphasize that the phrase world music could not help but be arbitrary and in fact more limited in range than its suggestion of something truly global. The catch-all designation cannot really be compared to "world literature," as Pascale Casanova has used that phrase in an ambitiously framed work called *La République mondiale des lettres*, published in France in 1999 and subsequently in English translation as *The World Republic of Letters*. In her view, Paris in modern times has been the place where value is conferred on literary works from remote places, especially apparent with postcolonial literature. She sees the city as the capital of a global "republic of letters," serving as a kind of stock exchange for negotiating the value of literary works.[57]

No one city, not even Paris during the 1980s, has performed that kind of role for a truly "world" music, but the attention accorded music from African and other locations well outside the European sphere has been significant there. Laurent Aubert, a Swiss ethnomusicologist, has characterized the very large FNAC store in the Forum des Halles as one of the most important showcases in Europe for that branch of recorded music the industry decided to call world. He cited a study the FNAC des Halles itself carried out that found that of the roughly three hundred thousand compact discs sold from the world music category during 1996, sub-Saharan African recordings accounted for 16.6 percent, behind Antillean and European music, but ahead of reggae, Latin American, or Asian music.[58] Whether or not it is correct to see the store in the Forum des Halles as a site for conferring validation on what Aubert calls *la musique de l'autre*, it seems that African music continued to hold its own in the Paris market well after the decade usually associated with it.

The year 1987, when world music was proclaimed, was also the year that Salif Keïta began to make a larger impact on the Paris music scene, as his successful recording

and touring career also put him successfully on the international stage. He had come to Paris from Abidjan in 1984, and first won the acclaim of the large Malian community with a concert he gave in Montreuil in 1985.[59] He signed with Mango Records, the subsidiary of Island Records to which Philippe Constantin would move in 1990 from Barclay. In 1987 his first album *Soro* was released on Mango. It had been produced in Paris by Ibrahim Sylla,[60] and became a huge success, both in terms of the singer's career and the reputation of Paris as a center for recording African music. The album featured the characteristics many would come to associate with African music coming from Paris, including heavy use of electronics, for example, synthesizers and drum machines, and the kind of pop music framework, complete with horn section, used for big singing stars such as Tina Turner or Michael Jackson. Keïta had been very pleased to avail himself of the forty-eight-track digital studio Sylla's production provided, but some critics felt he had gone overboard in a Western pop direction.[61]

In any case, *Soro* launched him on a European tour that put him on the path to international stardom. But there was much more to Salif Keïta than his ambition for pop music success. He was deeply troubled by the deportations his fellow Malians in France were facing, and expressed the wish to be the kind of immigrant artist who takes stands for human rights and against discrimination and racial prejudice. Despite his own stature as an artist, he had experienced firsthand the kinds of administrative humiliations to which African immigrants could be subjected. Interviewed by the American Arts and Entertainment network for a documentary dealing with the 1989 bicentennial observance of the beginning of the French Revolution, he described the disrespectful treatment he had received when he appeared at the prefecture to apply for his residency permit. With bitter irony he remarked, "I was French before being Malian."[62]

Salif's outrage over the deportations of Malian immigrants Charles Pasqua had been pursuing led him to compose the defiant song "Nou pas bouger," which would appear on his next album recorded in Paris, *Ko-yan*, and released in 1989. The song's creolized title hinted at the complex ways in which various cultures within France now interacted, and drove home the strong message that "we are here to stay."[63] Moreover, it called attention to a less pleasant reality than the one promoted by the French Culture Ministry and the proponents of La World Music. "Nou pas bouger" became more or less the anthem of SOS-Racisme,[64] especially after the emergence of the so-called *sans-papiers* movement of the early 1990s—a movement spearheaded by Malians that Keïta's socially conscious song seems in retrospect to have anticipated.[65]

In late 1987 and early 1988 if any one hit song did more than others to put Paris even more squarely on the map as world music headquarters, it was "Yéké Yéké" by Mory Kanté, the musician from Guinea whose *kora* playing had figured so prominently in "Tam-Tam pour l'Éthiopie" (see chapter two). This song, whose title was taken from a kind of African couscous,[66] was one Kanté had first recorded in 1982 when he was still based in Abidjan (after his time in Bamako playing with the Rail Band). The originally more traditional version was included on his first album recorded in Paris, where he had moved in 1984. In 1986 Philippe Constantin of Barclay Records signed Mory Kanté to the label and encouraged him to record a more electronically reworked up-tempo version[67] for his 1987 album *Akwaba Beach*.

Both the album and the single "Yéké Yéké" met with enormous success internationally, the former selling some half-a-million copies and the latter nearly a million.[68] *Akwaba Beach* charted in a dozen countries, including The United States, Great Britain, and the Netherlands. The artist, commonly dubbed *le griot électrique*,[69] was lionized in Paris and taken to be a symbol of the success of African music there. Now, of course, every record company dealing with African musicians raced to try to duplicate this kind of commercial success. Unfortunately, especially after the demise of independent companies and the consolidation of the major multinational companies (see chapter four), this would mean that musicians who did not seem clearly destined for commercial triumphs found scant welcome in the world music business.

African Musicians, French Politics, and the Antiapartheid Movement

Having selected African musicians elevated to stardom did not mean that all such musicians in Paris succeeded, nor did it mean a corresponding acceptance of African immigrants (although media coverage occasionally seemed to imply such things). And of course in Salif Keïta's case, the same person both experienced professional success and confronted discrimination. In the spring of 1988 France was gearing up for another presidential election, which François Mitterrand would win convincingly in May. Le Pen's National Front party continued to be a force in French politics, and the RPR and other parties of the right were divided about the stance to take toward that movement. Officially there was no recognition of its legitimacy, but Jacques Chirac looked the other way when regional members of Le Pen's party forged alliances with his own party's candidates.[70] Harlem Désir and SOS-Racisme continued to be quite active and to receive much coverage in the French press. Not all of the press the movement received was favorable, as when Désir's group was denounced by the Congrès of the Union of Jewish Students of France (l'UEJF) for what that organization viewed as its excessively pro-Palestinian position. Désir had compared the occupied territories to South African townships.[71]

During that spring of 1988, the antiapartheid movement was at its peak internationally. In April the spring music festival "Le Printemps de Bourges" had featured Johnny Clegg, the South African singer Radio Nova had done much to popularize in France, where he became the subject of a short biography written by *Libération* journalist Philippe Conrath.[72] He appeared in concert in Bourges on April 10, taking part in a festival that included his band Savuka, the popular South African choral group Ladysmith Black Mombazo, Mory Kanté, and Manu Dibango, among others.[73] One article called attention to Clegg's defiantly interracial band, suggesting that this "cultural mixing of the white Zulu" was part of a "global political–cultural struggle"[74] that was quite timely in France. Harlem Désir was eager for SOS-Racisme to link its fight against racist politics in France to the antiapartheid movement, and he began to organize an ambitious international concert to be held simultaneously in Paris (before the Château de Vincennes), Dakar, and New York City.[75]

The three concerts took place on June 18, 1998, but with mixed results. The Paris venue was the most successful, with more than three hundred thousand persons in attendance.[76] Johnny Clegg and Savuka opened the concert—whose lineup included the reggae band Burning Spear, raï singer Cheb Kader, Mory Kanté, Ray Lema, and Ziggy Marley (son of Bob Marley)—at 7:00 p.m. Like the well-publicized concert in honor of Nelson Mandela's seventieth birthday held the previous weekend at London's Wembley Stadium (at which Salif Keïta performed), this one was dominated by the theme of fighting against apartheid, and much support was shown for the still imprisoned African National Congress leader. Clegg and his band had not been invited to the London event, and one reason given was that the racially mixed appearance of the band might give Europeans a false impression of actual conditions in South Africa.[77] The French audience, however, remained eager to embrace Clegg and Savuka, and sang along enthusiastically in support of Mandela.[78] President Mitterrand, as had become his practice when SOS-Racisme staged large events such as this one, marked the occasion with a statement delivered from the Élysée Palace. He called attention to the tripartite international location for the concert, stating rather solemnly that "all through the night, music will be the link between men and women of good will." Tying the event to the values of the French republic, he welcomed the contribution being made through music to "la possible et courageuse fraternité des hommes."[79] Having been reelected the previous month and with a new government under socialist Michel Rocard as prime minister, Mitterrand once again could at least give the appearance of support for the new French cultural *métissage*.

The Dakar venue, where the crowd filled a forty-thousand-seat stadium, was notable for the participation of several of the most illustrious names in Senegalese music, including Youssou N'Dour, Baaba Maal, and Ismaël Lô. Also on hand were Kanda Bongo Man from Zaïre and The Wailers, the late Bob Marley's band (minus several other of its well-known original members).[80] Least successful was the New York City concert, which Harlem Désir had been pleased to set for the famed Apollo Theater—in *Harlem*. Publicity had been poor, apparently, and no well-known musician was contracted for the show. Of the theater's fourteen hundred seats, only about half had been reserved, and only four hundred or so actually attended the concert.[81] It should not be all that surprising that at least one of these three events turned out to be a flop, especially given the plethora of politically minded concerts underway during the early months of 1988, such as the Wembley Stadium concert for Nelson Mandela and the Amnesty International concert tour for human rights headed up by Bruce Springsteen, Sting, Tracy Chapman, and Youssou N'Dour.[82]

African Music, Immigration, and Integration

During the latter 1980s a growing number of Western pop music stars climbed on the world music bandwagon. A short list of names would include Paul Simon, Peter Gabriel, Stewart Copeland (once the drummer for The Police), Kate Bush, and Talking Heads—particularly its lead singer David Byrne. In 1988 Talking Heads released its final studio album *Naked*, recorded in Paris at Studio Davout in the

Eleventh Arrondissement. On the inside sleeve, the band thanked Jean-François Bizot among others. Wally Badarou, the influential Paris-based musician from Bénin, received billing as "chief inspector" for his assistance with production. He also supplied keyboard accompaniment, and other African musicians who appeared on several tracks included Mory Kanté on *kora* and Brice Wassy of Cameroon on percussion. This sojourn by the much-admired American band provided beneficial publicity for the Paris African music scene, and the band made it known in interviews that they considered Paris to be *the* center of the new world music.

This same celebratory theme played out frequently in the French press. In September 1987 *L'Humanité* ran an article about the band Touré Kunda to publicize their forthcoming appearance at the annual "Fête de L'Humanité" organized by the newspaper. The journalist, who frequently wrote about African immigrant themes and music in particular and who signed her article "Fara C.," described visiting the brothers Touré's homes in Belleville and sharing the Senegalese national meal of *thieboudienne* (fish, rice, and vegetables in a spicy tomato sauce), sitting on the floor to eat from the common platter in the Senegalese manner. She went on to discuss their background in Casamance, and the debt their music owed to a traditional dance called the *djambadong*. The African folkloric emphasis she chose to make was somewhat in contrast to remarks she quoted from Sixu Touré. In discourse that seemed to echo the famous statement by Mamadou Konté about French people coming to "understand" African immigrants, Sixu spoke of the need to get beyond the opposing categories of "the French" and "immigrants," and pointed to a new type of citizenship by saying, "We have the chance to have two cultures: yours and ours."[83]

Typically newspaper and magazine articles dealt with established figures such as the Senegalese brothers and, unfailingly, Manu Dibango. *Le Monde* extolled his founding role in contemporary African music (actually, they referred largely to jazz) in a July 1988 article about the festival "Francofolies de La Rochelle" where Dibango was to receive special recognition and had been given the opportunity to invite several of the other musicians who were to perform at the festival.[84] Much later that year Gérald Arnaud devoted an article to Manu Dibango that used the technique of observing a day in the musician's life in order, he argued, to gain insights into the way Paris "had become the capital of African musics." Dubbing him the "griot of Ménilmontant," the article emphasized Dibango's long residence in an apartment building close by Père-Lachaise Cemetery and two doors from the house in which Maurice Chevalier was born.

The author described Dibango going about his late morning routines, including time spent in his favorite café, and celebrated him as an "Afro-European in Eurafrica." Dibango for him was someone in whom many contemporary currents intersected—musical, social, cultural. Plus, he was unusually well-connected in Parisian society (Arnaud referred to his friendship with the hugely popular tennis star Yannick Noah, also of Cameroonian origin). In Arnaud's view, Manu Dibango was helping to transform Paris into a city of multiple cultures (or at least a somewhat African city), something for which a native of Cameroon—with its complicated colonial history (Germany, France, and England), multiple languages, and religions (Islam, Catholicism, Protestantism, Animism)—was well-prepared.[85] Arnaud's article

was a striking example of placing emphasis on a well-established African musician to encourage a certain picture of Paris, if not France in general.

The August 1988 issue of *Le Monde diplomatique* included an article whose title asked the question "Le rock, creuset pour une intégration?" Speculating that rock music, including the contributions of Salif Keïta, Mory Kanté, and Johnny Clegg, could make for some kind of French "melting pot" perhaps can be explained by the extensive commentary historian Gérard Noiriel's *Le Creuset français*, published this same year, had received (see chapter one). The article's author, Paul Moreira, also seemed swept up in the euphoria over the mega-level concerts earlier in the summer in Paris (Château de Vincennes), London (Wembley Stadium), and elsewhere.[86] *Le Monde* also displayed its sympathy in this way with the efforts of those government officials and academic experts who were working to overcome the isolation and separateness of immigrant communities in France and instead to achieve "integration," that is, differences giving way to the norms of French republican citizenship. Dominique Schnapper was the intellectual figure most associated with this position, summed up in her 1991 book *La France de l'intégration: Sociologie de la nation en 1990*. In it she contrasted the French model of national integration with the acceptance shown national groups "such as they are" in the United States.[87] In any case, Moreira's hopeful view that music's appeal to youth, including young immigrants, could achieve a truer sense of national community could remind us today of the ecstatic expressions in the French media after the national team's World Cup victory in 1998, where the fact that the son of Algerian immigrants had achieved heroic status was taken as a similarly hopeful sign that ethnic hostilities and prejudice could be overcome.

Yet all the while anti-immigrant opinion also found its way into the media, and the media's coverage can be said to have helped Le Pen and his movement have a national platform from which to fulminate against what they held to be the alien incursions that threatened French identity. While much of the vitriol was directed against North African immigrants, it would be enough to poison the atmosphere so that the black Africans with whom the French were said to be enamored would suffer their share of discrimination. When Le Pen said in an interview in 1987, "I adore the Maghrebans, but their place is in the Maghreb,"[88] the sentiment found its way into the ongoing hostility shown the Malians, still the object of deportation efforts while Pasqua remained interior minister and under his successors. Pierre Joxe replaced Pasqua after the Socialist government of Michel Rocard was formed in 1988, but he did not do away with all of his predecessor's laws. The French media might continue to promote the idea that blacks were "in fashion," as an article in *Le Monde* suggested in November 1988,[89] but their position remained precarious, as even a government supposedly of the left eyed nervously the strength of Le Pen's movement.

Political opinion in France and media coverage continued to define immigration as a problem to be faced, but how much real hostility did French people have toward (especially African) immigrants? It all depended on how the topic was framed, for example, in relation to the unemployment rate or the outbreak of Hezbollah bombings that had taken place in 1986 in Paris. At least as far as the level of support for SOS-Racisme's concerts and rallies suggested, a considerable amount of pro-immigrant opinion existed in France. Press coverage reflected the conflicting tendencies. In early 1989,

at a time when a great deal of fretting had been taking place, especially over the question of Muslims in France, many Paris newspapers reported on an episode involving a small Pyrenees village whose inhabitants had rallied to the support of a young African immigrant living there who was faced with expulsion. Kerfala Damba Saginou, known as "Papis," was a twenty-three-year-old immigrant from Guinea who had been living and working as a cook in the village of Matemale since 1984. He had become a great favorite of the villagers, and it did not hurt that he was the star of the local football team. He lacked legal immigration status, but had waited for three years for an answer to his request to be granted political refugee status. His request was denied in September 1988, and he was threatened with immediate deportation. But the villagers, through a Socialist deputy, prevailed upon Interior Minister Joxe to reverse the decision, and eventually President Mitterrand announced that decisions in several cases that were inequitable and unjustified were going to be revised. That of Papis was among them.[90] Here at least was a case of people in a region of France known for anti-immigrant sentiment reaching out to an African in their midst, and of course it made good copy.

The episode seemed to reinforce the arguments of two prominent French intellectuals who were quoted frequently in the French press at precisely this time and who called for acceptance of the cultural differences being displayed in contemporary France. These writers were Julia Kristeva (1941–) and Tzvetan Todorov (1939–), both Bulgarian immigrants themselves who had lived their entire adult lives in France. Late in 1988 (Kristeva) and very early in 1989 (Todorov), each weighed in with books that treated themes of French nationality faced with the new immigration, in a word, the newfound cultural diversity that was the changing face of France. Both authors embraced this diversity and argued that it was beneficial for France. They brought to their arguments their own experience as immigrants and their late-1960s affiliation with the *gauchiste* literary politics of the influential journal *Tel Quel*. Among the writers who regularly published in that review, poststructuralist theory and post-1968 politics had brought about critical suspicion of received orthodoxies and a strong appreciation of all that was divergent, marginal, and "other." Both books published at this late point in the 1980s received ample commentary in the French press, preoccupied as it was with the ongoing debates over immigration.

Kristeva, who became a psychoanalyst, drew from her clinical experience to argue for recognition of the "otherness" within each person, which she applied to the politics of immigration. *Étrangers à nous-mêmes* (published in English translation in 1991 as *Strangers to Ourselves*), bristling with references from the Bible, ancient philosophy, and the canon of Western literature and philosophy, was Kristeva's argument that prejudice against members of other races or against foreign immigrants was founded upon a misrecognition, or refusal to acknowledge, the "stranger" within oneself.[91] Her debt to psychoanalytic theory (especially that of Jacques Lacan), and the challenges it posed to a unified concept of self or personality, was clear. Writing at a time of heady expectation regarding the collapse of the Communist regimes of the Eastern bloc countries, Kristeva penned an essay for *Le Monde* in February 1989 that described two challenges facing "French identity," those being "Maghreban immigration, African immigration, and, more generally, third-world immigration" and the expected movement of populations newly mobile once the restrictions imposed upon them by their governments were removed. In addition, she anticipated the coming

freedom of travel within the European Union. The convergence of all of these elements, Kristeva argued, should lead to a reexamination of French national identity, one that would no longer insist that immigrants divest themselves of all markers of difference in order to become French.[92]

Kristeva was one of many French intellectuals and public figures (in France they so often have been one and the same) who had commented, in her case frequently, on SOS-Racisme. She had appeared in a forum with Harlem Désir. In an interview published in January 1989, part of the wave of publicity that followed the publication of *Étrangers à nous-mêmes*, Kristeva was asked if she "adhered" to the ideas promoted by the organization. She declared that she was "completely in sympathy" with it, and went on to say that it was an honor for France to have such an organization. Even though "the problem of foreigners," as she put it, was global, she regarded it as significant that it received such heavy emphasis in France. No other country had an association such as SOS-Racisme, she said.[93]

Todorov also emphasized a view of France as defined by tolerance and openness, suffering dishonor whenever its politics turned toward the opposite. In 1997, at a time of vigorous government crackdown on illegal immigration, he would write, "Xenophobic laws do not protect France. They attack her."[94] From his early career as a writer of books on linguistics and semiological analysis of literature, Todorov by the 1980s had turned his hand to works of intellectual and cultural history, emphasizing European encounters with other world cultures. His book published early in 1989 was *Nous et les autres: La réflexion française sur la diversité humaine* (published in 1993 in English as *On Human Diversity: Nationalism, Racism, and Exoticism in French Thought*). In this book Todorov provided a history of European (especially French) attempts to come to terms with the diverse human cultures encountered through global exploration and colonialism, and argued that the beneficial aspects of Enlightenment thought had been distorted by the racialist philosophies of the nineteenth century. Accordingly (and interestingly for someone widely considered a postmodernist), Todorov called for a reassertion of the Enlightenment spirit and its application to a changing France.

Todorov's book was a *tour de force*, examining writers from Buffon to Lévi-Strauss and demonstrating how central the preoccupation with "the other" (complementing Kristeva's emphasis) had been for French intellectuals throughout modern history. Published at the time that it was, *Nous et les autres* allowed readers to consider the ways racist assumptions and blind spots had been found in even the greatest of modern French writers, for example, in the tendency toward "exoticism" (whether "natives" were viewed favorably or unfavorably) and to compare the celebrated discourses of the past to the pronouncements of Le Pen.[95] The theme of exoticism struck a chord in the year in which France would devote a significant part of its bicentennial observance of 1789 to its new African residents. In an interview published in February 1989, Todorov clarified his positions, saying that he had wished to reveal the ethnocentrism lying behind the "scientistic" pose of the French social sciences. He explained that he preferred to practice the "moral and political sciences"—an expression that predates "social sciences." His other strong point of difference with the social sciences was his refusal of the distinction between facts and values they took for granted.[96] In his view, there was no innocent position from which a social scientist could speak, especially where the subject under consideration was human diversity.

The Expanding Field of African
Music in Paris

Most of the 1989 news involving African musicians in Paris continued to feature the usual short list, that is, Manu Dibango, Mory Kanté, Salif Keïta, Touré Kunda, and so on. But musicians had continued to arrive all during the decade, and a number of them began to make names for themselves. Meanwhile La World Music was expanding in definition to encompass portions of the globe beyond Africa, including new innovations in *flamenco* from Spain and *saudade* from Portugal. Papa Wemba was the best-known of immigrant musicians from Zaïre working in Paris, where he had moved in 1986 after the first great wave of enthusiasm for African performers had crested.[97] His popularity owed not only to his exciting brand of *soukous* and his powerful singing voice that bore comparison to someone like Salif Keïta, but also to his sartorial *panache*. Sharp dressing had long been *de rigueur* for performers in Kinshasha, and Papa Wemba made it a practice to promote young, hip *couturiers* with his stage attire. Wally Badarou, the talented musician and studio wizard born in France to parents from Bénin, also enjoyed a good deal of recognition as he divided his time between his residence at La Défense and the recording studio maintained by Island Records in the Bahamas.[98] A fellow musician from Bénin, Angélique Kidjo, was another rising star in the Parisian African music firmament.

Like many African musicians who took part in the Paris music scene during the 1980s, Angélique Kidjo (1960–) first came to record and only later settled in to claim Paris as her base. Born in Bénin in 1960, she had from a very early age been a performer, appearing as a singer and dancer in her mother's theater company from the age of six. One of nine children, by the time she was eleven she was performing with her brothers, who called their group the Kidjo Brothers band. Her brothers influenced her taste for American rhythm 'n' blues music, particularly the songs of James Brown. During her teen years Kidjo became a singing sensation in Bénin, becoming also an admirer of the South African singer Miriam Makeba as well as a committed antiapartheid activist. The strength of her reputation as a singer led to an invitation to record her first album, which she did in Paris in 1980. The album, called *Pretty*, did quite well, but Kidjo did not make her real move to Paris until 1983.

While she responded enthusiastically to the African and Antillean music she heard there, she struggled to find her footing, even making an abortive attempt at law school. She studied singing at Les Ateliers-Chansons, and fell in with a group of German musicians called Pili Pili, whose bland of funk, jazz, and African rhythms would make its mark on her own musical style. She performed with Pili Pili off and on from 1984 to 1988, with time away to record another solo album in the United States in 1986. She began putting her own band together, which included bassist Jean Hébrail, who would later become her husband. In 1989 she released her album *Parakou*, named for a city in Bénin known for its blend of cultural styles. The new work announced what would be her trademark musical hybrid for the 1990s: soul, rock, funk, and various West African motifs, all performed at a high energy level. The release of her album was followed by her appearance on the bill with Miriam Makeba at the Olympia Theater in Paris.[99] This bolstered her reputation further,

and by the end of 1989 she had become one of the best-known African musicians based in Paris.

Kidjo is an example of the kind of Francophone African musician who was able to profit from the vogue for African music in Paris during the 1980s and then was able to make a successful transition to international success once Paris had ceased to be quite as central to the world music market. During the 1990s she would include more songs in English on her albums (while still favoring her native Fon), and would appear frequently with established Western pop stars. Several times she toured with Carlos Santana, for example. In 1998 Angélique Kidjo left France altogether, moving to New York City and making it her base of operations.[100]

As it happened, she was one of the very first African musicians I ever interviewed. Many years later, I would interview her again before she performed at a club in North Carolina. Her manager set up the first interview. I was invited to meet her at her home in Sucy-Bonneuil, a little town well to the southeast of Paris. Her husband and band member Jean Hébrail was to pick me up at the railroad station. Early on a warm June morning in 1995, I made my way to the RER station at Place de la Nation to get my train to Sucy-Bonneuil. It was the last stop before the terminus of Boissy St-Léger on line A2. I arrived earlier than I expected to and decided to wait at the station bar for my rendezvous with Hébrail. I ordered a coffee and stood among men dressed in their blue laborer's jackets as they drank beers at 9:30 in the morning. A little before 10:00, Jean pulled up in his car and we drove off to their house.

When we arrived, Angélique Kidjo was there and ready to talk. I was glad to see her because I had enjoyed her concert in New York City the year before. As many others have been, I was struck by the overwhelming physical dynamism of this diminutive woman with an imposingly full, throaty vocal delivery. She made sure that the audience came up to her energy level, and it made for a memorable performance. In her home she displayed a similarly intense conversational manner. She and her husband made me welcome and served coffee. At that point I was still unaccustomed to my trusty Panasonic portable cassette tape recorder, and spent some agonizing minutes fumbling with the settings. Kidjo very kindly came to my rescue and we settled into the interview.

She talked at first about her family, including her young daughter (born in 1993). She said she had come to France in 1983 to stay with her brother, adding that she left Bénin more to escape the dictatorship of Mathieu Kérékou (1972–1990) than to pursue her musical career. This was a pattern common to musicians from Bénin at that time, including Wally Badarou.[101] At the time Kidjo and I spoke, she had a brother and a sister living in France, and three brothers in Belgium. She said she had obtained French citizenship in 1989. The conversation then turned to immigration and the French politics surrounding it. Kidjo expressed strong feelings about the existence of racism in France:

> I often say that racism is not only when someone tells you "Go back home, nigger." It is a general attitude . . . I began to sense racism in France from the moment of the first cohabitation between the left and the right (1986) . . . People did not have to hide it any longer. They were proud to display their racism. And at the moment that I am talking to you, racism is more and more ferocious. The proof is that a party of the extreme right (Le Front National) is in power in three cities in France.[102]

As she pointed out, there had been a steady rise in support for Le Pen's party. But whatever the level of racism in France, she was quick to say that certainly not all French people could be described as racist, no more than citizens of any other country:

> I detest people who generalize because it is too easy to generalize in place of making the effort to see individually who is racist and who is not.

And yet, she added, "In any case, everyone is a little bit racist."

What animated Kidjo's conversation most was the subject of music. She spoke eagerly of the many musicians she had admired and who had "very much influenced my life when I was a child." The list included Ella Fitzgerald, Aretha Franklin, Miriam Makeba, Ray Charles, James Brown, Otis Redding, Stevie Wonder, Jimi Hendrix, Joe Cocker, Carlos Santana, and Peter Gabriel. Perhaps she emphasized so many musicians from the United States because she was speaking to an American, but I believe her music shows that this list genuinely reflected her tastes. Her response to the music she heard early in life was profoundly emotional. She said, "When I heard Louis Armstrong, I cried," adding "That is the power of music." Then the question of language arose, or more specifically, the way that the emotion in musical performance can override language barriers. "There were gospel songs of Mahalia Jackson that I adored, that made me cry, but I understood nothing because I did not speak English," she said. She since has mastered English, one of the many languages at her command.

Anyone who gets the opportunity to talk with a large number of musicians comes away struck by the spiritual, even mystical, quality of the way they tend to speak about their craft, and especially about what sustains them in music. Angélique Kidjo displayed that quality in abundance, tensing her body and glowing from within as she delivered her philosophy of music. When I asked her whether she considered her music "African" or "a form of Western pop," this is how she responded:

> My music is a mode of universal expression, because music belongs to no one, and music has always been there. Music has always existed . . . I grew up in a traditional culture of song that carried messages and that carried education for children, one cannot say more than that . . . Music is there because I have a culture. It is there because a traditional song from my country gave me sufficient openings of the spirit to open up towards others. But, "my music," what is that? I detest labels . . . Music is there. We take it and remake it as we wish . . . It's a fact, because each person his own fashion of expressing himself. It's like a writer. No two writers are ever going to write the same thing because they do not have the same past . . . what they write is always different and it's the same for a singer.

Her remarks turned gradually toward the subject of her performances, but she continued as well to expound her musical philosophy, linking it to the conditions of her upbringing:

> I believe that the music that I make is very current because I was a part of my society and I had the chance by relation to other African artists to listen to everything that was coming from the rest of the world. In my home, nothing was ever treated as a taboo

subject. My parents were very open-minded. That is very rare in Africa, and that when I was very young they taught me to make a difference . . . All of the music I make is a message of openness and tolerance toward everyone.

As for the question of color, her own or that of her audience, she said she "didn't give a damn" about it. "That's not my problem," Kidjo declared, "What interests me is the power to create communication. If it's simply an hour and a half that I have with the public, that's it. And during that hour and a half, we will share something that is absolutely special." When I interviewed her again (briefly) before a concert in 2002, she mentioned her strong preference for live performance over working in the studio.[103]

When I asked her to state which genres of music she loved the most, she deflected the question, and said emphatically,

As for me, to say simply one thing I love, I have only my heart in relation to music. When I begin to listen to music, it gives me chicken skin. It can be perhaps in a language I understand, or it can be in a language that I don't understand. I don't give a damn. I let my emotion guide me.

Speaking of the difference between African music in Paris during the 1980s and the time (1995) of the interview at her home, she said that Paris was no longer the hub (*plaque tournante*) of music from Africa and other foreign sources. She judged the French public to have become "jaded" with regard to any kind of music. "They consume what the media tells them to consume," she said. But on the other hand, she believed that African music had spread throughout the world, with no one center remaining. Her own career certainly seemed to bear that out. When the interview was over, Jean Hébrail asked me if I wanted to see the home recording studio he had set up in a building behind the house, and the three of us walked out there, admiring the flowers along the way. I thanked my hosts for their time and hospitality and then Hébrail drove me to the train station.

Celebrating the Republic, Celebrating African Artists

As the July 14 bicentennial observance approached, the French press focused regularly on musicians, and also on the country's black population in general. The release of Salif Keïta's album *Ko-yan*, which included his song "Nou pas bouger," occasioned several articles. In one of them, the singer was quoted in a way that made him sound like an employee of the Paris Office of Tourism. He declared that he was "A Frenchman in miniature who could not live anywhere but Paris." Paris, he explained, offered the perfect intersection of African and Western musical influences, so that it was beginning to make a real impression on listeners outside France. Given the embattled sense Keïta had of being a Malian immigrant in France that gave rise to his defiant song, and given his later abandonment of his Paris life (in 1997), the mood in which journalist Philippe Martinet captured him in June 1989 remains quite striking.[104]

On the very eve of the July 14 bicentennial observance of the 1789 Revolution, the weekly *L'événement du jeudi* took stock of the mixed feelings, in the opinion of the article's two authors, French people had concerning their black population. The title of the article was "The French love blacks, but not too much." The article began by contrasting the Antillean and African populations, first of all in terms of population. Those who had come to France from the so-called *DOM-TOM* (Départements d'Outre-Mer and Térritoires d'Outre-Mer), including Martinique, Guadeloupe, Guiana, and Réunion (in the Indian Ocean), numbered around six hundred thousand, while sub-Saharan Africans, led by those from Senegal and Mali, totaled about two hundred thousand. The former were employed at a higher percentage, more than half in public services such as the post office, police, and hospitals. Africans suffered more unemployment and, unlike Antilleans, usually held at best a *carte de séjour* rather than a French identity card. The principal argument of these authors was that blacks in France were "in fashion," but poorly integrated into French society. They cited bitter comments by the French novelist Calixthe Beyala, originally from Cameroon, who said that whites in France only noticed blacks in terms of music or fashion.[105]

Yet there were other ways in which Parisians at least viewed African immigrants. There was much fascination with the section of the lower Eighteenth Arrondissement known as La Goutte d'Or, regarded by many as a kind of "little Africa," where the market area known as the *marché Dejean* was a meeting point for the African and Antillean populations. Later in the 1990s the focal point would shift southward to the Tenth Arrondissement, around Château-Rouge.[106] Parisians not only tended to associate African immigrants with certain neighborhoods, but also with certain occupations, especially that of a sanitation worker. Most visitors to Paris have noticed the significant number of green-suited African immigrants employed by the *Propreté de Paris*. In 1989 the very successful Congolese (then Zaïrean) artist Cheri Samba received a commission to illustrate a poster for the city of Paris with the title "*Paris est propre.*" It depicted black African sanitation workers confronted with the famously defiant *crottes de chien* left uncollected by recalcitrant Paris dog-owners. The caption claimed that immigrants do not like to see this filth and went on to assert that without their efforts the city would be buried in dog droppings.[107] This calls to mind Mamadou Konté's remark about Africans coming to Europe to "civilize" Europeans (see chapter one). It also serves to counter any assumption that African immigrants fail to take pride in their adopted city.

Africans were in the streets of Paris on July 14, 1989, not as cleaners, but as performers. The long-planned two-hundred-year commemoration of the birth of modern France included representatives of the varied new ethnic makeup of the republic, and marked something of a culmination of the Jack Lang era of state sponsorship of cultural figures from among France's African immigrants. Paris put on quite a show, planning a dramatic parade well beyond the usual scale of Bastille Day festivities, welcoming heads of state from more than forty countries, and holding an inaugural concert in the newly completed National Opera on the Place de la Bastille. Jean-Paul Goude, a successful figure in the world of fashion, took charge of the planning for the procession down the Champs Elysées to the Place de la Concorde. Originally, Jean-Michel Jarre had been the person selected by the committee in charge of the

commemoration, but he was unacceptable to Lang and others. Christian Dupavillon, a chief assistant to Jack Lang in the Culture Ministry, enlisted Goude for the task, and he gave him three basic charges: to "extol the *Marseillaise*," to represent the French provinces, and to make use of the Champs-Elysées.[108]

Goude plunged into the production filled with the fervor to express the universality both of the revolutionary spirit of 1789 and of the contemporary cultural diversity of France through a deliberate flaunting of racialized "exotic" figures, what he referred to as a "play of stereotypes." Representations of traditionally costumed French provincials would blend with present-day immigrants with music and dance that conveyed the global range of the great revolution's meaning.[109] The world music to be featured was intended, therefore, to play a metaphorical role.[110] Goude organized a grand parade, using enormous floats as well as dancers and musicians from many countries, including a significant number of African immigrants. The world-famous flamboyant marching band from Florida A & M University appeared in the parade, turning heads and igniting some controversy.[111] Régis Debray and some other prominent intellectuals objected to the inclusion of such an American element in a parade meant to celebrate France.[112]

Another highly dramatic political component of the July 14 parade, encouraged by Jack Lang, was its inclusion of Chinese students representing (by the bicycles they pushed) the victims of the Tienanmen Square massacre the previous month. They were preceded by flag bearers whose chests bore the Chinese characters for "Liberty/ Equality/Fraternity." Students in Tienanmen Square had worn t-shirts emblazoned with that cherished motto.[113] The parade route ended in the Place de la Concorde, with a dramatic rendition of *La Marseillaise* featuring the regal American soprano Jessye Norman. Prior to the performance, she rose up via an elevator to the top of an enormous float, garbed in a sumptuous tricolor gown.[114]

To coordinate the performances of the musicians and dancers in the parade that was called an "opera-ballet," Lang's Culture Ministry had enlisted the services of Wally Badarou, the multitalented musician born in France to parents from Bénin and the Senegalese percussionist Doudou Ndiaye Rose (1930–). Badarou was one of the internationally best-connected of all Afro-French musicians, having worked with Lee Perry and Bob Marley in Jamaica as well as with Grace Jones, Talking Heads, and many other artists. The government's anointing of a representative of the Parisian African music community in this way was taken by many as an indication of the end of the isolation or marginalization of the music—its release from a cultural ghetto.[115] Badarou composed the title music for the occasion of Goude's parade, proclaimed as the "March of Thousands." He incorporated the use of traditional French musicians, playing such ancient instruments as fifes and bagpipes, into the parade. In addition, he composed a prelude performed before the *Marseillaise* at the Place de la Concorde.[116] During Norman's performance of the national anthem, Doudou Ndiaye Rose ascended and descended an enormous staircase, directing the African drummers massed at the end of the Champs-Elysées.[117] Le Pen and his followers were scandalized by what they denounced as the inappropriate prominence of black performers in the celebration.[118]

The celebration did not wait for July 14. The night before, when the new Opéra Bastille officially opened, outdoor concerts took place throughout Paris, where the

BBC reported that "roads have become dancefloors." Hundreds of thousands of people were estimated to have been on the streets during the night.[119] Singer, guitarist, and restaurateur Péla Simba, in an interview some years later, joyfully remembered playing for the dancing throng gathered in the Place de la Bastille.[120] The events of July 13–14 gave many Parisians more of a sense than ever of the importance of the African artists in their midst, and the view that Paris was the appropriate stage for their activities continued to be held in the aftermath of the great celebration. An example of the way certain groups sought to attach themselves to the prestige of African musicians can be seen in the partnership between Salif Keïta and the organization France Plus, whose members stood for the full integration (political, economic, and social) of French immigrant youth. They cooperated with the Malian singing star on a video that featured his song of 1989 "Nou pas bouger," designed to promote their campaign for "integration."[121]

The media fascination with African musicians in Paris was still going strong in December of 1989, when the first music festival known as "Africolor" was held in Saint-Denis. Although the festival later would be known for its emphasis on acoustic, traditional African music, the 1989 edition featured guitarist Kanté Manfila, Nigerian musician Tony Allen, the Mailan diva Nahawa Doumbia, Sorry Bamba of Mali, Ray Lema, and Papa Wemba. High-profile music journalists such as Hélène Lee in *Libération* and Véronique Mortaigne in *Le Monde* treated the festival as a highly significant event, with Mortaigne especially emphasizing the fact that each of these musicians had moved to Paris to launch a "second career," having already been well-established in African countries.[122]

But as 1989 came to a close, the mounting national debate over France's Muslim immigrant population was beginning to create a climate of suspicion that began to damage the position of sub-Saharan immigrants, including many of the musicians who had been part of the era of La World Music in Paris. The story of those developments is the concern of the following chapter.

Notes

1. Gilles Anquétil and Philippe Conrath, "La Fièvre des samedis soirs: Paris, capitale mondiale des rythmes africains," *Le Nouvel observateur* (July 22–28, 1988): 76.
2. François Bensignor, author interview, Paris, May 21, 1998.
3. Alec G. Hargreaves, *Immigration, "Race" and Ethnicity in Contemporary France* (London, 1995): 169–170.
4. "Kassav': Biographie," Radio France Internationale (September 2004): http://www.rfimusique.com/siteFr/biographie/biographie_8933.asp.
5. "Le Blues des Antillais," *L'Express* 2769 (July 26–August 1, 2004): http://hello-caribbean.com/hello39/presse_lebbuesdesant.htm.
6. Claude-Valentin Marie, "Les Antillais de l'Hexagone," in *Immigration et intégration: l'état des saviors*, ed. Philippe Dewitte (Paris, 1999): 99–102.
7. "Le Blues des Antillais."
8. James A. Winders, " '*Le Français dans la rue*': Caribbean Music, Language, and the African Diaspora," in *Musical Migrations: Transnationalism and Cultural Hybridity in Latin/o*

America, Volume I, ed. Frances R. Aparicio and Cándida F. Jáquez (New York, 2003): 69–70. See also FaraC., "Pleins feux sur les Caraïbes: Festival en Seine-Saint-Denis," *L'Humanité* (May 26, 1988): 44.

9. Jocelyne Guilbaut, *Zouk: World Music in the West Indies* (Chicago, 1993).
10. François Bensignor, "Le Gwo ka: nouvelle conscience des jeunes Guadeloupéens," *Hommes & migrations* 1214 (July–August 1998): 106.
11. Kris Dean, "Caribbean Music," *Crisis* 98:2 (February 1991): 24.
12. Jocelyne Guilbault, "Créolité and the New Cultural Politics of Difference in Popular Music of the French West Indies," *Black Music Research Journal* 14:2 (fall 1994): 162.
13. Chris Stapleton and Chris May, *African All Stars: The Pop Music of a Continent* (London, 1989): 250–252.
14. Ibid.: 247.
15. Philippe Conrath, *Kassav'* (Paris, 1987): 81.
16. "Kassav': Biographie."
17. Jocelyne Béroard, author interview, Saint-Ouen, France, June 25, 1997.
18. "Kassav': Biographie."
19. For example, she gave an interview in 2000 for the influential journal *Africultures*, commenting on Kassav's then-new release *Nou la*. Among other things, Béroard spoke of the group's having spent time in the Antilles before recording the album, and then discussed the solo projects of various band members.
20. "Biographie," JocelyneBeroard.com: http://www.jocelyneberoard.com/bio.php.
21. Béroard, author interview.
22. "Biographie," JocelyneBeroard.com.
23. Béroard, author interview.
24. "Biographie," JocelyneBeroard.com.
25. Béroard, author interview.
26. D.R., "Bonjour le monde, bonjour l'Afrique," *Le Monde Radio T.V.* (May 22–23, 1988): 21.
27. Pascal Blanchard et al., *Le Paris noir* (Paris, 2001): 162.
28. Hargreaves, *Immigration, "Race" and Ethnicity in Contemporary France*: 190–191.
29. Danièle Lochak, "La Politique d'immigration en France et l'évolution de la législation," in *Les Nouvelles migrations: un enjeu européen*, ed. Emmanuelle Bribosia and Andrea Rea (Bruxelles, 2002): 212.
30. Miriam Feldblum, *Reconstructing Citizenship: The Politics of Nationality Reform and Immigration in Contemporary France* (Albany, NY, 1999): 19.
31. Maxim Silverman, *Deconstructing the Nation: Immigration, Racism and Citizenship in Modern France* (London, 1992): 64–65.
32. "Six skinheads racistes arrêtés à Perpignan," *Libération* (August 8–9, 1987).
33. Étienne Gau, "L'empreinte d'une petite main: L'heure de vérité pour SOS Racisme," *La Croix* (August 20, 1987).
34. E.Z., "Tout le monde (ou Presque) lui dit bravo," *Le Quotidien* (August 21, 1987).
35. Dominique Jamet, "Mauvaise soirée pour Le Pen," *Le Quotidien* (August 21, 1987).
36. Louis Pauwels, "Oui, Harlem Désir, oui, mais . . . : Éditorial," *Le Figaro Magazine* (September 5, 1987): 45.
37. Gau, "L'empreinte d'une petite main."
38. Marcin Frybès, "France: un équilibre pragmatique fragile," in *Immigrés en Europe: Politiques locales d'intégration*, ed. Didier Lapeyronnie (Paris, 1992): 85.
39. François Bensignor, "Sam Mangwana: Mémoires d'un Angolais de Kinshasha," *Hommes et migrations* 1243 (2003): 107–113.
40. Péla Simba, author interview, Paris, July 16, 1997.

41. Gary Stewart, *Rumba on the River: A History of the Popular Music of the Two Congos* (London, 2000): 378–379.
42. Ballou Canta, author interview, Paris, June 27, 1995.
43. Diblo Dibala, author interview, Paris, June 26, 1995.
44. Gary Stewart, *Breakout: Profiles in African Rhythm* (Chicago, 1992): 10.
45. Diblo Dibala, author interview, Paris, June 26, 1995.
46. Stewart, *Breakout*: 10.
47. Lokassa ya Mbongo, author interview, Pantin, France, June 28, 1996. Unless otherwise indicated, all information on Lokassa ya Mbongo is based on this interview.
48. Dally Kimoko, author interview, Paris, June 28, 1996. All information on Dally Kimoko is based on this interview.
49. Timothy D. Taylor, *Global Pop: World Music, World Markets* (New York, 1997): 2.
50. Simon Frith, "The Discourse of World Music," in *Western Music and Its Others: Difference, Representation, and Appropriation in Music*, ed. Georgina Born and David Hesmondhalgh (Berkeley, CA, 2000): 305.
51. Taylor, *Global Pop*: 2.
52. Timothy Rice, "World Music in Europe" in *The Garland Encyclopedia of World Music, Volume 8: Europe*, ed. Timothy Rice, James Porter, and Chris Goertzen (New York, 2000): 225.
53. Gérald Arnaud, "Pour une exception musicale africaine," *Africultures* 54 (January–March 2003): 90–91.
54. Elizabeth J. Miles, "Immigrant Music in Europe," in *The Garland Encyclopedia of World Music, Volume 8: Europe*, ed. Timothy Rice, James Porter, and Chris Goertzen (New York, 2000): 233.
55. Arnaud, "Pour une exception musicale africaine": 79–82.
56. Nicolas Jaujou, "Comment faire notre Musique du monde?: Du classement de disques aux catégorizations de la musique," *Cahiers d'études africaines* 168, XLII-4 (2002): 853–873.
57. Pascale Casanova, *La République mondiale des letters* (Paris, 1999), translated by M.B. Devoise as *The World Republic of Letters* (Cambridge, MA, 2004).
58. Laurent Aubert, Pierre Milza, and Émile Termine, eds., *La Musique de l'autre; Les nouveaux défis de l'ethnomusicologie* (Genève, 2001): 117–118.
59. Nago Seck and Sylvie Clerfeuille, *Les Musiciens du beat africain* (Paris, 1993): 140.
60. Frank Tenaille, *Le Swing du caméléon: musiques et chansons africaines 1950–2000* (Arles, 2000): 150.
61. Graeme Ewens, *Africa O-Ye!: A Celebration of African Music* (New York, 1992): 65.
62. Cheick M. Chérif Keïta, *Salif Keïta: L'oiseau sur le fromager* (Bamako, 2001): 91–92.
63. George Lipsitz, *Dangerous Crossroads: Popular Music, Postmodernism, and the Poetics of Place* (London, 1994): 123–124.
64. Keïta, *Salif Keïta*: 92.
65. Tenaille, *Le Swing du caméléon*: 150.
66. B., "Mory Kanté hit yéyé ?" *Libération* (March 9, 1988): 83.
67. Bensignor, "Africains en France: la compile": 39.
68. François Bensignor, *An Introduction to African Music in 100 CDs/Pour connaître les musiques africaines, Afrique en scènes: supplément au no. 6* (December 1996): 11.
69. Bensignor, "Africains en France: la compile": 39. Also see Miles, "Immigrant Music in Europe": 239.
70. Hargreaves, *Immigration, "Race" and Ethnicity in Contemporary France*: 185–186.
71. Judith Waintraub, "SOS-Racisme: Harlem Désir en froid avec les étudiants juifs," *Le Quotidien* (March 26–27, 1988): 24.
72. Philippe Conrath, *Johnny Clegg: la passion zoulou* (Paris, 1988).

73. Fara C., "Voix de tête et de fête: L'affiche noire du 10 avril," *L'Humanité* (April 1, 1988): 83.
74. Manuel Regnier, "Le Métissage du zoulou blanc," *Politis* 11 (March 31, 1988): 82.
75. Judith Waintraub, "Harlem Désir remonte au front," *Le Quotidien* (June 17, 1988): 34.
76. E.G., "300 000 Potes au diapason: Le concert de SOS Racisme," *La Croix* (June 21, 1988): 12.
77. Philippe Conrath, "Paris–Dakar: poids lourds et jeunes bolides," *Libération* (June 18–19, 1988): 5–6.
78. E.G., "300 000 Potes au diapason": 12.
79. "Le message du president," *Le Quotidien* (June 20, 1988): 46.
80. Conrath, "Paris–Dakar": 6.
81. "Harlem sans désir," *Le Quotidien* (June 20, 1988): 47.
82. A., "Springsteen, le dernier des rockers engagés," *Le Quotidien* (June 20, 1988): 46.
83. Fara C., "Les Touré Kunda inspirés par le djambadong: La Famille Éléphant sur la Grande Scène," *L'Humanité* (September 3, 1987).
84. Claude Fléouter, "Manu Dibango, le catalyseur: Les Francofolies de La Rochelle," *LeMonde* (July 17–18, 1988): 32.
85. Gérald Arnaud, "Une journée avec Manu Dibango," *CFDT Magazine* 133 (December 1988): 24–26.
86. Paul Moreira, "Le Rock, creuset pour une intégration?" *Le Monde diplomatique* (August 1988): 13–14.
87. Dominique Schnapper, *La France de l'intégration: Sociologie de la nation en 1990* (Paris, 1991): 93. Schnapper also expressed the view that the activities of SOS-Racisme and France-Plus provided ways for young people from immigrant families to take part in French political life on a more "universal" than ethnic basis (p. 94). In March 1991 *LeMonde* reviewed Schnapper's book, along with one by Noiriel, favorably, reminding readers that she was Raymond Aron's daughter. See T.F., "L'amour de la patrie: L'apparition et le développement du sentiment national en France," *Le Monde* (March 29, 1991): 112.
88. Marc Yared, "Jean-Marie Le Pen: Je ne suis pas raciste, mais . . . ," *Arabies* 9 (September 1987): 35.
89. Bertrand Le Gendre, "La mode est aux Noirs," *Le Monde: Supplément Radio T.V.* (November 27–28, 1988): 18. The article dealt with the ubiquity of blacks represented in advertisements, and claimed that a new, more positive style of representation had replaced the demeaning stereotypes of an earlier era. This claim has proved subject to debate (see chapter seven).
90. Jacques Molenat, "Nous garderons Papis: Solidarité et immigration," *La Croix* (January 15–16, 1989): 23.
91. Jean-Paul Enthoven, "Étranges étrangers: Les périples de Julia Kristeva," *Le Nouvel observateur livres* (December 15–21, 1988): 118.
92. Julia Kristeva, "Immigrés: Les deux défis de l'identité française," *Le Monde* (February 21, 1989): 1.
93. Elizabeth Gouslan, "Julia Kristeva: L'étranger est en nous," *L'événement du jeudi* (December 29, 1988–January 4, 1989): 32–33.
94. Tzvetan Todorov, "Institutions et xénophobie," *Le Monde* (February 19, 1997): 7.
95. Pascal Bruckner, "Dans le miroir de l'autre: Enquête sur la diversité humaine," *Le Nouvel observateur* (January 12–18, 1989): 51.
96. Philippe Petit, "Todorov critique l'ethnocentrisme et le scientisme: Un entretien avec l'auteur de <<Nous et les autres>>," *L'événement du jeudi* (February 16–22, 1989): 44–45.
97. Jim Winders, "Papa Wemba: Congo Style, Paris Fashion," *Rhythm Music* VII:6 (June 1998): 30.

98. Gérald Arnaud, "Les Voix de l'immigration," *CFDT magazine* 136 (March 1989): 35–36.
99. "Angélique Kidjo: Biography," *rfimusique.com* (April 2002): http://www.rfimusique.com/siteEn/biographie/biographie_6028.asp.
100. Ibid.
101. François Bensignor and Eric Audra, "Benin & Togo: Afro-funksters," in *World Music: The Rough Guide, Volume 1: Africa, Europe and the Middle East*, ed. Simon Broughton, Mark Ellingham, and Richard Trillo (London, 2000): 432.
102. Angélique Kidjo, author interview, Sucy-Bonneuil, France, June 22, 1995. Unless otherwise indicated, all information on Angélique Kidjo is derived from this interview.
103. Angélique Kidjo, author interview, Carrboro, North Carolina, June 20, 2002.
104. Philippe Martinet, "Salif Keïta, Black & White," *La Croix* (June 4–5, 1989): 64.
105. Emmanuelle Pontie and Patrice Lestrohan, "Les Français aiment les Noirs, mais pas trop: Heurs et malheurs de la négritude," *L'événement du jeudi* (July 6–12, 1989): 26–27.
106. Blanchard et al., *Le Paris noir*: 197.
107. Ibid.: 215.
108. Steven Laurence Kaplan, *Farewell, Revolution: Disputed Legacies France, 1789/1989* (Ithaca, NY, 1995): 270–281.
109. Patrick Garcia, *La Bicentenaire de la Révolution française: Pratiques sociales d'une commémoration* (Paris, 2000): 306.
110. Katja Tönnesmann, *Die Zweihundertjahrfeier der französischen Revolution: Bildrhetorik zwischen Aufklärung und Unterhaltung* (Weimar, 1999): 47.
111. Ibid.: 51.
112. Kaplan, *Farewell, Revolution*: 316.
113. Ibid.: 293–294.
114. Ibid.: 305.
115. Djeynab Hane and Francis Kpatindé, "Comment ils ont conquis le monde," *Jeune Afrique* 1485 (June 21, 1989): 8–9.
116. Philippe Martinat, "La Roue de la chance de Wally Badarou," *La Croix* (August 13–14, 1989): 100.
117. Kaplan, *Farewell, Revolution*: 306.
118. Garcia, *La Bicentenaire de la Révolution française*: 55.
119. "1989: Paris in 200-Year-Old Revolutionary Fervour," *BBC On This Day*: http://news.bbc.co.uk/onthisday/low/dates/stories/july/14/newsid_2.
120. Péla Simba, author interview Paris, July 16, 1997.
121. Laurent Léger, "Pour une touche de couleur en plus," *Libération* (September 21, 1989): 1.
122. "Une jam de griots: Quatre jours de musique africaine à Saint-Denis," *Le Monde* (December 22, 1989): 66.

Part II

No Longer Welcome? The Changed
Climate of the 1990s

Chapter 4

Anti-Immigrant Politics and Transformations of the Music Business, 1989–1996

Asked in 1997 to describe the most important differences between the early Mitterrand years (1981–1989) and the unfolding decade of the 1990s for the African music scene in Paris, Hélène Lee (1947–), long a music journalist for *Libération* as well as for other publications, was as blunt as possible. "It's very, very simple," she said forcefully:

> Under Mitterrand, we had money. There was money for the music and visas for the musicians. Now, there are no more visas for the musicians and no more money for the music. That's all.[1]

Certainly exaggerated for effect, Lee's assessment nevertheless seems accurate in terms of degree, as a means of contrasting what the two periods were like for a great many African musicians. For us to accept this characterization, we need first to ask what changed in French culture in order for the situation of immigrant musicians to be so much worse only a few years after the seeming high point of 1989. Not surprisingly, the answer has to do with much more than changes in the music business, although there certainly were some decisive changes there. For complicated reasons, as we shall see, the early 1990s marked the end of the apparent divergence between French attitudes toward the North African immigrant population and attitudes toward black African immigrants from south of the Sahara.

Musicians and others knowledgeable about the so-called World Music scene in Paris refer to *les années quatre-vingt* as the heyday of welcome and enthusiasm (not to mention commercial infrastructure and support) for the new African music and its creators. Likewise they contrast that decade with the more difficult one that followed. Yet, even if the 1980s had been far more welcoming for African immigrants in Paris than would be the case during the 1990s, it was not exactly as if a curtain rang down

at the conclusion of the euphoric Bicentennial observances of July 14, 1989, and a harsh new era abruptly began. Decades, like historical periods, do not operate that way. As we have seen, the period of seeming embrace had not been without its interruptions, as demonstrated dramatically by the Pasqua Law of September 1986 and the wave of deportations subsequently visited on Malians (see chapter three). And certainly not all responses to the high visibility accorded minority communities in France by such actions as those taken by SOS Racisme had been positive, as the steady rise of Le Pen's movement shows.

Hostility toward North African immigrants in France eventually would shift toward sub-Saharan Africans as well. When you read through the French press for the last years of the 1980s, the patterns of a gradually constructed animus against France's Muslim population become perceptible. By 1989 there would be some three million Muslims in France (with almost twice that number a decade later).[2] In response to a number of troubling events of these years, French anxieties increasingly mounted over the links and relationships between Muslims living in France and the parties involved in the Lebanese Civil War, the Iran–Iraq War, and the Israeli–Palestinian conflict. In 1986 the radical Shiite group Hezbollah set off bombs in several different Paris locations. Allied with the fundamentalist regime of Iran, they sought to dissuade France from its wartime support for Iraq.[3] Apart from the understandable alarm such events provoked in France, they also fed the perception that Muslims residing in France were more allied to their fellow Muslims internationally than they were to their French compatriots. In a country fiercely attached to an ideology of secularism and republicanism, this was unforgivable. And certainly the bitter legacy of the Algerian War of 1958–1962 continued to loom as a nightmare over the French political imaginary.

L'affaire du foulard and Anti-African Opinion

The year 1989 brought two new crises that intensified the sense of alarm many French citizens felt about Muslims in their midst. First, in February, came the thundering *fatwa* issued by Iran's Ayatollah Khomeini against the Pakistani–English author Salman Rushdie, whose satirical novel *The Satanic Verses* had been judged an offense against Islam.[4] A result of this condemnation was that French translators and publishers of the novel were at risk, just as certainly as was the author. Then, to launch a series of developments that cut far more deeply into the viscera of the French body politic, came the September incident at the Gabriel-Havez *Collège*[5] (or middle school) at Creil, a town approximately fifty kilometers due north of Paris. Out of an enrollment of some eight hundred students, nearly five hundred were from Muslim families. Three girls, two from a Moroccan immigrant family and one who was Tunisian,[6] appeared at the school wearing *hijabs* or headscarves in defiance of school regulations.

All three girls refused an order from the school's headmaster to remove their scarves, because they considered the requirement an attack on their religious beliefs and observance. His response was to suspend the students. The suspension was to last

only three weeks, and during this interval school officials worked with the girls' families to arrive at a compromise whereby the students would be able to wear their headscarves within the halls of the school, but would have to drape them over their shoulders during classes. Once all parties agreed to this makeshift solution, the tense confrontation was well on the way to being defused, but then the media got hold of the story and began to fan the flames of hostility.[7] This is certainly the impression one gains from examining the press coverage during October 1989, and it is also the considered argument of Françoise Gaspard and Farhad Khosrokhavar, two sociologists whose 1995 study *Le foulard et la République*, out of a flood of commentary on the controversy, provides the most complete account of the events and the polemic that carried on after them. Their book combines description of the unfolding affair and the consequences it had for French national politics with case studies that demonstrate myriad reasons why some Muslim girls would choose to wear the *hijab*. Through their many interviews with young Muslim women, they were able to conclude that the wearing of this bit of cloth so supercharged with symbolism was a means of fashioning an identity, something each person had to negotiate for herself. The decision to wear the scarf was neither categorically a rejection of French culture nor a proclamation of an uncompromising Islam. Instead, it was a means of bridging two worlds and of attempting to be both "French *and* Muslim."[8]

The first press report on what had happened in Creil was carried in *Libération* on October 4, 1989, with a headline that set the tone for the bitter showdown of the following weeks and months: "Le port du voile heurte la laïcité du collège de Creil" ("The wearing of the veil strikes against the secularism of the collège at Creil").[9] Coverage quickly spread to other French cities, and reports began to accumulate of female students disciplined in similar incidents. Amplified through a sustained sensationalist media fixation, an originally local incident, well on its way to being resolved by those immediately involved in it, was transformed into the occasion for a national debate over French identity and attitudes toward (especially) Muslim immigrants. One immediate effect in Creil was that negotiations broke down between the *collège* and the girls' families, and the students were suspended anew. Not only did the shrill tone of media coverage contribute to polarization, but choices of terms themselves also played a decisive role, amounting to an inflammatory hyperbole. Gaspard and Khosrokhavar paid careful attention to this phenomenon, and were able to show the steady slide in descriptions used from *foulard* (the more innocent "scarf") to *voile* (which would hide most of the face) to *tchador* (the French approximation of the term for the head-to-toe coverage dictated for Iranian women).[10]

The controversy this incident provoked raged for the rest of 1989 and on into the early 1990s. Indeed, its reverberations continue to be felt, and the controversy played out anew in 2004 with the passage of a new law against "ostentatious" religious displays (Muslim headscarves, *kippas* [yarmulkes], and large crosses). Predictably enough, the anti-immigrant voices of France rose in chorus to express alarm over a large "alien" population that rejected French ways and would remain incapable of dissolving into the French melting pot. The more the media trained its floodlights on the three girls and their defiant attitudes, the more the incident played into Le Pen's hands. Less predictable was the way *l'affaire du foulard* (*foulard* meaning scarf) shook up traditional political allegiances along the spectrum from left to right. Left intellectuals in

particular were split between, on the one hand, those who wrapped themselves in the French tricolor and demanded no compromise on the republican principle of secularism in schools and other state institutions, and, on the other hand, those who embraced *le droit à la différence*, or the right to difference, a concept closely akin to American notions of multiculturalism and therefore suspect in many Gallic eyes.

In 1985 Pierre-André Taguieff, one of France's most prominent scholars of race and racism who makes regular appearances in the media, denounced the latter position as "barbaric," and argued that there could be no middle ground between the "universalist" values of 1789 and the First French Republic (taken up again by its successors) and what he scorned as the "fundamentalism of difference."[11] For Taguieff, as for many other intellectuals on the left, the idea of respecting various ethnic "communities" and honoring their right to difference earns its own special pejorative label. The current French term for the kind of splintering into communal subcultures that seemingly contradicts the unity of republican claims on civic allegiance—*commautarisme*—conveys something stronger and more contemptuous than any English-language equivalent.[12]

The tone of Taguieff's stern condemnation found echoes in the influential manifesto published in *Le Nouvel Observateur* in November 1989 and composed by five prominent intellectuals. Bearing the title "Profs, ne capitulons pas!" ("Teachers, let's not give in!") this jeremiad bore the signatures of Élisabeth Badinter, Régis Debray, Alain Finkielkraut, Élisabeth de Fontenay, and Catherine Kintzler.[13] Their ringing defense of secularism (*laïcité*) was an angry response to the decision by Education Minister Lionel Jospin to overturn the order suspending the three girls from their *collège*.[14] An opposing group of five signatories—Joëlle Brunnerie-Kauffmann, Harlem Désir, René Dumont, Gilles Perrault, and Alain Touraine—responded to Badinter et al. the following week in the hebdomaire *Politis* with their rebuttal "Pour une laïcité ouverte" ("For an Open Secularism").[15] It is highly unlikely that these salvos persuaded anyone to change or rethink their positions. It was rather a case of battle lines being defined. Gaspard and Khosrokhavar go so far as to compare the polarized climate of opinion around *l'affaire du foulard* to the height of the Dreyfus Affair, memorably captured by the *belle époque* political cartoonist Caran d'Ache when he depicted a family dinner gathering shattered by mention of the controversial case.[16]

Both cases show us examples of old political alliances breaking down or being redefined, just as both offer illustrations of resentment against persons and groups deemed un-French (or "unnaturally French," in the phrase used by historian Peter Sahlins)[17] by the most xenophobic elements of the country. Sometimes anti-Muslim opinion focused on other practices that seemed to defy integration into French life. The celebrated film actress Brigitte Bardot, an outspoken animal rights activist, zeroed in on the ritual slaughter of lambs that traditionally marks the end of the Muslim observance of Ramadan, and continued over several years to condemn the immigrants who maintained that custom.[18] But no one symbol of "difference" stirred national debate as relentlessly as the *hijab* or *foulard*. In addition, no other issue played greater havoc with accustomed political allegiances. Throughout the last weeks of 1989, in more ways than can be recounted here, various officials, intellectuals, and journalists could be seen nervously testing the unaccustomed flow of new political waters with often unanticipated results.

In at least one very prominent case, that of the very president of the republic, a spouse was called upon to release a statement. Danielle Mitterrand, wife of the president, spoke out on October 20 in favor of toleration, denying that the wearing of headscarves threatened France, and arguing that specific expressions of religious traditions should be respected.[19] And finally, in late November, after most other government officials had weighed in, not to mention leaders of the major religious denominations and myriad other public figures, President Mitterrand delivered a forceful pronouncement of his views on the controversy. In a November 23 interview granted to *Paris-Match*, Mitterrand in no uncertain terms expressed his full support for his education minister's decision to nullify the suspension of the students at Creil. Speaking carefully, he pointed out that since France benefited from the labor of immigrants, it had an obligation to respect their traditions. He added, however, that patient, gradual efforts should be made to integrate immigrant groups (and of course he was speaking of Muslims) into French culture.[20] He seemed to be promising that if everyone would just be patient, immigrants would eventually blend in nicely.

While it may have seemed to many that President Mitterrand was attempting to have the last word on the subject, his intervention by no means closed the book on the matter. And now by late 1989 the man whose political agenda most clearly profited from anti-immigrant feeling, as demonstrated by new gains in regional elections, broke what one prominent journalist called his "discreet" silence on the polemic that had roiled the waters of French politics throughout the fall.[21] Jean-Marie Le Pen had not needed to speak out until this point, for one could say with real justification that the media and what contemporary Americans would label the "punditocracy" had been doing his work for him quite nicely. Now Le Pen pulled no punches, as in an interview he granted *Le Figaro* in December, in which he called for deportation of all immigrants who had arrived in France after 1974.[22]

In doing so, Le Pen was exploiting resentment of North Africans to mobilize opinion against all immigrants, certainly at least all African immigrants. As black African immigrants would be concerned, the National Front leader was being most prophetic. They previously may not have been targets of xenophobic suspicion and hostility, at least not consistently, but during the next few years many from the former French colonies south of the Sahara would encounter many more obstacles and setbacks in their efforts to find a new home in France. For it would seem that the animus building and building throughout the late 1980s toward the Maghreban population of the hexagon, reaching its fullest intensity during the scarf affair, was now available to be deployed against any group deemed insufficiently "French" by those with their backs well up above the everyday Gallic shrug. And, not surprisingly, the immigrants who manifested the most readily perceptible surface differences, most especially that of pigmentation, first felt the lash of the xenophobe's whip.

Meanwhile, as Le Pen's political agenda benefited from the climate of resentment *l'affaire du foulard* fostered, SOS-Racisme intensified its efforts to combat the ethnically restrictive definition of French identity embraced by the National Front. In 1990 Harlem Désir's organization mounted a poster campaign in the Paris region. Its centerpiece was a poster that featured a striking Mexican woman ("Rosie") standing with her right hand on her hip, the caption to her right reading *On aime tous le même pays* ("We all love the same country"). At the bottom of the poster appeared the logo

of SOS-Racisme, the raised open hand signifying its motto *Touche pas à mon pote* ("Hands off my buddy").[23] After five years, it was clear that SOS-Racisme had real staying power, with a gift for organizing large rallies and for keeping their message before the public. It was also clear that Harlem Désir's organization continued to be targeted by critics on the left as well as on the right. Pierre-André Taguieff remained a persistent critic. In the spring of 1992 he launched an attack on Harlem Désir in which he charged that the latter had gone too far in vilifying racism. The result, Taguieff argued, was that SOS-Racisme actually had created racism where it had not existed before.[24] Désir responded sharply, arguing that nothing could be accomplished through the more moderate approach Taguieff seemed to counsel.[25] Meanwhile, Harlem Désir was in the process of relinquishing the reins of his own organization (and not entirely willingly). On September 6, 1992, the organization conferred the presidency on Fodé Sylla, a Senegalese immigrant.[26] In retrospect, this seems propitious given the emergence that year of black African immigrants as the central actors in the national drama surrounding ethnicity and French identity.

Le Squat sur l'herbe: Malians at Vincennes

Much in response to the headscarf controversy, the socialist government of Prime Minister Michel Rocard (1988–1991) strongly endorsed a policy of "integration" for immigrants, its goal being to break down the separateness of ethnic communities and reduce the tension between French culture and its internal "others." To this end, Rocard established the Haut Conseil à l'Intégration, which would release a very influential report in February 1991. The text of the report blasted the whole concept of *les communautés*, arguing that they "imprison" people within ghettos and thus imperil the health of a republic that must genuinely achieve assimilation in order to have social harmony.[27] The Muslim North African immigrants were the ones the council members had in mind, but very soon another "community," one of the most established of all African inhabitants of France, would be at the center of controversy. This was the Malian population, many of them in France without benefit of legal permits, and they would be at the center of some of the most dramatic struggles of the 1990s.

A protracted standoff between Malian immigrant families demanding better housing and French authorities that lasted for some six months in 1992 brought to a boil the growing resentment simmering beneath the surface of French life—resentment many now felt toward all African immigrants, Northern or otherwise. As the confrontation wore on through the summer months and into the early fall, more and more people gave vent to their anger and bitterness. Those sympathetic to the Malians condemned the socialist government of Prime Minister Pierre Bérégovoy (and more particularly the Minister of State for Social Affairs and Integration Kofi Yamgnane)[28] for its intransigence, while the many who expressed hostility toward the African immigrants showed themselves willing to embrace the crudest sorts of stereotypes and generalizations. A 1991 poll published in *Le Figaro* had already revealed that 32 percent of respondents agreed with Le Pen's views.[29] By the end of the Malian

protest in October 1992, the strident slogans of the National Front—"Un logement pour les Maliens: au Mali!" ("Housing for the Malians: in Mali!") and "Des logements pour les Français, des charters pour les Maliens" ("Lodgings for the French, chartered planes, i.e., for deportation, for the Malians")[30] fell on more approving ears than ever.

This story began as a local matter, not unlike the affair in Creil. In May 1992 four Malian families decided to become "squatters" in a dilapidated apartment building in Fontenay-sous-Bois, a town east of Paris in the Val-de-Marne area. Their plight was typical of many in their situation: they had begun their time in France in the ridiculously overcrowded foyers administered by the housing agency SONACOTRA (see chapter one). While thus poorly situated, they had placed their names on a waiting list for public housing. However, as was all too common for recent African immigrants, the shortage of such housing meant that their wait dragged on for years. The shortage was especially acute since the HLM (*Habilitations à Loyer Modérées*—low-cost government-funded public housing) program had failed to grant additional units to immigrants precisely at the time (mid-1980s) of the greatest increase in the number of family members arriving in France.[31] Fed up, the families in Fontenay-sous-Bois occupied the "squat," which soon proved uninhabitable. To call attention to their predicament, they moved right under the windows of the mayor's office, whose occupant, Communist Party member Louis Bayeurte, expressed sympathy. He pointed out that since they worked in Paris they deserved a decent place to live there. Bayeurte arranged for municipal buses to transport them to the outskirts of Paris, specifically the Eastern edge of the city at the Château de Vincennes, and he furthermore provisioned them with food and mattresses. In just a few days the number of families encamped on the esplanade at Vincennes grew to twenty-five, and the historic intervention was underway.[32]

By late June the number of families gathered there had increased to one hundred and fifty, with people sleeping on tarps donated by a support committee composed of some forty organizations. A grand total of three portable toilets stood available for the use of the throng encamped at Vincennes.[33] One month later the number of families had more than doubled.[34] Clearly the initial actions of the families from Fontenay-sous-Bois had touched a nerve. Probably no group of African immigrants had a longer history of impoverishment and desperate need of housing than the Malians. This was especially true of the Soninké, the dominant ethnic group among them, and a population found all along the Senegal River Valley in Mali, Mauritania, and Senegal. Historically the Soninké, first arriving as laborers and in France without their families, were well-known for reproducing the structures of their home villages in the workers' *foyers* and for providing a large share—as much as 60 percent—of the expenses faced by their places of origin.[35] Typically they accomplished this through associations formed under French law.

Such a large expenditure made it difficult for immigrants to advance materially while in France. Nevertheless, like immigrants in all industrialized nations, they worked steadily and gathered the resources to support the families they hoped would join them. For Soninké laborers who had arrived in France well before the Mitterrand years, that could mean a very long wait. One such man, who at the height of the Vincennes controversy gave his name to a reporter as "Bakary," seems representative.

Arriving all the way back in 1962, he lived in a *foyer* in Montreuil and, like many Africans employed by the Propreté de Paris, worked as a street cleaner. After twenty-six years, he was able to send for his wife and son. First he needed to move out of the crowded *foyer*, and was able to do so by taking his brother's place in a squat. All the while, he presented himself regularly at the Paris HLM Office, growing increasingly bitter over the impossibly long waiting lists that never seemed to get any shorter. Like far too many of the working poor in the Western world, he enjoyed steady employment but could not afford housing on his wages.[36] And Bakary's family was small. Many Malians of comparable means or worse faced the challenge of seeking lodging for quite large families.

Once family members began to arrive during the 1980s they crowded into the workers' barracks along with the men. The result was that commonly seven or eight people might occupy a space meant for three or four at the most. To compound the problem, successive arrivals who happened to share the same village of origin typically were invited to stay with their friends from home, as traditional standards of hospitality dictated. The increasingly unbearable overcrowding in the *foyers* (in one example cited by the same reporter who provided the profile of Bakary, five hundred people were jammed into a *foyer* equipped with only half that many beds)[37] accelerated the pressure in the form of applications for government housing, where waiting lists already meant long delays and frustrated demands. It is also true that swollen family size was due in many cases to the polygamy practiced by many Malian immigrants, as well as a fertility rate estimated in 1992 at around six children per woman.[38] However, those who have studied the Malian immigrants closely argue that the level of polygamy has been exaggerated and that the practice was declining by the 1990s.[39] The majority of associations of African women in France were on record as having condemned polygamy.[40] Still, articles in the press regularly took aim at what one exposé called the "daily hell" of polygamy in African immigrant families.[41]

Certainly as public opinion turned increasingly against the Malians massed on the esplanade at Vincennes, negative portrayal of these particular immigrants frequently found expression in condemnation of traditional practices most obviously out of step with European norms: polygamy and female excision (or genital mutilation). Needless to say, these practices also violate French law. When I met with a government official charged with supervision of immigrant populations within the Ministry of Employment and Solidarity in 1998, and mentioned my interest in sub-Saharan immigrants (not, specifically, Malians), almost the first words out of her mouth were "polygamy" and "excision." It seems that even when someone has studied an immigrant group closely, the temptation remains to apply very general characterizations such as these. It seems the equivalent of the term *foulard* applied to Muslim women in France. In either case, the association of entire populations with practices abhorrent to French republican values obscures the fact that debate rages within the communities in question about these very practices.

To be fair, not all commentary in the French press portrayed the Malians in a negative light. From time to time, articles appeared that reacted to the Vincennes encampment by raising significant questions about conditions for African workers and their families and by proposing specific social remedies. In the fall of 1992 Hubert Prévot, who held the position of Secrétaire Général à l'Intégration, published

a report on the some 320,000 Africans living in France, and was interviewed in the press about the actions he urged. He warned of growing anger and despair likely to develop in the *banlieues*, and pointed out that African immigrant workers who needed to be in Paris for their jobs could not afford to live there. He also called for greater use of development programs that would improve conditions in the countries from which immigrants came to France.[42] All too often, such reasonable, thoughtful voices were difficult to hear over the shrill outcry of those whose opinions were pushed to extremes by the impasse and the sensational coverage it received.

The government's foot-dragging served to prolong the crisis at Vincennes and did much to contribute to popular resentment of the Malians. Early on, the various groups sympathetic to the campers demanding housing formed a loose network headed by Makan Sidibé, president of the Council of Malians in France. He sought to intercede on behalf of those petitioning Marie-Noëlle Lienemann, minister of housing in the Bérégovoy government, and regional authorities including the prefecture and the twenty arrondissements making up the commune of Paris. Grudgingly, in June the office of the prefecture of Île-de-France offered what they said was sufficient housing for some 150 of the roughly 500 persons whose petitions they had received. Groups of Malian families were then invited to inspect the fifteen sites identified as "emergency" shelters. They managed to visit four of them, and found them appalling, even lacking electricity and hot water. On top of that, several sites were at some distance from Paris, making commutes to jobs in the city burdensome in the extreme. The housing minister argued—more or less—that "beggars can't be choosers," and refused to do more. The Paris mayor's office, occupied at that time by Jacques Chirac, refused to meet with a delegation from the Malians.[43]

The standoff would drag on, and conditions would have to become much worse before authorities responded to demands from an irate public that they do something. Apparently, only the coming of autumn and the grim prospect of an encamped population facing a Parisian winter moved the authorities to act, and then they resorted to draconian measures. On October 29, by which time approximately two hundred families were on the esplanade of Vincennes, a forced evacuation ordered by Christian Sautter, prefect of the Department of Île-de-France, was carried out, beginning at 6:00 a.m., by seven hundred police officers, CRS, and members of the Gendarmerie. Under police supervision, they boarded buses to be transported to various locations, salubrious or otherwise, scattered throughout the Paris suburbs. Many who observed the roundup were deeply disturbed by the spectacle of children and infants being herded into the buses along with their families, and at least one person was reminded of the infamous forcing of Paris Jews into the Vél d'Hiv in 1942, preliminary to their relocation outside Paris to Drancy and eventual deportation.[44]

Many residents of the neighborhood displayed far less sympathy. The owner of a brasserie called "Le Sport" unloaded his pent-up frustration on a reporter from *Le Monde*. "Finally we have taken the situation in hand. It could not have lasted any longer," he exclaimed, complaining of Malians using his establishment's bathrooms, and lamenting lost revenues he suffered from patrons avoiding his place of business during the preceding months. And then, sounding like Jacques Chirac, he bemoaned the "smells" emanating from the encampment. Many others in the neighborhood echoed his sentiments. Perhaps members of the nobility during the *ancien régime*

spoke this way of the peasants they felt themselves most unfortunate to have encountered. Yet others argued that the situation had been equally bad for the Malians, and one woman, approached by the reporter while out doing her shopping, skewered the government for its hypocrisy, pointing out that the same government that had announced it was sending food relief to beleaguered Somalia had behaved callously toward its own African immigrants.[45]

The same reluctance to act that government officials had exhibited during the Vincennes episode would continue for years to follow in the snail's pace at which authorities moved to find suitable housing for the unfortunate people bused away from their encampment on that late October morning. And, as subsequent political demonstrations would show, the Malians were not going to disappear from French politics. Even more profoundly for the evolution of French popular opinion, the negative stereotypes (polygamy, illiteracy, marginality in all its forms) promulgated in media coverage and in political agitation against African immigrants worked to stigmatize sub-Saharan African immigrants in ways comparable to the North African population in France. Almost prophetically, Jean-Paul Tauvel, writing in December 1992 in an academic journal devoted to immigrants in France, wondered if (black) Africans might now be "in the process of replacing *maghrebins* in the national imaginary."[46] And to be sure, the kinds of articles that begin to appear in the French press for the next few years drive home the theme that *Les Blacks* constitute a problem for France, polygamy being one of several favorite themes of journalists approaching sub-Saharan immigrant groups in this way.[47]

By focusing so frequently on the most "alien" aspects of African immigrant culture, the media served to magnify the widely held belief that the most recent immigrants were not capable of being integrated into French culture. Whether the theme was headscarves or polygamy, it received the kind of monolithic representation that coded it as inherently expressive of hostility to French values. Therefore such ingredients could never be stirred into the French melting pot. But the question arises whether perceptions fostered by media attention squared with social reality. Studies based on extensive research have tended to suggest that the answer to this question is a resounding *non*. For example, in 1994 the historian and anthropologist Emmanuel Todd published a substantial volume called *Le Destin des immigrés*. He argued that the data he was able to accumulate showed dramatically that France's immigrants were much more successfully integrated into the social fabric of the host country than could be said of the immigrant populations of other large Western nations. The most unique feature of his analysis was the emphasis he placed on mixed marriages, which he argued occurred much more frequently in France.[48]

Most French people paid little attention to the gradual process highlighted by Todd's research. If elements of African culture were taking root in French culture, most assumed that it applied only to specific zones or districts. In Paris, African immigrant culture was associated in most minds with the areas of the Eighteenth Arrondissement known as La Goutte d'Or (immediately to the East of the Boulevard Barbès) or Barbès (the area immediately surrounding the Barbès-Rochechouart Métro stop). By the early 1990s the neighborhood had evolved into the commercial center for African immigrants, although by no means was it the residential center.[49] But this was the district in which Parisians most felt themselves to be entering

"Africa," and it was both celebrated as a "black" economic center and reviled as a high crime area where legitimate business operated alongside illegal activities.[50] Even when journalists called attention to the African commercial enterprises to be found in this district, the assumption was that the clientele would be limited to other immigrants and of greater importance for the economic fortunes of African countries than for Paris.[51] At the same time, Paris authorities demonstrated a willingness to fund improvements in La Goutte d'Or and even to celebrate it as a model of diversity in the capital city. Observing this trend, a 1993 article in *Le Monde* proclaimed that the neighborhood had overcome its "bad reputation."[52]

When it comes to the African presence in Paris, even at the times of greatest tension and conflict it seems there are always two sides to the story: that the French can never accept such irreducibly different immigrants as fellow citizens, and that the process of African immigrants becoming French and adding their cultural flavor to the *creuset français* is well underway and becoming more and more accepted. As for the media, which story has it emphasized? Even more importantly, what reality has it helped to shape?

Shrinking Opportunities in the "World Music" Business

African immigrant musicians living or seeking to live in France most certainly did not fit the profile associated with the most desperate of their counterparts, such as those who found themselves in the media spotlight during the summer of 1992. They tended to be uniformly literate, often quite well-educated, and proficient in French at a level of mastery far in advance of most other immigrants. These points were highlighted in the 1995 report by the Institut National d'Études Démographiques, which emphasized the international appeal of many of the "world music" artists who had made Paris their home.[53] Nevertheless, in contrast with their elders who arrived and took advantage of the welcoming climate for world music musicians during the 1980s, the more newly arrived musicians faced diminishing prospects and a hostile political climate as they attempted to manage their careers from a base in Paris. The major reasons were structural and organizational as regards the music business. For, just as the late 1980s had been marked by flourishing independent record companies in France—such as Sonodisc, Barclay, and Celluloïd— that encouraged and supported African artists, the 1990s brought a new trend of corporate mergers and the predictable tightening of the market that such mergers invariably bring about.

By the end of the previous decade, most prominent independent labels had disappeared or become subsidiaries of the six major "transnational" music corporations: Time-Warner, Sony, MCA, Thorn-EMI, Polygram, and BMG.[54] The consolidation was complete by 1990, by which time the six companies had cornered 83 percent of French market shares.[55] This trend had coincided with the adoption of the new technology of compact discs, which were more convenient to store and distribute and for which the companies felt justified in pushing through a major price hike. Two of the

most important independent companies associated with world music had now been absorbed by the "majors." Virgin, the largest of the independents, was purchased by EMI, and Island, the feisty company originally founded by Chris Blackwell in Jamaica in 1962, now belonged to Polygram. The fate of Virgin's employees was typical of the "downsizing" that always seems to follow large corporate mergers. Of them, 45 percent were dismissed, and the artist roster was reduced to half its former size.[56] Critics of media corporate consolidation argue that the range of products offered is invariably diminished by these mergers. Island and its related label Mango had been vital for the popularity of reggae and then African "worldbeat," with such artists as Salif Keïta and Mory Kanté (whose French label Barclay was distributed internationally by Island).

Independent record labels had represented the last hurrah of vinyl albums, so that by turning exclusively to compact discs at the time of their transnational consolidation, the major labels effectively had shut the independents out of the market. Moreover, once having purchased the smaller companies, the majors now stood poised to reissue their back catalogues on compact disc, a source of even greater profits.[57] Paradoxically, it was by no means necessary to be a transnational company to afford the technology of compact disc manufacture. The process is relatively inexpensive—becoming more so all the time—and once surviving independent companies retooled to use the new technology, they began to release CDs and some new independent labels even emerged. But the independents, new and old, would continue to be held back because they could not hope to distribute their products on the scale that was possible for the major labels. This meant that success for an independent disc would remain at a modest level, and by the mid-1990s it had become common practice for musicians to peddle their recordings directly to their audiences, a practice that has become more deeply entrenched with the availability of the internet.

Mamadou Konté, the influential founder of Africa Fête, lamented in 1990 that a real gulf of understanding existed between record companies and African recording artists, and he saw himself as someone trying to bridge the gap. The companies, he claimed, had no idea how to promote the music, whereas the musicians had little patience with or clear understanding of marketing practices.[58] François Bensignor, an experienced music journalist whose area of greatest expertise has been African music, has explained that the consequences of the consolidation of the market by the six transnationals have meant greatly reduced opportunities for African musicians in Paris, especially younger ones hoping to duplicate the kind of success the likes of Manu Dibango, Mory Kanté, Touré Kunda, Kassav', Salif Keïta, and others had enjoyed during the 1980s. After 1990, he pointed out, the major labels preferred to stick with established stars, and smaller labels without major distribution could not commit to new artists—or at least could not promise them much in terms of monetary gain or visibility.[59]

We have to keep in mind, Bensignor insisted, that the African musicians elevated into the national spotlight "already had very important careers in African countries before arriving in France." Now, "decisions were being made by label chiefs in London or elsewhere." Bensignor explained that the companies affiliated with major labels in separate European countries communicated not with each other but with

the corporation headquarters (in London, New York, etc.). The affiliates based in Paris operated without authority or the resources to launch the career of an African musician in France. Also, by definition, no independent *maison de disques* had the power on its own "to make an international product" or to "launch the career of an African artist." This does not mean that independent companies had no role to play in the world music business. They simply had to occupy a less conspicuous sector of the market. A good example of a small company that, through stubborn persistence and an ambitious catalogue, has managed to make its mark and supply at least a modest level of support for African artists is Buda Musique, which operates out of a small office in eastern Paris. At the time I interviewed the label's owner and director Gilles Fruchaux, his company was based in the Boulevard Voltaire.

During the 1980s, Fruchaux had worked with François Post at the influential record company Celluloïd (see chapter two), later affiliated with the label Mélodie. By 1988 he had left to start Buda Musique with his partner Dominique Buscail, who died two years later. As this was precisely the period of major label consolidation, it clearly was not the most auspicious time to launch an independent label. However, Fruchaux made it work through a combination of "folkloric" emphasis (his *Musiques du Monde* series harks back to the kind of ethnomusicology one associates with the Musée de l'Homme and later with the label Sonodisc that flourished in the 1960s and 1970s) and strategic marketing of a handful of contemporary African artists, including Ray Lema, So Kalmery, and, more recently, Henri Dikongué.[60] But even the modest level of success enjoyed by such musicians as these remained out of reach for the majority of African musicians trying to make it in Paris during these years.

Organizing concert tours or bringing African musicians to Paris temporarily in order to record increasingly became next to impossible since more and more restrictions were placed on the granting of visas and temporary residence permits. During the 1980s if a musician from Mali or some other African country needed a visa to be able to tour with French-based musicians or to participate in a Paris recording session, the Ministry of Culture could intervene and accomplish the objective easily enough. However, by the mid-1990s, requests for residency permits and the like were being handled by local prefectures, some of whom routinely imposed delays or showed great reluctance to grant the requests.[61] Music promoters based in Paris, dealing with sometimes long lists of foreign clients and trying to organize concert tours or music festivals, were obliged to spend long hours and ever-increasing amounts of money to get their artists over the many hurdles placed in their paths. Corinne Serres, one of the most successful promoters of African music in Paris, remarked that she felt increasingly more like an ambassador than someone running a business.[62]

Even very successful African musicians of Paris suffered regular vexations and inconveniences from the increasingly restrictive climate. Ray Lema, originally from Zaïre, had arrived in Paris in 1982, and says he found throughout the rest of the 1980s a casual, accepting atmosphere, as well as a real *mode africaine*. To illustrate the difference between the casual attitude of the previous decade and the suspicious climate of police surveillance that marked the mid-1990s, he described the way the musicians in his band used to travel with borrowed passports, or would exchange passports with each other. They assumed that French authorities would not perceive the difference.

"I was afraid," he said, "I said 'You shouldn't do that.' But they said, 'But you know that whites don't know how to tell the difference between blacks.' And I saw what really happened in front of the customs official. He took the passport and looked at it. He looked at it and looked at it and he saw no difference. But now that doesn't happen anymore. Now the French have begun to distinguish between blacks."[63]

Speaking of this change, Lema had little to say about larger political issues, and seemed to see the issue more in terms of a focus on individuality. He said that 1991 was the point at which attitudes changed. When I asked why that year, he said he did not know, but that it seemed to him that people in France ceased thinking in terms of "Africans" generally, and instead made critical distinctions between persons. Could that be a positive development? He didn't say, but related it to the waning of a vogue for things African: "There was an African fashion, but that fashion is *passé*. We have begun to go toward other things. We have begun a more personalized, more individualized search." Here Lema may have been speaking more of his iconoclastic music, for he pursued some very diverse directions during the 1990s, from producing reggae to recording with a Bulgarian chorus to performing solo piano music, all the while collaborating with a host of other African musicians.

(Pascal) Lokua Kanza (1958–), a singer from Zaïre who first arrived in France in 1984,[64] launched a successful career in Paris during the 1990s, managing to sign with BMG, one of the major multinational record companies. He first began singing in church choirs during his youth, and then moved on to singing with various groups in the bars of Kinshasha. Later he studied in a music conservatory there, then began performing his music in Zaïre before leaving for France, where he would work with his compatriots Ray Lema and Papa Wemba, as well as with Manu Dibango, among many other prominent African musicians.[65] In addition to performing African music, he embraced French popular music, recording versions of some well-known *chansons*.[66] In 1993 Kanza released his very successful first album, to be followed by his even more successful second album *Wapi* in 1995. When I was in Paris in the spring and early summer of 1995, several people who granted me interviews urged me to seek out Lokua Kanza. It was clear they regarded him as the rising star of the scene. He had impressed his fellow musicians with his songwriting talent, his fine, expressive singing and his excellent guitar playing. Singing in Lingala, Swahili, French, and English, his music was aimed at the widest possible audience.[67] I had a brief interview with Lokua Kanza just before his album was released.

He radiated goodwill and optimism, and clearly was pleased that he had become a French citizen a few months earlier. He said that he wished he could work in Kinshasha as well as in Paris, but the political upheaval in Zaïre precluded that. Eventually he would succeed (in 1997) in getting his two daughters out of there and in reuniting his family in Paris.[68] In any case, music had been the primary reason for his coming to France. When I asked about his intention to remain there, he said, "I think that I would like to go back home, but for now I have a lot of things to do (in Paris)." The success Lokua Kanza was enjoying with his own career colored his view of the vitality of the African music scene in Paris. He disagreed with those who saw it as declining relative to the previous decade, saying that African music could look forward to "a future as much in Paris as anywhere else in the world." If anything,

there were more African musicians than ever in Paris, he insisted, adding, "Now there is a new generation coming."[69]

Awilo Longomba (1962–), also originally from Zaïre, first came to France in 1986 as drummer for the famous singer Papa Wemba. His father, "Vicky" Longomba, was a very popular singer with Zaïre's prominent band O.K. Jazz.[70] In 1989 Awilo moved permanently to Paris, and became a French citizen in 1994, having married a French woman. When we talked in July 1996 in his apartment in a building near the rue du Temple, he was very focused on his solo career, having recently released his first CD. Even though he was glad of the advantage of a French passport for his travels as a musician, he was quick to say that racism and mistreatment by the police was all too common. When he came to France the first time and applied for his *carte de séjour*, he saw firsthand discriminatory attitudes against African immigrants in action:

> It was there that I saw that there was discrimination coming from the prefecture—how they spoke to people, to Africans, to others who did not understand French well. It was there that I saw that there is a very dangerous discrimination.

Longomba was bitter about the rise of Le Pen's movement, which he argued showed that racism was a greater problem than it had been previously in France. I asked him if he believed that a lot of French people were racist. He replied, "Yes, a lot." I said, "Especially today?" and he agreed, underlining the racist reputation of some political parties, especially the National Front. He added, "Those people—they are the French people who vote."[71]

While not as high-profile a musician as Ray Lema, Awilo Longomba clearly had settled into life as a Parisian and for personal reasons had formed an attachment to the city. So Kalmery (1955–), another immigrant from Zaïre, displayed a markedly different attitude. For him, Paris made sense as his headquarters because of the French language and the political impossibility of living in his home country. When I asked him if he wanted to stay in France because of his career, he said no. "But I have to do what I have to do, so I stay here," he added. "I can't say that I want to stay in France," he said. Referring to his frequent touring, he remarked, "I am in Guadeloupe, I am in Africa, I am in Australia. And I want to come to the United States."[72]

So Kalmery's travel itinerary is an unusual one, and has especially included extended periods of time in Australia. He learned to play the didgeridoo there, and has used it in his recordings. Together with his friend Steve Kozumba, a musicologist also from Zaïre, we talked at length, seated on a park bench in the bright sunshine of a warm summer morning. At their suggestion, we had met each other in the Place de Clichy, in front of the McDonald's restaurant, no less. I have learned that the infamous establishments, so prominently placed throughout Paris, are frequently used as landmarks for rendezvous. The staircase leading up from the Place Clichy Métro stop is just in front of the McDonald's, and that is where we found each other. We crossed over into the edge of the Ninth Arrondissement, stopped into a neighborhood convenience grocery by the small Square Berlioz to buy some cold beers, and then stationed ourselves on one of the benches in the shade of the square. It was a very warm July day.

Kalmery and Kozumba shared a strong interest in *brakka* music, a style originating in Egypt but influential throughout much of Africa. *Brakka* is a highly percussive

music played often on marimbas accompanied by stringed instruments and bells. Kalmery's interest extended beyond the music to the early civilization out of which it developed.[73] This fascination with indigenous cultures and their expression through music is one of his strongest characteristics. It has taken him well beyond such genres associated with Congolese music as *soukous*, which he played when he was a guitarist with Papa Wemba during the late 1970s.[74] After moving to Paris in 1984, he embarked on a solo career distinguished by experimentation with a variety of global influences, such as the incorporation of aboriginal influences from Australia into his music.

Even though he was one of the African musicians featured on the Buda label, Kalmery expressed real bitterness over the many obstacles he had encountered in attempting to pursue his career in Paris. He arrived in Paris from Zaïre in 1984, and when interviewed contrasted the more welcoming climate (both musically and politically) of the 1980s with the situation a decade later. He complained of police harassment, as in being stopped in the street "three, four, ten times" and having his *carte de séjour* examined. On such occasions, he said, the police seemed to take malicious pleasure in taking up his time as they regarded his card suspiciously, asking snidely "Do you have an appointment?" He also resented the lack of opportunities to have his music played on radio stations. This was due in part to his use of Swahili and English in his songs, rather than French. Kalmery saw the radio issue as an example of a lack of "openness" on the part of the French:

> The problem in France is that there are French people of African origin who have no rights, because France does not want to discover their culture. We (Africans) are open. When you live in France, you speak French. We also bring music, but apparently the government does not want us to be heard on the radio. . . . the French do not want to engage with African musicians. But Africans engage French musicians, Japanese, everyone (*tout le monde*). But we do not have the right to be on the radio.

Steve Kozumba said that even though he had French nationality (with a French wife and children), he had to endure frequent identity checks. "The humiliations are constant," he declared.[75] Both he and Kalmery spoke of police not believing in the legitimacy of their identity papers.

During the decade of the 1990s, as many African musicians encountered often extreme difficulties in Paris, due to the changes in the music business as well as the more threatening political climate, the "stars" who had established their careers well during the 1980s continued to receive glowing notices in the press, even as they too were affected by the changed conditions—finding it more difficult to secure visas for musicians with whom they wished to record or tour, for example. The annual festival at Bourges (Le Printemps de Bourges) continued to receive very favorable coverage in the press. In 1990 the headline acts included Youssou N'Dour and Ray Lema, whose great musical eclecticism received praise.[76] Equally common in the French press was regular coverage of new recordings released by well-established stars such as Mory Kanté, whose 1990 album *Touma*, following the success of the 1988 album that contained his huge hit "Yéké Yéké," received a glowing sendoff from *Le Monde*.[77]

Salif Keïta's concert appearances in Paris and elsewhere in France were considered major cultural events, as in a November 1992 show at L'Olympia in Paris.[78] When he and his compatriot Ali Farka Touré performed at an annual summer festival in Nantes in 1995, their appearance was treated as a defense of the Malian culture that had been so embattled in recent years in France.[79] While Ali Farka Touré remained a resident of Mali, Salif Keïta based himself in Montreuil. There he had firsthand knowledge of the political struggles of Malian immigrants in France, and his role as a bandleader brought him the growing vexation of the battle to secure proper papers for the musicians in his band. Eventually such problems would bring about his departure from France.

For the most part a real "disconnect" seemed to exist between media attention to well-known African musicians and coverage of embattled immigrants from the same former French colonies. The colorful personality of Papa Wemba, the singer from Zaïre who first delighted Paris audiences in the mid-1980s, regularly made for good copy, especially through his well-known sartorial excesses. Major newspapers tended to return to such themes each time the musician released a new disc.[80] And just as in the previous decade, the distinctive persona of Manu Dibango continued to exert a strong appeal as the embodiment of the successful African presence in France. Throughout the 1990s, as opportunities declined for many other musicians, he clung to a stubborn optimism, proclaiming his conviction that Paris remained the capital of world music, and indeed even the global cultural capital in general.[81]

It appears that, as with the promotion of African music by major recording companies, a select few figures served to represent what remained of the multicultural spirit of the 1980s, even as many signs of quite an opposite cultural mood commanded attention.

Hostile Government Policies
and the *Sans-papiers*

Trying to make one's way as a musician given the new, more forbidding corporate structures was one thing, but by 1993 more aggressively anti-immigrant government policies created hardships for a great many Africans in France, especially those who had not yet acquired citizenship. In March 1993, as passions heated up by the Vincennes encampment continued to simmer, the center-right parties made enough gains in parliamentary elections to gain the majority and to form a rightist government with Éduard Balladur as prime minister (thus creating what the French call a "cohabitation," with the president of the republic and the prime minister from opposing parties). Almost immediately, much tighter controls on immigration, exemplified by heavy-handed police activity, became the order of the day. An extreme example of an African immigrant fearful of relentless police identity checks captured headlines in August 1993, when an African man trying to escape an identity *contrôleur* plunged into the Seine near the Pont-Neuf and was drowned.[82]

Balladur appointed as his interior minister Charles Pasqua, who reprised the role he had played when he acquired the same position in the Chirac government formed in 1986 (see chapter two). Just as in 1986, when the success of Le Pen's party in

regional elections had prompted the government in power to adopt more restrictive immigration policy, the cumulative resentment of African immigrants owing to the headscarf affair and three years later to the Vincennes showdown led to new "Pasqua laws" that broke with precedent to impose dramatic new restrictions on the acquisition of French nationality.

This had to do especially with the long-standing concept of *jus soli*, that is, that one automatically became a citizen at the age of eighteen as a result of being born on French soil, even if the parents were not French at the time of the birth. The new law declared that such citizenship would be by no means automatic. Instead, the child, at some time between the ages of sixteen and twenty-one, would need to issue a formal request for French nationality, accompanied by a loyalty oath. The request could be denied on various grounds, for example, if the applicant had received a prison sentence of more than six months.[83] In addition, the new law did away with the practice whereby a child younger than sixteen could become a citizen based on the immigrant parents' declaration, and also eliminated the automatic *droit du sol* for children of parents born in the former colonies (prior to their independence) or overseas territories.[84]

The restrictions Pasqua wanted placed on recent African and other immigrants became available to his ministry thanks to laws enacted on four different dates in 1993: July 22, August 8, August 24, and December 30. In addition to modifying the Code de la Nationalité as just described, these laws tightened controls over national identity, entrance into France, and the permissible length of stay.[85] Some of the measures were clear responses to the negative publicity that had surrounded African immigrants in the coverage of recent events. For example, one of the laws outlawed polygamous status for foreigners in France. This would mean that wives now faced the difficult choice of separating from husbands—at the risk of failing to secure papers or jobs for themselves—or having their papers revoked if they maintained their marital status.[86] Mixed marriages—routinely suspected by opponents of immigration as mere marriages of convenience—were placed under much greater surveillance,[87] and the waiting period required for someone requesting French nationality as a result of such a marriage was lengthened from six months to one or two years.[88]

Residency permits would now become much more difficult to acquire, and the punishment for failure to possess them would be deportation. When he first became interior minister in 1986, Pasqua had pushed successfully for legislation that gave the executive branch of government the power to deport aliens, and he moved vigorously to reassert that power in 1993.[89] He made it quite clear that he saw deportation as a necessary response to what he viewed as illegal immigration. He also took steps to increase police powers, both internally and at France's borders, to run identity checks and both detain and deport those caught without proper identity papers. Restrictions that socialist governments had placed on deportations were lifted. As a result, the number of deportations doubled during the first three months that Pasqua was in office.[90] To be sure, the new policies met with some resistance, and even passionate denunciation. Danielle Mitterrand, speaking before a national commission on human rights, deplored the "atmosphere of mistrust and suspicion" that had resulted from the Pasqua laws.[91] This occurred in April 1994. In July, the communist-dominated city government of Noisy-le-Sec, in the Department of Seine-Saint-Denis, announced its intention not to cooperate with the police in rounding up people to be deported.[92]

Laurent Bachet, a French filmmaker who specializes in short subjects (*courts métrages*), based his film *Tout le monde descend* on a dismal incident that occurred as a result of the Pasqua policy of deportations. The fifteen-minute film, which had its first screening in Paris in July 1997, provides a stark and simple narrative account of passengers boarding a bus, going about their normal routines—but then transit police get on and begin inspecting tickets. All would be well, except for the African immigrant whose fate figures at the center of the story. At the beginning of the film's action, as he is boarding, he is about to validate (*composter*) his ticket in the box mounted at the front of the bus when he is distracted by a friend calling to him. He goes over to speak to his friend and forgets to "compost" his ticket. Then, when the ticket controllers inspect his ticket and find he has failed to perform this action, they demand to see his identification papers. However, since he lacks proper documentation, they take him into custody. At the film's end, viewers learn that the person whose life has been depicted in the film was deported to the African country from which he had fled seeking refuge in France, and that there he was put to death. Bachet's film created a stir when it was screened again at the annual festival in Clermont-Ferrand in early 1998.[93]

The enforcement of the Pasqua laws fueled the resurgence of the *sans-papiers* movement, many of whose members were living in deplorable conditions, much like the campers forcibly removed from Vincennes in 1992.[94] The *sans-papiers* were immigrants without residence or work permits who resented and resisted the term illegal or "clandestine" to describe their status. In many cases, initially they had entered France legally, but had overstayed the permitted terms on their *cartes de séjour* or had been declared illegal as a result of an action taken by some government agency, often at the local level, and very typically by the prefectures whose enforcement powers Pasqua's laws had increased significantly. By contrast with an earlier generation of immigrants, many families resided together in France under this precarious status. Originally the Malians spearheaded it, but by the end of the 1990s a broad range of ethnic groups were taking part in the *sans-papiers* movement. In 1996, when they first came to national attention, they were acting in response to the Pasqua laws (which continued to be enforced by later governments) and to the deportations taking place regularly, but also to the ongoing lack of attention paid to the many African immigrants who were so poorly housed. Several years after the evacuation of the esplanade at the Chateau de Vincennes, large numbers of Malians still had not been placed in acceptable housing. According to one report in January 1995, more than 120 families who had camped at Vincennes were still waiting for permanent housing.[95]

Not only were people enduring long waits for lodging, they were, in some cases, being threatened with expulsion from the crowded *foyers* they inhabited. This was the situation faced in 1994 by the three hundred or so inhabitants of a *foyer* in Pierrefitte (north of Saint-Denis),[96] and in early 1995 some five hundred Malians were threatened with being moved out of their *foyer* in Montreuil.[97] The mayors of small communes near Paris typically seemed to feel pressure to relocate African immigrants, but a particular extreme was reached in the summer of 1996 when the mayor of Courbevoie (not far from Nanterre northwest of Paris) proposed the relocation of a workers' *foyer* within the confines of the local cemetery.[98] On a regular basis during the mid-1990s one could find newspaper articles on families living as squatters in

Paris neighborhoods, or otherwise occupying substandard housing. For example, *Le Monde* in September 1995 ran a story about twelve families crammed into a dilapidated building in the rue de la Lune, on the northern edge of the central Paris Sentier district.[99]

The *sans-papiers* made their debut as a public presence on March 18, 1996, when some three hundred people mostly from Mali and Senegal[100]—men, women, and children—occupied the church of Saint-Ambroise in the Eleventh Arrondissement, declaring their intention to reject the clandestine life and to live openly in their chosen country.[101] Four days later, police in riot gear expelled them in a scene of great chaos: hitting hunger strikers and hurling racial insults. After this expulsion, the group sought other locations around Paris for their protest, finally settling on the church of Saint-Bernard in the Eighteenth Arrondissement on June 28.[102] They were to occupy this church for almost two months, continuing with hunger strikes and forming alliances with artists, intellectuals, and sympathetic neighborhood groups. On a regular basis, the church occupants issued statements through their Senegalese spokesman Ababacar Diop.[103]

Politically speaking, this was not the most promising time. Jacques Chirac had been elected president in 1995, and the government under Prime Minister Alain Juppé was stridently hostile to African immigrants. More exclusionary policies were the order of the day, and the government dug in its heels the more the *sans-papiers* issued their demands to be "regularized." As the confrontation intensified, Africans in France, regardless of their status with regard to citizenship, felt the pressure to identify with *les étrangers* or with their adopted country. Xénia Caraïbe (1959–), a singer from Guadeloupe (and therefore French), had lived most of her life in France but, during the summer of 1996, was made to feel like an immigrant, because "They don't look at your papers. They just care about your skin." Speaking of herself and her companion Tiacoh Sadia (1961–), a musician and naturalized French citizen (since 1986) originally from Côte d'Ivoire, she explained,

> During the Mitterrand years, there was a particular politics for immigrants, especially for musicians who were somewhat suited to the restoration of a certain life, a certain "cool" something. Now that becomes a lot more difficult because there is a new politics of immigration. Now, we see lately that there are a lot of immigrants who are in the churches because their situation has not been regularized and that has become very, very difficult. We have already quite a lot of friends who have been driven out. There are a good fifty of them already.[104]

She was speaking of the new climate of restrictions and deportations. Tiacoh Sadia remarked upon the controversy during the summer of 1996 over Jean-Marie Le Pen's disparagement of the French national soccer team. He had expressed the opinion that they (in their racial diversity) seemed less than French. "For me, personally," Sadia said, "Each to his own opinion, but that really makes no sense." He went on to say,

> If I was a football player, and I went to play in a foreign country and someone said to me, "Ah! How well you play, but where are you from?" Me, I would say, "Yes, but I come from France." Because if I represent France, that is very positive. It's like when I would go to play in a foreign country, in the United States or somewhere else, and

someone said to me, "But, where are you from?" And I'd say, "I come from Paris, but I was born in Côte d'Ivoire."[105]

Xénia Caraïbe was born in Senegal to parents from Guadeloupe, with whom she left Guadeloupe for France as a young child. At the time of our interview, she was performing as one of the sopranos in an *a cappella* group called Nipa (see chapter six), and later would perform frequently with Kassav' as well as with the Malian singer Rokia Traoré. Tiacoh Sadia (real name "André Tia"), an accomplished jazz-influenced drummer, arrived in France from Côte d'Ivoire in 1983, and soon began playing with Mory Kanté and Salif Keïta. For several years he also was the drummer for South African singer Miriam Makeba. Third child of seven in his family, he was the first to become a musician and the first to go to France. Although he enjoyed the advantage of French citizenship, he agreed with Xénia Caraïbe that racism and discrimination had become more noticeable in France. Examples for him came from daily life. "When I go to the supermarket," he observed, "people don't necessarily see that I am Tiacoh who makes records."

Both musicians contrasted the present period for African musicians in France with the celebrated decade of the 1980s; yet, despite the deportations Caraïbe had noted, Sadia pointed out that there still were many African musicians in France, and that many of them were unable to work because they were *sans-papiers*. While there had been such cases during the previous decade, Lang's ministry had frequently used its influence to speed up the regularization of such musicians. Caraïbe also argued that Paris remained a place of great importance for African music. "Paris is, and will become, and is in the process of becoming, in my opinion, the crossroads of world music in Europe," she said. At the same time, she described what she believed was a real paradox for her and her fellow musicians—that African music was meant to reach a broader audience than that afforded by the structures of the Francophone music business within which they were "stuck (*coincés*)." Insistence on the French language could be an obstacle, both musicians agreed. Singing in Creole, which Sadia called *le français dans la rue*, was a necessarily "political" act, according to Caraïbe, and she credited Kassav' (whose lead guitarist Jacob Désvarieux is her cousin) with the courage to insist on doing so. "We no longer have to be ashamed," she emphasized, reminding me that use of Creole had been forbidden in "proper" households in countries such as Guadeloupe. As for the political impact of her own music in France, she said that her aim was something more modest than social transformation. "We are supplying small pieces of the puzzle to broaden the view," she stated.

Both Caraïbe and Sadia expressed exasperation with the political climate that seemed to prevail during that summer of the occupation of the church of Saint-Bernard, and things were to become much worse. Having refused to negotiate with Diop and his group, the Juppé government announced that the three hundred persons occupying the church had forfeited their right to remain in France, although Juppé's statement was softened somewhat by the acknowledgment that those needing medical treatment should receive it and that mothers should not be separated from their children. He also held out the possibility that one hundred or so of the *sans-papiers* could be regularized.[106]

On the same day that these statements were publicized, Juppé ordered the forcible removal of the church occupants. It took place early in the morning of August 23, 1996, when around one thousand police and riot police entered the church after smashing through its heavy wooden doors with axes. They fired tear gas canisters, despite the presence of infants and other very young children, and rained blows on those who sought to resist them. Some of the occupants of the church were white, and were spared arrest. All of the blacks there were arrested. This racial policy ignored the fact that some whites did not possess papers and some blacks, there to show solidarity with the African *sans-papiers*, did.[107] Shortly after these events, Ababacar Diop wrote a moving political testament explaining the motives of the protestors. His statement was especially striking for the "love" he professed for France.

Diop described the situation of those in his movement as "absurd," since their presence in France had been desired by their employers, and they had come out of love for a country whose "merits" and "welcoming tradition" had been vaunted to them in advance. And yet, once in France, they faced continual police surveillance and harassment each time they left home to seek employment, as if they were guilty of violent crimes.[108] He argued as well that immigrants had been instrumental in the economic development of France and "the European continent in general," and that the more recent problems such as unemployment and that of the *banlieues* could not be attributed to their presence. Diop's statement is notable for its sense of history and the complicated nature of the relationship between France and the immigrants from its former colonies. "We are not here by accident," he wrote, "We are those who have come from former French colonies super-exploited to the profit of the *métropole*."[109]

The year following the events at Saint-Bernard, Diop published his memoir titled *Dans la peau d'un sans-papiers* (1997). In it, he describes his life in Senegal and then in France after he arrived in July 1988. He was nineteen years old.[110] He goes on to describe the various jobs he held in France, his young family, and his loss of legal status that led him to decide to go public as a *sans-papiers*. One of the most remarkable things about his narrative is the way he weaves, in between descriptions of terrible indignities suffered as a result of the church occupations and the response of authorities to them, frequent testimonies regarding his identification with French culture and his determination to be part of it. He wanted to be in France because that was where his family resided, but he had also come to regard the French language as essential to his everyday life. Describing the group with whom he occupied the church at Saint-Ambroise, he explained:

> Not everyone spoke the same language. We were divided into Bambaras, Sarakolés, Toucouleurs, Peuls, and Soninkés, and it was France that already united us. It was in French that we communicated. France was the element that brought us together, and not the fact that we had black skin.[111]

An immediate result of the expulsion of the occupants of Saint-Bernard was the intensification of the movement throughout the Paris region in support of the *sans-papiers*. In fact, ever since that late August of 1996 there have been regular demonstrations and other events in solidarity with the immigrants seeking regularized status. Nya Soleil, a singer and guitarist from Cameroon who has lived in France as

an immigrant since 1981, heads an association called Soleil Pour Tous, which raises money for a variety of African-related causes, often through staging benefit concerts. He first formed the association to help families of those who took part in the occupation of Saint-Bernard, and staged a concert to raise money for their expenses. The concert included the participation of Ray Lema, Geoffrey Oryema, and Lokua Kanza, among others. In December 1996 he organized another concert for survivors of the Rwanda massacres, and he has gone on to provide many other occasions whereby Paris-based African musicians perform to raise money for various relief efforts. All the while, he has had to fight his own battles, particularly since his marriage to his French wife was challenged by authorities who questioned its legitimacy and refused his request for French nationality.[112]

President Chirac, in a political gamble that backfired, called for new elections in January 1997, which eventually led to a victory for the left and the new Socialist government of Prime Minister Lionel Jospin. It was widely assumed that a government of the left would dramatically alter immigration policy and come to the aid of the *mal-logés* and the *sans-papiers*. These expectations were to be disappointed more often than not, but that is a story we will explore in the next chapter.

Notes

1. Hélène Lee, author interview, Clichy, France, June 29, 1997 (my translation).
2. "Que veulent les musulmans de France?" *Le Nouvel Observateur* (March 23–29, 1989).
3. Martin Kramer, "Hizbullah: The Calculus of Jihad," in *Fundamentalisms and the State: Remaking Polities, Economies, and Militance*, ed. Martin Marty and R.S. Appleby (Chicago, 1993): http://www.geocities.com/martinkramerorg/Calculus.htm.
4. Adrian Favell, *Philosophies of Integration: Immigration and the Idea of Citizenship in France and Britain*, 2nd ed. (Basingstoke, 2001): 175.
5. "Chronologie," *Hommes & migrations* 1129–1130 (February–March 1990).
6. Alec G. Hargreaves, *Immigration, "Race" and Ethnicity in Contemporary France* (London, 1995): 125.
7. Françoise Gaspard and Farhad Khosrokhavar, *Le foulard et la République* (Paris, 1995): 14–15.
8. Ibid.: 207, 204.
9. Ibid.: 12.
10. Ibid.: 19.
11. Quoted in Herman Lebovics, *Bringing the Empire Back Home: France in the Global Age* (Durham, NC, 2004): 132.
12. See the explanation by Favell, *Philosophies of Integration*: 184.
13. Élisabeth Badinter, Régis Debray, Alain Finkielkraut, Élisabeth de Fontenay, and Catherine Kintzler, "Profs, ne capitulons pas!" *Le Nouvel observateur* (November 2–8, 1989).
14. Hargreaves, *Immigration, "Race" and Ethnicity in Contemporary France*: 125–126.
15. Joëlle Brunnerie-Kauffmann, Harlem Désir, Renó Dumont, Gilles Perrault, and Alain Touraine, "Pour une laïcité ouverte," *Politis* (November 9–15, 1989).
16. Gaspard and Khosrokhavar, *Le foulard et la République*: 11.
17. Peter Sahlins, *Unnaturally French: Foreign Citizens in the Old Regime and After* (Ithaca, NY, 2004).

18. "Abattage rituel," *Le Figaro* (January 25, 1990).
19. Ibid.: 21
20. "Chronologie."
21. Alain Duhamel, "Le Retour de Jean-Marie Le Pen," *Le Quotidien* (December 1, 1989).
22. "Le Pen: Renvoyer les immigrés arrivés depuis 1974: Une interview du président du Front national," *Le Figaro* (December 6, 1989).
23. S.P., "SOS-Racisme aime Rosie et Rosie aime la France," *Libération* (May 31, 1990): 57.
24. Pierre-André Taguieff, " 'Vous avez trop diabolisé!': Polémique sur l'antiracisme," *Le Nouvel observateur* (March 26 au 1er April 1992): 16–18.
25. Harlem Désir, "La timidité ne paie jamais: Réponse à Pierre-Andre Taguieff," *Le Nouvel observateur* (March 26 au 1er April 1992): 19.
26. Ph. Be., "M.Fodé Sylla remplace M. Harlem Désir à la tête de SOS-Racisme," *Le Monde* (September 8, 1992): 1.
27. Maxim Silverman, *Deconstructing the Nation: Immigration, Racism and Citizenship in Modern France* (London, 1992): 4.
28. Hargreaves, *Immigration, "Race" and Ethnicity in Contemporary France*: 223.
29. Annie Kriegel, "Que pèse le Front national?" *Le Figaro* (November 13, 1991).
30. D.S., "Le FN dans la rue contre les Maliens," *Libération* (October 20, 1992): 27.
31. " 'Des liens étroits avec la communauté d'origine': Entretien avec Diadié Soumaré," *Espace social européen* (November 13, 1992): 26.
32. Renaud Leblond, "Mal-logés: le séparatisme malien," *L'Express* (July 30, 1992): 34.
33. Henri-Stéphane Petit, "Maliens de Vincennes: Toujours l'attente," *Politis* (June 25, 1992): 18.
34. Leblond, "Mal-logés: le séparatisme malien": 33.
35. Pierre Belet, "Entre Bamako et Paris, une population déracinée," *Espace sociale européen* (November 13, 1992): 25.
36. Richard Bellet, "Squat et black micmac," *L'événement du jeudi* (September 10–16, 1992): 23.
37. Ibid.: 24.
38. Ibid.: 25.
39. " 'Des liens étroits avec la communauté d'origine' ": 26.
40. Bellet, "Entre Bamako et Paris, une population déracinée": 27.
41. Blandine Grosjean (avec Louisette Fandard), "Polygamie Made in France: Derrière le fantasme, l'enfer quotidien," *L'Événement du jeudi* (May 10–16, 1990): 62–65.
42. Claude-François Julien, "Demain, le 'black power' en banlieue?" *Le Nouvel observateur* (October 22–28, 1992): 23–24.
43. Petit, "Maliens de Vincennes": 18.
44. Pierre Gallerey, "Les Maliens de Vincennes dispersés en banlieues," *Le Monde* (October 30, 1992): 18.
45. Françoise Lemoine, " 'Cela ne pouvait plus durer': Choses vues et entendues auprès des riverains de l'esplanade," *Le Monde* (October 30, 1992): 19.
46. Jean-Paul Tauvel, "Éditorial," *Migrants-formation* 91 (December 1992): 3.
47. See, e.g., the special issue of *L'Événement du jeudi* titled "Les Défis des Blacks à la France" (September 16–22, 1993), which includes an exposé on polygamy called "Bonjour, je vous présente mes femmes."
48. André Burgière, "La France du melting potes: À propos du Destin des immigrés d'Emmanuel Todd," *Le Nouvel observateur* (December 22–28, 1994): 39–40.
49. Vasoodeven Vuddamalay, Paul White, and Deborah Sporton, "The Evolution of the Goutte d'Or as an Ethnic Minority District of Paris," *New Community* 17:2 (January 1991): 256.
50. Farid Aîchoune, "À La Goutte d'Or, marché le jour, trafics à toute heure," *Libération* (June 28, 1993): 64–65.

51. Sylvain Estibal, "L'Économie noire à Paris," *Perspectives africaines* (July–August 1991): 43–46.
52. Marc Ambroise-Rendu, "La Goutte d'Or retrouve la fierté," *Le Monde* (July 25 and 26, 1993): 32.
53. Michèle Tribalat, ed., *Enquête mobilité géographique et insertion social, rapport,* Institut National d'Études Démographiques (Paris, 1995): 501, 511.
54. Robert Burnett, *The Global Jukebox: The International Music Industry* (London, 1996): 50.
55. Ibid.: 60.
56. Ibid.: 54.
57. Ibid.: 59–60.
58. Bouziane Daoudi, "Si Mamadou m'était Konté," *Libération* (November 23, 1990): 75.
59. François Bensignor, author interview, Paris, July 1, 1997. Unless otherwise noted, all information on Bensignor is derived from this interview.
60. Gilles Fruchaux, author interview, Paris, June 1, 1998.
61. "Pas de visa pour les artistes de la world music," *Libération* (March 14, 1994): 45.
62. Frank Tenaille, "Artistes du sud: tournées casse-tête," *Visa permanent* 7 (April–May 1994): 7.
63. Ray Lema, author interview, Villiers-sur-Marne, June 23, 1995.
64. Lokua Kanza, author interview, Paris, June 26, 1995.
65. B.D., "Le Sacre de Lokua Kanza," *Le Figaro* (October 23, 1995): 41.
66. Hélène Lee, "Lokua Kanza, le cas français," *Libération* (October 5, 1992): 34.
67. Ibid.: 41.
68. Hélène Lee, author interview.
69. Lokua Kanza, author interview.
70. Gary Stewart, *Rumba on the River: A History of the Popular Music of the Two Congos* (London, 2000): 68–69.
71. Awilo Longomba, author interview, Paris, July 2, 1996. See also Jim Winders, "Awilo Longomba," *Rhythm Music* VI:1/2 (January/February, 1997): 33–34.
72. So Kalmery, author interview, Paris, July 13, 1997. Unless otherwise indicated, all information on So Kalmery is derived from this interview.
73. Nago Seck and Sylvie Clerfeuille, *Les Musiciens du beat africain* (Paris, 1993): 131.
74. Ibid.
75. Steve Kozumba, author interview, Paris, July 13, 1997. All information on Steve Kozumba is derived from this interview.
76. Fara C., "Bourgeons multicolores; Parfums musicaux du monde entier," *L'Humanité* (April 11, 1990): 94.
77. Thomas Sotinel, "Mory Kanté le conquérant," *Le Monde* (September 26, 1990): 40.
78. Véronique Mortaigne, "Salif Keïta, prince lunaire: Le chanteur malien louvoie entre tradition et modernisme californien," *Le Monde* (November 7, 1992): 80.
79. Véronique Mortaigne, "Ali Farka Touré et Salif Keïta défendent la culture malienne," *Le Monde* (July 8, 1995): 44.
80. "Papa Wemba, roi des sapeurs zaïrois et précurseur du rock africain," *Le Monde* (July 28, 1995): 42.
81. Bouziane Daoudi, "Makossa Dibango: Porte-Parole," *Libération* (March 16 and 17, 1991): 66.
82. Cathy Capvert, "Un homme se noie par peur d'un contrôle d'identité," *L'Humanité* (August 17, 1993): 77.
83. Jane Freedman, *Immigration and Insecurity in France* (Aldershot, 2004): 43, 46.
84. Catherine Wihtol de Wenden, "France: les mirages de l'immigration zéro," in *L'Europe et toutes ses migrations,* ed. Wihtol de Wenden and Anne de Tinguy (Bruxelles, 1995): 60.
85. Mylène Stambouli, "Comment la loi fabrique des clandestins," *Sociétés africaines et diaspora* 4 (December 1996): 117.

86. Bertrand Bissuel, "Divorcer ou vivre sans papiers: le dilemme des femmes de polygames," *Le Monde* (February 10–11 2002).
87. D.M., "Le retour en force d'un dossier brûlant," *Le Parisien* (December 17, 1996): 3.
88. Marie-Amélie Lombard, "Ce qui va changer pour les immigrés," *Le Figaro* (April 27, 1993): 1.
89. Hargreaves, *Immigration, "Race" and Ethnicity in Contemporary France*: 191.
90. Freedman, *Immigration and Insecurity*: 42.
91. Ph. Be., "Mme. Mitterrand dénonce les effets pervers des lois Pasqua," *Le Monde* (March 12, 1994): 5.
92. Bruno Peuchamiel, "Contre la vague des expulsions une ville se met en état d'alerte," *l'Humanité* (July 11, 1994).
93. Michel Guilloux, "Arrêt sur un bus," *l'Humanité* (January 31, 1998): http://www.humanite.presse.fr.
94. Ibid.: 45–46.
95. Alain Hertoghe, "Les Maliens de Vincennes oubliés en région parisienne," *La Croix* (January 19, 1995): 31.
96. Laurence David, "Les Maliens craignent d'être expulsés de leur foyer," *La Croix* (June 23, 1994): 22.
97. François Wenz-Dumas, "Le foyer malien de Montreuil s'oppose au déménagement voulu par la préfecture," *Libération* (January 28 and 29, 1995): 22.
98. Alain Auffray, "La Place des vivants c'est pas le cimetière: La mairie de Courbevoie propose de déplacer le foyer africain au milieu des tombes," *Libération* (August 22, 1996): 50.
99. Ch. G., "Rue de la Lune, à Paris, un immeuble pour les sans-logis," *Le Monde* (September 17–18, 1995).
100. Freedman, *Immigration and Insecurity*: 72.
101. Ababacar Diop, "Réalités et perspectives de la lutte des sans-papiers," *Sociétés africaines et diaspora* 4 (December 1996): 95.
102. Freedman, *Immigration and Insecurity*: 72.
103. Jacqueline Costa-Lascoux, "Les sans-papiers de Saint-Bernard," *Revue française des affaires sociales* 51: 2 (April–June 1997): 101–115.
104. Xénia Caraïbe, author interview, Paris, July 1, 1996. Unless otherwise indicated, all information on Xénia Caraïbe is based on this interview.
105. Tiacoh Sadia, author interview, Paris, July 1, 1996. Unless otherwise indicated, all information on Tiacoh Sadia is based on this interview.
106. David Dufresne, "Sans-papiers: Juppé donne le feu vert pour les expulsions," *Libération* (August 23, 1996): 26.
107. Freedman, *Immigration and Insecurity*: 72–73.
108. Diop, "Réalités et perspectives": 95.
109. Ibid.: 102–103.
110. Ababacar Diop, *Dans la peau d'un sans-papiers* (Paris, 1997): 37 (my translation).
111. Ibid.: 89 (my translation).
112. Nya Soleil, author interview, Paris, May 12, 1998. Unless otherwise indicated, all information on Nya Soleil is derived from this interview.

Chapter 5

High Expectations, Dashed Hopes: The Left and African Immigration, 1997–2002

The years 1997–2002 brought new political developments and continued to be a time of diminished opportunities for African musicians trying to establish themselves in Paris. At the same time, the influence of African music continued to be felt, along with cuisine and fashion. Paris was truly an international city, and African cultures remained recognizable elements in the mix. Established music stars such as Manu Dibango, Ray Lema, or Papa Wemba still commanded attention, and their recordings sold well. Music festivals continued to feature African performers, and the annual Fête de la Musique in Paris gave prominent positions to African musicians. But Paris certainly was no longer *the* center of African music. It was one of several, including London, New York, and Los Angeles.

Immigration certainly continued to be a much-debated topic. The movement of the *sans-papiers* continued into 1997, and the government continued its efforts to tighten immigration controls and expel those it considered illegal. A number of the occupants of Saint-Bernard who had been rounded up in August 1996 were among those deported to Mali, and their arrival in Bamako was met with criticism throughout West Africa. The aggressive French policy toward the *sans-papiers* created strained relations with its former African colonies.[1] In Mali there was lingering resentment of the forceful removal from Saint-Bernard, viewed as a bitter and shocking humiliation.[2] In Paris political demonstrations in solidarity with the *sans-papiers* of Saint-Bernard had continued through the autumn of 1996, as when some fifteen hundred persons held a candlelight vigil on October 25 in the Place de la République in memory of Amara Fofana, a cancer patient and one of the church's occupants whose hunger strike had hastened his death. Some held signs that read, "Juppé surrender your papers to us."[3] Such public manifestations calling for regularization of the *sans-papiers* and an end to police actions against them would become a mainstay of French political life for the remainder of the century and on into the following one.

The new year brought fresh indications of the sharp divisions within French society over the question of undocumented African immigrants, as the government continued to enforce policies demanded by the right. On January 2, 1997, a group calling itself Jeunes contre le racisme en Europe organized with the *sans-papiers* collective a demonstration to block the embarkation counter for Air Afrique flight RK 141, one scheduled to deport persons to Bamako.[4] Through its interior minister Jean-Louis Debré, the Juppé government proposed new laws that were adopted in April 1997, shortly before the legislative elections that brought the Socialist government of Lionel Jospin to power. Among the measures included in the bill first introduced in December 1996 were those that increased police powers already significantly bolstered by the Pasqua laws. New powers would include fingerprinting persons who applied for residency permits and confiscating passports of foreigners deemed "irregular."[5]

The most notorious of the proposed Debré laws was one that required any French citizens who received non-European foreigners[6] into their homes to notify local authorities in order to obtain a *certificat d'hébergement*.[7] To some in France, this smacked of the Vichy regime, something suggested in an article Tzvetan Todorov published in *Le Monde*. He ended his piece with the lines "Xenophobic laws do not protect France. They attack her."[8] In the month that Todorov's article appeared (February), large demonstrations and petitions against the law created enough pressure to have the provision withdrawn, even though polls showed overwhelming support for it.[9] Then on April 22 the Constitutional Council struck down two of the Debré law's twenty provisions: one that called for nonrenewal of a ten-year residency permit in the case of a "menace to public order," and another that permitted the Interior Ministry and the national Gendarmerie to have access to confidential fingerprint files of persons seeking asylum in France. Most of the law's provisions, such as police retention of passports belonging to persons deemed irregular, were validated.[10]

Combined with the Pasqua laws, the Debré laws would have the effect, as one writer pointed out, of making it more difficult than ever to "become French."[11] Throughout the winter and early spring of 1997 many articles and editorials appeared in the French press about the proposed laws, and the Socialist Party pledged to repeal the Pasqua/Debré laws if it prevailed in the elections. Leading intellectuals continued to weigh in, as had Pierre Bourdieu with an article deriding the "phantasm" entertained by many French people about immigration, namely that immigrants returned to their countries of origin only to be replaced by new "waves."[12]

The publicity surrounding the *sans-papiers* encouraged those inclined toward xenophobic opinion to view all African immigrants as suspect, and to believe mistakenly that they had all arrived in France only very recently. Moreover, as demographer Michèle Tribalat pointed out in an interview, the government often was careless in reporting immigration figures, exaggerating its level. The problem, she explained, was that those counted as immigrants included both foreigners living in France and those born abroad who had acquired French nationality since arriving. Too many in France tended to forget about the latter category. In the same interview, she dismissed the argument often used by government officials that it was necessary to halt further immigration in order to achieve the successful integration of those already in France. No necessary conflict existed between continued immigration and the integration of

previous arrivals, she argued, and insisted that the path to integration was impeded by excessive enforcement of laws hostile to immigration.[13]

The habit of overestimating the number of immigrants in France was an old one, and it had become more pronounced as African immigration had increased. Former president Giscard d'Estaing, writing in *Le Figaro Magazine* in 1991, had used the word "invasion" in reference to immigration. Such language used by politicians and appearing frequently in the media has had a decisive impact on public opinion. A comprehensive study of French attitudes about immigration showed that more than two-thirds of French people polled believe many more immigrants reside in France than actually do.[14] And, as *Le Monde* announced in February 1997, the percentage of immigrants in the total French population had not risen in twenty years.[15]

President Chirac had called for early elections in 1997 hoping to strengthen his party, but the Socialist Party showed surprising strength, and many in France were hopeful that they would be able to form a government. Many who were sympathetic to the plight of immigrants, including musicians and other artists, voiced their opposition to the right-wing government's newly proposed laws. In early April 1997 a newly formed collective called "Pour des artistes sans frontières" organized a series of concerts in the grand hall of La Villette. The collective, which included Jocelyne Béroard of Kassav', Ray Lema, Mory Kanté, Lokua Kanza, and Papa Wemba, signed a statement against the Debré laws and against the rise in xenophobia.[16] The belief that a new government of the left would be more favorable to the *sans-papiers* and to African immigration in general was widely held. Meanwhile, early April also brought the discouraging news that Salif Keïta, one of the biggest African stars who had been residing in Paris, had become fed up with constant battles with French officials over visas for his band members, and had announced that he was going back to Bamako.

Keïta had himself endured unpleasant encounters with local officials in Montreuil when he applied for residency in France (see chapter three), and by 1997 had become one of several successful musicians for whom Paris was no longer appealing as a base for a career. The fact that the composer of "Nou pas bouger," someone who had been named a Chevalier des Arts et des Lettres, could give up on Paris showed how much the climate there had changed. Even though he possessed a ten-year residency permit, as a Malian he felt increasingly unwelcome (and discouraged by the terms of the new laws) and decided to move his family back to Bamako. In addition, some twenty fellow musicians from Mali had been denied visas during the previous two years. Keïta's decision was especially bitter because he was someone who identified strongly with French culture even as he proudly proclaimed his African identity. He liked to perform songs from the French *chanson* tradition, such as tunes made popular by Jacques Brel and Serge Gainsbourg. This enthusiasm somewhat dismayed his fans back in Bamako.[17]

In the *Nouvel observateur* article that announced Salif Keïta's departure, Philippe Conrath was quoted several times, and he observed bitterly that the hostile laws then in place meant that no Mory Kanté would be able to move to France. Conrath also complained that, as a festival director (Africolor), he was increasingly under pressure to play the role of a "cop" when it came to vouching for the legitimacy of musicians' visas and promising that they would not exceed the duration of their allotted time in France. Often, the obstacles musicians trying to work in France faced were absurdly

contradictory, as in the case described in the same article of a *balafon* player named Lansine. He had been in France for eight years, using a one-year *carte de séjour* that he had renewed each year. It bore the phrase "forbidden to work," but each time he presented himself at the prefecture, he was asked to supply his pay stubs. The indignities suffered by struggling musicians weighed on the minds of those who had been more successful. Angélique Kidjo said that during the ten years she had lived in France it had become her second home. "But," she added, "since the Pasqua laws they have made me feel that I am black," and she spoke of fellow musicians who, as she would do eventually, were now setting their sights on London and New York.[18]

For musicians and others sympathetic to immigrants, opposition to racism and xenophobia seemed to dictate support for the Socialists, and on the other side, the Juppé government and its interior minister appeared to be doing the bidding of Le Pen's movement. Juppé himself taunted Jospin, asking what he intended to put in place of the Pasqua and Debré laws his party pledged to repeal.[19] The author of the article that quoted Juppé suggested that by running on the Debré law the government in power ran the risk of putting the FN "back in the saddle." The emotions that had been evident during the large demonstrations of February continued to run high during the campaign, and helped contribute to the defeat of the right in the legislative elections of May and June.[20]

Music and High Expectations: A Journey with Kassav'

By early June the new government of the left was in place. June also opened with the twenty-second annual festival Musiques métisses d'Angoulême, which had done much over the years to promote African and other "world" musicians. An evening was devoted to Cuban music for which there was a growing vogue in France (indeed throughout Europe), but another was given over to the music of Mali. It featured Ali Farka Touré, Salif Keïta, and Rokia Traoré, a young singer who was becoming popular in France. Given his recent announcement, Salif Keïta's performance was filled with emotion. Also, there was evidence at several points during the festival of support for the Malian *sans-papiers*.[21]

I arrived in Paris later in the month, and found musicians and others with whom I spoke to be at least guardedly optimistic about the immigration policy Jospin et al. would pursue. Music journalist François Bensignor expressed relief at the change of governments. He said that once the Pasqua laws had been enacted, "those in the government who dealt with foreigners suddenly became fifty to seventy-five percent more racist."[22] But whatever government France had, Bensignor judged the situation for African musicians in Paris to be less favorable than it had been in the previous decade. He said,

> Today we speak less about African musicians. They are less popular, less popularized, less broadcast [contrasted with] the tremendous explosion of creativity in the first half of the 1980s.

Contrasting the two eras further, Bensignor said that "the great irony was that Mory Kanté represented France in the *Bicentennaire* of 1989." Of course, the sea change in the music business had much to do with the diminished opportunities for African musicians. In the era of the multinationals, London now played the dominant role. Paris-based labels, he explained, had no authority to launch the career of an African musician in France. "None of the [Paris record companies] have the power to make an international product," he said. Despite all of this, Bensignor nevertheless viewed the presence of African music in Paris as remaining "strong."

This was true as well of Antillean music, and Kassav' remained the leading light of this part of the Parisian cultural mix. In late June 1997 I met with lead singer Jocelyne Béroard and guitarist Jacob Désvarieux at Studio Zorrino, their recording base in the northern Paris suburb of Saint-Ouen. For years they had worked here with Didier Lozahic, the recording engineer responsible for much of their sound (although Lozahic told me that Jacob's musical ideas deserved much of the credit).[23] The band was as popular as ever, with enviable record sales, but they had cut back on their touring schedule, involved as they were with solo projects. The day I visited the studio to talk with Béroard and Désvarieux, they both were at work on solo albums. We spoke some about politics, but while they were pleased with the recent elections, the focus, especially with Béroard, was on the politics of the wider Francophone world. She spoke of the fact that 1998 would mark the 150th anniversary of the abolition of slavery in French colonies. A number of concerts would be held in commemoration.[24] I spoke with the two of them together and found that they differed on the subject of politics. Désvarieux spoke approvingly of the recent elections, but quickly dismissed the idea that musicians had any kind of role to play as "opinion leaders." Béroard, however, as her participation in the collective mentioned earlier would suggest, disagreed, saying that musicians had "a message" to contribute to politics through their cultural participation. Thinking about what she had said, he modified his views somewhat, agreeing that black musicians, like athletes, might help to combat racism through their appeal to fans.[25]

After the interviews were concluded, Jocelyne Béroard opened up her laptop computer and began searching through an extensive address list she kept there, suggesting other people I should meet. She also very kindly asked me if I would like to accompany the band on their bus trip to a concert they were giving on June 28 in the town of Méry-sur-Seine, 138 kilometers east of Paris. I accepted the invitation eagerly, and two days later her fax arrived at my hotel. She instructed me to meet them the next day at the well known café Canon de la Nation at the end of the rue du Faubourg Saint-Antoine on the Place de la Nation. I arrived at 4:30 p.m. and waited around for some time until everyone was ready to leave. The long delay was due to the bass player's failure to appear. The musicians decided to set out and pick up their substitute bass player at the Place d'Italie, near his apartment. Patrick St.Éloi, one of the three main vocalists of the group, eyed me warily as he stood by the bus and asked, "Are you coming with *us, monsieur*?" I explained how I happened to be there and then we boarded the bus.

This particular Saturday happened to be the day of Paris's annual Gay Pride parade, and traffic was snarled frightfully everywhere the bus driver took us. By the time the bass player was collected and the trip got underway, it was clear the band

would arrive far behind schedule. Cell phones, something new to me at the time, were going off one after another, often simultaneously, each one with a different ring. This frequently occasioned small arguments about whose phone was the one actually ringing. This cacophony had been present ever since the efforts to achieve the rendezvous with the fill-in bass player.

On the bus, I sat with a bemused-looking Claude Vamur, the band's drummer on concert tours (drum machines typically being used in the recording studio). His beard and eyeglasses gave him a professorial look. Originally from Guadeloupe, he said he had lived in France since 1965 and had been the band's drummer since 1983. With the band's reduced touring schedule, he had not been playing with them as frequently of late. He began his musical career in the mid-1970s, after briefly studying at a conservatory. Then he informed me that, prior to joining Kassav', he had played for a time (before 1981) with Manu Dibango. He said this with obvious pride, adding that, "with Manu, black music began to occupy a place in France."[26] A market for black music, especially American music, had "always existed," Vamur said, and it was always "well received." Manu Dibango, however, was "really the precursor figure for Afro-Antillean music in France." I had become accustomed to hearing people speak of Manu in reverential tones.

Why, I asked Claude Vamur, had Paris become such an important center for this music? He had several answers. For one, Paris was the center of Francophone culture, a common draw for the musicians who found there way to the city. The increased mobility of African musicians was important to mention. Paris, Vamur said, was "a point of departure for the music," and "a place for musicians and their music to develop and evolve." As many others have observed, the difficulty of managing a musical career in Africa, with its "vastness," its lack of "formation" and "structure" for the music business, drove musicians to Paris, where the recordings were of "superior quality." When I asked him what impact he thought the music of the recent immigrants had made on France, he responded by saying, "I think, in general, that African, Antillean, and black music has transformed European culture." But what about racism and anti-immigrant attitudes, I wanted to know? Without hesitation, he replied, "In spite of racism, people are open to the music." Whether or not it was possible for someone to be racist and yet fond of the music remained unclear to me. The assumption of nearly every musician I have met has been that acceptance of the music means overcoming racism. Vamur acknowledged that racial discrimination existed in France, but insisted that he, personally, had not been subjected to it.

Echoing what others have told me about the significance of the Paris-based African music of the 1980s, Vamur said that a "good part" of the population had developed a taste for this music, "not just immigrants." In other words, one of the most significant changes of the 1980s was that music began to circulate beyond the separate immigrant communities from which the musicians had emerged and to reach a more general audience. That was about to be demonstrated for me at the concert toward which the bus was taking us. My conversation with Claude Vamur took place amid general chaos, as my recording demonstrates: people talking and laughing, horns honking, and sirens wailing. Our talk turned to musical genres and his drumming technique. He admitted to a fondness for "American pop," traditional Antillean music, *zouk*, and "classical music from time to time." He said that the

drummers he most admired were Art Blakey and Max Roach. The "challenge" of *zouk* drumming, Vamur explained, was to maintain the beat's "regularity" while delivering "a lot of syncopation." It was a question of keeping the beat steady while being "expressive." As the conversation drew to a close, I asked him a question similar to the one I had asked other Kassav' members about the political role a musician might play. Claude Vamur considered the question and said, "A musician plays an important social role, but not a political one." He went on to say that the musician's role was "to create different states in the lives of people," something one might say about any kind of artist.

Two full hours late, the bus rolled into the campground where the concert was being held. The local concert promoters and hosts showed no signs of being disconcerted by the delay, and directed the musicians to their dressing rooms, makeshift arrangements in what clearly were camp quarters. It being summer in Northern Europe, it was still light at almost 10:00 p.m., and the band took to the stage as the sky began to darken. Claude Vamur's drum kit was set up on risers in the middle of the back of the stage. The musicians, three vocalists, bassist, guitarist, keyboard player, horn section and backing vocalists/dancers took their places. I stood to the right of the stage where I could see both the band and the eager audience who pressed toward the large stage.

The sound of the band in concert was powerful with heavy electronic effects. The stage was a scene of frenzied motion, and the audience was responsive from the very first notes. Claude Vamur used every weapon in his percussive arsenal, and Jacob Désvarieux coaxed a torrent of piercing notes from his electric guitar. The way the band fed on the energy of the crowd (and vice-versa) taught me that *zouk*, for all its recording studio complexity, is best experienced in live performance, where drummers and dancers can interact and communicate through the powerful and intricate languages of rhythm. Kassav' charged through its string of hit records for the delighted throng, and Jocelyne Béroard marveled that the rural French audience knew all the (Creole) lyrics to their songs. I had the same surprised reaction, especially as I surveyed the sea of smiling faces facing me. They were a diverse crowd in terms of age, but their ethnicity appeared to be almost solidly what traditionalists think of as "French." It was like looking at the faces in Robert Doisneau photographs. Pressed tightly together in front of the stage, the people swayed in time with the music. Waving his arms, vocalist Jean-Philippe Marthély exhorted the crowd to continue to sing along with the group—*que tout le monde participe!*

The question that came to me, and that continues to haunt my memory of that evening was this: which is the true picture of France? Whether the left or the right held power, the French media would continue to report strong anti-immigrant opinion and to represent immigration as a problem and ethnic diversity as a challenge to traditional France. But there in front of my eyes was what seemed a tableau of *la France profonde*, and they could not get enough of the *zouk* music of Kassav', a manifestation of the new France. Focusing on issues of language, as in the radio broadcast laws or the issue of Creole versus "correct" French, can create the impression that the French seek to rid themselves of all foreign influences. Yet, simultaneously, there has existed an equally French tendency to welcome them. The happy throng of fans in the field in Eastern France provided an example of the latter. Perhaps it is as Claude

Vamur said: that the appeal of the music could exist in spite of opposition to immigration, or even racist attitudes. What remains unclear is whether the divisions are absolute. That is to say, could it be possible that someone in France could enjoy the music while nevertheless supporting the politics of xenophobia?

The *Sans-Papiers* Fight for Regularization

In any case, late June 1997 seemed a time of hopeful expectations, including anticipation that the Jospin government would undertake a bold policy of repealing the Pasqua/Debré laws and regularizing as many as possible of the *sans-papiers*. Many officials favored a more cautious approach, one that would have the prefects handle demands for regularization on a case-by-case basis. The argument for this policy, as opposed to granting blanket regularization, had been made well before the 1997 elections. Fodé Sylla, the Senegalese militant activist who had replaced Harlem Désir as president of SOS-Racisme in 1992,[27] was asked in an interview published in 1996 whether it would be preferable to pursue the case-by-case policy rather than to push for the repeal of the Pasqua/Debré laws. He replied in no uncertain terms that his organization would insist on their repeal, and plan their political actions accordingly.[28]

After the *sans-papiers* led by Ababacar Diop had occupied the church at Saint-Ambroise (see chapter four), a group of French intellectuals and other public figures had constituted themselves as the "Collège des Médiateurs," and began to promote dialogue between the *sans-papiers* and the government. Soon after the Socialist government of Jospin came to power, this same group sought to play a similar role. Stéphane Hessel, chief spokesman of the group and former French ambassador to the United Nations, was interviewed about his hopes for the new government's prospects for a solution to the crisis. He pronounced himself generally pleased with Jospin's stated policies, but also argued that ruling on demands for regularization case by case was the only realistic policy. It was important, he argued, to distinguish between *sans-papiers*, who typically had once been documented workers but had lost that status through punitive legislation, and the true "clandestines," those who had entered France illegally and had never sought to become residents. Although he supported proceeding with regularization case by case, Hessel urged that the process by accelerated as much as possible. He estimated it would be possible to achieve around twenty thousand regularizations. Asked if this would encourage a new wave of immigration, he called that a *lépeniste* argument, and said that immigration was on the decline in France.[29]

The Malian *sans-papiers* continued as a major story in the French press, but sub-Saharan Africans, especially where music was concerned, typically received less coverage than they once had. When I interviewed longtime *Libération* journalist Hélène Lee at the end of June (see chapter two), she expressed the opinion that attention was shifting to new music of the *Beurs*, the youth of North African origin who lived in the *banlieues* and in such neighborhoods as Barbès in the Eighteenth Arrondissement. She said as well that older *raï* stars such as Khaled were commanding a lot of attention. He had just performed in Paris for the Fête de la Musique. She mentioned especially

the exciting new band Orchestre National de Barbès, with its hybrid jazz rock sound based in Algerian *raï* and flavored with reggae.[30] Articles in the press, as well as prominent displays in Paris record stores, bore out what she had told me. One article called attention to the way the twelve members of the band had been born on both sides of the Mediterranean, bringing together a host of regional influences into a rich "musical palette."[31] The following year the group would be the subject of a television program on France 3.[32] Gnawa Diffusion, an equally adventurous Algerian band Lee had mentioned, based in Grenoble, also received favorable publicity in the press.[33]

If in the 1980s the topic of immigration typically referred to Africans, increasing attention was now focused on a wider range of immigrant groups entering France, including those from Indian Ocean territories and South Asia. A scholar writing for a journal devoted to the topic of migration analyzed in some detail the various derogatory slang expressions improvised by young people in the Paris *banlieues*, suggesting that the cultural mix found there was somewhat uneasy.[34] When the French press did turn its attention to African immigrants, it was often to return to old arguments, such as the topic of mixed marriages, suspected by many as marriages of convenience meant to gain French nationality for immigrants. *Libération* reported in July 1997 that by the beginning of the 1990s, approximately one-third of all adult foreigners who had become French had done so through marriage. They also reported that the divorce rate for such marriages was only slightly higher than the divorce rate for the general French population. The author of the article concluded that available statistics gave the lie to the belief that mixed marriages were *mariages blancs*, or marriages of mere convenience.[35]

While expectations remained high that the new government would introduce reforms, the leaders of the *sans-papiers* movement began to grow increasingly impatient. They also experienced discord among themselves, eventually leading to the replacement of Ababacar Diop as *porte-parole* of the former occupants of Saint-Bernard by a fellow Senegalese, Madjiguène Cissé. The two had very different ideas about the direction of the movement, and had disagreed consistently. Apart from his interest in the cause of the *sans-papiers*, Diop was less politically driven than Cissé, and was interested primarily in access to the media and using information technology effectively. A student of German philosophy, Cissé was much more a person of the radical left. Distrustful of the Collège des Médiateurs, she was far more interested in organizing demonstrations and acts of civil disobedience. They agreed on their ultimate goal, namely the regularization of all *sans-papiers* and the return of those who had been expelled from France. But they differed significantly on tactics. As the August 23 anniversary of the expulsion of the *sans-papiers* from Saint-Bernard approached, the divisions within the movement weakened it, especially as it became clear that Jean-Pierre Chevènement, the new interior minister, would resist their demands.[36]

Jospin had asked Patrick Weil, a prominent academic specialist on immigration, to prepare a report for the government that would serve as the basis for the changes they would introduce in this area. Weil delivered his report at a press conference on July 31, 1997,[37] and it resulted eventually in laws enacted in December 1997 and April 1998 (see later). The cautious report, seeking both to retain "the capacity to control immigration and to demonstrate a welcoming attitude," was quite well-received by Jospin and the other ministers. There was unanimous agreement on

returning to the principle that existed before the Pasqua laws whereby children born automatically acquired citizenship at age eighteen. But the most controversial response to the report came on August 21, when Lionel Jospin announced to the assembled government ministers at Matignon that he had decided against seeking the repeal of the Pasqua/Debré laws.[38] This was a stunning reversal of the promise made during the legislative campaign, where the repeal of these laws had been a cornerstone of the Socialist platform.

To those demanding regularization of the *sans-papiers*, it now appeared that the new government would in some ways be as resistant to them as the preceding one had been. Petitions, often bearing the signatures of prominent cultural figures, regularly circulated in support of the *sans-papiers*. The principal complaint of the petitioners was the slow pace of regularization. *Libération* reported a rate of only 3 percent of demands being granted as of September 30 (five thousand out of one hundred and twenty thousand). The same article also described Interior Minister Chevènement's scornful reaction to the more than twenty-five hundred signatories of a petition submitted on October 3. He called them "irresponsible."[39] Regularization was not the only issue under discussion. Frequently articles appeared in the press on the persistent problem of housing, for a great many of the *sans-papiers* still in France remained without lodging, as requests continued to exceed availability. This crisis had lasted throughout the decade, and remained symbolic of the slow pace of bureaucratic response. A political cartoon by Willem, published in June 1997, had cleverly commented on the new government's inheritance of an old problem. The cartoon depicted three large jets on an airport tarmac, atop and around which were positioned African figures engaged in a variety of activities, including an impromptu soccer match. The jet in front was marked "Charter Debré," a reference to the previous interior minister's policy of deportation. In the foreground was one politician saying to another, "This is where we are lodging the old sans-papiers."[40]

From time to time in the press, prominent intellectuals weighed in on the topic of immigration and the *sans-papiers*. In early October eleven such persons, including Alain Finkielkraut and Pierre-André Taguieff, published an appeal in *Libération* for an "end to passions" on these subjects. Condemning the "demagoguery" that surrounded the debate, they sought to position themselves between the two poles as they saw them: the extreme anti-immigration forces of the National Front, and those demanding the immediate regularization of all *sans-papiers*. Of the latter position they wrote, "It would be dishonest and disastrous to let the populations tempted by emigration in France understand that at the present time they could be welcomed and integrated without limits."[41]

The Jospin government also staked out a middle position, and by late 1997 it was ready to implement legislation it had been considering since receiving the Weil report in July. In December the Guigou law, named for Justice Minister Élisabeth, amended the Pasqua and Debré laws. The most important step taken was to restore the acquisition of citizenship at age eighteen for children born in France to foreign parents. It was not to be an absolute right, however. They had to prove residence in France for at least five years beyond the age of eleven. It would also be possible for naturalization to be granted by age thirteen if parents consented and could demonstrate that the child had resided in France for a minimum period of five years since the age of eight.

The Guigou law also established an identity card to be given to any child born to foreign parents in France. The purpose of this measure was to guard against the creation of stateless children, one of the results of the Pasqua/Debré laws.[42]

If, from the point of view of pro-immigrant militants on the left, the government was doing too little to address the plight of the *sans-papiers*, opinion on the right condemned Jospin for going too far to appease the government of Mali. Jospin visited the country in December and made a speech filled with comments about the need for "humane" treatment of immigrants and avoidance of charter flights for deportations. Leading politicians from right-wing parties called Jospin's remarks "shocking" and pronounced themselves scandalized by what they took to be his throwing open the door for further immigration.[43] Other events in late 1997 and on into 1998 would keep immigration issues at the center of French debate and fuel further division of opinion. In October 1997 the long-awaited trial of Maurice Papon, the Vichy official accused of crimes against humanity, began. The trial, which outraged those on the right who did not feel an eighty-seven-year-old man should have to endure it, had been sought for more than a decade. The publicity around it served to remind people of the connection between Vichy anti-Semitism and anti-immigrant politics. In Papon's case, this had to do with his having been prefect of police in Paris at the time of the massacre by police of some three hundred Algerian demonstrators on October 17, 1961. Long buried by silence and denial, this episode had come to light in 1991, and the 1997–1998 trial occasioned renewed discussion of it.

The political climate concerning immigration seemed to become ever more polarized. Even though little remained of the Mitterrand era's emphasis on plurality of cultures and the right to difference, President Chirac forcefully asserted in January 1998 that "France will never be a mosaic."[44] From the left came continued criticism for Interior Minister Chevènement for his use of some of the harsher provisions still in effect under the Pasqua/Debré laws. One that came in for special condemnation was the "double penalty," whereby someone judged guilty of violating immigration laws was subject first to imprisonment and then to expulsion from the country. This practice had been endorsed by the Weil report, and was softened only for those persons with family ties in France, who were protected under the European Convention of the Rights of Man.[45]

Chevènement's approach to regularization also provoked criticism. By early April he was following a more-or-less 50 percent solution that left all parties dissatisfied.[46] The practice of approving roughly every other request could have especially absurd consequences when applied to members of families. For example, twin brothers from Mauritania were separated when the request of one was granted while the other was denied.[47] Generally speaking, however, within the population of *sans-papiers*, applications for regularization were more likely to be successful when they came from families rather than from single men. Only 16 percent of bachelors who applied in January 1998 for *cartes de séjour* received them.[48] Protests continued throughout late winter and early spring as what would become the Chevènement law was being presented and debated in the National Assembly. Such humanitarian associations as SOS-Racisme and "Gisti" (Groupement d'information et de soutien des travailleurs immigrés) viewed it as a hardening of the government's position against immigrants.[49] At the same time, these groups expressed solidarity with the some sixty *sans-papiers*

who had occupied the cathedral of Évry (about twenty-five kilometers south of Paris).[50] Chevènement was inclined to deal swiftly with such occupations, as he did with a group of protestors who briefly occupied the church of Saint-Jean de Montmartre in March. Groups sympathetic to the occupiers chanted the slogan "Debré, Chevènement, même loi, même combat!"[51]

Accusations proliferated on all sides, producing some memorable and sometimes surprising exchanges. Like his predecessor Debré, Chevènement made use of charter flights to deport some *sans-papiers*. Reacting to groups who went to Roissy-Charles de Gaulle to protest this, and to members of the Green Party who announced their intention to sponsor some five hundred *sans-papiers*, Chevènement scornfully denounced "the little groups of the extreme left," which in turn earned him a fresh round of denunciations.[52] Alain Finkielkraut, the philosopher who usually could be counted on to criticize what he took to be the dangerous implications of certain forms of political protest, granted an interview to *Libération* in which he complained that critics of Chevènement were equating him with Le Pen himself. It was wrong, he argued, to call the government fiercely repressive, and he accused those on the left of using vitriolic language that unfortunately resembled the rhetoric of the extreme right.[53] On the very same day that Finkielkraut's interview was published, *Le Figaro* reported that Jean-Pierre Chevènement had accused Roman Catholic authorities in France of aiding the cause of the extreme right by allowing the political occupations of their churches.[54]

A new challenge to the government began to emerge from Air France. On the same page of *Le Figaro* that contained the report about Chevènement's criticism of church officials, a small inset appeared with the information that Air France did not want to "systematically" accept *sans-papiers* being deported to Bamako. Later in the month, Air France and Air Afrique pilots pressured the airlines to announce their refusal to accept passengers being expelled toward Mali. This was an embarrassment for Matignon and a direct slap at Chevènement. François Hollande, first secretary of the Socialist Party, expressed "regret" over this decision, saying it would make it much more difficult to combat illegal immigration.[55] He needn't have worried for long, however, for almost immediately thereafter a new agreement between Air France and Chevènement led to the resumption of deportation flights to Bamako.[56]

By this time the bill that would be known as the Chevènement law had been passed by the National Assembly and would become law on May 11, 1998. It had passed over objections both from the left and the right. The left, for example, continued to press for complete repeal of the Pasqua and Debré laws. While retaining much of that earlier legislation, the new law softened some aspects by eliminating many conditions imposed on potential immigrants, especially those concerning family reunification. The law also established that one-year residence permits could be issued to certain types of foreigners, such as those who had entered France before ten years of age, any person who could prove they had resided in France for more than fifteen years, foreigners who were married to French nationals, and foreign parents of French children.[57] But the law also imposed more restrictive measures on bachelors, who had to show proof of their regular income and "respect their financial obligations."[58] In an interview published not long before the law took effect, Patrick Weil, whose report had provided the basis for what was adopted, pronounced himself

enormously pleased with it, and declared that, with this new law, "Jospin had depoliticized immigration." When asked how it would be possible to send back the sixty thousand some foreigners left "non-regularized" by the law, Weil replied that a lot of them would go back on their own. "We forget," he said, "that the irregulars circulate, notably through the function of the labor market." The ones who happened to be arrested by the police would have to be taken out of the country.[59]

Left intellectuals and especially leading figures in the arts were busily mobilizing on behalf of the *sans-papiers*, trying to keep pressure on the government. Yet in one notable case, the government, through Culture Minister Catherine Trautmann, had mobilized some cultural figures of its own. In April a group of twenty-two actors, writers, musicians, and others, under the wing of the government, had formed a "committee of vigilance" to monitor and seek to counteract the National Front.[60] Several filmmakers and theater directors, led by Patrice Chéreau, launched a unique appeal in *Le Monde*, published on May 13. The authors (Chéreau, Jean-Luc Godard, Anne-Mairie Miéville, and Stanislas Nordey) pointed out that some eighty thousand *sans-papiers* faced the expiration of their demand for regularization at the end of the month. Quoting from the *Déclaration des droits de l'homme* and calling attention to the fact that it was the year that marked the 150th anniversary of the abolition of slavery, they called for an equal number of persons to serve as "godfathers" or sponsors, accompanying the *sans-papiers* to prevent their deportation. They spoke of an "uninterrupted chain" of persons that might be formed, and announced a symbolic representation of it to take place on May 17–18 at the Théâtre Gérard-Philippe de Saint-Denis.[61] Some thousand or so persons came forward during a thirty-six-hour period to volunteer their sponsorship. As the *sans-papiers* with their sponsors filed past, the Communist mayor of Saint-Denis said to each of the "godchildren," (*parrain* means either "godfather" or "sponsor"), "We wish you a long life in France." The "godparents" pledged to assist the *sans-papiers* in their pursuit of regularization, and provided them with an emergency telephone number.[62]

Despite the sense of urgency, a small advantage had opened up for foreign musicians in France. In keeping with recommendations made in Patrick Weil's report, the law of May 11, 1998, had defined certain categories of foreigners who should be encouraged to come to France, as well as those who should be excluded. The former group would include scientists, engineers, researchers, investors, and so on. At first artists were not mentioned as a desirable group. However, on December 11, 1997, during their third meeting to discuss the bill, the deputies took up the question of artists, and two different amendments were proposed to make it easier for artists, including musicians, to enter and circulate in French territory. The author of one of the amendments, Patrick Braouezec, spoke to his fellow legislators about the styles of foreign music that had been "integrated" into French music, including jazz, blues, and rap.[63]

Eventually, the National Assembly approved an amendment to the second part of the Chevènement circular that granted a temporary *carte de séjour* for a foreign artist in France who could demonstrate the need to be in France for more than three months and also that he or she would be employed (e.g., as a performer).[64] The card would bear the phrase *profession artistique et culturelle*, and would be valid for up to one year. It could be renewed, but in order to achieve this, the artist would need to

show a new contract. The law also made some provision for so-called independent artists who might arrive in France as visitors before gaining employment. However, they could not obtain the same kind of state support enjoyed, for example, by French actors between performances. While it was a step forward that the French state recognized the status of the foreign resident artist, the advantages won were still rather small, and required the artist to appear regularly before authorities whose rulings might be arbitrary. But at least the provision of the law that allowed an immigrant to be recognized as a member of an "artistic" or "cultural" profession opened a small door, at the same time distinguishing between artists and other kinds of foreign workers.[65]

In other ways France seemed to continue to exhibit contradictory attitudes toward sub-Saharan Africans, continuing to pressure the *sans-papiers*, yet still celebrating the contributions of musicians. Rapper MC Solaar, at this time the dominant star of French rap music and a politically outspoken "anti-Le Pen," had headlined the Printemps de Bourges festival in April 1998.[66] Claude Solaar was born in France to Senegalese parents, and represents the second generation of African immigrants, many of them children of the *banlieues* whose musical preference is rap (see chapter six). Later that spring the annual festival Musiques métisses d'Angoulême continued its tradition of spotlighting sub-Saharan musicians, this time led by the venerable Cameroonian diva Anne Marie "Maman" Nzié.[67] The bill also included Rokia Traoré, the popular young singer from Mali.[68]

The July of 1998 brought even sharper contradictions. *Le Monde*, through several articles published in the same paper, reported on the results of a poll conducted by the Institut CSA and based on a nationally representative sample of 1,040 persons[69] in which around 40 percent of people questioned characterized themselves as "rather" or "a little" racist.[70] Only one in three declared themselves in total opposition to the views of the National Front. A middle group, some 40 percent, called themselves "tempted" by racism.[71] Another article compared responses from five European countries, including France, and found that France by far had the largest percentage of people willing to call themselves "racist." The figure for France was 38 percent, followed by Germany (23 percent), The United Kingdom (22 percent), Italy (21 percent), and Spain (13 percent).[72]

Just a few days later, on July 5, Lionel Jospin spoke about immigration on a Europe 1 radio broadcast. He reacted at some length to a hunger strike by some thirty *sans-papiers* and their sympathizers currently underway at the Temple des Batignolles, in the Seventeenth Arrondissement of Paris. He became angry, complaining that the hunger strikers were "using emotion" and "playing with people's health" in order to pressure his government. He reiterated his belief in the case-by-case approach to regularization, stating emphatically that his government would not for any reason favor the regularization of all *sans-papiers*. Alain Lipietz, spokesman for the Green Party, criticized the intemperate nature of Jospin's remarks, and Emmanuel Terray, an anthropologist who had joined the hunger strike, said that the prime minister had confused the criminal with its victim, that is, "The *sans-papiers* are the victims of clandestine labor, a system largely tolerated by the French administration."[73] Later in the month, a recommendation that all identified *sans-papiers* be regularized came from a most unlikely source—former interior minister Charles Pasqua. He explained

in an interview that such a move would break the current impasse and perhaps lead the government to negotiate immigration quotas with the countries of the former French empire.[74]

The event that most captured public attention in July 1988 and indeed swept the country up in a kind of euphoria was the upset victory of the French national team over Brazil in the final match of the World Cup soccer championship series. The game was played on July 12 and so the overwhelming reaction to it (which included perhaps the largest throng gathered on the Champs-Elysées since the Liberation of 1944) spilled over into the patriotic celebration of July 14 and beyond. Much was made of the ethnic and racial diversity—*black/blanc/beur*—of the team (*les bleus*), the very thing Jean-Marie Le Pen had disparaged two years earlier. In the flush of national pride over this victory, speculation was rife that the adoration being showered on the players heralded a new era of racial tolerance and acceptance of new immigrant populations. Zinedine Zidane, the star player of Algerian ancestry, became the face of this wishful thinking in the national—and indeed the international—media. The delirious hopes and fantasies that was placed on the football heroes amounted to a greater weight than they could bear, and saner voices began to point out that no amount of idolizing of the players could compensate for the real divisions and prejudices that remained in France. The government was happy to bask in the reflected glory of the triumphant national team, but never once considered abandoning their immigration policy.

The Persistence of African
Musicians in Paris

There was not much room for musicians in the spotlight that fell on athletes, but some African musicians continued to thrive in Paris, and the city remained an important center if no longer *the* center of African music. Musicians still chose to base themselves there for the same reasons as those during the heyday of "La World Music." Some musicians found obstacles in their paths, but they continued to try for the kind of success the biggest stars had achieved during the previous decade. Some longtime observers of the African music scene became discouraged. Journalist Achille Ngoye, who came to France from Zaïre in 1982, told me in 1997 that, as far as African music was concerned, "the market is saturated—blocked."[75] An example of a musician facing obstacles in this way was Manuel Mobolo (stage name: "Robby Cool"), a singer from Congo-Brazzaville who had been in France since 1990.

I interviewed him at the apartment where he lived with his family near the Place de la Nation. He had just recorded a CD single and was trying hard to interest record companies in his music. He called his music "ethno-rock," and cited as his influences jazz, gospel, B.B. King's blues, James Brown, and the Rolling Stones—as well as Congolese *rumba*. "The same day on the radio," he told me, "I listened to 'Satisfaction' and 'Sex Machine.' " Robby Cool said he had been a musician since childhood. "In Brazzaville in the early 1980s," he said, "I created a group that played blues, rock, and funk." Like many African musicians, he had come to Paris hoping to find improved conditions for supporting his career. But he had found it "difficult to

be a foreigner in France," even though he had found many "caring" people. Like so many musicians I had met, he displayed pride and interest in both African and French culture. "I was born into African culture," he explained, "school brought me into contact with Western culture."[76] Unfortunately, he did not enjoy the successful musical career he had hoped would be his in Paris. More often than not, this was true for African musicians in Paris during the 1990s.

Recordings of African music continued to sell well enough, even if in competition with reggae, rap, and other world genres. Some musicians complained about a new law concerning the use of the French language in radio broadcasts. The law, which required that at least 40 percent of all broadcasts (between the hours of 6:30 a.m. and 10:30 p.m.)—including songs—be in the French language, went into effect at the beginning of 1996.[77] Since most African musicians performed songs in African languages, this seemed threatening. When I interviewed the Senegalese record producer Ibrahim Sylla in July 1997, I asked him about racial discrimination in France, but he replied that the "40 percentage law" was much more important than that as an impediment to African musicians in France.[78] In actual practice, the law proved difficult to enforce. Also, eventually, many African musicians began recording at least a few of their songs in French in order to guarantee radio play.

As in previous years, a network of music journalists and other enthusiasts did much to promote African music, aided increasingly by the growing use of the internet. One important association, created in 1990 by the Ministry of Cooperation (under the auspices of the Prime Ministry and the Ministry of Culture and Francophonie), was Afrique en Créations, comprised of more than three hundred persons involved with African culture in France. Its mission was defined as promoting artistic creation and intercultural dialogue,[79] and it regularly published a magazine called *Afrique en scènes*, as well as guides to African music. In 1993, a group of festival directors, music producers, artistic directors of record labels, music journalists, and others involved with world music formed Zone Franche, defined as *Le réseau des Musiques du monde* ("The Network of World Musics").[80] Responding to a directive from the Ministry of Francophonie,[81] they published an important directory of music in the Francophone world called *Sans-Visa* in 1995. They continue to maintain a very informative internet site, with much emphasis on African music. In 1997 *Africultures*, a new monthly devoted to African, Antillean, and Afro-American culture and criticism, appeared, and in 1999 inaugurated a web site. Both formats remain quite active and *au courant* on African musicians and other artists.[82] During the 1990s festivals continued to feature African musicians, and prominent performers continued to give concerts in Paris, even when, as in the case of Salif Keïta, they no longer lived there.

One of the most successful African performers in Paris during the 1990s was the former Zaïrean singer known as Papa Wemba. Born Shungu Wembadio[83] in 1949, he began his singing career in 1966 and was one of the founders of the influential Zaïrean group Zaiko Langa Langa. In 1977 he formed Viva la Musica, which, after he relocated to Paris in 1986, he would continue to maintain as one of his two distinct ensembles. Over the years he would use Viva la Musica when playing for exclusively African audiences. The other, Molokai, became the band he would use for his brand of rumba-rock meant for Western audiences, and has been the band featured on his recordings for Peter Gabriel's Real World label, the ones that have circulated

most widely.[84] He sings in the high, soaring style associated with many other popular African vocalists (e.g., Salif Keïta, Youssou N'Dour, Baaba Maal), and has been strongly influenced by American "soul" singers. He featured a cover version of Otis Redding's "Fa-Fa-Fa-Fa-Fa (Sad Song)" on his 1995 album *Emotion*.

Papa Wemba has faced some criticism for making so many concessions for Western ears. At the very least, his performing career split between two bands has been remarked upon by other musicians. When I interviewed Jocelyne Béroard in 1997, she remarked upon it; she described it as "two different careers: his international career where he makes music frankly for Western Europe," and "the local career that he makes uniquely for Africa." She was not, however, critical of his international aspirations, since, as she put it, "Everyone dreams of the American market."[85] Something about Papa Wemba that has received much more comment is his flamboyant sartorial style. Drawing upon the tradition of displaying one's finest attire that developed in Kinshasha night spots (see chapter seven), Papa Wemba is known for changing outfits several times during a concert, and for wearing the latest fashions of the most avant-garde Japanese designers.

He even founded an organization called "La Société des Ambianceurs et des Personnes d'Élégance," which yielded the acronym *la sape*. Papa Wemba's young Congolese fans on either side of the Congo River tried to emulate him by dressing in the fashions of leading *couturiers*.[86] The singer himself became known as *le roi des sapeurs*,[87] a latter-day dandy in a French tradition that harks back to the Second Empire Paris of Baudelaire. Although he has expressed impatience with critics who emphasize his attire over his musical performance, he nevertheless brings to each concert shopping bags containing several outfits. Both times I saw him perform, outside Paris in 1996 and in New York City's Central Park in 1998 (as part of the Africa Fête tour), he was resplendent, and the concerts reminded me of Motown or Memphis soul revues, with Papa Wemba playing the James-Brown-style role of "the hardest-working man in show business."

I interviewed him backstage after the 1996 concert. His makeshift dressing room was in a small trailer, and we sat among the shopping bags that contained his finery. He apologized for his inability to speak English, saying (in French), "Almost everyone speaks English, but not me!" I remarked that his two-hour set had been a generous one, but he protested, "Oh, that was a short concert!" He explained that with his band Viva la Musica he had been known to play until dawn. I wanted to know why he was called "Papa," and he informed me that it was customary for first-born sons to have that title. He began to show me some personal photos, including one of his late mother. She was a professional *pleureuse*, someone hired to sing mournful songs at funerals. It had been rumored over the years that Papa Wemba had begun his singing career in that way, but he denied it. However, he did say that "that style of singing was an influence on my career."[88]

In early 1998, while in New York City, I spoke with Papa Wemba again, this time by telephone in preparation for a magazine article I was to write about him. He spoke to me from Paris. His album *Molokai*, named for his band, was about to be released. I wanted to know if his music struck a balance between the two styles of his different bands. "I think it manages to begin to," he said, "but it's up to me to qualify and define it. If you don't know one of the two musical styles well, then it is hard, but if

you are familiar with the musical genres in question, then you can manage it. You make them your own." What about criticism from one direction or another, I asked. "When someone criticizes in a way that distracts from the music, then it's a problem. When someone doesn't criticize intelligently, it's dangerous."

We also talked about the use of Paris as a base, for which Papa Wemba was grateful. He said, "Paris permitted me to establish my name on the international level and to travel a bit everywhere. I thank Paris for that." But, he added gravely, "Paris no longer promotes African musicians. African music is no longer in fashion in Paris." I then asked if that means the era of African music in Paris is finally over. He replied, "It's both over and at the same time open to those African musicians who already have a name. If you don't already have a name in Paris or in France, then it's difficult."[89]

In spite of everything there were a few musicians able to establish themselves during this period without already "having a name." One of the most successful has been Sally Nyolo (1971–), a singer originally from Cameroon. She hails from the south of Cameroon, where she was raised until the age of thirteen, when her father, who had taken a job with the Cameroonian embassy in Paris, moved the family there. She continued her studies, eventually becoming a student at the University of Nanterre.[90] "I took on European culture," she remarked in an interview, "and I saw the world through others' eyes."[91] She and all of her family became French citizens. After her university days were over in 1993, she formed her own group and began to perform in Paris. She was invited to perform that year in Peter Gabriel's WOMAD ("World of Music, Art, and Dance") festival in England, and later recorded a four-song EP on his Real World label. Soon thereafter, she accepted an invitation to join the Belgian all-female *a cappella* vocal group Zap Mama, and recorded and toured with them.[92] In 1995 she lived for a time in New York City, where she contributed a song to the soundtrack of the Wayne Wang/Paul Auster film *Blue in the Face* (1995). She said that David Byrne (formerly of Talking Heads) created this opportunity for her.[93]

In 1996 Nyolo released her first full-length album *Tribu* on the Paris-based label Lusafrica, best known for its recordings by the Cape Verdean singer Cesaria Evora. I interviewed her in Paris in July 1997, and then again in November in New York City, the day after she had opened for Cesaria Evora at Town Hall. I was able to attend another of her concerts the following year at the club New Morning in Paris. On stage, Sally Nyolo was a compelling presence, costumed in the manner of the Beti women of her native culture. She wore several long elaborately wrapped scarves, which she unwound, twisted, and otherwise manipulated throughout her performance. Her musical accompaniment was mostly acoustic, with two backup singers. Most of the songs she performed were from the album *Tribu*. The Town Hall audience received her enthusiastically, much more than an opening act typically sees.[94]

When we spoke in Paris, in a crowded hotel bar on the Place de la République, Sally Nyolo described her music to me this way:

> For *Tribu*, I tried to work a rhythm that's called *bikutsi* that originates from the south of Cameroon. Les Têtes Brûlées [a flamboyant band from Cameroon—see chapter seven] also use it. You have to be from that region to understand this rhythm. It is a traditional and complex rhythm. Les Têtes Brûlées have used an electronic style. I try to fashion a more traditional style.

She said that while she tries to have a traditional sound, she knows that her music is influenced by the modern forms she loves, such as jazz. "My influences always come out in one way or another," she said.

When we spoke in New York a few months later, the subject of language was on her mind. She expressed the desire to be able to sing in any of the world's languages she chose, and then informed me, laughing, that "we have two hundred languages in Cameroon." Her first language was Eton, which she described as very similar to the Fon spoken in Gabon. It is a language, she explained, with clicking and throat sounds, and she said that for her songs, "I chose Eton to remain faithful to the rhythms of *bikutsi*." Wondering about the language question with an American audience, I asked her if she felt accepted by them. With loud laughter, she said, "It's incredible!"

> Yes, I feel accepted, and I feel flattered that when one buys the disc they are affected by the sound—just uniquely by the sound—and that touches me.

I asked her at one point if she changed anything about her music for the American audiences, and she said no, and went so far as to say that for any audience for which she performs, the reaction is "exactly the same."

> Whether they are African listeners, European listeners, or American listeners, they all have the same reaction by relating to the spirit and the rhythms.

As for her songs, she agreed that they are uniquely stories of daily life in her part of Cameroon. "Yes," she said, "I was inspired by the memories I had of my aunts, of my cuisine, of my uncles." One of the most striking songs on *Tribu* is "Mamterry," about a wise woman who listens to others' troubles but perhaps lacks anyone to provide the same service for her. " 'Mamterry' is the story of my aunt," Nyolo said. The experiences of the Beti women of her ancestry are the most important sources for her songs.

In Paris I had asked her if it was more difficult there for a female singer to have a musical career, saying that perhaps someone who plays an instrument could find more opportunities to play. She responded this way:

> Yes, it's true that it is more difficult for a *chanteuse*. It took a long time for me to apply myself to try to accomplish my career. In Paris we have a lot of musicians, but few places to play, to sing. "World music" (*La musique du monde*) doesn't really have a scene in Paris. It's easier for *un jazzman*. For a female singer, it's really rough work. You really have to have a lot of courage.

Reacting to the way she had said world music, I asked her what she thought of that phrase. She gave one of the more memorable answers I have heard:

> That makes me laugh because it depends on where you find it. In Africa, world music, it's from here (Paris)! There are musics in all the world.

Speaking of the often bitter immigration debates in France and the role of a musician, she described herself as "very optimistic," and became very expansive on the theme of

cultural mixing, with each culture having something of value to contribute to "the richness of the world." She said this was something of an "antiracist message," and added, "I am a citizen of the world." The interview on that warm July day came to an end on that note, and Sally informed me she was off to go swimming.

In New York we took up the threads again of the "world citizen" idea. She seemed even more emphatic on the question, speaking of her extensive travels, her admiration of the black liberation struggles of the Southern United States, South Africa, and elsewhere, of her admiration for people's attachment to their roots combined with her recognition of the uprooted condition of an artist like herself. Speaking of contemporary cultural blends (she used the word *mélanges* repeatedly), she said, "You have to live with these things." Her voice rising, she spoke of her need for cultural diversity:

> I need my African culture. I need my European culture. I need that which is American. I need world culture.

In response to my question about the elaborate scarves she had used in her concert, she gave me a fascinating explanation. It seems they have highly ceremonial uses, in mourning, for example. A scarf worn about the head signifies something serious or grave. One worn around the neck suggests nobility. If worn about the shoulders, it has to do with playing an assisting role in a ceremony. A scarf tied around one's hips signifies strength and work. Then, each color has a separate significance. "Blue is a very solemn color," she said. "Orange," she added, "is joyous."

During the late 1990s, in the course of my research in Paris, it seemed I was meeting musicians from Cameroon more and more, and I had noticed a restaurant or two featuring the country's cuisine. I asked Nyolo if there had been a unifying experience or theme for Cameroonian immigrants in France. She replied in the negative, and added that musicians from Cameroon had tended to travel back and forth between there and France. But she noted as well that there was no particular neighborhood in the Paris region associated with immigrants from Cameroon, the way Montreuil, for example, had been with those from Mali. "It's not at all the same," she declared. With her music rooted in the Beti people of Cameroon and her embrace of her adopted country's culture, Sally Nyolo is a very good example of the new kind of global citizen who may lend validity to the phrase world music.

A successful singer of the 1990s with a very different orientation to Paris is Nayanka Bell (real name, Louise de Marillac), originally from Côte d'Ivoire. I had been introduced to her when I was at Studio Zorrino to interview Jocelyne Béroard and Jacob Désvarieux, where the latter was working with her on one of her albums. Born in 1962 to an Ivoirean father and a Corsican mother, Nayanka Bell moved to France when she was twenty years old. Married to a Frenchman and the mother of two children, she said "I feel more Ivoirean than French." I was struck by this comment, sitting as we were in a lovely sun-filled room of her house on a street overlooking the vast Parc des Buttes Chaumont. However, the context in which she stated it was one in which she had been talking of the difficulties of being a mixed-race person. "Mixed nationality doesn't exist," she declared, "I always dream of Africa."[95]

Abidjan, Côte d'Ivoire, has been an important center for African music, known for its high-quality recording studios and thus attracting musicians from other African countries, many of them, such as Salif Keïta and Sam Mangwana, basing themselves there before making the move to Paris. Unlike other Francophone African countries, Côte d'Ivoire has lacked its own musical identity. Its most internationally famous musician Seydou Kone a.k.a. Alpha Blondy (1953–) became the first African reggae star.[96] The reggae influence has remained strong in the country, and it has been one of the influences on Nayanka Bell. She has been among the most successful female Ivoirean singing stars in a country known for producing them. Known as well for her flair for fashion and her glamorous stage persona, she has been dubbed "the Barbara Streisand of Africa." This was also due to her recording her own version of a Barbara Streisand song that became very popular in Côte d'Ivoire.[97] Bell's music blends traditional elements with electronic instruments in a style influenced by funk and contemporary Caribbean music. Her concerts feature dancers as well as musicians.[98] She had spent time in the United States, and for several years before the time of my interview with her she had been performing songs in English.

It was clear from the conversation with her that Nayanka Bell focused largely on the popular music of her native country and her position in it. She had much less to say about the music being made in Paris, even though she had worked with such important musicians as Ray Lema and Jacob Désvarieux. "It is absolutely necessary to be in France for the musical career," she said, but added that "for inspiration, as far as Africa is concerned, you have to be in Africa." She had praise for Alpha Blondy for his talent and for his invigoration of Ivoirean music, and also admired his ability to appeal to audiences in Anglophone countries such as Ghana and Nigeria. François Lougha was another Ivoirean singer whose influence she credited. Her own music she saw as "the way between folklore and the modern."

Even though she expressed the desire to succeed in the American market (mentioning Salif Keïta, Oumou Sangare, and Ali Farka Touré as examples of musicians who had done so), she emphasized the necessity of retaining her fan base in Côte d'Ivoire. "We exist because of tours, because African need shows (*spectacles*)." She stated. Touring then aids the sale of cassettes in African countries, but, she lamented, "I have run into problems with piracy." It seemed she preferred her popularity with African audiences to her reception by European ones. "If you lose your African fans," she explained, "and you have only European fans, you have only those who are attracted to 'exoticism.'" Turning again to her reasons for using Paris as her base, she used the word I have heard used often in reference to the music business: "structure." These structures, she said, "are not yet adapted to the folkloric (a word she seemed to prefer) musics of Africa." Certainly she is proud of her accomplishments since recording her first album, assisted by Jacob Désvarieux, in 1980. "I was the first Ivoirean *chanteuse* to record on 48 digital tracks," she informed me.

Ivoirean female singers, according to Gérald Arnaud, are known less for being "charmers" than for being "spokespersons of emancipation." He cites Nayanka Bell as a prominent example.[99] As for her sense of French politics as it related to African immigrants, she said she was much more aware of "musical discrimination" than racial discrimination. She expressed some frustration with the lack of attention currently being paid to African music by most French radio stations. At the end of the

interview, however, she expressed the hope that things would change for the better with Jospin's leadership.

Henri Dikongué (1967–), another singer from Cameroon, began to attract very favorable attention in Paris music circles after 1995 for his melodic, acoustic style that drew from a wide variety of sources. He began to attract a wide audience as a result of opening for Cesaria Evora in a series of concerts in the spring of that year, the year in which he released his first album.[100] Dikongué has been a musician virtually all his life, having first learned to play guitar at the age of six.[101] He sang in church choirs and absorbed influences of Cameroonian *bikutsi* and *makossa*, which he eventually would weave into a gentle soothing style influenced by a wide variety of sources, from Latin America to modern *flamenco* to various African genres.[102] However, despite having played music throughout his life, having grown up in a family of musicians, neither he nor his family ever assumed he would become a musician professionally. Music was for family and community pleasure, not for a career. As Dikongué explained in an interview, his parents in Cameroon wanted their children to prepare for professions such as medicine or journalism.

His second album *C'est la vie*, released in late 1997, was his breakthrough. The title track, the only one in French, was especially successful, and reminded listeners of the *chanson* tradition. I spoke with Henri Dikongué in March 1998 at the beginning of his first American tour, which coincided with the American release of *C'est la vie*. I asked about his background and how he happened to come to France. He explained that he had first gone to live in Switzerland for two years, then enrolling in the University of Besançon to study law, as his family had encouraged. He soon abandoned the study of law and went to Paris to study at the École Normale de Musique for three years. He became involved in music and then in theater. By 1989 he was settled into life in Paris and concentrating exclusively on music, including working intensively on his classical guitar technique. He also worked with many important African musicians in Paris, including Manu Dibango and Papa Wemba.[103]

Along the way, he absorbed many influences and managed to forge them into his own signature style. Here is how he responded to my question about the musical combinations he had created and their relation to traditional forms of African music, and his remarks include some surprising references:

> What I would say is that from the 1960s until the Mitterrand years, people had begun to catalogue African music as only a music of dance, of ambiance. I was influenced by the music of Joan Baez, James Taylor, etc. From the side of Africa in France: Ray Lema, Manu Dibango, Francis Bebey. From the side of the West in France: Charles Aznavour. The music of Brazil also was important.

He spoke also of classical music, reggae, and blues, and said the most important thing about his music was that

> The base is the song, the words. The melody is the first thing. The voice is the most important instrument. You have to arrive at your own identity.

Although recording his most famous song in French had boosted his career in his adopted country, he did not, he said, see the need to record songs in French or in

English for career purposes. He would continue, he said, to sing most in African languages such as Douala and Swahili. "When the music gets across, it is the listeners who are going to decide," he remarked. Dinkongué's music has been very well-received back in Cameroon, and, as with Sally Nyolo, I wanted his sense of the Cameroonian community in Paris. "They are everywhere," he said. "Cameroonians play with everyone, with the greatest musicians in Paris and London," Dikongué added. Then he spoke of the importance of Manu Dibango and Francis Bebey.

Despite his own good fortune, he was quick to agree that things were difficult for the current generation of African musicians in Paris, but added,

> It was always difficult. The Mitterrand *époque* brought nothing. Jack Lang, he made some names. One thing is certain: everything is signed in Paris. The Francophone system, they decided that they are going to advance one single artist that year and that's all. (Speaking of major record companies) You can't sell artists like you sell some meat. Me, I don't want it. I prefer to work with the independents (His own records were released on the Mélodie label), people who believe in what I am doing.

Even for longtime enthusiasts, sub-Saharan African music by the late 1990s had become just one very recognizable flavor among many to be tasted in the expanding world music mix of Paris. The popularity of Caribbean music remained undiminished, as Martinican bandleader Jean-Michel Cabrimol could attest. His polished dance music *zouk* and *salsa*, among other regional influences, and his big band was much in demand at Paris night spots. I interviewed him briefly as he took a break during a sound check prior to a late night dance concert at the famous Montparnasse nightspot La Coupole. He described his music as something "spicy" for European audiences.[104] I thought about the spatial significance of a new generation of Francophone performers appearing in a place associated with an earlier chapter in the history of bohemian Paris (see chapter seven).

François Bensignor turned his attention to a new generation of Caribbean musicians, those inspired by the traditional Guadeloupan music *gwo ka*.[105] He also alerted readers to a relatively new group of Francophone African immigrants and their music. The people in question were from the Comoro Islands north of Madagascar in the Indian Ocean.[106] Press attention continued to be trained on Orchestre National de Barbès, regarded as voices representative of the second generation of immigrants from the Maghreb.[107] Other articles emphasized the qualities of the neighborhood itself (Barbès) that contributed to the musical *métissage* of such a group.[108] An article that appeared in *Le Nouvel observateur* in 1999 attempted to make sense of "the expanded market of world music" in France, situating the already familiar figures of African music newer stars of Cuban, raï, and the "Celtic rap" of the popular Breton group Manau.[109] Was this evidence of Paris claiming its place as a truly global city, or was it just so much "planet soup?"

One pattern from the earlier era that continued to hold true was the importance of music festivals as showcases of world music. Musiques métisses in Angoulême continued to promote African music energetically, although the festival also included everything from Brazilian performers to zydeco musicians from Louisiana. Youssou N'Dour of Senegal headlined the 2000 festival, attended by more than forty thousand

persons over a three-day period.[110] Fortunately, once in a while someone came up with a new way to involve people with music, including African music. In 1998 some one hundred thousand persons in Saint-Denis—a locale always seemingly ready for something new—participated in something called "la Carnavalcade," a street festival that, not unlike the Fête de la Musique, combined professional artists with amateurs. The idea was to be true to the carnival spirit of old, with its rambunctiousness and laughter. In 2000 Ray Lema took a leading role in the event, collaborating with choreographers and hip-hop artists.[111] Ray Lema was not the only example of a well-established African musician for whom the French press found time. Manu Dibango's celebrity remained undimmed. A typical article would describe his latest musical project, while portraying him as a contented resident of his neighborhood, where he was a familiar figure in the bistrots and cafés.[112] And certainly the death in 2001 of fellow Cameroonian trailblazer Francis Bebey was an event duly noted in the press.[113]

The struggle of the *sans-papiers* continued as a challenge to the government and as a persistent topic in the media. Musicians, like other artists and intellectuals, from time to time lent their support to the movement. In the spring of 1999, when Gisti, the group that had worked for many years on behalf of the *sans-papiers*, was deep in debt, the influential pop music magazine *les Inrockuptibles* organized a benefit concert and multi-artist compact disc to raise money for the organization. One of the most outspoken musicians involved was Bertrand Cantat, the controversial lead singer of the group Noir Désir. In response to the widely reported disparaging comments of Jean-Pierre Chevènement against those who demanded total regularization of the *sans-papiers*, Cantat said, "It's those who think we can totally close the borders who are unrealistic."[114]

The Forgotten *Sans-Papiers* and Changing French Politics

In September 1998 *sans-papiers* in a cathedral in the Parisian suburb of Créteil, in Le Havre, and in Bordeaux staged hunger strikes, and as usual the government reacted with stubborn insistence that they would never consider regularizing everyone who requested it.[115] The political cartoon by Pessin in *Le Monde* that showed a man urging a hunger striker in a church to go back into hiding (see chapter seven) neatly captured the mood of much of the French public. The scandal of the *sans-papiers* was their insistence on becoming visible, whereas the labor market and French opinion preferred that they remain "clandestine," despite the supposedly pejorative sense of that word.

Issues of immigration were at the center of debates throughout Europe. One topic often under discussion was that of permitting immigrants to vote in elections at various levels. A poll taken in late 1998 showed that 51 percent of French people opposed this idea, but *Libération* reported in a brief notice that the percentage of those in favor was on the rise. In April 1997 53 percent had been opposed, and only a year earlier the figure was 69 percent.[116] Meanwhile, as for the perennial question

of the *sans-papiers*, pressure came from the European Parliament in the guise of a figure very familiar to late-twentieth-century French history. In November 1998 Daniel Cohn-Bendit, leader of the Greens in the European Parliament, appealed directly to Lionel Jospin for full regularization,[117] adding his voice to that of the many prominent persons already making such demands. Later that month some six thousand demonstrators in several French cities marched in favor of regularization.[118] The leaders of the *sans-papiers* released a communiqué that stated, "In no way are we going back into the shadows." In Paris the protest included women who, in many cases, had lost their papers through divorce or abandonment by polygamous husbands. They were casualties of the Pasqua law of 1993 that banned polygamy for the immigrant population.[119]

As usual the Malians remained at the center of the immigration controversy. The Jospin government continued to dig in its heels on the question of expelling persons whose demands for regularization had failed. The decision of a Paris court to condemn a man who had refused to be sent back to Bamako to a year on a prison farm was denounced loudly by human rights associations and groups fighting against the case-by-case regularization of the government.[120] A government circular of November 4, 1998, had created new procedures for assisting those immigrants who would be willing to re-emigrate to Mali, Senegal, or Morocco. Since bachelors were least likely to be regularized under the Chevènement Law, some reluctantly chose the option of returning to Mali with hopes of starting businesses there. Still, there was humiliation in leaving France, often after many years of residence. Some men felt that their status back home depended on their being in France.[121] One way or another, the government appeared to wish to prevent the majority of Malian immigrants from becoming regularized.

Like its predecessor, the Jospin government seemed to be trying to walk a tightrope between the extremes of opinion on the immigration question. Yet at times evidence surfaced that appeared to suggest that France was no longer as sharply divided over the issue as it had been, and that people were becoming more accepting of the immigrant population in their midst. Or, as a reporter for *Le Parisien* expressed it late in 1998, "The national, multicolored enthusiasm last July that accompanied the triumph of the French national football team was not a parenthesis or a sort of anomaly, but the inverse." The statement was inspired by a new study that suggested growing tolerance for immigrants in France. In 1991 58 percent of those polled had agreed that immigrants profit from advantages that should be reserved for the French. Seven years later, only 47 percent agreed. In 1998 55 percent of respondents agreed that the presence of foreigners in France was good for France, contrasted with 38 percent who felt that way in 1991.[122] Perhaps the Jospin government was locked into a pattern whereby they feared alienating opinion on the right more than on the left.

If the government was playing a waiting game with the *sans-papiers* movement, it may have been working to their advantage. By March 1999, as the third anniversary of the Saint-Ambroise occupation came and went, the energies of the movement seemed to be flagging. Some agreed that the Jospin government was less repressive than the one that preceded it, but most felt great disappointment at the government's refusal to abandon its case-by-case approach to regularization. A substantial number

of the 140,000 demands had been accepted (around 90,000), but Chevènement continued to threaten expulsion of those still irregular. His ministry also offered monetary assistance (4,5500 francs per adult, 900 per child) to those willing to return to their countries of origin. Madiguène Cissé, leader of the *sans-papiers* and herself vulnerably in an irregular status, was adamant that all European borders be opened. "It is not only the free circulation of goods," she said, "it is also that of persons."[123] The standoff continued.

So did the demonstrations and open letters in the press. The government's defenders pointed to the figures that showed how many persons had been regularized, but the movement sought to focus attention on the substantial number caught in an uncertain and dangerous position. They had shown confidence in the government by applying for regularization, but as their demands went unmet they were exposed and vulnerable. Several rallies and demonstrations were scheduled around the time of the anniversary of Saint-Ambroise, with emphasis on the group so much at risk.[124] The tension heightened in the midst of these events with the news that nine Malians who had refused deportation had been sentenced either to short prison terms (two–six months) or to banishment from French soil for three–five years.[125] On March 21 several dozen persons demanding regularization of the *sans-papiers* found a new kind of institution to occupy. They chose the foyer of theater of the Palais de Chaillot during a performance of Molière's *The Miser* (see chapter seven).[126] Then, the very next day, a ringing demand for full regularization of the remaining sixty thousand or so *sans-papiers* came from within Jospin's own party in the form of a column in *Libération* by Serge Blisko, a deputy from Paris. Among other things, he argued that "We do not have the technical and political means to expel them." Inevitably, then, they would return to a clandestine existence.[127]

The third anniversary of the forcible end of the occupation of Saint-Bernard in late August 1999 provided another round of observances and protests on behalf of the same group, called in a mournful *Le Monde* editorial "the forgotten sans-papiers,"[128] now estimated at sixty-three thousand.[129] By autumn, Chevènement stepped up the pressure on those immigrants in irregular situations, and, to paraphrase one report, opened the hunting season on those who were clandestine. He chided the prefects over the low number of persons being apprehended, and urged them to "motivate and mobilize the services of the police" to produce more arrests and eventual expulsions.[130] Chevènement also called for the establishment of a fingerprint file for those demanding residence permits, something very similar to one of the proposed (and invalidate by the Constitutional Council) Debré laws of 1997. Emmanuel Terray, Directeur d'Études of the École des Hautes Études en Sciences Sociales (EHESS), accused the interior minister of having taken France back to the harsh Debré era.[131] As for the *sans-papiers* who had been granted regularization, their position was far from secure. The need to prove their employment by producing pay stubs meant they were under pressure to accept often very marginal and poorly paid jobs. Having a residence permit of just one year prevented the signing of a long-term lease on an apartment, just one example of the many complications of daily life the minimally "regularized" faced.[132]

From all over Europe, it was clear that African immigration would continue, often in the most desperate manner. The press carried reports of such extreme incidents as

Senegalese or Guinean stowaways who perished while clinging to the landing gears of airplanes,[133] and reported as well on the growing number of persons entering Europe through southern Spain. Occasionally also reports appeared on immigrants who died while being smuggled through Gibraltar or Dover. The press also reported from time to time on rising immigration rates in France, although that could be attributed to the regularization of *sans-papiers*.[134] Non-European immigration was well up by the end of the decade,[135] although the total percentage of immigrants in the French population by 1999 held steady at some 7.4 percent. The portion that was sub-Saharan African had increased by 43 percent since 1990. One must remember that immigrants who had acquired French nationality still were counted as immigrants.[136]

As the year 2000 approached, the continued efforts of Le Pen's movement and the policies vigorously pursued by Chevènement, a tone of at least resignation, if not of genuine acceptance, toward the inevitability of immigration and a multiethnic France, became increasingly perceptible in French culture. It is apparent in an article in a conservative newspaper on the heavily African district of Château Rouge (north of Barbès-Rochechouart) that is both celebratory and condescending toward the flavors, sights, and sounds to be encountered there. Calling the neighborhood a "symbol" of "cosmopolitan Paris," the article ends with the comment "Like it or not, that is Château Rouge. It is also the Paris of today."[137] The sense of greater acceptance can be seen as well in a report in the press emphasizing the "record" number of persons who acquired French citizenship in 1998 (124,000), a number attributed to the Guigou reform of the Pasqua laws (making it easier for children born to foreign parents to become citizens).[138] And in an unusual twist, a more positive attitude about immigration accounts for an article in *Le Monde* suggesting that immigration might be the needed stimulant for economic growth.[139]

But by no means were the paths cleared for everyone who wished to reside in France. Imprisonment continued as a penalty for a significant number of *sans-papiers*, something loudly denounced by Madjiguène Cissé,[140] who herself would be sent back to Senegal in July 2000, after six years in France.[141] The more than sixty thousand *sans-papiers* still denied regularization, meanwhile, still found themselves without status, while groups on the left debated the question of open borders (favored by Gisti) versus immigration quotas (supported by SOS-Racisme).[142] Pressure for regularization continued, but opinion remained divided in France. The issue of the *sans-papiers* kept the focus on those African immigrants in the most desperate straits, and the difficult quest to make a life for oneself in France might occasionally receive wry social commentary that questioned the supposed spirit of acceptance so taken for granted in the afterglow of the 1998 World Cup victory. But admiration for an athlete of African origins by no means carried over into real support for struggling immigrants. A political cartoon in *Le Nouvel observateur* commented on this fact with bitter humor in early 2001. It depicted a white job interviewer at his desk in front of a computer terminal. He has his hand on his hip, and faces a desperate-looking young black man standing and holding his cap in his hand. The seated man says to him, "And you don't even know how to play football?"[143]

Yet as the individual African musicians profiled in these pages show us, not all African immigrants were the most disadvantaged members of their societies. In 2000 INSEE reported statistics that received comment especially for showing that the

overall percentage of foreigners in France had been reduced by 9 percent between 1990 and 1999. As for African immigrants during the same period, the census showed a shift away from poorly educated immigrants from rural areas to a newer immigrant population primarily from urban areas, much more likely to be educated, and possessing much greater fluency in French.[144] One example of good fortune who resurfaced in the news in the latter part of 2000 was Ababacar Diop, the original spokesman for the *sans-papiers* movement who had been pushed out of leadership by Madjiguène Cissé. Unlike her, he finally had secured a *carte de séjour*.

Moreover, he had become wealthy as a result of damages paid him by the Vivendi corporation over their use of a trade name similar to the name (*Vis@Vis*) he had given a cybercafé he founded,[145] in keeping with his long-standing interest in media and communication. Diop opened the café not far from the cathedral from which he and his group had been expelled in 1996. Its purpose was to assist the African immigrant community to keep in touch, both within the *métropole* and with their communities of origin.[146] Diop also funded "friendship charters," organizing travel from Dakar to Paris in order to show prospective immigrants aspects of French life they would have to negotiate should they choose to come there. He was convinced that France would need workers from Senegal in the future.[147]

The *sans-papiers* movement had not ended by any means, but it no longer received the kind of attention that it had in the late 1990s. Issues of immigration and race nevertheless continued to matter in early-twenty-first century France. In May 2001 SOS-Racisme, now under a new president Malek Boutih, sought to expose the discriminatory practices of certain night clubs through a night of "testing," which involved sending three couples—"un blanc, un black et un beur"—to a club to seek admittance. They claimed that results showed discrimination still existed in 42 percent of cases in Paris and in 44 percent elsewhere in France. Henri Dikongué told me during his interview that he had seen signs in bars and clubs in the Seventeenth Arrondissement announcing "no blacks."[148] SOS-Racisme vowed that they would continue their *nuits du testing* until the discriminatory practices disappeared.[149]

By fall 2001 most French political observers were looking ahead to the presidential election to be held in the spring, when Prime Minister Jospin would challenge the incumbent Jacques Chirac. Perhaps to position himself more carefully for the coming election, Jospin began to soften his tone regarding immigration. In early November he spoke about the group of African soldiers fighting for France in World War I who were executed by firing squad as mutineers, urging that they be "fully reintegrated into our collective memory." This episode from the Great War was the subject of a film called *La Dette* by Fabrice Cazeneuve, and was later broadcast on the *Arte* channel.[150] Then, on November 22, Jospin made the dramatic announcement of the creation of a national museum of immigration (scheduled to be opened in 2007) that would exhibit and celebrate "the role of immigration in the economic, social, and cultural development of France." It would also be a research and archival center, as well as a place for cultural exchanges and meetings. The report in *Le Monde* called it a *lieu de mémoire de l'immigration*.[151]

As the election approached, Africans in France felt that their concerns were being thoroughly ignored. Calixthe Beyala, in an opinion column published in March in *Le Monde*, complained that the size and sophistication of "the African community in

France" was not at all reflected in the campaign, or perhaps their votes were taken for granted.[152] Then, when the first round results on April 21, 2002, placed Jean-Marie Le Pen in second place ahead of Lionel Jospin (seemingly ending the latter's political career), Africans in France were as shocked as everyone else. The choice was now between a right-of-center incumbent president and a far-right challenger. Preventing a Le Pen victory and overcoming a national sense of shame about his relatively strong showing became top priorities. The *sans-papiers* movement sprung into action, this time by organizing a fourteen-hundred-kilometer march from Marseille to Paris in order both to call for regularization on all *sans-papiers* and to demonstrate against Le Pen on April 27.[153] The following week, writing of the first-round results in *Libération*, Fodé Sylla, the former president of SOS-Racisme and now, like Harlem Désir, a member of the European Parliament, said in his title "Our France deserves better." His subtitle proclaimed, "Progressive nation, land of welcome, it must advance in spite of fascism."[154]

The second round of voting on May 5 brought Chirac a resounding victory, and a new government was formed with Jean-Pierre Raffarin as prime minister. With the return of the right to power in 2002, resistance to the demands of the *sans-papiers* and tight restrictions on legal immigration seemed assured, yet the movement has persisted. Like most Western nations, France needs immigrants, yet politicians fear alienating the support of anti-immigrant constituencies. Whether left or right, recent French governments have kept things difficult for immigrants. Moreover, by focusing heavily on immigration and on discussions of ethnicity and citizenship—framed typically as a showdown between republican values and respect for "difference"—mainstream parties have accepted as central the very preoccupations of the Le Pen movement that they officially profess to repudiate. In actual practice, the *Front National* sets the agenda, especially through their success in persuading the media to keep the spotlight fixed on these topics.[155]

The political events of spring 2002 were discouraging for Africans in France, but their presence remained strong. There was still African music to be heard, restaurants and shops to be visited, and the still persistent demands of the *sans-papiers*.

Notes

1. Thomas Sotinel, "La France est de plus en plus critiquée en Afrique," *Le Monde* (September 3, 1996): 31.
2. Laurent Kamaté, Jacques Pulh, and Pierre Ropars, "Retentissement de l'affaire des sans-papiers au Mali," *Cahiers de l'Atelier* 475 (September–October 1997): 4.
3. Béatrice Bantman, "La dernière veillée des sans-papiers: Ils se sont réunis vendredi à la mémoire d'Amara Fofana, mort le 16 octobre," *Libération* (October 26–27, 1996): 6.
4. Cathy Capvert, "Des sans-papiers menacés d'expulsion: Saint-Bernard," *l'Humanité* (January 1, 1997): 5.
5. Danièle Lochak, "La Politique d'immigration en France et l'évolution de la legislation," in *Les Nouvelles migrations: un enjeu européen*, ed. Emmanuelle Bribasia and Andrea Rea (Bruxelles, 2002): 213–214.
6. Jane Freedman, *Immigration and Insecurity in France* (Aldershot, 2004): 22.

7. D.M., "Le Retour en force d'un dossier brûlant," *Le Parisien* (December 17, 1996): 3.

8. Tzvetan Todorov, "Institutions et xénophobie," *Le Monde* (February 19, 1997): 7.

9. Philip Gourevitch, "The Unthinkable," *The New Yorker* (April 28, 1997): http://www.newyorker.com/archive/content/?020422fr_archive05.

10. Nicole Gauthier, "La loi Debré revue et censurée par le Conseil constitutionnel," *Libération* (April 24, 1997): 4.

11. Jean-Luc Pouliquen, *A La Goutte d'Or, Paris 18ème: Chroniques pour un quartier* (Paris, 1997): 178.

12. Pierre Bourdieu, "Les Représentations de l'immigration," *Hommes & migrations* 1099 (January 1997): 41.

13. Elisabeth Fleury, "Michèle Tribalat: On se sert de l'immigration comme d'un leurre," *l'"Humanité* (February 27, 1997): 16.

14. Yvan Gastaut, *L'immigration et l'opinion en France sous la Ve République* (Paris 2000), cited in Freedman, *Immigration and Insecurity*: 17.

15. "La part des immigrés dans la population française n'a pas augmenté depuis vingt ans," *Le Monde* (February 28, 1997).

16. Fara C., "L'Afrique plus que jamais déclinée sur tous les tons," *l'Humanité* (April 3, 1997): 27.

17. Frédéric Ploquin, "Salik Keïta en français dans le texte," *l'Événement du Jeudi* (April 10–16, 1997).

18. Emmanuelle Bosc and Anne Crignon, "Pas de visa pour la musique noire," *Le Nouvel observateur* (April 3–9, 1997): 13.

19. Nicole Gauthier, "Argument de campagne: De la difficulté d'utiliser la loi Debré sans remettre le FN en selle." *Libération* (April 24, 1997): 5.

20. Lochak, "La Politique d'immigration en France et l'évolution de la legislation": 214.

21. Fara C., "Les Musiques du monde sans papiers," *l'Humanité* (June 4, 1997): 19.

22. François Bensignor, author interview, Paris, July 1, 1997. All information on Bensignor is based on this interview.

23. Didier Lozahic, author interview, Saint-Ouen, France, July 13, 1997.

24. Jocelyne Béroard, author interview, Saint-Ouen, France, June 25, 1997.

25. Jacob Désvarieux (with Jocelyne Béroard), author interview, Saint-Ouen, France, June 25, 1997.

26. Claude Vamur, author interview, en route from Paris to Méry-sur-Seine, June 28, 1997. All information about Claude Vamur is based on this interview.

27. Philippe Bernard, "M. Fodé Sylla remplace M. Harlem Désir à la tête de SOS-Racisme," *Le Monde* (September 8, 1992): 1.

28. Cathy Capvert, "Questions à Fodé Sylla (Président de S.O.S.-Racisme)," *l'Humanité* (April 29, 1996).

29. Antoine Fouchet, "On ne peut régulariser qu'au cas par cas: Entretien: Stéphane Hessel," *La Croix* (June 12, 1997).

30. Hélène Lee, author interview, Clichy, France, June 29, 1997.

31. Zoë Lin, "L'Orchestre National de Barbès, la musique connexion," *l'Humanité* (June 24, 1997): 23.

32. Eliane Azoulay, "Saga-cités," *Télérama* (March 11, 1998): 34.

33. Florence Aubenas, "Bled Runner," *Libération* (January 8, 1998): 25.

34. David Lepoutre, " 'Les Réunois,' i'mangent du mafé: Tensions interculturelles et acculturation dans une jeunesse de banlieue," *Migrants-Formation* 109 (June 1997): 168–183.

35. Samantha Cagica, "L'apport des marriages mixtes," *Libération* (July 15, 1997): 18.

36. Antoine Fouchet, "Même divisés, les sans-papiers poursuivent leur combat," *La Croix* (August 13, 1997): 5.

37. Philippe Martinat, "Jospin a dépolitisé l'immigration," *Le Parisien* (April 14, 1998): 15.
38. Nathaniel Herzberg and Fabien Roland-Lévy, "Lionel Jospin renonce à abroger les lois Pasqua et Debré," *Le Monde* (August 23, 1997): 7.
39. Beatrice Bantman, "Sans-papiers: l'impatience monte," *Libération* (October 4–5, 1997).
40. "L'oeil de Willem," *Libération* (June 12, 1997).
41. Christian Bachmann, Sophie Body-Gendrot, Guy Coq, Alain Finkielkraut, Nicole Le Guennec, Juliette Minces, Daniele Sallenave, Alain Seksig, Pierre-André Taguieff, Emmanuel Todd, and Georges Vedel, "Sortir l'immigration de l'arène démagogique: Onze intellectuals en appellent à la fin des passions," *Libération* (October 7, 1997): 3.
42. Freedman, *Immigration and Insecurity*: 49.
43. "L'opposition se scandalise," *Le Figaro* (December 23, 1997): 11.
44. A.F., "Chirac: La France ne sera jamais une mosaïque," *Le Figaro* (January 30, 1998).
45. Béatrice Bantman, "Chevènement maintient la sanction prison-expulsion," *Libération* (January 29, 1998): 5. For a detailed examination of the Chevènement law, see Mirielle Rosello, "Fortress Europe and Its Metaphors," *Working Paper Series in European Studies* 3:1 (1999): http://polyglot.lss.wisc.edu/eur/.
46. Élie Maréchal, "Sans-papiers: L'Église se défend," *Le Figaro* (April 8, 1998): 6.
47. "Des jumeaux séparés par la France," *Libération* (March 11, 1998): 4.
48. Nathaniel Herzberg, "Les régularisations de sans-papiers privilégient les familles," *Le Monde* (February 22–28, 1998): 4.
49. Philippe Bernard avec Anne Rohou, "Protestations contre le durcissement du projet Chevènement sur l'immigration," *Le Monde* (March 14, 1998): 3.
50. Olivier Bertrand, "Des sans-papiers se retournent vers l'église," *Libération* (March 9, 1998): 5.
51. Armelle Héliot, "Les sans-papiers s'en prennent à Chevènement," *Le Figaro* (March 19, 1998): 14.
52. Ariane Chemin, "Sans-papiers: des associations protestent contre les déclarations de M. Chevènement," *Le Monde* (April 3, 1998): 6.
53. Dominique Simonnot, "Alain Finkielkraut, philosophe: Le Gouvernement ne fait pas preuve d'acharnement répressif," *Libération* (April 8, 1998): 4.
54. Élie Maréchal, "Sans-papiers: l'Église se défend," *Le Figaro* (April 8, 1998): 6.
55. Jean-Alphonse Richard, "Air France refuse des expulsés," *Le Figaro* (April 27, 1998): 6.
56. Philippe Bernard, "Les reconduites de sans-papiers maliens vers Bamako ont repris sur Air France," *Le Monde* (April 28, 1998).
57. Freedman, *Immigration and Insecurity*: 49–50.
58. Philippe Bernard, "Les ouvertures de la loi Chevènement," *Le Monde* (September 25, 1998): 4.
59. Martinat, "Jospin a dépolitisé l'immigration," p. 15.
60. A.D. Bouzet and F. Devinar, "Création ministérielle d'un comité de vigilance anti-FN," *Libération* (April 10, 1998): 37.
61. Patrice Chéreau, Jean-Luc Godard, Anne-Marie Miéville, and Stanislas Nordey, "Sans-papiers: avant qu'il ne soit trop tard," *Le Monde* (May 13, 1998): 7.
62. Catherine Bédarida, "Un millier de parrains s'engagent à aider des sans-papiers," *Le Monde* (May 19, 1998): 5.
63. Stéphanie Meissonnier, "De l'acceuil de l'artiste étranger du spectacle vivant en France," Mémoire: l'Université Lumière, Lyon 2 (1998): 103–112.
64. Ibid.: 115.
65. Ibid.: 123–130.
66. Hélène Hazera, "22, revoilà Bourges," *Libération* (April 16, 1998): 2.
67. Bouziane Daoudi, "Maman Nzié, Crooneuse du Cameroun," *Libération* (May 29, 1998): 22.

68. Véronique Mortaigne, "Musiques métisses à Angoulême affirme son ancrage dans la ville," *Le Monde* (June 2, 1998): 23.
69. Roland Cayrol, "La société française reste taraudée par le racisme," *Le Monde* (July 2, 1998): 6.
70. Nonna Mayer, "L'ethnocentrisme caractérise la moitié de la population," *Le Monde* (July 2, 1998): 8.
71. Cayrol, "La société française reste taraudée par le racisme": 6.
72. Jérôme Jaffré, "La France est-elle le mouton noir de l'Europe?" *Le Monde* (July 2, 1998).
73. Nathaniel Herzberg, "Lionel Jospin déclare: Notre politique n'est pas de régulariser tous les sans-papiers." *Le Monde* (July 7, 1998): 4.
74. Raphaëlle Bacqué and Philippe Bernard, "Charles Pasqua suggère de régulariser tous les sans-papiers identifiés," *Le Monde* (July 17, 1998): 5–6.
75. Achille Ngoye, author interview, Paris, July 8, 1997.
76. Robby Cool (Manuel Mobolo), author interview, Paris, May 26, 1998. All information on "Robby Cool" is based on this interview.
77. Barry James, "Pop Radio in France Goes French," *International Herald Tribune* (January 2, 1996): http://www.iht.com/bin/print_ipub.php?file=/articles/1996/01/02/seine.t.php.
78. Ibrahim Sylla, author interview, Paris, July 2, 1997.
79. http://julienas.ipt.univ-paris8.fr/~culteuro/consult/28/creation.htm.
80. http://www.zonefranche.com/qui1.php.
81. François Bensignor, author interview, Paris, July 1, 1997.
82. Valérie Osouf, "www.africultures.com: Actualité artistique et critique culturelle africaine," *Le Monde* (April 7, 1999).
83. Nago Seck and Sylvie Clerfeuille, *Les Musiciens du beat africain* (Paris, 1993): 230.
84. Jim Winders, "Papa Wemba: Congo Style, Paris Fashion," *Rhythm Music* VII:6 (June 1998): 30.
85. Jocelyne Béroard, author interview, Saint-Ouen, France, June 25, 1997.
86. Frank Tenaille, *Le Swing du caméléon: Musiques et chansons africaines 1950–2000* (Arles, 2000): 205.
87. Véronique Mortaigne, "Papa Wemba, roi des sapeurs et précurseur du rock africain," *Le Monde* (July 28, 1995).
88. Papa Wemba, author interview, Bondy, France, June 29, 1996.
89. Winders, "Papa Wemba": 31.
90. Laurent Gervereau, Pierre Milza, and Émile Termine, eds., *Toute la France: Histoire de l'immigration en France auXXe siècle* (Paris, 1998): 184. On this page is a picture of Sally Nyolo with a small bottle she uses to "reproduce the sounds of Cameroon."
91. Sally Nyolo, author interview, New York City, November 2, 1997.
92. "Biographie: Sally Nyolo," rfimusique.com: http://www.rfimusique.com/siteFr/biographie/biographie_8869.asp.
93. Sally Nyolo, author interview, Paris, July 9, 1997. Unless otherwise indicated, all information about Sally Nyolo comes from the two author interviews.
94. Jim Winders, "Two *Chanteuses* Sing the Afro-European Blues," *Rhythm Music* VI: 3 (March, 1998): 52–53.
95. Nayanka Bell, author interview, Paris, July 8, 1997. Unless otherwise indicated, all information on Nayanka Bell is based on this interview.
96. Graeme Ewens, *Africa O-Ye!: A Celebration of African Music* (New York, 1992): 77.
97. Seck and Clerfeuille, *Les Musiciens du beat africain*: 71.
98. "Nayanka Bell," *Les Archives du MASA 95: Les spectacles:* http://masa.francophonie.org/francais/archives/masa95/spectacles95/. See also "Nayanka Bell," http://www.centrohd.com/bio/bio6/nayanka_bell_b.htm.

99. Gérald Arnaud, "Un pays fou de musique," *Africultures* 56 (July–September 2003): 118.
100. "Biographie: Henri Dikongué," rfimusique.com: http://www.rfimusique.com/siteFr/biographie/biographie_8906.asp.
101. Henri Dikongué, author interview, New York City, March 20, 1998. Unless otherwise indicated, all information on Henri Dikongué is based on this interview.
102. Christina Roden, "Henri Dikongué Does Not Play 'World Beat,' " rootsworld.com http://www.rootsworld.com/rw/feature/dikongue2.html.
103. "Biographie: Henri Dikongué."
104. Jean-Michel Cabrimol, author interview, Paris, July 10, 1997.
105. François Bensignor, "Le Gwo ka: nouvelle conscience des jeunes guadeloupéens," *Hommes & migrations* 1214 (July–August 1998): 105–113.
106. François Bensignor, "Musiques des Comores," *Hommes & migrations* 1215 (September–October 1998): 101–106.
107. José Sánchez Garcia, "La musique maghrébine, deuxième generation," *Courrier international* 413 (October 1–7, 1998): 27.
108. Mingus B. Formentor, "Barbès, une république née du métissage musical," *Courrier international* 447 (May 27–June 2, 1999).
109. Bernard Loupias, "La Planète des sons," *Le Nouvel observateur* (February 25–March 3, 1999): 18–20.
110. Sylvian Siclier, "Musiques d'Afrique et rencontres métissées au Festival d'Angoulême," *Le Monde* (June 13, 2000): 20.
111. Patrick Labesse, "La Carnavalcade à Saint-Denis, manifeste citoyen et multicolore," *Le Monde* (June 16, 2000): 29–30.
112. Françoise-Marie Santucci, "Titi africain," *Libération* (July 23, 1999).
113. Bouziane Daoudi, "Francis Bebey rejoint l'eau et le vent," *Libération* (May 29, 2001): http://www.liberation.fr/quotidien/semaine/20010529marzn.html.
114. Isabelle Monnin, "Le Rock des sans-papiers," *Le Nouvel observateur* (June 3–9, 1999): 21.
115. Philippe Bernard, "Sans-papiers; Le dernier carré des laissés-pour-compte de la régularisation," *Le Monde* (September 25, 1998): 3–4.
116. "Les Français moins hostiles au droit de vote des étrangers," *Libération* (November 11, 1998).
117. Véziane le Vezins, "Les sans-papiers défiant l'Europe," *Le Figaro* (November 16, 1998).
118. Alexandre Garcia, "Maintenant, régularisez, demandent 6000 manifestants à Lionel Jospin," *Le Monde* (November 24, 1998).
119. Antoine Fouchet, "Naïma, Sadia et Bintou, femmes et sans-papiers," *La Croix* (November 27, 1998): 8.
120. Philippe Bernard, "Un an de prison ferme pour un sans-papiers ayant refusé d'embarquer," *Le Monde* (November 28, 1998): 10.
121. Béatrice Bantman, "Les Pieds en France, la tête à Bamako: Trois Maliens ont choisi l'aide au retour," *Libération* (December 7, 1998): 3–4.
122. Dominique de Montvalon, "La tolérance gagne du terrain," *Le Parisien* (December 21, 1998): 19.
123. Sylvain Gasser, "Les sans-papiers cherchent un second soufflé," *La Croix* (March 18, 1999): 4.
124. Émilie Rive, "Les Prochains rendez-vous franciliens de la mobilisation," *l'Humanité* (March 18, 1999): 6.
125. Béatrice Bantman, "Prison pour les sans-papiers rebelles de Roissy," *Libération* (March 19, 1999): 7.
126. "Les sans-papiers investissent le theater de Chaillot," *Libération* (March 22, 1999): 15.

127. Serge Blisko, "Sans-papiers: Jospin, encore un effort," *Libération* (March 22, 1999): 7.

128. "Les sans-papiers oubliés," *Le Monde* (August 22–23, 1999): 20.

129. Jeanne Llabres, "Sans-papiers: la marche de la dignité et du courage," *l'Humanité* (August 23, 1999): 8.

130. Blandine Grosjean, "Chevènement en manqué d'expulsions," *Libération* (October 27, 1999): 3; Sylvia Zappi, "M. Chevènement souhaite améliorer l'efficacité des reconduites à la frontière d'étrangers," *Le Monde* (October 28, 1999): 5.

131. Emmanuel Terray, "La victoire de Jean-Louis Debré," *Le Monde* (November 2, 1999): 19.

132. Sylvia Zappi, "Les conditions d'existence des sans-papiers régularisés restent précaires," *Le Monde* (November 20, 1999): 5.

133. Anne-Marie Revol, "La mort du miraculé du Dakar-Lyon: Le dernier voyage du jeune Sénégalais," *Le Figaro* (September 6, 1999): 34.

134. Nicolas Weill, "Après des années de baisse, les chiffres de l'immigration ont augmenté en 1997: Cette hausse s'explique par la régularisation des sans-papiers," *Le Monde* (April 1, 1999).

135. Sylvia Zappi, "L'immigration non européene a augmenté de 55% entre 1997 et 1998," *Le Monde* (January 13, 2000). Michèle Tribalat, member of the Haut Conseil à l'Intégration (HCI), was highly critical of the statistical methods on which the report was based. See Franck Johannes, "Immigration: les statistiques en question," *Libération* (January 25, 2000).

136. Freedman, *Immigration and Insecurity*: 17–18.

137. Éric Biétry-Rivierre, "Black micmac rue Doudeauville: Château Rouge, symbole du Paris cosmopolite," *Le Figaro* (November 12, 1999): 16.

138. Sylvia Zappi, "Chiffres records pour les acquisitions de nationalité en 1998: La réforme Guigou jaugée pour la première fois," *Le Monde* (April 5, 2000): 3.

139. Laurence Caramel, "L'immigration, prochain stimulant de la croissance?" *Le Monde* (June 20, 2000).

140. Madjiguène Cissé, "Les sans-papiers ne sont pas des délinquants: Tribune: pourquoi remplissent-ils les prisons?" *Le Nouvel observateur* (January 27–February 2, 2000): 29.

141. Solenn de Royer, "La sans-papière rentre au Sénégal: Madjiguène Cissé," *La Croix* (July 25, 2000): 3.

142. Charlotte Rotman, "Sans-papiers et sans espoir," *Libération* (June 24–25, 2000): 18–19.

143. *Le Nouvel observateur* (February 8–14, 2001).

144. Sylvia Zappi, "Le nombre d'étrangers en France a baissé de 9% entre 1990 et 1999," *Le Monde* (November 18, 2000): 4; "L'immigration africaine a change de visage," *Le Monde* (November 18, 2000): 5.

145. Béline Pobert, "La bonne fortune d'un sans-papiers," *l'Humanité* (August 4, 2000): 7.

146. Frédérique Pelletier, "L'ex sans-papier s'offre un cybercafé," *Le Figaro* (October 18, 2000).

147. Charlotte Rotman, "Le voyage organisé d'un ex de Saint-Bernard: Ababacar Diop guide six Sénégalais dans la vraie France," *Libération* (August 23, 2000): 10.

148. Henri Dikongué, author interview.

149. "Nouvelle nuit de testing sur les pratiques discriminatoires des boites de nuit," *Le Monde* (May 26, 2001): 4.

150. Isabelle Fontaine, "Les Oubliés de la Grande Guerre," *Le Nouvel observateur* (January 10–16, 2002).

151. Sylvia Zappi, "Lionel Jospin annonce la creation d'un musée de l'immigration," *Le Monde* (November 24, 2001): 4.
152. Calixthe Beyala, "Les Africains-Français attendent," *Le Monde* (March 12, 2002): 36.
153. Rémi Carayol, "Sans-papiers: 1400 km pour exister," *Libération* (April 26, 2000): 24.
154. Fodé Sylla, "Notre France mérite mieux," *Libération* (May 2, 2002).
155. Gérard Noiriel, *État, nation et immigration: vers une histoire de pouvoir* (Paris, 2001): 223–224.

Part III

Millennial Mutations: African Parisians,
Parisian Africans

Chapter 6

Paris, Dakar, and Bamako: New Directions in Music and Migration

During the late 1990s and the opening years of the new century, Paris continued to provide a base for many African musicians, and for many others it remained an important destination for recording and performing. Certainly it was no longer the center for African music (although arguably it was a major center for "world music" in the broadest sense of that phrase), instead sharing that role with London and New York. At the same time, through a combination of circumstances, the African cities of Dakar and Bamako—especially Dakar—developed as thriving centers for musicians who, in previous years, may have been inclined to head for Paris. Dakar's emergence as a significant base for musicians was signaled in part by Mamadou Konté's move there in 1994, where he founded an association called Tringa, dedicated to promoting African music and culture much as his Africa Fête had done in France.[1] From Dakar, Konté organized an annual Africa Fête international tour that flourished especially during the late 1990s.

Wherever they were based, African musicians during this period explored a number of different directions. These ranged from a return to traditional genres to hiphop. In some circles, a backlash against what some viewed as excessively Western pop-style production set in. Angélique Kidjo and Papa Wemba were among those who received this kind of criticism during the mid-to-late 1990s. In part, the resentment may have stemmed from the frustrations of musicians who felt the doors of major multinational record companies slamming in their faces. They typically commented that the "majors" were interested only in records that promised huge sales in the lucrative Occidental market. Each musician or African music aficionado seemed to plot his or her own line, which, when crossed, meant the music was no longer "African." Youssou N'Dour's (1959–) "7 Seconds," a duet with pop singer Neneh Cherry released in 1994 on his album *The Guide (Wommat)*, was roundly criticized in just this way. It became a huge international hit. When I interviewed Ray Lema in 1995, he expressed real anger over the song, declaring that it did not qualify as African music. Switching to English, he blurted out "Stop that crap! My goodness!"[2]

Some might see irony in Lema's reaction, since he became known originally as someone who performed African music on electronic instruments. However, his intention nevertheless had been to remain faithful to traditional sources. In fairness to Youssou N'Dour, we should acknowledge that in more recent years he also has explored more traditional styles in his recordings.

Return to Tradition

François Bensignor described the period from approximately 1993 to 1997 as a time of "strong debate over African music," especially over "the return to tradition." He explained further that some insisted "that there is *a* tradition that should remain as it is, and that excludes all mixing (*tout mélange*)."[3] Those who embraced the new emphasis on traditional forms of African music often expressed the view that people finally were coming to appreciate "real" African music rather than the heavily produced world music that had been the sensation of the 1980s. When I spoke with Francis Bebey in late 2000 and commented that a rediscovery of traditional genres had been underway in recent years, he was incredulous but said that if true, this news "would please me enormously."[4] Some persons associated with the "new" traditionalism had themselves previously been known as champions of such world music stars as Touré Kunda or Kassav'.

One important example was Philippe Conrath, who in 1989 founded the annual festival Africolor. Based in Saint-Denis, this late December event became known for the high profile it gave musicians of Mali and the Malian residents of Saint-Denis. Malians were not the only ones represented during the several days devoted to the festival, but each year the Christmas Eve concert bill was exclusively Malian and exclusively acoustic with traditional instruments. Africolor's reputation for such an emphasis developed gradually. The 1989 festival, while featuring the multi-instrumentalist Sorry Bamba (1938–) of Mali, an interpreter of the traditional music of the Dogon people,[5] also included such world music stars as Papa Wemba and Ray Lema.[6]

The same year Conrath inaugurated the festival, he revived his record label Cobalt (see chapter two), and has sought to operate it in tandem with the festival, especially to aid artists who otherwise could not hope to land recording contracts. To find musicians, Conrath worked closely with Malian associations—both in Paris and Bamako—and the inhabitants of the workers' *foyers*,[7] where regular weekend concerts were held. "Music is their life," Philippe Conrath said to me when I interviewed him in 1997, pointing out that the residents of the *foyers* sought to reproduce in them the structures of their home villages.[8] We spoke in the Africolor headquarters in the rue de Ménilmontant, near an area of Eastern Paris where many Malians reside. In Conrath's view, it was not correct to view the 1990s as a time of decline for African music in Paris. "African music is strong," he declared, "There is a return to tradition, to melody, to acoustic instruments that is very interesting." He contrasted what he called the "new wave" of traditional, acoustic music with what he now disparaged as the "kitsch" of African music played on Western electric instruments. He acknowledged, however, that traditional acoustic African music occupied only "a very small place in the market."

It was clear that Philippe Conrath wanted to assist the embattled Malian community, which he called "the most important African community in France." He especially emphasized the historically important presence of the Soninké people as immigrants in France, known as they were for contributing so much to their home villages. We spoke just after the Jospin government had taken office. Although this made him somewhat optimistic, he nevertheless deplored the worsening climate for African immigrants in France. Referring to the *sans-papiers* movement, he summed up the changes in France this way:

> Twenty years ago we spoke of the immigrant laborer; ten years ago, we spoke of the immigrant, and today we speak of the illegal immigrant (*le clandestin*).

As a promoter, organizing concerts and tours for African musicians clearly had become a headache. "It can take one to three months to secure a visa for an artist," Conrath explained. But he clearly was proud of the work he had been doing with *mandingue* (from Mali, Guinea, and Gambia) musicians in the Africolor concerts. "There is a large Malian community here," he said, and was pleased that they were well-represented in the concert hall of the Théâtre Gérard-Philipe[9] (located at the Métro terminus) in Saint-Denis. "It is very, very congenial in the hall," Conrath said with evident satisfaction.

Increasingly, the Africolor festival became known as a meeting place both for touring African musicians and those residing in France, some of them former *sans-papiers*, and some still seeking regularization. The December 1997 festival included an evening devoted to music of Cameroon (featuring Sally Nyolo and Henri Dikongué), an evening of Congolese music headlined by Ray Lema, and the Christmas Eve Malian concert with Sorry Bamba and the duo Amadou et Mariam (the former an accomplished electric guitarist), among others. Writing in *Le Monde*, Véronique Mortaigne used the occasion to call attention to the importance and vitality of Malian music, including the prominence of such female singers as Nahawa Doumbia and Oumou Sangare, and the acoustic blues style of guitarist Ali Farka Touré.[10] In July 1999 Conrath put on a summer version of Africolor that featured such traditional players as Moriba Koïta, master of the *n'goni*.[11] When I interviewed Conrath, he spoke quite a lot about his enthusiasm for Koïta, who recorded for his Cobalt label.

One must be careful when using the term "traditional" in any absolute sense where music is concerned. Even the seemingly "purest" forms of African music are themselves products of decades of articulation with European genres brought to the African continent and Western styles returning across the Atlantic. On the surface, the *griots or jelis* of Mali with their acoustic instruments and typically native costume would appear to offer something like a thoroughly traditional musical performance, especially as featured in the annual Christmas Eve concerts. Yet some of these very same musicians might alternate between playing for Paris audiences using traditional instruments and recording or performing in Bamako with electronic instruments.[12] They are capable of assuming varied roles as performers, for example, Papa Wemba with his two entirely different bands (see chapter five). Such moves may be due to changing professional considerations or assumptions about audience

expectations, but they may hint as well at the desire of African musicians in Paris to inhabit more than one type of cultural identity, to be Parisian up to a point, yet to cling to African roots. Whether the subject is music or national affiliation, one single definition can be seen as too limiting.

The role of *griot* is one that does not always sit comfortably with those who inhabit it. The *n'goni*, the four-stringed (usually) lute that typically accompanies both the *kora* and the *balafon* (a kind of wooden xylophone struck with mallets), is the instrument most associated with the *griots* of Mali, and thus Moriba Koïta (1948–) fits that definition. He came from a family of *griots* in the village of Kenenkoun, fifty-five kilometers from Bamako, and was trained by his father, beginning to play at the age of four.[13] During his years in Mali, he played widely with traditional musicians as well as with new-style stars such as Salif Keïta.[14]

He moved to Paris in 1993, after having made previous trips to perform with musicians during the 1980s. Philippe Conrath encouraged him to relocate to Paris, where he became part of the large Malian community in Montreuil. Once in Paris, he began to perform with his own traditional group Sorotoumou, as well as with such well-established musicians as Manu Dibango, Mory Kanté, and Nayanka Bell. His first album, named for his group, was released on Conrath's Cobalt label in May 1997.[15] After agreeing to be interviewed in July 1997, Koïta arranged to come in from his home in Montreuil and meet me near a rehearsal studio (*salle de répétition*) in a relatively obscure part of the Twentieth Arrondissement. Our rendezvous was to be at the Métro station Maraîchers. The musician described himself to me and I to him so we would recognize each other. When I arrived at the station, true to his description, I saw a tall, imposing man garbed in a large *boubou*. He had a ready smile and we chatted amiably as he led me to the Studio in the nearby rue du Volga. The name of the studio was Mercredi 9.

We settled into one of the rehearsal rooms, and he showed me the two types of *n'goni* he plays, a larger one with four strings and something of a bass tone (*n'goni Ba*), and a smaller one with three strings, a treble version of the instrument (*n'goni Micin*).[16] He explained that younger players in Mali were in the habit of adding extra strings, sometimes up to seven. This was true also of certain ethnic groups, but not of the Bambara, his own.[17] During the interview he paused several times to play for me. He pointed out that although he specialized in traditional music, he had accompanied musicians who use electronic instruments. He mentioned his work with Manu Dibango, Mory Kanté, Salif Keïta, and Nayanka Bell. The foundation of his career had been established in Mali, where the minister of arts and culture selected him to be the *n'goni* player for the Ensemble Instrumental du Mali, a group based in Bamako but charged with traveling throughout the country to perform, He did this from 1978 to 1989. By this time he had begun to make his name in Europe, and he journeyed to Nice where he was based for two years.

Since 1993, after his meeting with Philippe Conrath, he had been in Paris (living in Montreuil). I asked about his family, his residency status, and his intention to remain in France. He said he was the only member of his family in France. His older brother remained in Mali. "He is the head of the family now and can no longer move," Koïta explained. He said that he was expected to help support the family, adding that "When I find something, I send it to them." As for his status in France,

he said, "I have a *carte de séjour* good for one year, and it is renewable, thanks to Philippe (Conrath)." He also said that he intended to stay in France as long as his career was going well.

The success of his career clearly was linked at that time to the prominence of the Africolor festival and the traditional Malian players who remained its central focus. I asked him if he preferred the term *griot* and he said yes, that he had inherited the role from his father. However, he expressed real ambivalence about the role, pointing out that in the strictest sense, the definition of *griot* set limits on who could be allowed to play certain instruments. As he explained:

> If you are a *griot*, you cannot be considered a musician at the same time. But you are required to make music. You can be a musician, but that does not make you a *griot*. But you cannot play the *n'goni* if you are not a *griot*.

While on the one hand he acknowledged that the role of *griot* had been the basis for his musical career, on the other he found it confining. Like most dedicated musicians, he wanted to be appreciated beyond rigid categorical boundaries, and argued that music has no borders. Also, he felt that the status of *griot*, originally defined as someone tied to one certain noble, had become dispersed throughout broadly evolving styles of modern African musical performance, especially as it encounters new audiences and cultures. "The *griot* belongs to everyone now," he asserted. Savoring his own successful career, he added, "I belong to the French and to the Americans."

During the late 1990s, one of the surest places where one could find compact discs by artists such as Moriba Koïta was Cinq Planètes, a small shop in the rue Saint-Sébastien, just a few steps away from the St. Sébastien–Froissart Métro stop. The shop was jointly owned and managed by two musicians, Philippe Krümm and Jay Ryan. Krümm was a folk musician specializing in the Breton accordion, and Ryan was an expatriate American bassist. Their store had a world music inventory in the older folkloric sense of *musiques du monde*. In 1997 the two partners established an independent record label also called Cinq Planètes, and its catalogue was exclusively devoted to traditional music. One series featured solo recordings of masters of traditional instruments such as the *kora* or the Moroccan *oud*. They also released collections of specific musical genres or regions, including the Cajun and Creole music of Louisiana and the French *musette* tradition.

I interviewed Philippe Krümm in his office adjacent to the shop. A pleasant man with an infectious and ready laugh, he talked of his background, which had included journalism and recording production. "But my passion," he said, "is traditional French and European music."[18] He had been quite active on the folk festival circuit, and was in demand as an accordion player. It was clear that he had a strong interest in African music, especially of the traditional variety. In response to my question about the recent vogue for traditional music, he stated that "after twenty years, there are young people who have arrived and who have reclaimed traditional music." He complained, however, that it was next to impossible to find "roots" music (*musique des racines*) on French radio stations. As an enthusiast for traditional French music, he said that in order to have his music played on even as progressive a radio station as Radio Nova, "It's easier if I play exotic music." Despite the fact that the radio

language law seemed aimed at foreign performers, Krümm argued that "it is easier for a foreign artist to debut in France today than for a French artist." He said this with a hearty laugh, rather than with any apparent bitterness. He added that record companies currently were seeking only dance-oriented hits, which was another strike against the kind of music he wanted to promote.

As for African music, he denied any great expertise, but it was clear that he was quite knowledgeable about it, and that the 1980s had been the decisive decade in that regard. He said that "principally" he had worked only with traditional African musicians, and he mentioned several countries, including Madagascar (The Malagasy Republic). Krümm spoke of the Malian community in Paris, which he described as "strong." He cited the singer Mah Damba as a good example of someone drawing on traditional sources, and plugged Djelimoussa Cissoko, a Malian *kora* master he planned to release on his record label (in the series *Soliste*, devoted to master musicians playing solo). The great French specialists on African music, Krümm said, were Philippe Conrath and Christian Mousset. As for what made Paris the center of new African music during the previous decade, he said, "Mamadou Konté and Philippe Constantin—they are the people who really worked for African music." He then reminded me that Constantin had died in 1996. He reminisced as well about some of the specific artists and genres that had gained popularity during the 1980s, including Cheb Khaled, among other musicians of the Maghreb. He spoke also of the importance of such South African artists as Ladysmith Black Mombazo and Johnny Clegg. Although Krümm tended to divide music between traditional and pop categories, one got the impression from his conversation that he understood "folk" music casts a very wide net.

One of the more unusual groups performing traditionally based African music in Paris during the 1990s was the *a cappella* vocal sextet "Nipa." The name means "human being" in the Ashanti language,[19] actually a family of six languages found within an area overlapping the border between Ghana and Côte d'Ivoire, where the group's founder Pierre Wognin (1953–) lived and carried out his ethnomusicological research.[20] Nipa debuted in 1991, under Wognin's leadership. Wognin, one of the tenor singers in the sextet, was born in Côte d'Ivoire and later lived in Ghana (the two countries historically exchanged a portion of their respective populations). The other five members were Ahmed Barry (tenor) from Guinea, Paul Nemlin (bass) from Côte d'Ivoire, Jerrika Gustave (alto) from Martinique, Xénia Caraïbe (soprano) from Guadeloupe, and Shawna Wilkerson (soprano) from the United States. Wilkerson sang on Nipa's first album (released in 1993), but was replaced by another soprano named Angélique Annonier from Cameroon. Their music was based on the Ashanti songs Pierre Wognin had studied, but each member brought to the arrangements the specific musical influences of the African (e.g., "high life") or Caribbean (e.g., salsa) locales from which he or she had originated.[21] They became known for a complicated polyphonic vocal style that owed much to traditional sources, yet could seem at the same time futuristic in its innovative arrangements. Nevertheless, they became associated with the traditional musical emphasis taking hold in Paris, and made their first appearance at Africolor in December 1993.[22]

I had become aware of Nipa through meeting and interviewing Xénia Caraïbe (see chapter four), who put me in touch with Pierre Wognin. He agreed to meet me for

an interview in a café. It was not just any café but the Café des Phares on the Place de la Bastille. This was the original "Café Philo," where people met each Sunday for discussion and debate (see chapter seven). We spoke amid the hustle and bustle and constant clatter of coffee cups, saucers, and spoons being placed on tabletops or being cleared away, but Wognin spoke earnestly and forcefully, mindful of the little tape recorder placed between us. He began by giving me a linguistics lesson in which he listed the six languages that make up the Ashanti group, the source for much of his music. I then asked about his background. He explained that he taught music for a while in Côte d'Ivoire, and then (the first of his family to do so) came to France in October 1975 as a scholarship student to the École Normale de la Musique. There he studied ethnomusicology. At the time we spoke, he was working on a masters' degree.

His career as a musician began in 1979. He recorded a solo album that year, and another in 1983. By this time, he was performing with other musicians, exploring traditional sounds. As he reminded me, this was the same period during which African music in Paris was being defined by such musicians as Touré Kunda and Ray Lema. World music, which he saw as an amalgam of African and Western "colors," developed somewhat at the expense of traditional African music, in Wognin's opinion. Despite his dedication to the regional traditions he had studied, he expressed enthusiasm for such modern masters as Otis Redding and James Brown, and said he enjoyed rhythm 'n' blues, salsa, and reggae. He added that he appreciated all types of traditional music. It was better to be an African musician in France during the Mitterrand years, he said, "because people had access to many things, and had more respect. With the Pasqua Laws, it is worse, but it is necessary to remain in France for my career." At least for the moment, this was how it seemed, because, Wognin said laughing, "I love my place in the sun."

I wanted to know if he had experienced discrimination in France, or if he considered it to be a racist country. Very matter-of-factly, he said that discrimination is something found "on a daily basis," but it is necessary to deal with it "if one is to find a place in the sun," again accompanying this phrase with laughter. Of France, he observed that "I think France is a racist country, but whether it is more racist than others, I don't know." At least during the previous decade, there had been more openness "to foreign music in general." Now one encountered more obstacles, especially a musician not associated with a major recording company (Nipa's debut album was released by the independent label Buda Musique in 1993; their second disc by Sonodisc in 1999). Pierre told me he had retained his Ivoirean citizenship, and was married with two children. He said that from time to time he returned to Côte d'Ivoire "to see my family, to work, and to play (music)."

In characterizing Nipa's music, Wognin emphasized the importance of the melodies, which were intended to be "as faithful as possible to spoken language—to languages spoken in the field," that is, the Aboure, Agni, and other languages of the Ashanti whose music was his immediate inspiration. While the music was traditional, Wognin said, the arrangements were "Western" and "modern," making Nipa's music, especially given its diverse membership, a kind of music "between continents." The various members of Nipa, he said, not only come from different countries, but have had different experiences of living in France. These experiences shape the music and create interesting directions for it. It was important to show, he said, that African

music is not "fixed," that a style can be traditional, yet ever-changing. His remarks served as a reminder to avoid assumptions about what constitutes traditional performance. The division between traditionalism and modernism is not necessarily absolute.

Wognin said that he hoped to create "traditional music as lived in the modern city," a remark that both helps explain the decision to live in a major world city and that states more precisely the position he sought to stake out between the two poles of traditionalism and modernism. He said he would like for Nipa's music to become known to a larger public, including in the United States. He would also like to conduct musical workshops at universities, he added. Sounding almost like Mamadou Konté, he expressed the hope that by gaining wider exposure, audiences would get from Nipa's music more understanding and "respect" for the cultural differences and traditions embodied in the music.

Pierre Wognin had a number of things to say about the legacy of colonialism and contemporary patterns of migration. He reflected that his childhood had begun in colonial times and that eventually he had found himself in Paris, "trying to exist in a global context." His interest in languages began early, in a family that valued both French and their native languages. Once in Paris, he faced new questions of cultural identity. "To be a person from a traditional culture," he observed, "and at the same time to live in a modern culture with its constraints—I had to adapt." He faced questions of "authenticity," both personally and as a musician. Once you are no longer defined by living in your traditional village, said Wognin, you confront the necessity of continued development.

Conditions have changed significantly for Ivoirean immigrants since he came to France, Wognin explained. In the 1960s and 1970s young Ivoireans were itching to come to France. Now, in the 1990s, said Wognin, "France is no longer in fashion." By that point the United States and England had become the preferred destinations for those seeking their fortunes abroad. Of course, this had much to do with the greater difficulty facing those who tried to enter France during the 1990s, in marked contrast to the 1980s. "If you ask for a visa at the French embassy, you will not get it easily," Wognin remarked. He also explained that Côte d'Ivoire had imposed visa requirements on French people in retaliation. As for those Ivoireans who still managed to come to France, "in general," he said, "it is to pursue their education (*pour faire les études*)." The difficulty for Ivoirean musicians in France, said Wognin, was that their music was not represented on any of the major record labels. How to combat this problem? Pierre Wognin spoke of the necessity for African musicians to inform themselves, to read, and to improve their access to information.

French Rap and African Music

For French young people during the 1990s and beyond, as for young people globally, the most popular music was rap (or, as more broadly defined, hip-hop). Easy to find on the radio dial, rap music appealed especially to the young denizens of the bleak *cités* or housing projects of the suburbs of Paris and other major French cities, such as Marseille

(for many, the center of French rap, especially among its large youthful Arab population) and Lyon. Beset by high unemployment rates and menaced by the police, the youth of the *banlieues* identified with the oppositional style of the music that had originated in the South Bronx and other major American inner cities. Often, the affinity French rap enthusiasts felt for inner-city blacks in the United States expressed itself in a preference for "gangsta" rap with its violent motifs and confrontational attitude. Most French rap, however, has not adhered to this style. One of the most important differences between French and American rap has been that, as one author has put it, "In contrast to the United States, the common denominator of rappers is not skin color."[23] At the same time, it is true that the popularity in France or such black musical genres as jazz, rhythm 'n' blues, soul, funk, and reggae helped pave the way for the reception of rap music.[24] The popularity of hip-hop and rap music spread throughout France. In 1997 the city of Nantes became the site of the annual "Festival Energ'hip-hop."[25]

The often-repeated triumvirate *black/blanc/beur*, applied to the French national football team (see chapter five), is an apt phrase for much of French youth culture, and certainly fits the hip-hop culture. This point was underscored vividly by Mathieu Kassovitz in his extremely successful 1995 film *La Haine* (*Hate*). The film captured the grim reality of the suburban Paris housing developments, and centered on a trio of friends united by their love of rap music and their resentment of the police. One was white (*blanc*), one an African immigrant (*black*), and one of North African origin (*beur*). The film was linked to hip-hop culture not only through its soundtrack and overt references to the music, but Vincent Cassel, one of the lead actors, is the brother of a "hardcore" rapper called "Rockin' Squat," from the group Assassin.[26] The most notorious of French hardcore rap groups is N.T.M. (their initials stand for *Nique ta mère* meaning "Fuck your mother").

Rap music in France appealed to all young people who felt excluded,[27] such as those from immigrant families, and the *black/blanc/beur* catchphrase was all but inescapable in the French media whenever hip-hop culture was the topic. Hip-hop culture has always included dance, so it did not seem surprising that some contemporary dance troupes made use of "break-dancing" moves (or French versions, including one style called "smurfing").[28] One company in particular called itself "Black Blanc Beur."[29] Another element (and a very controversial one) of hip-hop aesthetics that took hold in Paris was the practice of spray-painting (known as "tagging") walls of buildings and other available surfaces, as anyone who travels past the RER stations between the Gare du Nord and Roissy can see.[30]

To someone whose ear is accustomed to American rap music, much of French rap has a decidedly different tone, with more smoothly flowing vocal lines that at times seem to owe as much to French literary traditions as to musical influences. Olivier Cachin goes so far as to describe some French rap performances as making use of "the language of Molière."[31] The French rapper especially known for this kind of delivery, and for many years the biggest name in French hip-hop circles, is MC Solaar, born Claude M'Barali[32] in Senegal in 1969. He has lived in France since his infancy. He studied philosophy and literature as a university student, and has been known to mention such writers as Diderot and Rimbaud in interviews.[33] He burst upon the scene in 1991 with his first album *Qui sème le vent récolte le tempo*,[34] and his second album *Prose combat*, released in 1994, sold six hundred thousand copies.[35]

The singer has been enormously influential not only in music, but also in contemporary French politics. He has spoken out especially against the xenophobic politics of Le Pen, so that he has played the role of an "anti-Le-Pen" whose opinions are sought by the media. One headline referred to him as "le philosophe hip-hop," as if to include him in the grand French tradition of *engagé* public intellectuals.[36] A further tribute to the influential role he has played in French culture came when the organization Droit du Cité and the huge retail chain La FNAC teamed up to sponsor a program to encourage young people's interest in writing. The name of the program was "Prose Combat."[37] This idea reminds one of observations sometimes made in the United States about rap lyrics encouraging greater literacy.

In April 1998 MC Solaar headlined the annual festival *Le Printemps de Bourges*. The festival, which I was able to attend, took place over several days of relentless rain, but the spirits of MC Solaar's many admirers certainly were not dampened. The climactic concert of the opening night of the festival featured MC Solaar and a fellow rapper who calls himself Bambi Cruz. The stage show was loud and flashy, with dancers, a drum machine, and electric keyboards positioned on a scaffold above the stage. MC Solaar kept appearing in different hats, including an aviator cap with fur-lined earflaps and, for his encore, an oversize collapsible bright orange hat. The concert, interspersed with the singer's impromptu remarks to the audience and featuring his often pointedly topical lyrics, managed to be both glitzy and political without delving into any of the violent gestures many audiences have come to expect from rap shows. MC Solaar's determination to remain a very positive public figure aids him considerably in his effort to combat racist politics.

On the afternoon of the festival's first day, prior to his evening concert, MC Solaar granted an interview to a group of journalists, and I was permitted to sit in. A conference room in the hotel where he was staying had been appointed for this purpose. The singer arrived and, African-style, went around the room shaking each person's hand. Then he took a seat behind a table and began fielding questions. Many of the questions had to do with the festival and its arrangements. He spoke of having had some difficulty with his tour arrangements, and expressed pleasure that he was able to be at the festival. One questioner wanted his opinion about security arrangements for the festival, and for his concert in particular. He responded calmly, saying it was to be expected because of the "tendance rap." One cannot really criticize the police presence, "Solaar" said, since the festival depends upon the national government and the local prefecture. A headline from a local newspaper lying on a nearby table caught my eye: "Soutenir le Printemps est un acte républicain" ("To support the Printemps is a republican act"). A number of political topics surfaced, including the approaching thirtieth anniversary of the May 1968 uprising. MC Solaar responded patiently to all questions, no matter how repetitious (as some were), and spoke quite knowledgeably about a terrible child abuse scandal in Belgium that was capturing headlines for the moment. The interview took the better part of an hour, then MC Solaar thanked everyone for coming, and chatted amiably with us as the session broke up.[38]

Like MC Solaar, a number of the people involved in rap music in Paris were of sub-Saharan African origin. Typically, they represented a younger generation than the one that figured at the center of the world music culture of the 1980s. Some of them, like their predecessors, had begun their musical careers in African countries. Others,

also like some of their predecessors, had arrived in France to pursue their education and subsequently had taken up music. A good example of the latter type was Edgar Yonkeu (1967–), who came to France from Cameroon as a student at the age of seventeen.[39] His parents were educators—his father a director of the École Normale Supérieure du Cameroun and his mother a lycée professor. He seemed headed for an academic career in mathematics, but he chose music instead. Two years after arriving in France, he released his first album, but he would gradually move from singing to producing. He worked with rap groups and with Nayanka Bell, among other artists.[40]

My meeting Edgar Yonkeu was a result of my visit to Studio Zorrino in Saint-Ouen, on the same day I interviewed two of the members of Kassav' and also was introduced to Nayanka Bell (see chapters three and five). He was in the studio that day to produce a rap group from Côte d'Ivoire called MAM. Yonkeu explained that he was one of four members of his family living as immigrants in France. The others worked in a variety of occupations or pursued advanced studies. He was not a French citizen and said he felt "more attached to Cameroon," but found it necessary to be in Paris for his musical career. The music business in Cameroon, he said, was not well-regulated, and musicians faced the constant vexation of recording piracy. He mentioned a well-attended concert in Cameroon in which it seemed everyone there had pirated copies of the musicians' cassettes.

For him, being an African in Paris meant enjoying his African and Antillean friends, and "speaking (his) own language at home." As someone involved in music, it meant being able to work with the "good African musicians (who) are always coming to Paris." It was necessary for African musicians to record and perform in Paris, he argued, saying, "If we play in Paris, we are more accepted in Africa." This was a view I was to hear expressed by other African musicians, whether or not they chose to reside in Paris. Yonkeu was critical of so-called world music, saying that "For me, it is Western music." For a disparaging example, he employed the familiar whipping boy of "7 Seconds" by Youssou N'Dour. "World music is not African music," he repeated, adding, "It is music for the international market." In music, Yonkeu said, there is always the necessity of roots (he used the English word). He said that traditional African rhythms were complicated and sophisticated, and furthermore that "identity" was linked to rhythm. In fact, for him, the appeal of the beats in rap music was similar to the communicative power of the *tam-tam*, or talking drum.

That search for identity through rap music was taking place in the Parisian *banlieues*, Yonkeu said. He was also quick to argue that French rap was less "violent" than American varieties. He was speaking especially of gangsta rap. The future of African music, Yonkeu believed, was in rap—*la musique de demain*, he called it. Despite the mixed fortunes for African musicians currently trying to pursue their careers in Paris, he said he believed that the African presence here was permanent. This would not apply to all recording studios, since some were, in his opinion, only appropriate for what he called Western music. The vitality of the immigrant music in Paris for Edgar Yonkeu lay in what he characterized as the African Antillean *mélange*. It was all really the same music, he said, but added, "Each keeps its own rhythms." Yonkeu's optimism about the prospects for the music he was involved in was matched by his hopeful attitude about the new direction in French politics. The Jospin government was

newly in place when we talked. Before turning to that subject, we had spoken about race and immigration. "Most French people are not racist," he asserted. Because of the Jospin government, Yonkeu pronounced himself "more hopeful."

Further out from Paris, northeast of Saint-Ouen and Saint-Denis, lies the multi-ethnic (more than one hundred ethnicities estimated) suburban community of Sarcelles, an area known for high unemployment and a (especially juvenile) high crime rate. This zone of soul-killing *cités* provided the base for a number of rap groups during the late 1990s. Among the best-known groups were Ministère AMER (standing for Action Musique et Rap) and Neg'Marrons. The name of the latter group carried a particular political message, deriving as it did from the escaped slaves of the Caribbean region.[41] It suggested flight and abandonment of the surrounding society. In late May 1998 I chanced to meet twin brothers Benjamin and Peter Ndocko from Cameroon, two rappers who called themselves "Masao" and who lived in Sarcelles.

I met them thanks to Nya Soleil, the Cameroonian musician and political activist who organized a concert in commemoration of the 150th anniversary of the abolition of slavery in the French empire. The concert, which featured Nya Soleil, Masao, and several other acts from Cameroon, took place at an arts center in the Twentieth Arrondissement. In typical fashion for African musicians, the concert went late into the night, and the set by Masao was one of the highlights. As twins, they exhibited a powerful rapport that was compelling to witness. After the concert, Nya Soleil introduced us, and they agreed to meet me the following week for an interview.

They picked me up in their car by the Métro stop at Porte de Clignancourt, the designated rendezvous spot. Then we drove out toward Sarcelles and around, all the while listening to *Esewe*, their debut compact disc, on the car player. They were giddy with happiness about their record, and commented in detail on the songs. After driving for a while, they headed back into Paris, and we parked and went into a small African bar (somewhere in the Eighteenth Arrondissement) for our interview. We greeted the proprietors and then settled in for our interview. Ben had more to say than Peter, but the latter took over the conversation at several intervals. The discussion began with the subject of their origins and their arrival in France. They were born April 18, 1963, in Tombel, Cameroon, near the Anglophone area of the country.[42] As children, they performed in church choirs. They had been called Benoît and Pierre,[43] but now used Anglo names. While still "very young" they had left Cameroon and traveled in Africa. Peter said that he even worked for a while on an oil tanker. They arrived in France in 1979. Even though they had performed as disc jockeys in Cameroon, music was not the reason for their coming to France.

Very soon after arriving, however, they resumed their "DJ" activities, and traveled widely in Europe, especially in Germany and England, where they performed in discos and came into contact with many varieties of music (at the time I interviewed them, the Ndocko brothers were keeping up with their sideline as DJs. They were featured at a concert-dance "until dawn" May 30, 1998 in Nanterre).[44] They especially liked to experiment with reggae. Gradually they developed their own rhythmic style, based on an ancestral dance of the Bantou Douala people of Cameroon.[45] The name for this dance is *esewe*, and the Ndocko brothers used it as the title of their album released in late 1997. The album, which they said they had been urged by friends to make, took them "almost five years," Ben said, "Because we prepared it

little by little. We didn't have much money, and it required a lot." In the course of putting the album together, they encountered many influences, and the resulting diversity can be heard on *Esewe*. According to Ben, "We worked (on the album) here and in England, in Brixton with a group in a Jamaican studio." They incorporated the reggae influences and used a Jamaican engineer and guitarist, but the overall sound they aimed for was anchored in the *esewe* rhythm of Cameroon. Recorded in both France and England, *Esewe* was remastered in Germany.

Ben explained that they took "the great risk" of modernizing the rhythm, but it became clear from his conversation and that of Peter's that they viewed their music as needing the traditional foundation as much as possible. It was for this reason that they insisted on singing in Douala rather than in French. Those who sing or rap in French, Peter said, are "those who refuse African culture." He called the effort by record companies to persuade African singers to perform in French "a trap." He made excuses somewhat for fellow Cameroonian singer Henri Dikongué for his recording of the popular song "C'est la vie," since Dikongué "remains very African" with most of his music. Given the radio language regulations among other things, Peter's (and Ben's) attitude about language struck me as one that could present obstacles to a career in French rap. But it seemed that rap for them was secondary to representing and being faithful to African music. Like Edgar Yonkeu, they connected rap music to the rhythms they remembered from Cameroon.

It seemed almost contradictory, this insistence on their identity coupled with their obvious interest in working with musicians from other traditions. To use African rhythms while singing in French, Ben feared, would lead to "a complete loss of identity." He explained himself further by addressing me directly:

> You, you are American, You are interested in us, and I think people should be like that. Me, I prefer to listen to French music, but not to sing in French, because that goes better if a French person does it. The same goes for a French person who wants to sing African music in French. Look, I am all for mixing, as, for example, we did with the Jamaicans. We made a *mélange* between us, but each kept his own identity. They kept their identity, and we kept ours.

Peter essentially agreed, even though he cited what he called the "French proverb" that states "Music has no boundaries." He said that people should enter into exchanges with those in other cultures, but at the same time hold to their own identities.[46] For him it was important to remember the link between each type of African music and the different ceremonies or aspects of daily life to which it was connected. Ben compared this to gospel music, emphasizing the communication of a message. Communication was the essence of African music, in the view of the twins, just as it was for contemporary rap music.

The topic of the conversation turned to questions of race and immigration, especially as they played out in French politics. Ben said immediately that racism was on the rise. Peter did not necessarily agree, explaining instead that the awareness of the topic was greater than before. While neither of them felt that they, personally, had suffered discrimination, they acknowledged that they saw it all around them, especially with the daily presence of the police where they lived. Ben said that when he

witnessed an instance of racism or heard racist remarks, it caused momentary pain, but this was followed quickly by his reminding himself "that I am a human being. I feel proud. I feel proud to be black, and I remain the way I am." Turning to Le Pen and his party, Ben said that at least Le Pen expressed his true opinions, so that you knew where you stood with him. The establishment parties practice deceit, he argued. He put it this way: "Le Pen spoke. Pasqua made into law what Le Pen said." Ben said he deliberately shocked his friends by saying that he was "for" Le Pen. This was not the same as saying he was "a friend" of Le Pen's. It was a question instead of where the real threat lay. "It was Pasqua who sent the police to people's homes to round them up. It wasn't Le Pen!" he exclaimed.

The Ndocko twins placed a great deal of blame on the media (in Africa as well as in France) for creating cultural misunderstanding and miscomprehension where African immigrants were concerned. Peter said, "When I watch French television, when I see the reporting, they are always showing the bad side of Africa (i.e., suffering, degradation, corruption, violence)." On the other hand, in the former French African colonies, France, said Ben, "is always shown as paradise." The result is that, once immigrants arrive, they undergo real cognitive dissonance when they fail to find "paradise." Said Ben, "When you arrive, you see whites who suffer like you, and you say, 'But that's not possible!' "

Ben and Peter talked some more about rap music in France, which they saw as more than "a fashion." They emphasized the beats, and, as Edgar Yonkeu had done, Peter connected the beats to the rhythms of the *tam-tam*. Rap also stood out for them because rap musicians had something to assert and; to advocate. This reminded me of American rappers who sometimes compare their function to that of editorial columnists. While we were on the subject, we touched on MC Solaar and his reputation for speaking out against Jean-Marie Le Pen. They acknowledged Solaar's importance, but I though I detected an undercurrent of envy or resentment when Ben said "MC Solaar cannot represent all the blacks in France."

Near the end of the interview, I asked about musicians from Cameroon in Paris, since I had managed to meet a number of them. I wanted to know if they constituted a community in the way that Malians had, thinking especially of the support Malian associations gave their home villages. They said that they and other musicians operated individually in this way, but did not form a community comparable to the Malians of Montreuil, for example. Benjamin and Peter were exceptionally warm people, and I was sorry for the conversation to end. They gave me a copy of their album and autographed the booklet. The inscription read, "To Jim, with all our affection and the protection of our ancestors." Seeing that flooded me with emotion, as well as remorse for the lack of regard for elders and ancestors too often found in my own culture.[47]

Rap: From Paris to Dakar

Francophone rap performers of African origin were by no means limited to those residing in France. A number of West African countries—especially Senegal—boasted

successful hip-hop artists who made stops in Paris from time to time but did not become immigrants. One of the most prominent groups was Positive Black Soul, based in Dakar. In fact, they were the first rap group ever formed in Dakar.[48] They were enthusiastically received when they made appearances in Paris (see chapter seven). The group was formed in 1989 as an alliance between two performers who previously had been rivals, Didier Awadi (1969–) and Amadou Barry (1971–), known as Doug E. Tee. They developed a rich, layered sound, drawing upon elements of Senegalese *mbalax*, reggae, and jazz and rapping mostly in Wolof, with occasional uses of French and English. In 1992 they received a boost from MC Solaar, who chose them as his opening act on his first concert visit to Senegal. In Paris Mamadou Konté helped promote their cassettes, and in 1994 Senegalese star Baaba Maal invited them to perform on his album *Firin' in Fouta*. As a result, they made contact with Mango Records, the subsidiary label of Island, and released their first album *Salaam* in 1995. The album included several songs from their cassettes.[49]

By the latter 1990s Positive Black Soul was traveling frequently, often to Paris, where they were featured in the 1996 Fête de la Musique, and where they headlined an African hip-hop bill at the Parc de la Villette in October 1998. They had been spending time recording, both in Dakar and in New York, where they worked with Wyclef Jean of the influential hip-hop group The Fugees. Earlier that year Didier Awadi and his fellow musicians also had opened a shop in Dakar that served as a gathering place for other rappers.[50] In a 1999 interview, Awadi explained that their business, called Hyper-Son, was set up to rent sound equipment for "concerts, parties, or weddings." There were two different locations. They also rented studio time there for musicians to record eight-track demos. These moves were in response to what Awadi called "a veritable explosion of groups" in the ten-year period since 1989. He said that there were now some two thousand rap groups found throughout Senegal, even if they were mostly concentrated in and around Dakar.[51]

The members of Positive Black Soul exemplify a generation of Senegalese musicians who have been much less prone than their predecessors to seek emigration to France. This has been a trend that is explained in part by the tightening of immigration restrictions in France, but it also has been encouraged by the development of a thriving music scene in Dakar, which includes recording studios and clubs that feature live music on a nightly basis. Much of this has been due to Youssou N'Dour, the most conspicuously successful of all Senegalese musicians. Youssou N'Dour first performed in France in 1983, and two years later made a very successful appearance at the Printemps de Bourges festival. He and his band Le Super Étoile de Dakar were considered the leading exemplars of the Senegalese traditional-pop hybrid music known as *mbalax*. His star rose internationally especially after his participation in a 1988 Amnesty International tour that included Sting, Peter Gabriel, Bruce Springsteen, and Tracy Chapman. In Dakar he founded a nightclub called Thiossane, where he and his band performed regularly, and also a recording studio called Studio Xippi ("eye" in Wolof). N'Dour also headed up an organization called SAPROM (Société africaine de production musicale). This organization has assisted younger musicians, featuring them especially at festivals in Dakar. Youssou N'Dour became by far the most prominent figure associated with the music scene in Dakar, and the local media, in which he himself has invested, has done much to call attention to

the wide shadow he casts.[52] From his base in Dakar, he has traveled regularly to major concert venues in London, New York, and certainly in Paris, where a 1993 appearance in the opulent Opéra Garnier received glowing praise in the French press.[53]

On a smaller scale, the members of Positive Black Soul have put their stamp on the rap music culture of Dakar. As in other West African countries, rap in Senegal is the expression of urban youth culture.[54] In Didier Awadi's opinion, by 1999 it had become more than that. Asked what had changed in the Dakar milieu during the past ten years, Awadi stated, "Today people respect us. The authorities listen to what rappers say. Our music is no longer considered as an unhealthy youthful phenomenon."[55] He did have one criticism of the newer "hardcore" groups he said relied heavily on vulgar expression in Wolof. He found this a "regrettable" tendency, something not good for rap music.[56]

In February 2000 I got the chance to interview Didier Awadi and to meet the members of Positive Black Soul at their home recording studio in a suburb to the north of Dakar. As a Dakar weekly had informed me, they had returned only recently from Berlin, where they had been part of an "Africa Fête" tour.[57] I came in on them as they were searching for a "sample" from a vinyl copy of Stevie Wonder's album *The Secret Life of Plants*. They made me feel very welcome, and tea was served. Tea in Senegal is called *ataya*, and it makes regular appearances whenever someone is greeted as a guest. It is a strong, sweet mint tea served in small glasses. Positive Black Soul even paid tribute to the popular beverage on their album *Salaam*, one of whose songs is called "Ataya."

The major theme of Didier Awadi's conversation with me was the importance for him and his fellow musicians of remaining based in Dakar, despite the fact that the musical "infrastructure" there, as he put it, still had a long way to go. I asked him if he had ever considered following the example of Senegalese musicians who, like the members of Touré Kunda, had become immigrants in France. "No," he answered emphatically:

> Me, I am one of those who think that it is necessary to remain in the country to construct it. In going to Europe or to the United States or no matter where, you would no longer be able to speak to the Senegalese with true words. We write better here. The examples of Youssou N'Dour and Baaba Maal have stayed here. It is our challenge also to stay here in order to speak of Senegalese things while living them. Many musicians who are expatriates have no more inspiration. Their music is no longer what people feel here.[58]

Awadi's sentiments regarding the need to remain in Senegal in order to "construct it" were much in keeping with a Senegalese government effort, announced in 1997, to try to convince young people not to leave for France, but to stay and "develop" Senegal.[59] On the eve of a 2001 Paris concert appearance, Didier Awadi said scornfully of those eager to leave Senegal for France, "If you refuse to be a street sweeper in your own country, why leave to do it in Europe?"[60] In our conversation, he said that the example of Jamaican music had shown that the pattern of migration from South to North should not be absolute. "There is no reason why we could not do the same (build up a national music industry)," he argued, adding, "If everyone goes away,

who is going to build up the country?" In his opinion, the work still remained to be done. He dismissed the idea that Senegal already had support system for musicians seeking to establish their careers there. "I believe that each artist makes of his career what he wants," Awadi said, explaining that no particular structure had been provided by the government or any other system that supported local artists. "Each person fights his own battles," he said. He illustrated what he meant about the relative lack of structure by explaining that his group used their studio in Dakar to record demos (*maquettes*), then completing the recording process elsewhere (such as in Paris and New York).

As with many of the African musicians I have interviewed, language seemed an important consideration for Didier Awadi. He acknowledged that American culture had provided the immediate sources for rap music, and said it was necessary to use American styles in the music. However, he said, "We try to *tropicalize* it," that is, to adapt it to a Senegalese reality, "with Senegalese words." Positive Black Soul uses Wolof and Bambara, but also French and English in their songs. I asked why they used an English language name for their group. He responded that those three words had become part of "the universal language," and were no longer "really English." He added that the selection of the band's name was "in order to be understood by the maximum number or people." As for their music, Awadi explained that they made use of the "fat beat" (he used the English words) common to American rap, but employed such traditional instruments as *kora, balafon,* and *djembe* to "color" the music.

What about the political role of the music, I wanted to know. Did their music play the kind of role in Senegal that MC Solaar's seemed to in France? "Is music political for you?" I asked. Awadi replied that "It is our *titre de combat*. It's our soul. We try to denounce the things we don't like. Rap in Senegal is socially and politically engaged." Then I asked, "What is the most important thing for a foreign listener to understand about your music?" He responded this way:

> Our objective is to make the maximum number of people outside of Africa understand that we don't live in trees. To show the positive side of the black soul. That's why we called the group Positive Black Soul. We don't want any more of the clichés that people see on television in foreign countries. We seize our own destiny. We also assume the errors of the past made by people of our own country, then by the men who came here from elsewhere, and then show a more positive image of the Negro with a capital 'N.'

The Musicians of Dakar

Didier Awadi struck me as a truly world citizen in the way many of the African musicians I had interviewed in Paris seemed to be: interested in and drawn to Western cultures and proud of his roots. The difference was that he had remained in Senegal, quite consciously so. I had gradually become aware of musicians like him in the course of my research, and realized that I should travel to Dakar to learn something about them first-hand. Interviewing Mamadou Konté in 1998 had been a turning point for me, with the very person in many ways most associated with African music

in Paris having relocated to Dakar, where his cultural foundation "Tringa" had become the new base for Africa Fête and a means of encouraging pan-African cultural exchange.[61] Leading up to that point, I had been able to meet and interview Jimi Mbaye, the lead guitarist for Youssou N'Dour's band Le Super Étoile de Dakar, in New York in late 1997. His great love for Dakar and his insistence on remaining there impressed me.

He and I had remained in touch, and he very kindly met my plane when I arrived in Dakar in early February 2000. He drove me to my hotel, and a few days later took me to his home for a meal and another interview. I had arrived in Senegal at a dramatic point in the country's political history. The presidential election, in which Abdoulaye Wade would defeat the longtime incumbent Abdou Diouf (who had been president since 1981),[62] himself the successor to Léopold Senghor, the country's first president, was underway. There were some sporadic incidents of violence, and I was cautioned to stay in touch with the U.S. Embassy. During my last few days there, the concierge at the hotel asked me why I was still there when most foreign visitors had departed. Even though I heard about the occasional incidents, and one evening was urged by a friend with whom I had planned to hear some live music to stay in the hotel to be safe, what struck me for the most part was the great sense of optimism people seemed to feel, that is, that Senegal was turning a corner for the better. Everywhere I walked in the city, I seemed to pass people gathered around radios, eagerly listening to the reports of the election campaign. The level of interest in the approaching vote threw sharply into relief the crushing apathy of voters in my own country.

Near the end of my first week in Dakar, Jimi Mbaye came to my hotel to take me to his home in Yoff, well to the north of Dakar. During the long drive to his place, he was clearly proud to show me his city, having told me in an e-mail before I arrived, "You will feel the pulse of Dakar heart." *Dakar Heart* is the title of his solo album released in 1997. Mamadou, "Jimi" Mbaye, born in 1958, grew up poor in the streets of Dakar, playing a homemade guitar, and eventually changing his name to "Jimi," in honor of Jimi Hendrix.[63] When I interviewed him in New York it was just after the release of his album, and I was fascinated by the distinctive, inventive guitar style he achieved. I wanted to know if he used different tunings, but he explained that he stuck mostly to standard tuning. However, he deliberately employed a strong picking style meant to imitate the sound of the *xalam*, the traditional stringed instrument of Senegalese *griots*. No wonder Youssou N'Dour had commented, "No one plays guitar like Jimi Mbaye."[64] I asked him also about his reasons for remaining in Senegal instead of heading for Paris or New York to pursue a career. He replied forcefully, "When you emigrate, you lose your soul, because you are far from your roots."[65]

The drive from Dakar up to Yoff took us through sun-dazzled bleached desert, with beaches and the blue ocean water on our left. We passed huge knobby baobab trees, eerie whitish formations that look like they belong on some other planet. All along the way we saw flocks of scrawny sheep, which were unlike any sheep I had ever seen. They looked more like goats to me. Next to some baobab trees some men were stationed with bags of something to sell. Jimi explained that it was food for the sheep, and he needed to stop to buy some for his own sheep. I was to learn that it is a common practice for Senegalese musicians to keep them at home. I helped Jimi load the

bags into the trunk of his car, and soon we were off on the last leg of our drive to his house.

When we arrived, I was introduced to his wife and family, and then he took me on a tour of the place, especially to show me the home recording studio he was in the process of outfitting. It was upstairs, and the view from the top floor of his house was stunning, with the afternoon sun glistening on the surf. Soon the meal was served, and we sat on the floor to eat it from a common platter, Senegalese style. It was *thieboudienne*, the fish and rice stew that is considered the country's national dish. Jimi and I had eaten a version of it from Harlem's "Little Senegal" neighborhood in 1997, but, as he had predicted, it could not compare to one that was home-cooked. We talked and ate our fill, then set up for another interview.

We took up the theme once more of his determination to remain in Dakar, about why he had never considered relocating to Paris, for example. "I can't be the real Jimi in Paris," he declared. I asked what he meant by that. "When making a record in Dakar," he explained, "traditional singers and instrument players are only a phone call away. In Paris it will never be what I really want." What he would want, it became clear, is a player still in touch with his Senegalese roots. "Even when I find a *kora* player in Paris," Jimi said, "I will see a new generation. A *kora* player in Paris will never be like a *kora* player in Senegal. They have met jazz performers, rap performers, etc, and they will try to do experiments." More importantly, however, the idea of becoming a Paris resident held no appeal for Jimi Mbaye. "When I went to Paris," he said, "I would lose my soul."

Jimi explained that he had been working on a new album, still experimenting with transposing the sounds of the *xalam* and the *kora* for guitar, and hoping for a "balance" between Senegalese *mbalax* and Western influences. I remarked that he had achieved that on *Dakar Heart*, but he said that he hoped "to improve it." One way of doing that, he hoped, would be to use "real *kora* players." This, he believed, would improve the rhythm and help "to make my music understandable to Western ears." For him, the way to do this was to find the right balance that would still remain faithful to "the roots and spirit of my music." I wanted to know if Dakar was thriving as a center for African music, and Jimi said that it "is going to be one of the centers of African music." "Before," he said, "it was Paris, New York sometimes." Now, he claimed, Dakar was drawing the same musicians to it, especially since record companies were not offering support. And while the "majors" did "nothing to help the newer groups in Dakar," conditions were "a little easier" for musicians in Dakar, he believed. Like Didier Awadi, Jimi Mbaye seemed to believe that it was worth the effort to stay in Dakar to maintain his career.

It was clear that home recording studios gave some musicians based in Dakar the means to develop their music and get it to the stage where it could be refined in a studio abroad. Certainly not all musicians in Dakar could afford to rig up a home studio. Aziz Dieng, perhaps the preeminent recording engineer in Dakar, created the first example of a home recording studio in 1990, and over the years has worked with virtually every well-known Senegalese artist, including Positive Black Soul. Although he has been able to achieve a lot in helping to make Dakar an important music center, he voiced some discouragement and pessimism in an interview published in June 2000. He acknowledged the growth in the number of studios and in media coverage,

but said that "musicians still encounter too many difficulties." Among these, he explained, were a lack of control over production and an "unreliable" distribution system, which, combined with the constant problem of piracy, meant that it never was possible to determine how many cassettes were sold.

"The sad reality," Dieng lamented, "is that most musicians live in a terribly precarious situation." For example, a reliance on verbal agreements rather than written contracts could not but lead to abuses. Another flagrant abuse was the practice whereby many disc jockeys demanded payment "under the table" to play cassettes submitted to them. "It's a scandal in Senegal," said Dieng. While it was true, he admitted, that Senegal could boast such great musical successes as Youssou N'Dour, Ismaël Lô (1956–), and Baaba Maal, most musicians were "still not organized." He added, "Each one tries to find individual solutions to his problems."[66] His comments seemed to dispel the notion that Dakar offered significant advantages to aspiring musicians.

When I interviewed Aziz Dieng during my stay in Dakar, he made some of the same kinds of comments, but, generally speaking, struck a more optimistic tone. A scholarly looking man, he received me at his home in the neighborhood called Sicap Baobab, where a mutual friend had brought me. Tea was served immediately, and we began to talk. He told me that he had lived two years in France, but had spent twelve years in the music business in Dakar, working with "nearly everyone." He mentioned Thione Seck, Ismaël Lô, Baaba Maal, and Positive Black Soul, among others. I asked him if he preferred any one style of music, and he answered that it was jazz. But he also said, "I am very eclectic. In each style of music, there are things that please me very much." I asked Dieng if there was a certain kind of sound he strove for in the recordings he supervised, and the question launched him into a discussion of the music for which Dakar was known most, and the importance of having it recorded there:

> Yes, little by little the dominant music here, *mbalax*, also begins to have its own sound. No one does it better than the Senegalese. The music goes also with a certain sound. (Speaking of recordings of Senegalese music made abroad) Even if it is recorded in a studio of quality, there are certain things that are not of the same manner as here. Here we have a manner suited to ourselves that has a certain warmth even though technologically we are less well equipped than the European studios. But technicians here have more and more experience, and the technology is becoming more accessible.[67]

It was clear that Aziz Dieng believed that the future looked good for Senegalese music, partly because of a decline in the tendency of musicians to emigrate from there. He pointed out that many of the musicians who tried to make their fortunes abroad had not succeeded, whereas in Senegal, "in typical fashion, there are instead examples of musicians who have stayed: Youssou N'Dour, Thione Seck, and the traditional singers who operate well here." He also mentioned the return to their respective West African locations of Mamadou Konté and Salif Keïta, two of the major figures of the African music presence in Paris. He viewed these moves as harbingers of a future trend. He said, "I believe that more and more it is the scene in West Africa where we can belong to our own country's base to make something of local and international interest."

Dieng expressed confidence that more studios like his would get off the ground. As for his hopes for the future,

> I am very optimistic if the authorities encourage us, if the musicians get organized, we better organize the producers, we fight against piracy, I believe that there will be an extraordinary boom. The Senegalese are very open.

He explained that the uniqueness of *mbalax* and the influences it had incorporated from jazz and other sources guaranteed ongoing interest in Senegalese music and in Dakar. Another key ingredient, as he saw it, was rap music, or as he put it, "global urban music." I returned to his remark about the need for the government to encourage Senegalese musicians. Do they, I asked?

> Not enough. Music here would be recognized as a great development if the political authorities encouraged us. For example, lower the customs duties on musical instruments. Musical instruments are very expensive. They are taxed as luxury goods. The musicians of Paris do not pay these taxes.

Despite all obstacles, Aziz Dieng said that he remained optimistic because "African music has become a force."

Thione Seck (1955–) was one of the singers with whom Aziz Dieng had worked most extensively. He is descended from a long line of *griots*, and in the Senegalese tradition, plays the *xalam* and the *tam-tam* and sings. He has been described as "the urban Senegalese *griot*."[68] "I have singing in my blood," he said to me when I interviewed him at his home in a pleasant neighborhood north of downtown Dakar.[69] Seck's father, who, his son said, "had a beautiful voice," was a *mouride* singer, that is, a member of a Muslim brotherhood founded in Senegal at the end of the nineteenth century.[70] His grandfather, he told me, sang "for the king." For that matter, he said, "Everyone in my family is a singer except for one who is a football player." He began singing at the age of fifteen, but this met with his father's disapproval. "My father did not want me to be a singer," Seck said, "He forbade me to go out. He wanted me to pursue my studies." I asked why, and he said, "He said that art had no future. He was right for his time."

Clearly Thione Seck had demonstrated otherwise. He was one of the original singers with the very popular band of the 1970s, Orchestra Baobab.[71] In 1984 he formed a group called Raam Daam that included his younger brother Napenda as another singer. As the name of the band would suggest, the music was inspired in part by Hinduism, which for Thione Seck complemented a Muslim spirituality. By the late 1980s he had brought these influences into his own version of *mbalax*, performed first in Dakar and then throughout Europe.[72] Rooted in the *griot* tradition, his performance drew both on Senegalese and Western pop influences. Over the years, Thione Seck has recorded and performed frequently in Paris, and his music has provided a link between Senegalese immigrants there and the home country. Once when I was having a meal at the Senegalese restaurant Paris-Dakar (see chapter seven), the VCR set up near the bar was playing a Thione Seck concert tape. On the day of our interview, he informed me that he was off to Paris the next day, but as a solo act instead of with his band. He would return by the coming weekend.

When I asked if he had ever considered moving to France, he said, "No, because experience has shown me if you are in Africa, in your country of origin, you have much more value than if you are in France." He added, "I prefer to remain here." Curiously for someone known for his openness to a variety of musical styles, Thione Seck expressed a view of West African music that kept each country's music isolated from the other. It would not make sense, he said, to "impose *mbalax* music" on, for example, Côte d'Ivoire. "They have their own music," he said, adding, "It would be worth more to stay at home and play one's own music." However, that did not mean that he would not "go from time to time to Côte d'Ivoire or to Zaïre because I am interested in what they have there." Even though he was resolute in his intention to remain rooted in Senegal, where he said he was "very well known" and had "nothing more to prove," he, like other prominent musicians, still needed to go abroad to record, for example, to the Paris studio Harry Son. He said the only music he had recorded in Senegal had been for a television broadcast.

Seck spoke of his busy touring schedule. After he returned from his brief Paris trip, he and his band were headed to Germany, England, Italy, and then to Scandinavian countries. Given the fact that European countries at the time were often quite suspicious of African musicians who crossed their borders, I asked him if he had ever encountered any unpleasant incidents of discrimination or mistreatment at the hands of immigration officials. He said he had not, and explained that the Senegalese government issued what were called *passeports de service*—the equivalent of diplomatic passports—to musicians such as himself. It seemed clear from this emphasis, thinking back to Seck's earlier comment about having "more value" by remaining in his own country, that he nevertheless gained in value—in the estimation of the Senegalese—through his travels and his appearances in France and other European countries. Discussion of national borders seemed to lead to discussion of musical borders, or lack thereof. Thione Seck professed himself to be open to all types of music, and especially cited jazz as "the basis of everything for us." In a remark I have heard so often from musicians, he said, "Music is universal. It has no borders."

One of the most influential of all Senegalese bands, formed in 1975 and still in existence, has been Super Diamano, which originally united the talents of singer Omar Pene (1955–) and guitarist Ismaël Lô, who left the group in 1984 to begin his solo career. Super Diamano gained prominence as performers of *mbalax* well before Youssou N'Dour's Le Super Étoile de Dakar.[73] Under Pene's leadership, the band's sound became defined by its affinities to rhythm 'n' blues and reggae, with use of horns and a soulful singing style. They called their music "Afro Feeling." Omar Pene, who survived a rough childhood on the streets of Dakar, and once seemed headed for a promising football career, went on to become something of a folk hero in Senegal, where he has been active politically on behalf of the disadvantaged.[74]

I interviewed Omar Pene at his home in a northern suburban neighborhood of narrow streets called Castor. Alloune Diop, a disc jockey with the radio station "7 FM," accompanied me. As we sat in Pene's well-appointed, comfortable living room, I was startled to hear sheep bleating just behind the wall by my chair. He noticed my reaction and explained that he was fond of the animals. Pene, who was soon to embark on a European tour, spoke about the musical influences that had

been absorbed by *mbalax*. I asked about the vogue for Cuban and other Latin American music in Dakar, to which he replied,

> Yes, *Mbalax* is very close to what the Cubans do. At the time before *mbalax* existed, bands played Cuban hits. The influence has always been there. *Music has no borders.* Salsa has a lot of influence in Senegal. Even today there are salsa groups in Senegal.[75]

I remarked on the geographical position of Dakar as a place to pick up influences coming across the Atlantic, to which Omar Pene responded,

> Even the blues. A lot of singers were influenced by Otis Redding (during the 1960s and 1970s). Senegalese music is very rich because there were many influences before *mbalax*. Now we play a lot of *mbalax*, but it is necessary to understand the other influences. *Music has no borders.* Openness is important.

Pene said it was important to recognize the Senegalese at the center of this welter of influences. "Senegal," he said, "has a very vast culture with many ethnicities. Each has its own culture, with a multitude of varied rhythms . . . There is not *one* Senegalese music. There are Senegalese *musics*. Each ethnic group has its own rhythm."

Clearly, Pene had thought a great deal about the question of musical influences and cross-fertilizations. I asked him whether it was more important to perform music faithful to African roots, or to make allowances for ears accustomed to Western pop music. This was his response:

> African music is a form of expression and that is extremely important. People know pop, funk, and jazz. African music, that is something new. Why not use Western instruments while remaining ourselves? We are Africans, but that does not mean that we remain 100% African. We should make the kind of music that those who are not Africans, who cannot understand our languages, can listen to in order to discover other things that they can understand. It is a question of cultural identity.

Like the other musicians I had met in Dakar, Omar Pene had no interest in taking on the life of an immigrant, despite his frequent travel to France and to other Western countries. "You don't need to immigrate to play good music," he said. "Here I have everything I need." He elaborated further in a way that made some sweeping generalizations about the musical preferences of Europeans versus Africans:

> To create, to write, it's better here. The inspiration is here. In France, there are automatically influences. You are in another environment. In Africa, we love rhythm very much. In Europe, they don't love rhythm. They like slower music. I prefer to stay here in my natural environment, but I well love to travel.

Unlike the other Dakar musicians I asked about recording, he expressed much more confidence in using the local studios. He said he had not recorded in Paris, although he had used Peter Gabriel's London studio. "For the most part," he said, "we record here because there are good studios now. We can take advantage of the experience in

Dakar." Also, he added, it was less expensive to record in Dakar. "Dakar is becoming a musical capital," he declared.

With this success has come respect. Pene said that when he was young, he used to sneak out to perform his music because, "I didn't want my parents to know it." Now, "a generation after, music has become a source of revenue. It is more respected. Musicians count for a great deal in the society." This, in turn, is related to the role musicians play in addressing political and social problems, in Omar's Pene's opinion. Here is his explanation:

> In Africa, we are confronted with many problems. Young people have confidence in us (musicians) and make us their spokespersons. Africa is not rich from the economic point of view, but it has its culture, an enormous richness. We condemn wars, genocide. Africans want things to change. We sing love, peace. We are messengers, and we speak for young people. We want a united Africa where people do not need to immigrate to seek their fortunes somewhere else. What we lack are people who are capable of managing all of that. We are here to sensitize the decision-makers. And from that point of view, we are very engaged.

How is it possible for musicians to provide solutions for such problems, I asked, and he replied,

> By singing. Music is a means of communicating. Music can supply many things. Musicians can be ambassadors. They can sensitize African opinion on vaccination and on AIDS. As communicators, musicians have a role to play.

Pene readily agreed that rap musicians play exactly this kind of role for a younger generation. As for rap music, he said, "I adore it, because it comes from the street." The confidence music fans place in Senegalese musicians as social and political communicators is what keeps him going, Omar Pene said: "They have more confidence in musicians than in politicians. Politicians always make electoral promises and then they forget them. Musicians are much more appreciated now."

During my time in Dakar I had been able to speak with *mbalax* and rap musicians. Near the end of my stay I had the opportunity to interview and to hear perform live a group whose music was much closer to what could be called a folk style. The group was a trio of brothers who performed as Les Frères Guissé. They consisted of Djibril, "Djiby" Guissé, Cheikh Guissé, and Aliou Guissé. The first two shared singing and guitar duties, and Aliou handled percussion.[76] The brothers hail from the Fouta region of Northern Senegal,[77] and are of the ethnic group known as the Toucouleurs.[78] They compose their songs primarily in Pulaar—their native language—and Wolof.[79] They also use Mandingue, and some French and English.[80] After playing during the early 1980s with groups who used electronic instruments, Djiby and his brothers made the decision in 1988 to begin using strictly acoustic instruments.[81] They evolved a sound that made use of traditional rhythms and vocal harmonies, while composing songs that often addressed topical themes such as anti-colonial history and the abuse of women.[82]

I heard Les Frères Guissé perform at a club called Alizé, located on the Avenue Cheikh Anta Diop (near the university of the same name). It seemed to be a

combination bar with dance floor and a few tables around the edges of the open floor in front of a small stage. A mostly youthful crowd milled about, some adhering to Muslim observance by drinking only fruit juices, while others nursed bottles of Flag, the popular local lager beer. When the trio took the stage, singer–guitarist Djiby commanded the microphone in front, with Cheikh flanking him with the other guitar and Aliou sitting in the rear with his percussion instruments. The music was a far cry from *mbalax*, with delicately picked guitar figures and plaintive vocals in close harmony. At times the guitar patterns seemed to suggest the *xalam* or the *kora*. A few dancers swayed softly to the music, and others stood and listened intently to the lyrics of the songs. There being little separation between the minimal stage and the dance floor, the musicians conversed amiably with the appreciative crowd once they concluded their set.

The next evening I met the Guissé brothers at their rehearsal site and interviewed Djiby, customarily the spokesman of the group. The conversation began on the theme of traditional music. Djiby explained their music this way:

> We try to play a Senegalese music that relies on a certain originality, to play for the peoples of the world. One does not only sense a certain Senegalization of the music, but more of an Africanness. Because we are Toucouleurs, it is especially Toucouleur music. We represent the Senegalese people who are diversified. We try to represent Africa and more particularly Senegal.

Djiby Guissé expressed pride in the "very rich" musical traditions of the Toucouleurs, but explained that the trio saw themselves as both linked to Dakar and to their original culture. I asked about the decision to shun electronic instruments and whether it represented a rejection of *mbalax* and other contemporary genres. He explained further:

> We want to play a music that lives and that will live. In music today, there are many influences. We like what is natural. We avoid electronic sounds, and we play with African techniques. It's a natural expression. We are a family and our music shows that kinship: three brothers with the same blood and the same influences—it's a certain energy.

In recent years, Les Frères Guissé had toured widely, including to Paris, London, and Québec. They also traveled to Vietnam in 1997, an interesting choice given the colonial history of Senegal. Senegalese troops were posted there under the French empire.[83] The Frères Guissé press kit includes notices from these concert tours as well as from Nice, Bordeaux, and other French cities. But despite their travels, Djiby said they had no plans to leave Senegal, which he described as "the source" to which they always returned.

I brought up the question of the languages they used, and asked what the songs were about. Djiby's reply demonstrated a strong sense of the *engagé* artist:

> We are messengers and communicators—not only musicians. We sing for the development of the country and for social concerns, including the themes of democracy and women. In Africa, woman plays a very important role. We sing a lot about women.

When I pressed him further on the question of the musician's political role, he said,

> What we condemn is singing for singing's sake. Each person has something to express. For us, the themes are something of importance. A musician who plays, plays what he dares.

We ended by discussing the presidential election then taking place, which he saw, hopefully, as evidence that people in his country were taking greater political responsibility. He was hopeful for the future.

As a first-time visitor to Dakar, eager to speak with as many musicians as possible, I found it very beneficial to be able to consult people with a strong sense of the city's recent cultural history. I was fortunate to be able to interview two such persons. One was Alloune Diop, host of a regular cultural program on Radio 7 FM (one of Youssou N'Dour's many local media investments), and the other was Ousmane Sow Huchard, an anthropologist, musician, and art critic—among other things. Diop had helped me by arranging several of the interviews with musicians, so I was glad that he also consented to an interview of his own. Through his work with the radio station, he seemed to come into contact with just about every cultural figure who passed through Dakar. We began by discussing his program and his work at the station.

He was proud of the fact that Radio 7 FM provided much more of the kind of cultural coverage that his regular show (*le Journal de la culture*) featured than did other stations. He explained,

> The radio station has existed since December 1, 1998 and *le Journal* has existed since July 1, 1999. The other stations do a show like that two times a week for eight to ten minutes. I do it every day for twenty minutes. It's hard, but I love it. I love to talk with artists, promoters, painters, and filmmakers. My director thought that a *journal* of this type would be possible.

Diop said that he does everything for the show, from planning it out to doing each of the reports. "It isn't easy, but I love it," he reiterated. He added, "There is a lot of information you can give people at the level of culture."

The conversation turned to the history of popular music in Senegal. I asked about types of rock music that had existed before the emergence of *mbalax*:

> No, *mbalax* was not the first music. In the beginning, just before and just after independence, music coming from the West like the Blues was well known, even doo-wop for my father. Next, there also was the French music that people loved a lot during the 1960s. Our grandfathers and our fathers danced to Zaïrean and Congolese music— *rumba and soukous*, Also, a little, Ghanaian high life, but that was not so well known.

He explained that by the beginning of the 1970s the Afro-Cuban music popular in Senegal was mixing with American rhythm 'n' blues influences, for example, the music of Otis Redding. The pivotal band in this regard was the Star Band, known for its adaptations of Cuban salsa. Diop said of the Star Band that they "had dared to introduce the *tama* (talking drum), a typically Senegalese instrument, into Afro-Cuban music. The first "Star Band" dated back to independence, and had evolved

into a training ground for successive Senegalese musicians, including Youssou N'Dour.[84]

It was with the latter, said Diop, that "*mbalax* was really born," and the singer's significance, in his opinion, lay in being the first to take Senegalese music beyond the country's borders. He acknowledged that Touré Kunda, with their success in Paris, could make some claim to having done that, but insisted that Youssou N'Dour had succeeded in doing this on a global scale. It was important to emphasize, he said, that *mbalax* "was inspired by typically traditional Senegalese music," the very name itself being the name of the implement with which one struck the drum. However, Diop explained, there were several rhythmic traditions within "Wolof folkloric music" that led to *mbalax*. There is more than just one type of Senegalese music, he reminded me.

Alloune Diop's view of the viability of Dakar as a musical base was somewhat mixed, although he seemed to believe that conditions had improved steadily over the years. "I believe," he said, "that at the beginning of the 1980s when Senegalese music had begun to exist, a lot of people thought that the solution was to go to Europe. In a certain measure, I accept that that was normal because there were not enough producers." But then things changed: "After some years, we realized that with Youssou N'Dour, Ismaël Lô, and Baaba Maal, it was possible to stay here *and* to be known in Europe." What began to make the difference, he explained, was the emergence of home recording studios, such as the one introduced by Aziz Dieng. Mamadou Konté's efforts on behalf of Senegalese musicians also had made an important difference. Konté, said Diop, "had rendered a great service to Senegalese music." Nevertheless, there were still problems and limitations. Despite the existence of adequate recording studios and able producers in Dakar, a well-organized system of distribution still was needed, with a coherent functioning network within which one could determine reliably how many recordings actually were being sold. The other remaining limitation, as Alloune Diop saw it, had to do with the number and frequency of concerts taking place. Dakar could claim to be a true musical center in terms of FM radio and the number of musicians collected there, but this had yet to result in a significant enough number of concerts, in his opinion.

Like others with whom I had spoken in Dakar, Diop viewed the role of Senegalese musicians as somewhat political, speaking out on "social problems." He pointed out that songs by Thione Seck and Youssou N'Dour had been used in political campaigns. "They (musicians) play a role," he said, "in raising the consciousness of the masses." His hope for the future was that this role would expand and that Senegalese music would have more influence around the world. This advance would have to include "penetrating the American market," which would be the most dramatic way to spread "the themes of Senegalese music."

On my last day in Dakar, before catching the overnight flight to Paris, I interviewed Ousmane Sow Huchard. He received me in his comfortable apartment high up in a large building across the street from the university. His home was filled with books, recordings, and art. He had recently finished his term as president of the International Biennial Exhibition in Dakar, which he explained was the largest such exhibition held in Africa. Huchard wore many hats, being an anthropologist, musicologist, museologist, and political activist. He showed me a flyer advertising his forthcoming book on the *kora*. He began to tell me about his earlier career as a

musician during the late 1960s and early 1970s. It was a time of heavy Western influence in Senegalese music, he explained. Otis Redding and Sam and Dave were among those who influenced him at that time. Openness to outside influences was the key to Senegalese music, he argued. "All the world's richness comes from fusion," Huchard said.[85]

This point of view was reflected as well in his opinion of world music. His was a much more unqualified, favorable opinion than I was used to hearing expressed, and he elaborated upon the theme to predict for African music and culture in general:

> "World music" is a meeting of sounds. Before, certain musicians had difficulty listening to African music because for certain kinds of African music you need a certain education of the ears. Today, people listen to the *kora*, etc. Tolerance is greater. It's a new world. Now the internet has arrived and the whole world listens to everything. We intellectuals have confidence in Africa. Africa has everything to gain with bits culture. If we have the means to diffuse it, we are going to conquer the world.

As for the current condition of the music business in Senegal, his comments echoed many that I had been hearing, but he mentioned one obstacle that should have been obvious to me but that I had not heard discussed before: the poverty of most Senegalese people. "The poverty of the population keeps the musical consumption from being what it should," Huchard said, adding that "The transistor contributed to the development of music in the smaller villages, but they do not have the means to purchase the music." This, in turn, fueled piracy, since "In a house, when someone buys a cassette, it is a cassette for fifteen people. Pals (*les copains*) share it. That favors piracy. People make copies each time there is a new cassette."

Huchard explained that a number of studios existed in Sierra Leone, Ghana, and Nigeria for the sole purpose of illegally copying recordings, and that those in charge of these studios made more money than the original producers. He quoted a local rapper who had said, "We sing, but we're dying of hunger." Huchard insisted that this problem had to be conquered in order for Senegalese music to flourish as a business. He suggested that the cassette format was a big part of the problem. If compact discs were being produced locally rather than cassettes, it would not prevent their illegal duplication but would result in a greater volume of foreign sales. "No one listens to cassettes any longer in the West," he declared.

Tradition and Innovation in the Music of Mali

Despite the fact that Malian musicians were featured regularly at the Africolor festival, during the 1990s the hostile climate for Malians in France epitomized by the plight of the *sans-papiers* certainly diminished the presence of musicians from that country in France. The return of Salif Keïta to Bamako in 1997 was highly symbolic of the new era. Once he was back in Mali, Keïta helped to encourage other musicians there. Like their counterparts in Senegal, many of them had never considered trying the immigrant life in France. They appeared regularly in Paris concert venues, as well

as in other major urban centers, but remained *chez eux*. Some of the best-known Malian musicians have been virtuoso guitar players, known for blending traditional sounds with blues and rock guitar styles coming from the West (which, of course, had themselves derived originally from West African sources). By far the most celebrated Malian guitar player was Ali Farka Touré (1940–2006),[86] whose music wedded *griot* performance style to Mississippi Delta blues influences, especially the example of John Lee Hooker, whose importance Touré acknowledged.[87] He achieved acclaim when he appeared at the 1990 Bourges festival, sandwiched in between two American blues artists: Clarence "Gatemouth" Brown and Albert Collins.[88] He also made memorable performances in Paris during the early 1990s, where one enthusiastic critic called him "the John Lee Hooker of Africa." The same critic, reviewing a performance the guitarist gave at New Morning, said that it demonstrated "that one could perfectly mix the sound of blues (the guitar) and the purer African tradition (the melodies, the texts and the song's arrangement."[89]

The highly regarded guitarist toured widely, and played with many other musicians around the world (most famously the American guitarist Ry Cooder on their 1994 disc *Talking Timbuktu*). In the process, Touré became one of the names most readily associated with world music. Despite his fame, however, he preferred life at home in his remote village of Niafunké (two hundred kilometers south of Timbuktu)[90], which gave its name to one of his most successful albums.[91] For the recording of this 1999 release, the English producer Nick Gold brought in a team to set up a state-of-the-art recording studio at the musician's home. The German photographer Thomas Dorn, known for his photographs of traditional African musicians,[92] captured his trademark grainy images of the remote desert setting.

As with Senegal and other countries, there is no *one* Malian music. Regional differences are linked to distinct musical varieties. The Wassoulou region to the South, overlapping with Guinea, has given rise to a musical genre known loosely as the "Wassoulou sound," which features traditional acoustic instruments and, typically, female lead singers. As the music has gained popularity outside Mali, this in turn has enhanced the status of the Wassoulou "divas." Because they frequently sing about the plight of women, for example, young girls forced into marriage or wives in polygamous marriages, the themes of their songs resonate with a feminist consciousness in the West. However, in the Malian context, the feminism is very low-key. Since audiences may include both men and women, Wassoulou singers try to perform so that men interpret their lyrics as instructions to young wives while women pick up a subtler message of empowerment.[93]

The most successful of all Wassoulou divas has been Oumou Sangare (1968–), one of the very few women in African music to lead her own band.[94] Like other singers in her tradition, Sangare performs accompanied by traditional instruments such as the *djembe* (drum) and a pentatonic harp–lute distinctive to the region and known as the *kameln'goni* and by backup singers.[95] On her third album *Worotan*, however, recorded in England in late 1996, these accompaniments were augmented by a horn section under the direction of Pee Wee Ellis, longtime saxophonist with the James Brown band.[96] To promote the album, Oumou Sangare embarked on an ambitious world tour. It took her to New York in November of 1997, where I attended her concert at Symphony Space. I was able to interview her briefly the following day.

Her bold commanding stage presence contrasted with her very shy demeanor during our conversation. She emphasized the distinctiveness of the music of her Wassoulou region, which she said differed especially from the music of the *jelis (griots)* elsewhere in Mali. She placed particular emphasis on the *kameln'goni*, which she described as a kind of "gourd with strings." This instrument, she explained, "announces" the music.[97] From her description, it became clear that through her music she was calling to people. "It is the young public that I am seeking," she said, and she added that she was more and more confident that her message had been getting across to a new generation. The "message," it seemed, was aimed especially at women. To me, Sangare sounded a consistently feminist tone. She urged resistance, she explained, to forced marriages, for example. "Women have to say no," she emphasized, and commented on the difficulty of being a woman in the music business. The purpose of her music, rooted in traditional ceremonies, was "to educate the public." As she gained more experience before international audiences, it made her wish she could speak more languages. She said she wished to learn English so that she could speak with her audience and so that they "could be with me on stage." Despite the necessity of travel for her career, she strongly felt the need to be close to her Wassoulou roots, and had never desired life in Paris, for example.

Malian musicians in recent years have run the gamut from those experimenting with modern influences to those who seek to carry on very ancient traditions. The Mandé culture of Western Mali (found also in Mauritania, Gambia, Côte d'Ivoire, and Senegal) continues in the hands of the *jelis* or *griots* who perform on such traditional instruments as the *kora* or the *balafon*. To be a *griot* traditionally meant to belong to a caste dedicated to preserving the oral memory of the people, but the role has taken on more of the sense of "artist" in recent years.[98] A generation ago such musicians may have found their way to Paris. More recently, they have been more likely, should they choose to emigrate, to seek their fortunes in the United States. Mamadou Diabate (1975–), a virtuoso *kora* player, is an example of this more recent tendency, having come to the United States from Mali in 1996. At the time I interviewed him in 2001, he was living in Ithaca, New York, but frequently performed with other Malian immigrants in New York City. He returned to Mali on occasion, and in fact told me he had recently played in Mali for the U.S. ambassador. In 2004 Diabate moved with his wife to Durham, North Carolina. He had never considered trying to live in France, he said, remarking that "France is happy to have Malians come to work but not to remain as citizens."[99]

Mamadou, who is the cousin of the famous Malian *kora* player Toumani Diabate, told me that he was the product of a well-known *griot* family from Kita, which he described as "a *griot* town." He discussed the different roles of the *griot*, from that of oral historian to performing on ceremonial occasions, and explained the difference between styles of *kora* playing in Senegal and Mali, respectively. His tradition, in Mali, made use of pentatonic scales. He said that the pentatonic scale lent itself to jazz improvisation, and contemporary players were prone to mix them with "normal keys." He showed me how the ring that slides up and down the neck of the instrument is used to change the key. Mamadou seemed to express contradictory emphases where his music was concerned. Several times he spoke of the ability of the scale he preferred to adapt to jazz, and pointed out that Malian music can be considered the

source of both blues and jazz. He was proud of the fact that he had performed in New York with such jazz musicians as Randy Weston, known for his advocacy of African music.

Yet when I asked him what he hoped to accomplish through his music, his straightforward answer was "To carry on the tradition." Just as his own father had made him his first *kora*, he said he had recently done the same for his young son. He viewed himself as someone working within an ancient tradition, but he made it clear that traditional did not mean opposition to new musical ideas. He said he wanted to remain in the United States. "My music has grown here," he said enthusiastically. As he talked and as he demonstrated his playing, he appeared to embody the sense of adventure that one finds in the most innovative musicians. How fitting then that the title of his debut album, *Tunga*, meant "adventure."

It is perhaps as fitting a word as any for the musical and migratory patterns this chapter has tried to trace.

Notes

1. Mamadou Konté, author interview, New York City, July 6, 1998.
2. Ray Lema, author interview, Villiers-sur-Marne, June 23, 1995.
3. François Bensignor, author interview, Paris, July 1, 1997.
4. Francis Bebey, author interview, Paris, December 2, 2000.
5. Nago Seck and Sylvie Clerfeuille, *Les Musiciens du beat africain* (Paris, 1993): 65.
6. "Africouleur, Paris-couleur," *Libération* (December 20, 1989): 64.
7. Samy Nja Kwa, "Africolor, colonne vertébrale de Cobalt: Entretien avec Philippe Conrath, producteur et programmeur," *Africultures* 29 (June 2000): 10–11.
8. Philippe Conrath, author interview, Paris, July 11, 1997. Unless otherwise indicated, all information about Philippe Conrath is derived from this interview.
9. Véronique Mortaigne, "Les musicians africains ont rendez-vous à Saint-Denis," *Le Monde* (December 23, 1995): 42.
10. Véronique Mortaigne, "La musique africaine brise les barrières à Africolor," *Le Monde* (December 19, 1997): 34.
11. Patrick Labesse, "Les affinités musicales captivantes d'Africolor," *Le Monde* (July 6, 1999): 29.
12. Gérard Arnaud, "Pour une exception musicale africaine," *Africultures* 54 (January–March 2003): 87.
13. "Moriba Koïta," Africolor Press Release, n.d.
14. Bouziane Daoudi, "Moriba Koïta, roi du n'goni," *Libération* (June 7–8, 1997).
15. "Moriba Koïta."
16. Ibid.
17. Moriba Koïta, author interview, Paris, July 10, 1997. Unless otherwise indicated, all information about Moriba Koïta is based on this interview.
18. Philippe Krümm, author interview, Paris, July 15, 1997. Unless otherwise indicated, all information about Philippe Krümm is based on this interview.
19. "Nipa," press kit, n.d.
20. Pierre Wognin, author interview, Paris, July 3, 1996. Unless otherwise indicated, all information about Pierre Wognin is based on this interview.

174 Notes

21. Valérie Petitpas, "Nipa: L'african-way retour aux sources," *Trad Mag* 33 (March\April 1994): 49; Jim Winders, "Nipa," *Rhythm Music* VI:1/2 (January/February 1997): 34.
22. L.E., "Nipa," *La lettre des musiques et des arts africains* 2 (November 15 1993).
23. Olivier Cachin, *L'offensive rap* (Paris, 1996): 67. Other useful books on French rap include Manuel Boucher, *Rap, expression des lascars: signification et enjeux du rap dans la société française* (Paris, 1998) and Alain-Philippe Durand, ed., *Black, Blanc, Beur: Rap Music and Hip-Hop Culture in the Francophone World* (Lanham, MD, 2002).
24. Boucher, *Rap, expression des lascars*: 31. Boucher also points out that the proto-rap American group The Last Poets, whose recordings dated from the early 1970s, had been popular in France.
25. Stéphanie Binet, "Nantes, Port Hip Hop," *Libération* (February 16–17, 2002).
26. Cachin, *L'offensive rap*: 76–77.
27. Amy Linden, "Le rap français, pluriethnique et engagé," *Courrier international* (February 26–March 4, 1998): 28.
28. Boucher, *Rap, expression des lascars*: 31.
29. Rosita Boisseau, "Black Blanc Beur célèbre le mariage achevé du hip-hop et la danse contemporaine," *Le Monde* (April 10, 1998): 36.
30. For vivid descriptions and photographs of life in the communities along this route, see François Maspero and Anaïk Frantz, *Les Passagers du Roissy-Express* (Paris, 1990).
31. Cachin, *L'offensive rap*: 72.
32. Robert Mallar, "MC Solaar exporte," *Le Point* (June 13, 1992).
33. Dan Glaister, "With Words of Peace, Solaar Puts French Accent on Rap," *Boston Herald* (January 2, 1995).
34. Ernest Hardy, "Solaar's System: French Rapper MC Solaar is Combining the Best of Both Worlds," *Village Voice* (June 17, 1994).
35. Fabrice Pliskin, "MC Solaar et les douze salopards," *Le Nouvel observateur* (March 2–8, 1995).
36. Frédéric Péguillan, "Le Philosophe hip-hop," *Télérama* (June 19, 1994).
37. Solenn de Royer, "Prose Combat propose aux jeunes de redécouvrir l'écrit," *La Croix* (October 21, 1998).
38. MC Solaar, group interview, Bourges, France, April 15, 1998.
39. Edgar Yonkeu, author interview, Saint-Ouen, France, June 25, 1997. Unless otherwise indicated, all information on Edgar Yonkeu is based on this interview.
40. "Edgar Yonkeu se raconte," *Top visages: le magazine du show biz et de la mode* (July 2, 2005): http://www.topvisages.net/musique599_1.htm.
41. Gilles Médioni, "Rap, label Sarcelles," *L'Express* (April 17, 1997): 23.
42. Ben and Peter Ndocko, author interview, Paris, May 25, 1998. Unless otherwise indicated, all information on the Ndocko twins is based on this interview.
43. "Biographie," *Masao: Site official du groupe camerounais*: http://masao.fr/biographie.html.
44. Ibid.
45. "Masao," Masao Press Kit, n.d.
46. Another example of this same attitude comes from Congolese singer Sam Mangwana, who declares himself absolutely opposed to "excessive musical mixing," which, in some forms of "world music," can become "absurd." Mangwana further says that "Musical mixing is fine, but each person should preserve his own specificity." Quoted in Gérald Arnaud, "Toute musique est métisse—bien sûr!" *Africultures* 62 (January–March 2005): 92.
47. The musical career of Masao did not meet with continued success. According to their web site, their friend Francis Bebey encouraged them to get more involved in musical studies and ethnomusicological research. Eventually, in 2004 they enrolled in the Conservatoire de Musique de Sarcelles.

48. Ayoko Mensah, "L'âge de raison des Positive Black Soul: entretien avec Didier Awadi (PBS)," *Africultures* 21 (October 1999): 17.

49. "Positive Black Soul: Biography," *rfimusique.com*: http://www.rfimusique.com/siteEn/biographie/biographie_6210.asp.

50. Bouziane Daoudi, "Dakar rappe et cartonne: Le hip hop africain marque un temps fort à la Villette," *Libération* (October 10–11, 1998): 25.

51. Mensah, "L'âge de raison des Positive Black Soul": 17.

52. Frank Tenaille, *Le Swing du caméléon: musiques et chansons africaines 1950–2000* (Arles, 2000): 250–254. Youssou N'Dour's prominence in Dakar and his relationship with Peter Gabriel are subjects that receive satirical treatment in a novel by Mark Hudson called *The Music in My Head* (London, 1998).

53. Véronique Mortaigne, "L'été festival Paris Youssou N'Dour à l'Opéra Garnier," *Le Monde* (July 18, 1998).

54. Michelle Auzanneau, "Identités africaines: le rap comme lieu d'expression," *Cahiers d'études africaines* XLI:3–4 (2001): 728.

55. Mensah, "L'âge de raison des Positive Black Soul": 17 (my translation).

56. Ibid.: 18.

57. "PBS et Pee Froiss tournent pour Africa Fête," *7 Week-end: Hebdomaire d'informations générales* (February 18, 2000): 12.

58. Didier Awadi, author interview, Dakar, February 24, 2000. Unless otherwise indicated, all information on Didier Awadi is based on this interview.

59. Antoine Fouchet, "Les Sénégalais rêvent moins de la France," *La Croix* (October 14, 1997).

60. Stéphanie Binet, "Le Rap africain y croit encore: Positive Black Soul, en concert à Paris, peine à sortir du Sénégal," *Libération* (March 29, 2001): 40.

61. François Bensignor, "Africains en France: la compile," *Hommes & migrations* 1191 (October 1995): 33.

62. Judith Rueff, "Sénégal: le poids des jeunes dans les urnes," *Ouest-France* (March 17, 2000): 4.

63. Jim Winders, "Jimi Mbaye: Heart of Dakar," *Rhythm Music* VII:6 (June 1998): 38–39.

64. Ibid.: 39.

65. Jimi Mbaye, author interview, New York City, November 17, 1997.

66. Sophie Bachelier, "Le Point de vue d'Aziz Dieng: Studio Midimusique, Dakar," *Africultures* 29 (June 2000): 44–46.

67. Aziz Dieng, author interview, Dakar, February 24, 2000. Unless otherwise indicated, all information about Aziz Dieng is based on this interview.

68. Nidam Abdi, "Thione Seck s'exporte un peu: Un pilier dakarois du m'balax en concert parisien," *Libération* (April 30–May 1, 2000).

69. Thione Seck, author interview, Dakar, February 23, 2000. Unless otherwise indicated, all information on Thione Seck is based on this interview.

70. Seck and Clerfeuille, *Les Musiciens du beat africain*: 207.

71. Graeme Ewens, *Africa O-Ye!: A Celebration of African Music* (New York, 1992): 70.

72. Ibid.

73. Ibid.: 75.

74. "Biographie," Oumar Pene Press Kit, n.d.

75. Omar Pene, author interview, Dakar, February 25, 2000. Unless otherwise indicated, all information on Omar Pene is based on this interview.

76. "Les Frères Guissé: African Folk Music," Press Kit, n.d.

77. "Les Frères Guissé," *Afrique en scenes* 7 (1997): 47.

78. Djiby Guissé, author interview, Dakar, February 25, 2000. Unless otherwise indicated, all information on Djiby Guissé is based on this interview.

79. "Les Frères Guissé": 47.
80. "Les Frères Guissé," Press Kit.
81. Modou M. Faye, "Frères Guissé," *Afromix.org* http://www.afromix.org/html/musique/artistes/freres_guisse/bio.fr.html.
82. "Les Frères Guissé": 48.
83. I noticed several Vietnamese restaurants in Dakar, and became a "regular" at one of them. I asked the manager there why there were so many, and her explanation was that Senegalese soldiers stationed in Indochina married Vietnamese wives and brought them back to Senegal, where many opened restaurants.
84. Ewens, *Africa O-Ye!*: 69.
85. Ousmane Sow Huchard, author interview, Dakar, February 29, 2000. Unless otherwise indicated, all information on Ousmane Sow Huchard is based on this interview.
86. Seck and Clerfeuille, *Les Musiciens du beat africain*: 222.
87. Tenaille, *Le Swing du caméléon*: 122.
88. Thomas Sotinel, "Le charme du Printemps," *Le Monde* (April 18, 1990): 12.
89. Véronique Mortaigne, "Le blues de Niafounké," *Le Monde* (October 11, 1991): 14.
90. Ibid.
91. Ali Farka Touré, *Niafunké* (World Circuit/Hannibal Records, 1999).
92. Thomas Dorn, *Houn-noukoun: Tambours et visages* (Paris, 1996).
93. Heather A. Maxwell, "Divas of the Wassoulou Sound: Transformations in the Matrix of Cultural Production, Globalization, and Identity," *Consumption, Markets and Culture* 6:1 (2003): 44–48.
94. C.C. Smith, "Oumou Sangare: Mali's Nightingale," *The Beat* 16:2 (1997): 43.
95. Maxwell, "Divas of the Wassoulou Sound": 48.
96. Smith, "Oumou Sangare": 47.
97. Oumou Sangare, author interview, New York City, November 17, 1997. Unless otherwise indicated, all information on Oumou Sangare is based on this interview.
98. Cheick M. Chérif Keita, *Massa Makan Diabaté: un griot mandingue à la rencontre de l'écriture* (Paris, 1995): 12–14.
99. Mamadou Diabate, author interview, Chapel Hill, North Carolina, March 10, 2001. Unless otherwise indicated, all information on Mamadou Diabate is based on this interview.

Chapter 7

A New Politics of Space:
Performance and Sociability

Any examination of a new episode in the history of Paris, such as the significant increase during the 1980s and later of sub-Saharan African immigrants, necessarily must begin with a consideration of how the developments in question affect that city's celebrated space(s). As every visitor to Paris knows well, the city's unique design and allocation of space—with its grand boulevards, sidewalk cafés, pleasant parks, regularly placed squares, and the methodical clockwork spiraling arrangement of the twenty *arrondissements*—is central to its hold on one's imagination. It is a city meant to be understood and to facilitate what urban geographers are prone to describe as mental "mapping." Emerging from a Métro station, you may find yourself momentarily disoriented and unsure of your direction, but you look up and there looms the Tour Eiffel or perhaps the upper floors of the Centre Pompidou to restore your bearings. Such experiences reinforce one's sense of inhabiting and negotiating reassuringly familiar space.

Access to urban space, frequently contested in a violent manner, was long a part of Parisian history even before the celebrated transformations of Baron Haussmann. And since the mid-nineteenth-century, the streets of Paris have constituted the stage setting for dramatic events. One thinks, for example, of the upheaval of the Paris Commune, the street-by-street fighting of the Liberation in 1944, or the student uprising of May 1968. Weaving like a strand throughout this same course of history has been a succession of writers for whom the Paris cityscape was a preoccupation of one sort or another. The iconoclastic mid-nineteenth-century poet Charles Baudelaire posited the urban idler or *flâneur* as the person best situated to observe the complexities and serendipitous encounters afforded by the great city, for him the city undergoing its fabled Haussmanization. The twentieth-century French sociologist Henri Lefebvre made the right to inhabit and use urban space a major theme of his brand of Marxist analysis. Both of these influences were to resurface in the writings, manifestoes, and films of the French Situationists, immediate precursors of the May 1968 student uprisings. The events of May still fire imaginations as a dramatic if

short-lived reinvention of the city, complete with everything from barricades and police battles to eye-catching graffiti and posters to everyday speech and behavior.

In all of these cases, what has typically been at stake is the audacious penetration of the city's space in a way that lays claim to it anew or competes with others' prior claims. Baudelaire's wandering figure invents the city for his own purposes, with no regard to its prescribed uses and ordered arrangements. Adhering to no schedule, he (and it is inherently a "he") is an implied threat to regimes of work or social institutions. Lefebvre argued that right of access to urban space should inhabit the heart of any modern social-ist politics worthy of the name, and denounced the displacement of the working class to the outskirts of Paris engineered over a long period by the triumphant *bourgeoisie*. The most recent version of the relatively affluent central city neighborhoods ringed by dismal, squalid suburbs is, of course, the thriving contemporary Paris with its recent immigrants exiled to the grim *cités*, or housing projects, in such locales as La Corneuve and Sarcelles.[1] Situationists such as Guy Debord retrieved Baudelaire's concept of the *flâneur*, linking it to the aleatory experiments of the modernist avant-garde (e.g., Dada and Surrealism), and embraced the strategy of the *dérive*, meandering through the city with no fixed agenda, and *détournement*, the use of social space for purposes other than those originally intended for it. These ideas continue to resurface in more recent dis-cussions of Parisian life, including in the debate over spray-painted "tags" found not only in suburban areas, but even occasionally in such venerable districts as the Marais (see chapter six). Most observers experience these displays as unwelcome intrusions, but they are not without defenders who echo the Situationist sensibility in their arguments.

French Perceptions of Radical Otherness

Perceptions of African immigrants in Paris, and increasingly hostile reactions to them by those who may consider the familiar urban milieu "theirs" can be understood in part along some of these same lines, and certainly African residents of Paris in recent years have staged some dramatic interventions into the city's celebrated spaces that bear comparison with some of the historic manifestations mentioned earlier. As sub-Saharan immigration to Paris began to increase after 1981, the newest Parisians, bringing with them their cuisine, their native dress, and patterns of everyday living they had known in their countries of origin, slowly began to make their mark on the urban environment, just as the musicians crowding into the Paris studios and per-formance spaces provided sounds not heard there previously. For not a few Parisians, the reaction was one of bewilderment, sometimes followed by resentment: "What are people who look/dress/sound like this doing in my country?" As the reactionary movement led by Jean-Marie Le Pen gained traction during the 1980s, such attitudes were intensified by the mistaken perception that France was being overwhelmed by a greater than ever immigrant population. In the popular mythology of the day, as assailed by historians of French immigration beginning with Noiriel (see chapter one), immigration per se was a break with the past, and the surface differences observed in the sub-Saharan population produced in some the morbid anxiety that they were becoming strangers in their own land.

Such views were by no means limited to the shrill outcries coming from the Le Pen camp. While serving as mayor of Paris (and enjoying many questionable economic benefits thereof), Jacques Chirac made a speech in 1991 in which he expressed empathy with those citizens unfortunate enough to find themselves living near immigrants, with their attendant "noises" and "smells."[2] The speech was cited in *Le Monde* and other papers. Similarly xenophobic comments could be found throughout the pronouncements of supposedly moderate politicians and in the seemingly endless flood of sociological studies, potboiler current affairs (*actuelles*) tracts, and the mass-circulation magazine features that screamed for the French reader's attention. Jean-Pierre Moulin's *Enquête sur la France multiraciale* (1985) provides a case in point. At the very outset, its author, a journalist, assumes that what he calls "foreigners" constitute a "problem," and he devotes many pages to describing a Paris grown unrecognizable to its longtime inhabitants, thanks to the newcomers who seem so irreducibly different. Moulin vividly describes the ethnically diverse ridership of the Paris Métro, which, referring to recent immigrants of color, he does not hesitate to call "their" domain (*Le métro est l'endroit où on les voit le mieux. C'est leur domaine, leur région*):

> *A partir de certaines stations du centre de la ville, quand on roule en direction des XIIe, XVIIe, XXe arrondissements, les Français descendent, les étrangers montent. "Le métro, c'est chaud, c'est plein de copains!," me dit un étudiant camerounais.*[3]
>
> (After leaving certain stations downtown, when you roll toward the 12th, 17th, 20th arrondissements, the French people get off, the foreigners get on. "The metro is where it's at, it's full of homeys," a Cameroonian students tells me.) (my translation)

"Leur" and "ils" are Moulin's favorite words, for he is the type of observer of the immigration phenomenon for whom it is a question of "those" people. Despite passages that argue for more attention to the multiethnic character of contemporary France, he appears to hold on to the view that immigration is a startlingly new development, although he ends his book by declaring that he has been describing "the France of tomorrow."[4]

This sense of at least mildly xenophobic alarm, bordering on racism, may seem at odds with the many accounts we have seen that describe French culture, or at least Parisian culture, as welcoming those with black skin. What about the African American soldiers who experienced Paris as a haven from Jim Crow racism? They helped boost the reputation that Paris enjoyed for several decades, as it received a steady stream of American jazz and blues musicians who no longer could stomach the racial climate in the United States. Yet as Tyler Stovall's work has shown, the welcome accorded blacks during the interwar years did not extend into each of the following decades of the twentieth century in quite the same way. By the time French people started using the English word "blacks" to refer to Africans, that is, by the 1970s and 1980s, the term did not necessarily signal acceptance.[5] Affection for black Africans has often been attributed to the French, but much of the variety celebrated in the mystique of the Senegalese troops who fought for the colonizing power can be shown to be downright paternalistic or worse. Think of the blatantly racist caricatures in the early-twentieth-century ads for the breakfast food "Banania," often depicting a Senegalese *tirailleur*, or "rifleman," in battle dress. In the most famous *affiche*, such a

soldier relaxing with his steaming hot bowl of mush exclaims "Y a bon!" in highly imperfect French. Léopold Senghor was famous for having articulated a desire to rip such posters from French walls, no matter where he found them.[6]

Strangely enough, this kind of imagery did not disappear with the end of the colonial era. Observers of the contemporary French scene have remarked on the resurgence of so-called *négripub*, or the use of often extremely stereotypical African imagery in advertising.[7] This resurgence has coincided with the increased sub-Saharan immigration of the late twentieth century and also, not surprisingly, with the increased strength of Jean-Marie Le Pen's *Front National*. However, as Leora Auslander and Thomas Holt argue in their very personal, interesting account in "Sambo in Paris: Race and Racism in the Iconography of the Everyday," the function of apparently over-the-top caricatures in French culture can often be complex and contradictory. They remark on what struck them as grotesque "pickaninny" statuary used to decorate and advertise restaurants and other places of business, eagerly snatched up, along with memorabilia advertising "Banania" and other food products, by those who frequent the flea markets at such locations just beyond the city boundary as Saint-Ouen. They have found that collectors of such *kitsch* include persons of color, who approach the objects often in a highly ironic manner. Auslander and Holt include a discussion—with an accompanying photograph—of what they regarded as a demeaning figure used to hold the daily menu at a Martinican restaurant that flourished in the 1990s in the Fifth Arrondissement.[8] To their dismay as American visitors, the restaurant owners did not consider the object to be at all derogatory.

Indeed, some of the uses of black faces in ads with devilishly clever slogans can be downright breathtaking, as in a poster used during the same decade to advertise a new version of convenience food manufactured by a company calling itself—not surprisingly in English—"Free Time." Their product was *longuettes de poulet*, a type of breaded chicken "nugget" sold in a package accompanied by two kinds of dipping sauce. The photograph shows an African man, his face bursting into a wide grin and his eyes popping out with excitement over the gustatory pleasure he anticipates. Shown only from the chest up, he wears but a simple beaded necklace. Chicken feathers cascade down upon him, settling on his shoulders and even, in one case, on the tip of his nose. The words appearing at the top of the image, just above the "Free Time" logo, are "A quelle sauce je vais le manger, le blanc!" (Literally: "With what sauce—i.e., which of the two dipping sauces—am I going to eat it, the white!") While the "white" in question may be chicken breast meat, clearly the slogan with the imagery plays on the savage stereotype of cannibalism, even an implied revenge on white colonizers.[9] The meaning also depends somewhat on the idiomatic French expression "*Ne pas savoir à quelle sauce on sera mangé*"—a way of expressing the view that you never know what form future disaster will take (but literally that you do not know with what sauce you will be eaten).[10] However, given the delirious presentation in the image juxtaposed with this peculiar slogan, the most appropriate loose translation might well be "With what *relish* I am going to eat it, the white (person)!" The strongest impact of the ad therefore would be guaranteed by giving full rein to the scandal of cannibalism.

The meaning of such a representation, while apparently direct in a very ham-fisted way, will nevertheless depend on the groups in a position to (attempt to) control or

assign meanings. We would need to know about the people who designed the ad, the model who posed in the photograph, the response of consumers according to ethnic identity, and so on. In the two sources I have located (note 9), the ad simply was presented as evidence of gross stereotyping. But if we are to follow Auslander and Holt's analysis carefully, it is possible that even the groups presumably most likely to be offended approach the image through multiple levels of irony. African American cultural critics have employed the term "signifying" to designate how a represented image or element of discourse can be turned back upon itself, redeployed in a playful, inventive manner (even nineteenth-century minstrel shows have been reexamined in this way). Using this idea, while it may be predictable that some would be offended by the imagery in this ad for a junk food product, it may also be possible to imagine a response that would be amused at the implication of cannibalism— cannibalism as a form of cultural revenge. Eat the former colonizers!

The 1998 world championship victory of the multiethnic (*black/blanc/beur*) French national soccer team created a brief upsurge in the use of celebrity black faces—such as models, singers, star athletes—in advertising, and, perhaps also related to the affirmative attitudes toward the victorious athletes of color, by 1999 observers noted a new nostalgic vogue for the "Banania" imagery. In 2000 a very striking poster that was used on some billboards made its appearance and was much remarked upon. It was an ad for Uncle Ben's rice, and it depicted a woman's hands reaching down to grasp the head of a cherubic smiling little African girl by her ears, as if lifting up a small burlap sack of rice by its handles (indeed, such was the packaging Uncle Ben's had introduced to appeal to Afro-French consumers known for their appetite for rice). Underneath the image was the message *Le dernier né d'Uncle Ben's aime qu'on lui tire les oreilles* (the youngest of Uncle Ben's children likes for you to pull its ears). The masculine pronoun certainly refers to the sack of rice, but those who commented on the ad agreed that the face was that of a little girl. Response to the ad was overwhelmingly positive with 72 percent approval of consumers questioned in one poll.[11] This ad and the response to it seems every bit as paradoxical as the "chicken nuggets" example.

Meanwhile, some kind of relationship had to exist between the obvious fact that black Africans were increasingly to be found in France in recent years and their availability as images in print advertising. By the 1990s the growing presence of black faces fed the perception that immigrants were flooding in more than ever. Actually this was not true as a 1997 study demonstrated. Published as *Les immigrés en France*, it showed that the proportion of immigrants in France had not risen in two decades.[12] What had changed was that more sub-Saharan Africans than in previous stages of the history of immigration had been coming. As the Guadeloupan/French singer Xénia Caraïbe stated in a 1996 interview, "they only care about the color of your skin."[13] The perception of dermatological difference must certainly be at the heart of the mistaken belief, cited by any number of observers, that immigration in France is a very recent phenomenon.[14]

The astonishment French people could feel at the sight of black faces they encounter in public has been explained by some as the result of the nonexistence of these faces on French television (the other side of the coin from the common use of caricatured images in print advertising).[15] Calixthe Beyala, a French novelist born in

Cameroon, has been active in efforts to correct this imbalance. She calls Afro-Antillean French people the "visible minorities." Paradoxically, their social visibility contrasts with their invisibility on the screens in front of which French people while away their evenings.[16] This very paradox intensifies resentment, an extreme example of which was hostile public reaction (to which Le Pen's movement responded vociferously) to the encampment—for several weeks—in 1992 on the esplanade of the Château de Vincennes of the Malians demanding better housing (see chapter four).

Familiar Stages, New Actors

In the charged Parisian climate surrounding African immigration during the 1990s, many of the most dramatic confrontations involved contested or redefined (if only on a temporary basis) space. Some interventions took traditional forms, such as parades or rallies, while others seemed unprecedented. Parades of protest down the major Paris boulevards, especially between such sites of symbolic importance—*les lieux de mémoire*—as the Place de la République and the Place de la Bastille, have long been common to Parisian politics. Taking a page from the annals of working-class manifestations, groups fighting for better treatment of African immigrants took to the streets during this decade. If the most notable examples of the 1980s had been the rallies of SOS-Racisme (see chapters two and three), the marches in solidarity with the Malian hunger strikers—the *sans-papiers*—who occupied l'Église de Saint-Bernard in 1996, as well as in support of the same population in later years, typified the activism of the 1990s (see chapter four).

The summer 1996 occupation of the church near the Goutte d'Or neighborhood certainly was a dramatic appropriation of a familiar space by Malian immigrants (see chapter four), and scandalized the very kinds of French people described by Calixthe Beyala—the television viewers for whom the black Africans remain invisible. The "becoming visible" is the real scandal in this sense. In the years after 1996 the *sans-papiers* have returned to their tactic of church occupation, both in Paris and elsewhere in France.[17] A wry cartoon published in *Le Monde* in September 1998 neatly sums up the reaction of that portion of the French public that wishes not to be reminded of the *présence africaine*. Bending over a black hunger striker lying on the church floor in his sleeping bag, a white man counsels him to "Be reasonable. Go back to hiding yourself (*Sois raisonnable. Retourne te cacher.*)."[18] Strategic occupation of auspicious Parisian spaces has not been limited to the ecclesiastical variety. On March 21, 1999, after first rallying in a demonstration held at the Place de la République, a large group wishing to show solidarity with the *sans-papiers* forced their way into the lobby of the Théâtre de Chaillot (part of the Palais de Chaillot) just before a performance of Molière's *L'Avare* (*The Miser*).[19] In a truly secular nation such as France, this "in your face" gesture toward the *patrimoine littéraire* potentially could have been a more potent action than occupying a cathedral.

Another important intervention into the Parisian cityscape by the recent immigrant groups often either resented or unacknowledged by many French people would have to be the annual nationwide music festival of June 21 known as Fête de la Musique.

Sponsored by the Ministry of Culture and Communication, this event emerged out of the Jack Lang era, having first been observed in 1982. The idea for this celebration of the summer solstice was to have music performed all over, on street corners and in cafés as well as parks and public stages. Undue emphasis was not to be placed on "stars," but everyone was to be encouraged to participate.[20] Over the years an important result of the fête has been that people who might not otherwise experience the music of the immigrants have the opportunity to do so. Serendipitous or not, some of the encounters can be quite remarkable, and this annual event serves to remind French people of the varied cultures contributing to the musical richness of the hexagon.

My travels to Paris in search of African music and musicians have allowed me to bask several times in the singular atmosphere of this event. Any day, especially in good weather, is a good day to walk about the city, but on June 21 you get a musical bonus in dozens of small doses. For me memories of the fête begin with the sensation of familiar spaces transformed, sometimes hauntingly so, through investment by musical performers who render the familiar unfamiliar. Examples for me have included a choral group huddled under the heavy stone vaults of the Colonnade of the Louvre and a solo Algerian singer of Berber songs alone in the courtyard of the Archives Nationales. And always, everywhere, there are bars and cafés with much larger crowds than usual, with patrons spilling out of them singing and, sometimes, dancing. Once in a while unfortunate episodes have occurred, as when an overflow crowd of young toughs streaming down the rue du Temple after a June 21, 1995, concert by James Brown in the Place de la République got out of hand and started beating up bystanders after they turned and headed west on the rue Rambuteau (I escaped).

Most years, things go smoothly enough. The 1996 Fête de la Musique produced some especially striking examples of the temporary transformation of Parisian space that concerns me here. A number of high-profile appearances took place around the city, especially from late afternoon through the evening hours. One of the most crowded events on that June day was the performance by Lokua Kanza, the very popular Congolese (ex-Zaïre) singer who wins French audiences over by sprinkling his Afropop repertoire with *chanson*-style numbers in the courtyard of the Palais-Royal. This "place of memory" was already seen as one that had been invaded, so to speak, by a public artwork some regarded as an aberration, that is, the two hundred and sixty columns of the artist Daniel Buren—stumpy columns of unequal height, painted white and black. One could make the analogy to the Louvre's courtyard, with the I.M. Pei pyramid jutting up through it. Jack Lang had posed in this very spot in 1989 with a visiting group of South African Zulu musicians.[21]

At the Lokua Kanza concert, an adoring, predominantly white crowd perched on the Buren columns, packed close to the stage, and sang along enthusiastically to the songs they knew. In the audience, marveling at what felt like a staged event for a music video, I wondered what Cardinal Richelieu would think if he could see what was taking place here at his old haunt in 1996. No doubt his *éminence* would have turned some color other than *grise*. But of course, there is much that historians, especially historians of the 1789 revolution, could say about all that has transpired in the same setting. After all, this stylish haven was where the tormented early-nineteenth-century poet Gérard de Nerval had startled the public by taking a lobster on a leash for a stroll. Far from a case of the temporary introduction of radically new elements into a

monumental space, the courtyard is now a veritable palimpsest onto which many historical interventions have been inscribed.

Such a layered, complex history certainly could apply to the Place Vauban in the Seventh Arrondissement, in front of the great Église du Dôme, housing the stupendous crypt that contains the mortal remains (even if only *les cendres*) of Napoleon Bonaparte. Louis-Philippe had hoped to bask in its reflected glory after he presided over the transfer of the emperor's remains in 1840. Dramatically illuminated by spotlights, this auspicious setting provided the stage for a memorable concert later that same evening of June 21, 1996. The principal performers were Geoffrey Oryema, the soulful Ugandan singer who has resided for many years in Paris, the bizarre rock band from Cameroon called "Les Têtes Brulées," and Positive Black Soul, the best-known of Dakar's hip-hop ensembles, rapping in Wolof, French, and English. The latter group put on an especially energetic show, interacting with the audience as most rappers do, practicing dance moves, and keeping up the high-volume beat. But for sheer stunning visual display, no one can match Les Têtes Brulées, exemplars of the Cameroonian rock genre known as *bikutsi*. They don native "jungle" dress, paint their bodies in wild designs, and insert foreign objects in their electric guitars to simulate the sounds of indigenous instruments. As they and the other musicians performed, enormous screens behind the stage held video projections that allowed even those at the far edge of the square to follow the action and to see them as larger than life. It was an evening in which the "empire rocked back," as artists representing former colonies gave the long-dead Emperor a reason to spin in his ornate tomb.[22]

The day of June 21, for all its prominence, is by no means the only day on which one might encounter France's new musical genres and the immigrant cultures from which they have emerged. The annual festivals in Angoûlème and Bourges (see chapters two and three) are still going strong, as is the more recently instituted Africolor Festival at Saint-Denis (see chapter six). Consulting the week's entertainment offerings in *Le Pariscope* or *L'Officiel des spectacles*, you usually can find a club concert. New Morning in the Tenth Arrondissement remains a perennially reliable venue, and clubs in such areas known for night life as the Place de la Bastille feature African music. Café de la Danse, in the latter district, is an example. Also, quite frequently commuters encounter African musicians, many licensed by the city or the local arrondissement *mairies*, set up and playing in various halls and platforms in some of the more prominent Métro stations. Players of *koras, balafons*, and other instruments associated with *griots* in recent years have been spotted regularly in the large Strasbourg–Saint-Denis station. Further down the No. 4 line at the Odéon station during the late 1990s and the earlier years of the present century, one frequently happened upon a trio of *balafon* players filling the echoing underground hallways with the reedy percussive tones of their mallet-struck sounding tubes. They were highly gifted players, and not a few hurrying citizens took a break from their routines to enjoy their unique sounds.

The pace of urban life is such that most people might not stop to reflect on the transformation of familiar spaces in this way. As you hurry down the sidewalk of the Boulevard Saint-Denis near its intersection of the Boulevard Sébastopol— where the Second Arrondissement abuts the Third—if you are not looking down you will fail to notice the litter of corncobs awaiting the rounds of the faithful Paris *éboueurs*, or street cleaners. Corncobs? Such objects would not readily be associated

with the city known to tourists the world over. But grilled corn, found invariably as an appetizer on menus in African restaurant, is a popular snack proffered by street vendors in the crowded streets around the Porte Saint-Denis and the large Strasbourg–Saint-Denis station. In recent years the sight of a pedestrian weaving down the boulevard, past the cell phone shops and the dueling fast food joints ("Quick" vs. "McDo"), and chomping away at a roasted ear of corn has become quite common. Just as with the music in the corridors of the Métro stations, it gives us another example of the African population leaving its mark on the city's changing surface.

Only eight days after the 1996 Fête de la Musique, a close friend and I journeyed to the charmless northern Parisian suburban community of Bondy to take in a free outdoor concert featuring the flamboyant Zaïrean singer Papa Wemba with his large band. Held on the lawn next to the town's Hôtel de Ville, the event was part of a summer series called *Y'a d'la banlieue dans l'air*. But as for the air, it was astonishingly chilly for a late June day, although this is not entirely unusual for "summer" days in northern France. As the crowd of all ages milled about waiting for the concert to begin, many could not resist the aroma of the fresh-grilled spicy *merguez* sausages wafting in the brisk air. Cans of Heineken and soda were available to wash them down. Every kind of attire was visible among the assembled audience members. Papa Wemba is known for his sartorial bravado, and of course he was to go through several costume changes during the performance. Once the show was underway, the combination of flashy clothing, dancing, and high-energy pop music resembled a classic Motown revue as much as it did a Congolese *soukous* concert.

Just before the show began, I took a stroll around the grounds and passed a small cathedral from which parishioners were just being to file out. Typically for European churchgoers, they were very much an elderly throng. Confronted with a gathering of people clad in African robes or designer athletic clothing, many sporting dreadlocks, the crowd of *français de souche* eyed them warily, in a response equivalent to that expressed by Jean-Pierre Moulin in his description of "alien" Métro riders. The guarded postures of these nonplussed senior citizens mimed "what are *they* doing in our country?" It was another case of a familiar space rendered unfamiliar by persons entering it who were neither expected nor exactly welcome. That they should have been expected is clear, just as it is clear that, for the kinds of reasons previously described, they were not. Immigrants have been present, have been participating in French culture, but nevertheless continue to be met with reactions that suggest they have only that moment arrived. The surface reaction is divorced from the complex processes at work in a changing culture. For it seems clear that both the music and the cuisine of immigrants undergo important transformations through contact with the country that receives them, and in turn they make their mark on the host country.[23] The process is subtle yet constant, surrounded by contradictions.

Restaurants, Bars, Cafés—But More Than That

Today the African immigrant presence is diffuse throughout Paris and its suburbs. A generation ago, businesses were much more concentrated on the northern edge of the

city, most notably in the Eighteenth Arrondissement. This was particularly true of restaurants. West African restaurant owners I have spoken with agree that the now-closed Fouta Toro, on an obscure street called the rue du Nord (near the Métro stop Simplon), was the first such establishment (although a long defunct restaurant called the Baobab, in the part of the rue de l'Université that passes through the eastern edge of the Seventh Arrondissement near Métro stop St. Germain-des-Prés[24] is also mentioned). Fouta Toro, whose name designates the arid mid-region of the Senegal River Valley,[25] was a Senegalese establishment that set the pattern later to be emulated of having a *kora* player who appeared nightly. It remains true that the musical ambience is an important feature of the African restaurants of Paris. Most feature live music (usually a *kora* player/singer) each evening and keep their compact disc players busy during other hours.

The restaurants and cafés are important centers for the resident immigrant community and for visitors and tourists eager to enjoy the cuisine of their home countries. Simultaneously, they have served to introduce longtime Parisians to cuisine and music that is new to them. Moreover, they help to keep alive a great modern Paris tradition: the central role of café sociability, about which social historians have written a great deal. In fact, African immigrants can be said to have rescued café culture from its steady decline in the age of televised entertainment and the privatized existence fostered by consumer society. Much of this stems from the village life immigrants seek to reinvent in the new context of the host country. Whether in the workers' *foyers* or in the large apartment buildings they would populate later, Africans in Paris sought to duplicate their traditional public culture in new, often inhospitable settings.

This is a particular emphasis of Guy Boudimbou, who has written one of the most complete accounts of the lives recent immigrants have constructed for themselves in France, published as a study by the influential house L'Harmattan in 1991, in their series "Collection Habitat et Sociétés." In the book, Boudimbou describes the patterns of daily life in the immigrant *cités* and HLMs (Habitations à Loyer Modéré), or rent-subsidized housing projects. Calling these patterns "strategies and spatial practices," he paints a vivid picture of the tensions between African immigrants and their non-African neighbors, the latter much annoyed by the noises and smells of which Chirac had spoken.[26]

In the words of a team of authors describing African immigrant life in one Paris neighborhood, "Social life is lived outside the home, in public space and in cafés."[27] Reminding his readers that notions of privacy and intimacy are circumscribed by culture, Boudimbou argues that African immigrants are uncomfortable with the very domestic design they have come to occupy, that is, that they experience the routines of home life as unnaturally "folded" back upon itself within an interior space walled away from the street (where one potentially might greet passersby and erase the boundary between public and private existence), and thus as a real constraint.[28] They may seek to overcome such a constraint by gathering socially in the courtyard of a housing complex, once again to the potential annoyance of residents with different preferences regarding domestic life. Those in the latter group have difficulty comprehending the view their immigrant neighbors take of everyday residential sociability. Unquestioned cultural assumptions that can lead to condemnation of the way groups perceived as threateningly different go about their lives similarly have been examined

by those concerned with the Mahghreban community in France. One example among many that could be cited is the resentment non-Arab neighbors express over groups of youngsters playing outside with no apparent immediate adult supervision. Sociologist Jacques Barou has argued that these neighbors fail to recognize that the North Africans in France have reinvented the life of the *bled*, or Mahgreban village, whereby children are viewed as the common responsibility of the entire adult community. One cannot make sense of the group recreation of the young people and their relationship to adults through the lens of the modern Western-style nuclear family.[29]

When they establish restaurants, cafés, or bars, African immigrants in Paris intend that they should be more than mere places of business. At best, they are to be veritable crossroads where the resident African communities, other Parisians, and travelers from African countries can encounter one another. They function on several levels, as places to seek refreshment, perhaps just a quick coffee or drink, or to enjoy a more leisurely meal. They are also places to get the latest news, and to socialize outside the context of home or workplace. With their décor and the inevitable music playing— whether traditional or "pop"—the eating and drinking establishments serve also to promote immigrant cultures and to assert their presence in the urban center of French cultural life.

Primarily, they are centers of conversation, the activity celebrated by students of the Parisian café, and by historians of the city's restaurants (who have pointed out the origin of this particular cultural institution as more a center for relaxed conversation than a place to consume meals).[30] As is well-known to contemporary scholars in a variety of fields, including political theory, the Enlightenment-era coffee house is at the center of the celebrated notion of the "public sphere" introduced by German philosopher Jürgen Habermas.[31] Focusing on such early modern cities as London, Paris, and Berlin, Habermas extols the freewheeling conversation of the eighteenth-century coffee house or café as a model for the kind of ideal speech community necessary for genuinely democratic culture, and of course he argues strongly that the public sphere has eroded dangerously in the advanced modern era. Critics of Habermas have argued persuasively enough that his eighteenth-century model is overly class- and gender-specific,[32] or, as such postmodern philosophers as Jean-François Lyotard objected, is too reliant on strictly rationalist notions of discourse.[33] Nevertheless, the public sphere debate that Habermas launched several decades ago has generated a veritable cottage industry of commentary, and can never be far from the minds of historians who research Paris cafés and restaurants.

The café of Enlightenment Europe was a place where a busy merchant could come in for the news (often it was the only place where one could read newspapers), have a cup of the stimulating beverage, smoke a pipe, and generally let his hair down (if not his powdered wig). Even in the embattled, diminished contemporary public sphere, the quintessential Parisian café still provides this kind of refuge. Moreover, the unhurried atmosphere of a café or brasserie often features a kind of blending and blurring of public and private existence. At one table, friends will be conversing happily, perhaps even calling out to other acquaintances (as well as having the inevitable cell phone conversations). At another, two or three businessmen might be having an earnest discussion about a deal in the works. Close by, a tense couple, in angry whispers punctuated by hurtful silences, may be having an argument about their relationship. Perhaps

they are on the verge of breaking up. Across the way you might see someone leisurely stirring a cup while perusing a newspaper or magazine. Someone else idles near a group of young people engrossed in a video game.

An entire way of life, however threatened by the revved-up velocities of the contemporary world, flourishes in such milieus, and recent Parisian immigrants, especially—as many have begun to argue—African immigrants, have sought to embrace and revive this way of life. The public sphere concept may have been demonstrated to be culture-bound, but it just may be that immigrants from former colonial countries have come to recuperate it. It is one of many examples we have seen of immigrant groups paradoxically being the ones to embrace aspects of social life in the process of being discarded by the host country. Café frequentation is one of many aspects of the good life proffered by French civilization that colonial educators extolled to their African pupils, and the recent immigrants want to experience it.

As African immigration stepped up during the 1980s, the new arrivals wasted little time in turning their energies toward setting up restaurants, cafés, and bars. They seem to have continued to crop up even after the introduction of more stringent immigration policies during the 1990s. Regular visitors to Paris will have noticed the striking proliferation of these establishments within the last decade or so. Some of the oldest Senegalese restaurants such as Paris–Dakar, until recently on the rue du Faubourg Saint-Martin, are still active, but have been joined throughout Paris by newer ones and by Cameroonian, Ivoirean, Guinean, and Congolese restaurants.

Paris–Dakar, a successful Senegalese restaurant named for the annual overland vehicle race, was a spot that contrasted favorably with the somber uniformity of the buildings on the street (rue du Faubourg Saint-Martin) that stretches from the Porte Saint-Martin to the Gare de l'Est. The restaurant operated there from 1986 until late 2004, when it moved west into the Ninth Arrondissement on the rue de Montyon (just north of the "Grands Boulevards" Métro stop). On the ground floor of its former location, one found a small cozy space with a bar facing the door. Upstairs was another dining room where the resident *kora* player performed most evenings at around 9:00. A tall, burly man named Mamadou Coumdoul was the proprietor, and he presided nearly always dressed in the loose-fitting *boubou* traditional to West Africa. His family shared the work of the restaurant, and on more than one occasion I spotted his schoolgirl daughter doing her homework at one of the tables.

On the bar sat a large television with videocassette player, next to which were heaped concert tapes, many recorded at Paris venues, of important Senegalese musicians. The menu featured traditional dishes of Senegal, including *mafé* and *yassa*, and the house specialty *thieboudienne*, the fish and rice dish in a spicy tomato sauce considered the national dish of Senegal. In Dakar, one eats it from a common platter or bowl with dining companions equipped with individual spoons and careful to eat only from their portion of the dish. As with ethnic cuisines in other Paris restaurants, concessions are made to French custom. At Paris–Dakar an extremely generous individual portion served in a rectangular wooden dish is placed before the customer who orders it. Long a Paris resident, Coumdoul considers himself a willing cultural ambassador, as eager to introduce his customers to the food and music of Dakar as he is to converse about politics.[34]

After one of several meals I had enjoyed there, the ambassador/restaurateur agreed to be interviewed, pulled up a chair, and we entered into a prolonged discussion.

Coumdoul said he had long wanted to have his own restaurant, but first he had to learn the trade. In Senegal he had studied in a school that trained persons for hotel management and worked in a Meridien hotel before leaving for France at the age of eighteen. Having been born in Senegal before independence, he enjoyed the advantage of French citizenship. He did not plunge into restaurant work right away. But by the mid-1980s, as the number of sub-Saharan immigrants increased in the Paris region, Mamadou began to think that maybe the time was right to start the restaurant he'd dreamed of. As it seemed to him: "I thought to myself, I have always said that African cuisine is very fine, the culture is equally strong, and there is a large community here. But, in general, no restaurant has caught on." But how would Parisians react to his attempt to establish a new restaurant? Coumdoul reasoned that

> France is a gastronomical country. Gastronomy is part of [French] culture. [French people] have been developing a taste for African food, its flavors and spices. They travel a lot. After that, I began to work on all of this. How could I put out a quality African product?

Two or three years after the closing of Le Baobab, he wanted more and more to try his own restaurant. "People said to me, 'How are you going to do it?' " He took the leap, and the gamble paid off.

From the very beginning, Coumdoul intended for Paris–Dakar to be more than just a restaurant, but a place that would represent the unity of Senegalese culture. "Whether on the level of gastronomy or art, we say that life is one," he asserted. He has used the restaurant as a true cultural center, working, for example, with a television channel, interviewing more than two hundred African and Antillean musicians in the restaurant, including Youssou N'dour, Senegal's most celebrated contemporary singer, something of which Coumdoul says he is "very proud," since he admires his music so much. "You know," he said,

> I believe that I am not a *restaurateur* like others. In my head, I am an African ambassador. I feel like saying that because I want people to love my version of Africa. And through my efforts, I want to be able to make beautiful things. That's to say, I am a professional *restaurateur*, I make people welcome, and ensure they have a good time. It is my wish that, as a result, they will come to accept Africans.

Despite speaking in such a general way about "Africa" or "Africans," Coumdoul was quick to deny sharp distinctions between Senegalese and French culture:

> As Senegalese, we participate in this French culture. France was in Senegal for three centuries. It is something that was made a part of our culture, therefore we take part in a certain French culture.

Beyond questions of "French" or "African" identities, Coumdoul emphasized the larger cosmopolitan nature of Paris–Dakar, which, advertised widely in tourist guidebooks, attracts clientele from many parts of the world, including Japan. Striking a tone one often hears from African immigrants, he upheld a view of his establishment as contradicting the abject image—fueled by famine, brutal postcolonial

dictatorships, or Rwandan genocide—that so many hold of contemporary African countries:

> I want to be the positive Africa, the Africa that is young, that is modern, that wants to get things done, instead of falling behind, being sick, poor, and in need of aid. No, I don't want to be *that* Africa.

Holding such lofty views did not keep Mamadou Coumdoul from acknowledging the difficult challenges faced by someone in his line of work. For example, the type of menu that Senegalese restaurants offer in Paris necessitates bringing many of the ingredients in from the home country on a regular basis. "That elevates the price of the dishes, and makes them quite expensive," he lamented, and of course that can make meals in restaurants such as Paris–Dakar surprisingly costly. The challenge, he said, is to find ways to keep costs at a minimum without compromising the integrity of the cuisine. The ultimate goal, naturally, is to satisfy the customers. It was clear that, as long as he remained at the helm, Paris–Dakar would remain a source of traditional Senegalese delicacies as well as a lively music spot.

Another West African establishment of long duration is Le Dogon, off the Place de la République on the small rue René Boulanger meandering southwest back toward the Boulevard Saint-Martin. The restaurant is named for the large ethnic group found in several West African countries, each of them represented in the distinctive décor of the upstairs dining room (the kitchen is downstairs). Each table in the small dining area, partly for the convenience of the staff, bears the name of an African capital city, for example, "Bamako," "Dakar," "Conakry," and "Abidjan." When you receive your bill at the end of a meal, you will be reminded of your particular location. A large aquarium separates the two halves of the dining area, and behind the bar a dumbwaiter brings prepared food from the kitchen below. The *kora* played by the resident *griot* is stashed in a corner of the unisex bathroom. On the wall just on the way to the bathroom hangs a portrait of a typical *tirailleur sénégalais*, that is, one of the expert marksmen first employed by the French army during the brutal trench warfare of World War I. The cordial host and proprietor is Bécaye Tounkara (1953–), a trim man clad invariably in Western attire. He comes from Mali, although the restaurant is largely Senegalese in its presentation. Like his counterpart at Paris–Dakar, he was born before his country's independence from France and so he automatically acquired French citizenship. Tounkara is keenly aware of Le Dogon's importance as a gathering place for musicians, and sees to an ongoing procession of recordings of the latest in African popular music. He enjoys talking of the prominent musicians numbered among his regular customers.[35] "Second in command" is the equally affable Faira Gueye, a Senegalese-born man who first came to Paris in 1990. Now a French citizen, he has family in both countries, and enjoys talking of his relatives back in Senegal.[36]

Gueye always seems to know as soon as a customer enters from the street and, after enthusiastically pumping your hand, indicates the small spiral staircase you need to ascend to the dining area. Once you gain the upper floor, the pleasantries continue, and Bécaye Tounkara offers his hand and may introduce you to the others already seated at their small tables. West African men, when they enter a room, immediately

shake hands with the other men present. It is a reminder that the public space of a restaurant or café tends to be a male preserve, but it also seems that women are welcome and usually also present at such establishments in Paris. One interesting phenomenon about dining customs and gender arrangements among Senegalese people is that they have adjusted and adapted in moving from rural Senegal to Dakar and then on to Paris. For example, it seems to have been the custom in Senegalese villages for men and boys to eat together while women and girls eat separately. However, when in Dakar, families dine in mixed company. Once in Paris, the arrangement *à la Dakar* prevails for immigrant families.[37]

At Le Dogon on some occasions, a degree of anonymity might prevail from table to table, but quite often everyone present seems connected, participating in the general, casual conversation. Wolof predominates at times, then the flow switches back to French. The owner/manager encourages the camaraderie, but makes it clear that a certain degree of propriety is called for. During a visit I made to Le Dogon in early 2004, a young man seated by himself at his table became loud, strident, and increasingly argumentative. Tounkara put a stop to it with a stern *"Laisse tomber ça!"* ("Let that drop!" or "That's enough of that!").

Bécaye Tounkara, who has been in Paris since 1973, did not found Le Dogon, but purchased it in 1991 from a woman who had started it during the 1980s. "Since I am Malian, I kept the name," he explained. He is from the fabled Soninké people of the Western Sahel (see chapter one), and also enjoys pointing out that Le Dogon was the first of the several African restaurants currently in the neighborhood to be established. Like his counterpart at Paris–Dakar, Tounkara values music and is quite proud of the fact that Mory Kanté (see chapter two), an occasional customer, dedicated an album to him. He is also inclined to view his surroundings as something more than merely a restaurant. His work, he argued, is a way of "defending a culture," with music and cuisine as equal "elements." He believes those who patronize Le Dogon hold similar views:

> When people come here to eat, it is also to discover other things, not simply to eat. At least, [the purpose of the restaurant] is to defend a culture, African culture and its origins. That is the goal."

By the late 1990s, the streets of the Eleventh Arrondissement one approaches from the southeastern corner of the Place de la République had become home to a significant number of African eating and drinking establishments. One finds them especially along the avenue Parmentier, a locale increasingly considered *très branché*— hip, cool, "in." Quite a number of other places operate on nearby streets, for example, the rue Jean-Pierre Timbaud, as it extends from République to Belleville. One of the most successful places on the avenue Parmentier is Au Village, another Senegalese restaurant owned and managed by Alpha Diallo, a member of a younger generation of French citizens of Senegalese origin (he was born in Senegal in 1960, thus entitled to French citizenship). Diallo opened the restaurant in 1998.[38] The traffic in and out of the place seems constant during the evening serving hours, and Diallo supervises the hustle and bustle from behind the restaurant's small bar, dispensing both alcoholic drinks and the wide array of fruit juices (such as the sweet drink *bissap*) and soft

drinks favored by the Senegalese (more than 90 percent of whom are Muslim). Conversations among patrons crisscross with the ones being held with remote interlocutors, as cell phones ring continuously, snapping open and shut. Typically, the language heard seems a hybrid of Wolof and French.

When interviewed, Diallo was very positive about the location of Au Village, and considered it significant that African restaurants were to be found now in arrondissements other than the Eighteenth. Diallo exuded an attitude of upbeat optimism about his restaurant and the culture it represents. Somewhat in contrast to other owners of Senegalese restaurants, he said that it was not difficult to acquire the special ingredients and food products needed for the menu. This is because he had taken it upon himself to see to their importation and distribution directly. He explained that he fell into the restaurant business in the following way: he arrived in France in 1983 to begin his military service. After completing it, he began traveling back and forth between France and Senegal—enjoying the advantage of dual citizenship—to work with Senegalese food products. While this began more or less "by accident,"

> In fact, I was the first Senegalese person who worked with food products that come from Africa . . . I worked like this for almost ten years. It was there that I made contact with people in the restaurant business, since everyone who had African restaurants in Paris had to come to provision themselves in our country (Senegal).

After he returned to France, he remained in touch with the people he had met in Senegal, and was invited to help manage the restaurant that became Au Village. It had been preceded in the same location by a restaurant called Le Village.

The success of Au Village was especially striking considering that it was Diallo's first such venture. His know-how in the food importation area must certainly have been instrumental. He pointed out that African immigrants have been slow to open stores that feature food products from home countries. Perhaps overgeneralizing, he argued, "You don't find them in Paris. In fact, in Paris it's the Chinese who sell African products." Diallo emphasized the appeal of Au Village to a heterogeneous clientele ("80 percent of our clientele is French," he said) treated to live music nightly by the enthusiastic *kora* player/*griot* Moussa Konaté, who greeted customers as they entered with a jaunty wave of his hand. An especially gifted player, Konaté carried on running conversations with the restaurant's patrons as his fingers showered listeners with notes from elaborate runs on the *kora*'s twenty-one strings. Many *griots* or *jelis* in Konaté's position have been persons coming to Paris only temporarily to earn money for major expenses in their home countries,[39] but Konaté is an example of someone serious about pursuing a career in Western countries. He has traveled widely, and recorded a CD during a visit to San Francisco.[40] The musical offerings at Au Village also extend to jazz, with a trio performing each Thursday night.

As we have seen with other restaurant proprietors, Alpha Diallo wanted to win a French clientele to African cuisine, and at the same time wanted Au Village to be an all-around community cultural center. "That is my goal," he affirmed:

> It is a very good restaurant, really warm and all that. But that has already happened. A greater success is to have a place for musicians who are passing through and for people in other walks of life to create something.

He worried that diners might find the food too spicy (a well-known objection of the traditional French palate). "We try not to make the food too spicy, but put some of the hot sauce (*du piment*) on the table for people who want to add a little." This calls to mind the gentle, concerned tone Bécaye Tounkara at Le Dogon uses in cautioning his clientele about the fiery sauce.

Asked why so many of the restaurants in Paris seem to be Senegalese, Diallo mentioned that some establishments were Cameroonian and some Ivoirean, but that the majority indeed seemed to be Senegalese. He speculated the reason is that Senegalese cuisine might be easier to prepare, "not easier to eat, but easier in relation to that of other African countries." Then he argued that African cuisine was making inroads into French culture, slowly converting those who have preferred pasta to rice. Previously, Diallo observed, "rice was very rare, just for making salad and such things. And now you see rice in French restaurants." As for the noticeable fact that the number of African restaurants had been steadily declining in the Eighteenth arrondissement (such as in the Goutte d'Or district) and cropping up in other parts of the city such as his own neighborhood, Diallo explained the crime rate and drugs had made the former area "a little hot," thereby discouraging potential visitors who might appreciate African cuisine.

For energetic musical performance as well as dining, one of the most popular African night spots from the late 1990s until its closing in 2002 was Au Petit Tam-Tam (named for the traditional drum common to Central and West African traditional musical genres). It was also an elegant restaurant, replete with white tablecloths, plush carpets, and ornate mirrors. Its proprietor was a Congolese (ex-Zaïre) singer and guitarist named Péla Nsimba (1955–),[41] who performed in recent years as "Péla Simba." His restaurant, with its heavy vaulted ceiling, occupied the basement floor of a massively constructed building that dates from the sixteenth century, in the small rue Amelot, running between the Third and Eleventh Arrondissements southeast of the Place de la République. Au Petit Tam-Tam attracted a smartly dressed professional (*les cadres*) African immigrant crowd, and on any given night served as a magnet for visiting African musicians. In keeping with traditional preferences, meals were served quite late in the evening (midnight being an early time slot), and the music and dancing commonly did not begin until well after midnight. In 1998 he gained permission to keep the place open until 4:00 a.m. If not exactly *jusqu'à l'aube*, this was better than the previously mandated 2:00 a.m.[42] Once his food service duties were complete, Simba strapped on his electric guitar and joined fellow musicians on the small stage, often in lengthy jam sessions that incorporated a wide variety of musical genres. Reggae (Bob Marley's popularity never seems to wane in Paris) was featured regularly, along with the more standard Congolese *rumba* and *soukous*.

Péla Simba was part of the first wave of Zaïrean musicians who came to Paris (rather than to Brussels, as an earlier generation had done) in the late 1970s and began contributing to the growth of the Parisian network of recording studios. First of his family to emigrate, he did so to continue his studies, not principally for music—although he'd been an active musician in Zaïre, where he was one of the founders on an influential band called Thu Zaina.[43] Long a musician, he was associated with some top musicians in Zaïre, including the towering singing star Tabu Ley Rochereau (his uncle by marriage), Papa Wemba, and the band Zaiko Langa Langa (see chapter one). Arriving in Paris in 1977 on a student residency permit, he was

required to make satisfactory academic progress in order to remain in France. He pursued his studies and his music on "parallel" tracks, he stated. Péla spent three years as a student before turning to music again full time. Meanwhile, other Zaïrean musicians were arriving steadily. "Everyone from Zaïre came after me," he said. "I welcomed Papa Wemba and Sam Mangwana (another very influential Congolese singer, in his case by way of Angola)."

A true witness to the unfolding of the "World Music" era in the Paris of 1980s, Péla described himself as both "a spectator and a participant." He also expressed dismay that the growth of the music was not reflected in television coverage. Radio offered some hope, although often limited to surreptitious *radio libre* broadcasts. Friends of his operated such a pirate station until the police came looking for the equipment. During the 1980s Péla recorded and played concerts with a number of musicians, including Ray Lema, but the careers of other Zaïrean musicians "advanced more than mine," as he put it. "My problem," Péla allowed, "is that I studied so much." But the many contacts he had accumulated and his knowledge of France stood him in good stead when it came to opening his restaurant, which for the length of its operation lived up to his wish that it would be a place for artists, intellectuals, white-collar workers (*cadres*), and prominent athletes (*sportifs*) to gather to discuss and debate political and other issues pertaining to Congolese life. To this end, he sponsored weekly Sunday meetings to discuss the former Zaïre and helped organize a philanthropic organization called *Action Zaïre*.

Péla Simba's view of his restaurant as a place that could provide a forum for important discussions will remind many observers of 1990s' Parisian culture of the "Café Philo" movement, whereby cafés were encouraged to set aside time each week for philosophical discussions, with topics to be suggested by café patrons themselves. The first café to be designated as a "Café Philo" was the Café des Phares, prominently located on the Place de la Bastille between the rue St. Antoine and the Boulevard Beaumarchais. The idea came from a philosopher named Marc Sautet (1947–1998), a veteran of May 1968 known for his books on Nietzsche. Cafés all over France gradually came to emulate the Parisian model, and Sautet's 1995 book *Un Café pour Socrate*[44] became the manifesto of the movement. According to his model, café patrons were to converge on the scene at an established hour and then choose a moderator and set about the task of suggesting topics, voting on them, and so on. But in the case where persons in a café or restaurant are already acquainted, it is not unusual for intellectual discussions to unfold as a matter of course. Péla Simba's desire to have such regular discussions at Au Petit Tam-Tam shows that African immigrants in Paris find it natural to participate in such a fundamental aspect of French cultural life.

In the case of each restaurant described here, the owners relish their successful efforts to showcase West African culture through distinctive food and music. They are Parisian, yet they remain in tune with the people "*là-bas*." Wrapped in the atmosphere that pervades the warm interiors of their businesses, it can be Senegal or Mali in their heads, but reminders that one is in Paris are never far away. In striking ways, they and their musician counterparts illustrate what Benedict Anderson has described as "imagined communities," that is, national identities and even aspirations that transcend the physical limits of actual boundaries.[45]

Studies of modern African musicians point to the importance of bars as centers of social networks for musicians.[46] In addition to restaurants and cafés, bars play an important role for African immigrants in Paris, and here the deployment of social space ranges from the clandestine to the very public. An example of the latter is Le Conakry, a busy Guinéan bar on the Boulevard Saint-Martin in the Third Arrondissement. Unlicensed drinking establishments have thrived in many African countries, and in Paris they have provided a livelihood for *sans-papiers* otherwise unable to seek employment. Moreover, they afford society and sociability for specific communities much as the "aboveground" restaurants have. In recent years in Paris, a thriving nightlife has been unfolding in out-of-the-way locales throughout the Île-de-France, sometimes in dilapidated *cités* of the suburbs, sometimes even in the abandoned buildings used (as *les squats*) by the *mal-logés*, more-or-less homeless immigrants, many of them the remnants of the *sans-papiers* dispersed by police actions as far back as 1992. Typically run by women, the illegal bars also serve as places for undocumented workers to while away their nights, since some of them may sleep in crowded flats during the day while the other occupants go to their jobs. A great number of these establishments, called *ngandas* or *gandas*, are Congolese. The Cameroonian equivalents are *chantiers*, while the Ivoirean variety are *les maquis*.[47]

Congolese *ngandas*, which draw especially on the centrality (until very recent years) of Kinshasha and Brazzaville bars as places to dance and hear music (even called *bars-dancing* during the late colonial and early postcolonial periods),[48] are known in their Parisian incarnation especially as settings for conspicuous displays of reckless spending—signaled by the ordering of many bottles of expensive liquor— and flashy dressing, as well as for the usual themes of socializing and catching up on the latest. Emulating many of the musicians they admire, Congolese men adhere to the code of "SAPE," that is, the Société des Ambianceurs et des Personnes Elégantes.[49] Like Papa Wemba (see earlier) they might sport knockoffs of the trendiest Japanese *couturiers*. The women are equally elegant. One journalist, describing spectacularly attired *habituées* of a clandestine bar in a squalid setting, mentioned elegant stiletto heels sinking into the moist earth.[50]

Then there is the far less clandestine life of the Parisian *café*—that unique blend of public interaction and undisturbed intimacy that few places on earth seem to offer. Michèle Tribalat and others have asserted that African immigrants have helped significantly to revive the dying art of café sociability.[51] Scott Haine, a historian of Paris café life, agrees, and suggests that Africans in Paris, in the age of the internet, DVDs, and French Disneyland, have in this way behaved as the truest Parisians.[52] Tribalat views the sociability of sub-Saharan African immigrants as linked to their organizational activities in associations,[53] and furthermore argues that their spoken French is superior to that of other immigrant groups, including North Africans.[54] As someone who has spent many hours arranging interviews with Paris-based immigrant musicians, it has been the case more often than not in my experience that a café has been the rendezvous point—and not just prominent ones such as Au Bon Pêcheur or the Café des Phares. Quite often a modest, little-noticed neighborhood spot has been the appointed place. These are not always merely casual associations. Since 1990 combined financial support from the Ministry of Culture and city and departmental governments has allowed the *cafés musiques* to flourish. After 1996 they were

designated *Scènes de musiques actuelles* (SMAC). By 2000 more than one hundred such cafés were thriving throughout France, a dozen or more of them in Île-de-France.[55] In the first years of the new century, Africans were becoming known for the establishment of cybercafés.

As they play their parts on the Parisian stage, African musicians and restaurant owners are in some ways acting out a new story, a new chapter in the city's history. Yet they also are part of a very old story, the story of an ever-changing city that has long welcomed creative souls from all corners of the earth. Moreover, many of these newer arrivals are coming home, in a sense, having been French in a very real sense in their African locales, where they learned the art of café sociability and frequented bars in the manner of Parisians. Today's world confronts us with sometimes baffling admixtures of cosmopolitanism and parochialism. Some people seem simultaneously capable of expressing themselves as world citizens and asserting deep attachment to their ethnic origins. It is not quite what the architects of French Republican ideology had in mind, but it may be what the future has in store.

Notes

1. The book that most vividly captures the grim reality of these (especially northern) outposts on the Paris perimeter is *Les Passagers du Roissy-Express* (Paris, 1990), by François Maspero.
2. Alec G. Hargreaves, *Immigration, "Race" and Ethnicity in Contemporary France* (London, 1995): 115.
3. Jean-Pierre Moulin, *Enquête sur la France multiraciale* (Paris, 1985): 15–16.
4. Ibid.: 243.
5. Mar Fall, *Des africains noirs en France: Des tirailleurs sénégalais aux . . . Blacks* (Paris, 1986).
6. Stephen Smith, "Nègre, noir, black," *Le Monde* (May 17, 2002): 32.
7. See Raymond Bachollet, Jean-Barthélem, and Anne-Claude Lelieur, *Négripub: L'image des noirs dans la publicité* (Paris, 1992).
8. Leora Auslander and Thomas C. Holt, "Sambo in Paris: Race and Racism in the Iconography of the Everyday," in *The Color of Liberty: Histories of Race in France*, ed. Sue Peabody and Tyler Stovall (Durham, NC, 2003): 147–184.
9. Philippe Dewitte, "Le Noir dans l'imaginaire français," in *L'Autre et nous: Scènes et types*, ed. Pascal Blanchard, Stéphane Blanchoin, and Nicolas Bancel (Paris, 1996): 32. For a vivid color reproduction of the poster, see Pascal Blanchard et al., *Le Paris noir* (Paris, 2001): 230.
10. Josette Rey-Debove and Alain Rey, eds., *Le Nouveau Petit Robert: Dictionnaire alphabétique et analogique de la langue française, Nouvelle Édition du Petit Robert de Paul Robert* (Aris, 1993): 2039.
11. Florence Aubenas, "La Pub française fait l'impasse sur les minorités ethniques," *Le Monde* (May 23, 2000): 18.
12. Philippe Bernard, "La Part des immigrés dans la population française n'a pas augmenté depuis vingt ans," *Le Monde* (February 28, 1997): 21.
13. Xénia Caraïbe, author interview, Paris, July 1, 1996.
14. Philippe Bernard, *L'immigration* (Paris, 1993): 15.

15. Alec G. Hargreaves and Antonio Perotti, "The Representation on French Television of Immigrants and Ethnic Minorities of Third World Origin," *New Community* 19:2 (January 1993): 251–261. Perhaps we should say also that more French people pay attention to television broadcasts than heed the messages of advertising posters.
16. Philippe Gavi, "Quand la télé lave trop blanc," *Le nouvel observateur* (October 14–20, 1999): 5.
17. Olivier Bertrand, "Des Sans-papiers se retournent vers l'église," *Libération* (March 9, 1998): 5.
18. *Le Monde* (September 25, 1998): 4.
19. "Les Sans-papiers investissent le théâtre de Chaillot," *Libération* (March 22, 1999): 15 (this is the actual page number in the newspaper, and not the one obtained from the *ADRI Presse* volumes).
20. http://fetedelamusique.culture.fr/fr/esprit/index.html.
21. Jack Lang, "Préface," in Nago Seck and Sylvie Clairfeuille, *Les Musiciens du beat africain* (Paris, 1993): 10.
22. Jim Winders, "Roll Over, Napoleon," *Flagpole Magazine* (November 20, 1996): 24.
23. Sophie Chevalier, "Musiques, cuisines et transformations identitaires," in *Les défis migratoires: Actes du colloque CLUSE Les defies migratoires à l'aube du troisième millenaire*, ed. Pierre Centlivres and Isabelle Girod (Neuchâtel, 1998): 423.
24. Roderic C. Knight, "Music Out of Africa: Mande Jaliya in Paris," *The World of Music* 33:1 (1991): 65.
25. Michael C. Lambert, *Longing For Exile: Migration and the Making of a Traditional Community in Senegal, West Africa* (Portsmouth, NH, 2002): xvi.
26. Guy Boudimbou, *Habitat et modes de vie des immigrés en France* (Paris, 1991): 5.
27. Vasoodeven Vuddamalay et.al., "The Evolution of the Goutte d'Or": 254.
28. Boudimbou, *Habitat et modes de vie des immigrés en France*: 252.
29. Jacques Barou, "Les Cultures et leur espace de cohabitation: Modes de vie et transmission," *Migrants-Formation* 98 (September 1994): 125–126.
30. See especially Rebecca L. Spang, *The Invention of the Restaurant: Paris and Modern Gastronomic Culture* (Cambridge, MA, 2000).
31. Jürgen Habermas, *The Transformation of the Public Sphere: An Inquiry Into a Category of Bourgeois Society*, trans. Thomas Burger (Cambridge, MA, 1989). Among many critical studies of this influential treatise, see Craig Calhoun, ed., *Habermas and the Public Sphere* (Cambridge, MA, 1992).
32. See the application of the public sphere concept to the subject of women's involvement in the French Revolution in Joan B. Landes, *Women and the Public Sphere in the Age of the French Revolution* (Ithaca, NY, 1988). Also see Dena Goodman's critique in her study of women's eighteenth-century salons in *The Republic of Letters: A Cultural History of the French Enlightenment* (Ithaca, NY, 1994).
33. Jean-François Lyotard, *The Postmodern Condition: A Report on Knowledge*, trans. Brian Massumi (Minneapolis, 1984).
34. Mamadou Coumdoul, author interview, Paris, August 4, 2001. All information about Mamadou Coumdoul is based on this interview. English translations are mine.
35. Bécaye Tounkara, author interview, Paris, July 31, 2001. All information about Bécaye Tounkara is derived from this interview.
36. Faira Gueye, author interview, Paris, March 1, 2002.
37. Albert Nicollet, *Femmes d'Afrique noire en France: La vie partagée* (Paris, 1992): 99.
38. Alpha Diallo, author interview, Paris, August 4, 2001. All information about Alpha Diallo is based on this interview.
39. Knight, "Music Out of Africa": 62.

40. Moussa Konaté, author interview, Paris, March 4, 2002.
41. Gary Stewart, *Rumba on the River: A History of the Popular Music of the Two Congos* (London, 2000): 244.
42. Taina Tervonen, "Wine Cellar Tam-Tam," *Djembe Magazine* 24 (April 1998): http://www.djembe.dk/no/24/22wctt.html.
43. Péla Simba, author interview, Paris, July 16, 1997. Unless otherwise noted, all information about Péla Simba comes from this interview.
44. Marc Sautet, *Un Café pour Socrate: Comment la philosophie peut nous aider à comprendre le monde d'aujourd'hui* (Paris, 1995).
45. Benedict Anderson, *Imagined Communities: Reflections on the Origin and Spread of Nationalism*, Revised Ed. (London, 1991).
46. Phyllis M. Martin, *Leisure and Society in Colonial Brazzaville* (Cambridge, UK, 1995): 136–142.
47. Stéphanie Binet, "Nuits noires, nuits blanches," *Libération* (March 8, 2002): 36.
48. Charles Didier Gondola, *Villes miroirs: Migrations et identités urbaines à Kinshasha et Brazzaville, 1930–1970* (Paris, 1996): 216–219. By the 1990s, a time of great danger during the civil war that followed the end of the Mobutu regime, *ngandas* had given way in Kinshasha to the more structured "fans-clubs," organized around prominent celebrities, especially musicians. See Émilie Raquin-Ngasho, "Pouvoir et représentations à Kinshasha: les musiciens congolais, nouvelle élite d'une jeunesse urbaine en crise," *Africultures* 61 (October–December 2004): 137.
49. Janet MacGaffey and Rémy Bazenguissa, "Ostentation in a Clandestine Setting: Young Congolese and Zairean Migrants in Nganda Bars in Paris," *Mondes en développement* 23:91 (1995): 106.
50. Binet, "Nuits noires, nuits blanches": 36.
51. Michèle Tribalat, *De l'immigration à l'assimilation: Enquête sur les populations d'origine étrangère en France*, avec la participation de Patrick Simon et Benoît Riandey (Paris, 1996): 216.
52. W. Scott Haine, "Shift and Renaissance in Parisian Café Sociability: Immigrant Improvisations Since 1950," unpublished conference paper, Western Society for French Historical Studies, October 30, 2003, Newport Beach, California.
53. Tribalat, *De l'immigration à l'assimilation*: 253.
54. Ibid.: 250.
55. Philippe Bavarel, "Les Quartiers vivent au rythme des cafés musique," *Le Parisien* (March 27, 2000): 32.

Chapter 8

Culture and Citizenship for a New Century

Twenty-first-century Paris continues to display the contradictions that inhabit contemporary French culture where questions of identity and citizenship are concerned. Evidence of African cultural influences is there for everyone to see, and often meets with a matter-of-fact response, since Parisians are accustomed to their city being truly a world city. African musicians are still to be found there, even if their presence is not celebrated in the way it certainly was two decades previously. They have become part of a long history of Paris as a home for foreign artists. At the same time, as demonstrated by the 2002 presidential election, the continued controversy over the *sans-papiers*, and the riots that spread throughout French suburban neighborhoods during the autumn of 2005, the Republic has yet to come to terms with the genuine ethnic diversity of its population.

Plus ça change . . .

The early years of the new century have been marked by dramatic changes, from rapidly developing technology to the adoption of the Euro as the common currency for most European nations. The proliferating use of the internet in France—not without controversy in the Francophone world—has produced a growing number of cybercafés throughout the country, including many run by immigrants. The cybercafé Vis@Vis, the brainchild of the former *sans-papiers* leader Ababacar Diop, had received much publicity when it opened in 2000 (see chapter five). Situated directly across from Saint-Bernard, the church occupied by hunger strikers in 1996, the café became a focal point for Senegalese in Paris. A little more than a year after Vis@Vis opened, Diop established a connection between it and the Dakar cybercafé Metissacana[1] (founded in 1996)[2] that allowed users in either location to communicate via videophone. This proved enormously popular with immigrants and families still

in Senegal, and provides a high-tech reminder of the expanded sense of *le monde francophone*.

For Parisians today, the presence of African residents is less something to celebrate or profile as in the 1980s, and more something to be regarded as an obvious phenomenon scarcely worth mentioning: just one flavor among the many that make for Parisian cosmopolitanism.[3] A curious example of this attitude may be seen in the use made of a Senegalese *griot* named Nuru Kane (1973–) as France prepared in late 2001 to adopt the Euro. Efforts were made to find novel ways to explain the new currency to groups in various settings. On the eve of the adoption of the new currency, French television news broadcasts included footage of residents of homes for the aged being shown the brand new notes. To introduce residents of immigrant *foyers* in the Paris region, specifically those containing workers from West Africa, to the new currency, Kane, a member of the Toucouleur ethic group, visited the *foyers* and performed his music. He had produced a CD called *Diamano Euro* (Wolof for "aujourd'hui l'euro") as a result of a competition sponsored by the Fondation de France et de la Fondation Caisse d'Épargne.[4] Through the assumption that—of course—a *griot* would be the best person to communicate with this specific immigrant group, French authorities implicitly acknowledged the values that they have so often denounced as threatening.

But for every instance that marks a positive French response to an African musician, examples of opposing tendencies can always be located as one researches the topic. The same culture that elevates a star musician, athlete, or writer of African origin often displays hostility to the general African immigrant population, including the lesser-known artists within it. As the spring 2002 presidential election with its stunning result came and went, the French media continued to represent these opposing tendencies. The election also produced much soul-searching in the national media, and, as usual, prominent intellectual figures weighed in. An example was philosopher Élisabeth Badinter calling for greater national representation of France's real ethnic diversity.[5] Well-established music festivals such as Musiques métisses in Angoulême continued to receive enthusiastic coverage, as when the twenty-seventh edition of the festival in 2002 brought together such Malian musicians as guitarists Boubacar Traoré and Habib Koité, the Malian duo Amadou et Mariam, Cesaria Evora of Cape Verde, Ismaël Lô of Senegal, the formerly Zaïrean French star Lokua Kanza, King Sunny Ade of Nigeria, the Malagasy guitar virtuoso D'Gary, and many others.[6]

Even more predictably, the plight of the *sans-papiers* remained a recurring topic in French news coverage. For several weeks during the summer of 2002, more than one hundred of them from Mauritania, Senegal, and Turkey took refuge in the church of Sainte-Geneviève-des-Bois in the diocese of Évry-Corbeil-Essones, south of Paris. They were sheltered and supported there by the parishioners.[7] It was yet another example of the kind of solidarity with the *sans-papiers* individual churches and parishes had shown since the birth of the movement in 1996. In September 2002 *Le Nouvel observateur* devoted several pages to what it deemed a new generation or new phase of the *sans-papiers* struggle. Their analysis included undocumented Chinese workers as well as the more familiar African (both North and sub-Saharan) examples. They also included brief profiles of persons from each of these categories who were

stuck in the purgatory populated by those who had petitioned for regularization but had been waiting years for the resolution of their cases. These were among the sixty thousand who had been forced to return to clandestine existence as a result of the "case-by-case" approach introduced by the Chevènement circular (see chapter five), an approach newly embraced by the controversial politician Nicolas Sarkozy, whom Raffarin had named interior minister.

The lead article in the magazine's dossier emphasized the changes that had come over the *sans-papiers* movement since its previous leaders (Diop and Cissé) had stepped down or had been deported. The members of the movement were now more or less making things up as they went along, reinventing themselves as changing circumstances warranted, always trying to rekindle public interest and support.[8] The article was accompanied by an interview with immigration expert Catherine de Wenden, who denounced the case-by-case method of regularization, and argued that the situation had worsened dramatically in the previous five years. In a real sense, she said, the Chevènement law had produced large numbers of *sans-papiers*, namely persons who had petitioned for permission to stay in France but who, while waiting for some resolution of their status, were left to the "slavery" of the clandestine labor market and the mercy of the police.[9]

The case of a certain "Ousmane" from Senegal provided one very telling example. He had resided in France, without papers, since 1983. He worked at a construction job, and even managed to save some of his illegal earnings. In 1988, encouraged by what he thought would have become a more accepting climate fostered by President Mitterrand, he sought regularization. When he applied at the prefecture, his request was rejected. The reason given was the illegal pay stubs he showed as proof of his employment. He went further underground, closing his bank account, and living as frugally and quietly as possible. He responded to the Chevènement circular in 1997 by seeking once again to be "regularized." When asked what he had been doing in France for the past ten years, he was required to show his pay stubs, even though they were illegal (contradicting the treatment he'd received in 1988). Stuck in limbo while waiting to learn the disposition of his case, he said bitterly of his adopted country, "We need you and you need us," adding, "At least show us some respect."[10]

Certainly not all Africans in France were in desperate straits, and press coverage occasionally took note of that. Dogad Dogoui, a successful businessman originally from Côte d'Ivoire, gained attention in the summer and fall of 2002 for his efforts at organizing African business leaders to assist Africans in France as well as in the home countries. For these purposes, in 1999[11] he formed an organization called Africagora, which began holding monthly meetings in an African American restaurant in the Ninth Arrondissement of Paris. Gradually they formulated plans for investing in development projects in Africa, for creating tutoring programs for African students in French schools, and for encouraging and financing black candidates for elected office.[12] Dogoui, whose father was deputy director of the port of Abidjan, is the oldest of twelve children.[13] He came to France in 1981 as a student, eventually married a Frenchwoman and became a French citizen himself in 1992.[14] One of his principal concerns became the need to have black candidates elected to office. He felt strongly that the black population of France, estimated in 2002 as at least 1.5 million out of nearly 60 million, was shockingly underrepresented in politics. He and a group of

black leaders unsuccessfully tried to persuade Prime Minister Raffarin to appoint a black minister for African affairs.[15] Despite that discouraging experience, he and his group have persevered, and have continued to use their resources to reach out to less-fortunate African immigrants.

Those in the latter category continued to be plagued by lack of housing and employment. In October 2002 *Le Monde*, citing government statistics, reported that more than five thousand persons were living as "squatters" in derelict buildings in the Île-de-France.[16] No doubt many of these were *sans-papiers*, some even representing the dispersed population from the Esplanade de Vincennes ten years earlier (since housing needs had continued to be unmet for them). As for the new government, the problems they had inherited thus were far from new, nor were the ideas and approaches they were prepared to offer. Both Chirac and Raffarin touted the tried and true theme of "integration," and to that end Raffarin announced a reinstallation of the Haut Conseil à l'Intégration with newly appointed members.[17] Some former government officials and political observers had begun to recommend that immigrants be allowed to vote in certain elections, but Raffarin rejected this idea in favor of continuing the policy of regularization.[18]

Meanwhile, the same government busied itself with schemes to entice African immigrants to return to their countries of origin. As usual, Malians were the principal targets. Interior Minister Sarkozy decided to double the amount of money offered to Malian immigrants to return to their country in order to found businesses there. However, the sum, upped to seven thousand euros, was a pittance compared to the amount many immigrants had paid to finance their undocumented entries into France. The government's attempt was also colored by the stereotypical assumption that anyone of Malian origin living in France remained connected primarily to Mali and thus incapable of becoming French. This was an assumption that overlooked the reality of immigrant existence, that is, that Malian immigrants progressively had lost contact with Mali and had become increasingly oriented toward France.[19] Moreover, immigration statistics showed that Malians remained the most substantial of all sub-Saharan groups in France (some 46,500 by 1999 in contrast to approximately 32,000 Senegalese and 20,000 Ivoireans).[20]

Interior Minister Sarkozy, ever the publicity hound, wasted little time in trying to leave his own stamp on the nation's immigration policy, often moving in seemingly contradictory directions. In November 2002 he announced a relaxation of procedures for prefects dealing with the demands of the *sans-papiers* for regularization. Initially this was viewed as a concession to the *sans-papiers*,[21] but soon thereafter even the conservative newspaper *Le Figaro* reported that Sarkozy's circular would benefit at most one-quarter of those seeking regularization.[22] Even as he was sounding conciliatory on the one hand, on the other Sarkozy spoke of "undesirables" among the immigrant population,[23] and in February 2003 traveled to Bamako to negotiate the return of Malian immigrants (including a proposed increase in aid to reverse the tide of migration).[24] He also negotiated an agreement with Senegal for that country to send its own police to look for "irregular" Senegalese immigrants in France.[25] When criticized for his statements and his policies, Sarkozy reacted testily.[26]

By the spring of 2003 the government had begun to address the issue of refugees requesting asylum in France, especially those fleeing not governments but rebel or

terrorist forces within countries. Algerians seeking to escape that country's bloody civil war were examples. The number of persons requesting asylum had been increasing, and in response the French government proposed the reorganization of l'Office français de protection des réfugiés et apatrides (Ofpra).[27] On the face of it, this seemed a humane gesture, but immigrant groups in France greeted its announcement warily. In an interview published in *Le Nouvel observateur*, historian Gérard Noiriel criticized the move, pointing out that it was contradictory to seek to appear to defend the right of asylum while in other ways seeking to close the borders. In a detailed historical analysis of recent French governments and their immigration policies, Noiriel brutally dissected the way the present government masked its repressive policies with platitudinous language about the French "tradition of welcome." He showed as well how talk of "irresponsible" behavior of immigrants cleverly shifted the blame for repression onto its victims. He argues that it was actually the so-called left, recently in power, that had introduced such a discourse, pretending to wrap itself in the tricolor that represents the principles of 1789.[28]

The *Nouvel observateur* dossier that included the Noiriel interview listed as one of the hoped-for reforms the fact that the government was said to be considering the elimination of the "double penalty" that had been so controversial under Chevènement. The phrase referred to the one-year prison term to be followed by deportation. Sarkozy had mentioned adding certain protections so that only the most extreme cases would be dealt with in this way.[29] These measures became law in November 2003, the result being that the double penalty, while softened, nevertheless was retained. It was clear that Sarkozy continued to stand for an overall toughening of immigration policies, and the new law bearing his name came under criticism with an editorial in *Le Monde*. Titled "Need of Foreigners," the piece began by arguing that France needed immigrants both economically and socially, and ended by saying that even if integration "remains a difficult problem," this was no reason to justify restrictive laws that threatened "the freedom of immigrants."[30]

Groups agitating on behalf of the *sans-papiers* had long considered *la double peine* especially odious. Some forty association and unions, working for many months, sponsored a large concert to express opposition to it. The concert took place on May 10, 2003, in the Place de la République. A crowd of some fifteen thousand heard performances by the politically engaged groups La Tordue (who composed a song on the theme for the occasion) and Zebda, the "punk-musette" band Les Têtes Raides, Bertrand Tavernier, and several rap groups.[31]

African Music in Paris: The New and the Old

African music, when covered in the French press, also continued to be associated with political movements and issues. The June 2003 Musiques métisses festival in Angoulême kept tradition with its long history of spotlighting musicians involved in political struggles. During the 1980s, the antiapartheid movement had been its focus. In 2003 the festival emphasized the integration of ethnic communities, and on the

grounds festival goers could purchase food advertised as *cuisines du monde*, with proceeds going to aid children. The *sans-papiers*, as in the past, were represented, as was the "world music" organization Zone Franche.[32] The festival's lineup included the revived Senegalese "supergroup" Orchestra Baobab, Bembeya Jazz (from Guinea), The Super Rail Band de Bamako, Tiken Jah Fakoly (Côte d'Ivoire), and Malouma (from Mauritania), among many other artists. The latter group was one of several at the festival whose performances called attention to the terrible drought plaguing the Sahel region.[33] In 2005 Musique métisses marked its thirtieth anniversary, guided all those years by its director Christian Mousset, clearly one of the central figures in the promotion of African music in France.[34]

Reggae and related forms of Jamaican music continued to be very popular in France. Here, of course, the tradition was Anglophone, and I remember marveling at the ecstatic reception accorded Linton Kwesi Johnson, the Jamaican–English "dub poet" at the 1998 Printemps de Bourges festival. Johnson's thick patois is daunting enough for an English-speaking audience, let alone one for whom English is the second language. Bob Marley reigns supreme, naturally, and his records are always prominently on display in major French stores such as La FNAC. Thanks to Alpha Blondy, Côte d'Ivoire has developed into the second capital of reggae music, and his concerts in Paris have been major events. In recent years, Tiken Jah Fakoly, another dreadlocked Ivoirean singer, has become quite popular in France.[35] Like Alpha Blondy, his version of reggae makes maximum use of the politically visionary side of the music. He has been championed by Hélène Lee, the most authoritative French writer on Rastafarian culture and Reggae music.[36]

Reggae influences have been obvious in the music of adventurous contemporary *beur* groups in France such as Orchestre National de Barbès and Gnawa Diffusion. While the latter has been based in Grenoble, the former has been much discussed in relation to the quarter of Paris from which they take their name.[37] Within this general area is the specific neighborhood called La Goutte d'Or, associated in most French minds with the North African immigrant population. And, unfortunately, the practice of referring even to persons born in France to immigrant parents as immigrants or foreigners stands in the way of recognizing that this new generation is French, linguistically (the most important index)[38] and otherwise. And their music, a hybrid of Algerian Kabyle music, Moroccan *gnawa*, rap, jazz, funk, and reggae is French if by "French" we mean the truly multiethnic France that has asserted itself in recent years. This is the reality that Orchestre National de Barbès, increasingly visible in the French media since the late 1990s, has been able to capture.

While some of the newer musical currents in Paris had displaced the African music of the world music heyday, some of the stalwart figures from the 1980s continued to hold their own and to receive attention and even adulation. Manu Dibango remains the most vivid example of such a musician, described as "the most celebrated African in France" by a writer paying tribute to him on the occasion of his seventieth birthday.[39] As he entered his eighth decade, Dibango was busier than ever. In 2004 he released a three-CD career retrospective, and made frequent concert appearances with his old friend Ray Lema. Not only did he keep up an ambitious recording and performing schedule, he also took on a number of other roles that kept him at the

intersection of French and African cultures. UNESCO named him an "artist for peace," and in addition he served as president of both the association Francophonie Diffusion and the Cameroon Music Corporation. The purpose of the former association was to encourage the broadcast of Francophone music, while the other was to oversee the rights of Cameroonian musicians faced with the ongoing problem of piracy and copyright infringement. He may have become the most recognizable African in France, but he also had embraced a way of life that one thinks of as essentially French. In Manu's case, this refers to the habit of spending long hours frequenting cafés: smoking, drinking coffee, greeting friends and acquaintances. Dibango commented to a reporter that the side of French life that he had adopted was the spirit of café and bar life—*l'esprit du zinc*.[40]

Not all prominent African musicians in Paris received the kind of adulation reserved for Manu Dibango. In the case of the singing star Papa Wemba, the publicity he received was far from favorable. His name was in the news throughout 2004 because he was arrested and charged with aiding illegal Congolese immigrants. The investigation had begun in 2000, and police suspicions especially were aroused in December 2001 when some ninety nationals from the Democratic Republic of the Congo disembarked in Paris and claimed to be members of Papa Wemba's band.[41] They carried no musical instruments, and in many cases were discovered to be fishermen or goat herders.[42] In February Papa Wemba was arrested at his home in Aulnay-sous-Bois and taken into police custody. At the time of his arrest, his real name was given as Shungu Wembadio Pene Kikumba, and his nationality was listed as Belgian.[43]

He was charged with aiding illegal immigration, obtaining fraudulent administrative documents, and "association with malefactors." He could have received as much as ten years in prison and a fine of 750,000 euros.[44] At his trial in November 2004, Papa Wemba admitted receiving sums of 3,500 euros to obtain visas at the French embassy in Kinshasha for seven persons claiming to be members of his band, but he denied knowledge of the other cases. He received a thirty-month jail sentence, but all but four of those months were suspended.[45] He also received a fine of 10,000 euros.[46] Since he had been held in custody nearly four months earlier in the year, he faced no further imprisonment. Eight other defendants, including his wife, were convicted and received lesser sentences.[47] The prosecutor had asked for a sentence of five years for the singer and sentences of eighteen months to four years for the eight others charged.[48] At his trial, Papa Wemba complained that many other people had profited from the use of his name.[49]

The presence of African musicians in Paris has continued, but it no longer has an assigned meaning, nor is it made to represent an era the way it seemed to during the Mitterrand years. Sub-Saharan African musicians—and persons associated with the music business—living and working in Paris during the early years of the present century had a variety of reasons for doing so (perhaps this was no less true in the earlier era). Some felt Paris remained very much the center for African music, but others rejected this idea. Paris was just where they happened to be. They had become accustomed to life there and intended to remain, whatever their citizenship status. If they were musicians and Paris happened to be where the jobs were, then it simply made sense to stay.

Musicians and Varieties of
National Identity

Brice Wassy (1958–)—that name often appears in the opposite order in some credits—a seasoned drummer and percussionist much in demand by other musicians, and pursuing his solo career on the side, provided a good example of this very practical attitude. I interviewed him at his apartment in the suburban town of Montreuil, known especially for its Malian population. Brice Wassy is from Cameroon, of Bamiléké origins. His musical background is in Cameroonian *makossa*, and in his own music he combines traditional elements with jazz, a heavy influence in his playing. To illustrate the versatility this gives him, he said, "I have played with Salif Keïta, Miriam Makeba, and Jean-Luc Ponty."[50] The latter is a French jazz violinist. Brice Wassy is also known for having played on the 1988 album Talking Heads recorded in Paris. He has recorded three solo albums, and is the author of an instruction manual for drummers. He arrived in Paris in 1974, but has never taken French citizenship. For his first six years in Paris, he played with Wally Badarou and Manu Dibango. He spent an equal number of years, beginning in 1994, as musical director of Salif Keïta's large band.[51]

I asked Wassy if he considered Paris to be the center of African music still. A man not given to lengthy explanations, he replied, making every word count, "It is for those who find it like that." I suppose he meant that it is what you (the musician) make of it. He quickly added that for him, "It's necessary to stay in Paris to be accepted for my music." It is not that easy for many musicians, he acknowledged. "Many doors are closed now," he said of contemporary Paris. He pointed out the contradictory position of his Malian neighbors, that is, they were not welcome yet their music was very "important" in France. France is also contradictory with regard to racism and discrimination, Wassy added. It is more a question of "ignorance" than outright racism, he observed. In some ways, he said, France today is both "more open" and "more hypocritical."

As a Cameroonian resident of France, he pointed to the importance of Francis Bebey's work. Like his predecessor, he remains very drawn to Cameroon, and has traveled back there "a lot." He has also recorded there. We briefly discussed the Senegalese musicians who have no wish to live in France. "So much the better," he said tersely, and I cannot decide whether he meant so much the better for them that they avoid the immigrant life, or so much the better because the competition among musicians in Paris was already stiff enough. Brice Wassy observed that African music in Paris, while still around, had been more important during the 1980s. More recently had come the vogue for Cuban and other Caribbean music, as well as Brazilian music. Yet, he also pointed out, all of this is included in the broader definition of "African" music.

Wassy said that what is most important in understanding the reason for a musician such as him to reside in Paris is Francophone identity. That is the basis, he argued, of any "welcome" extended to Africans by Parisians. I asked his opinion about current French politics, and he acknowledged his sympathy for the Socialists. "I'm interested in politics," he emphasized, "but from a distance." What about the

potential political role a musician can play, I wanted to know. He explained that although he does sing, he is primarily an instrumentalist, and therefore has less to communicate through his music about political or cultural issues than a vocal artist might. I got the impression from talking with Brice Wassy that he believed African musicians make a kind of political statement simply by their residence in Europe. Just before me parted, he said that more needs to be researched and known about African musicians.

If Brice Wassy has kept his distance from politics, his fellow Cameroonian musician Nya Soleil (1961–) has plunged into them during his years in Paris. Born in Douala, he has been in France since 1981, having arrived "just after the election of Mitterrand," as he put it.[52] Like Brice Wassy, he is of Bamiléké origin, and he described growing up in Cameroon and hearing his father, a veteran of French colonial military service, express nostalgic longing for French life. He uses the name "Soleil" from the Bamiléké equivalent in meaning, a name that came from his grand-mother. "Nya" is the family name. He studied guitar, sang, and played music from an early age, and cites *makossa* as the formative musical genre for him. In later years, he has performed on *sanza* and bass, in addition to guitar. He is an accomplished guitarist and a soulful, compelling singer. One hears in his music deep respect for the musical traditions of Central and Western Africa, as well as influences from rhythm 'n' blues, funk, reggae, salsa, and jazz.

Nya Soleil is one of several persons of Cameroonian origin who have figured prominently among my interview subjects, and he is one with whom I have spoken on several occasions. As a body, Cameroonian immigrants defy generalization with regard to citizenship or location in the Paris region. They also span the generations of recent immigrants in Paris. Over the years Nya has traveled frequently between France and Cameroon, although his contested residence status has made that increasingly risky in more recent years. By the mid-1990s, having played with many prominent African musicians in Paris at one time or another, he became known especially for organizing concerts meant to publicize and raise money for various political causes, beginning with a concert in 1996 to raise money for the families of the Saint-Bernard hunger strikers. During the previous year, he had founded an association called Soleil Pour Tous[53] that has continued to serve as the organizational framework for all of his projects and causes. When I first met him in May 1998 he was busy organizing a concert scheduled for later that month to com-memorate the 150th anniversary of the abolition of slavery in the French empire. Titled "Africa Celebrates Abolition," this was the concert at which I met the Ndocko brothers Ben and Peter (see chapter six) and other musicians from Cameroon, including Brice Wassy. I first spoke with Nya Soleil at the apartment he was living in then in a building just off the rue du Faubourg Saint-Martin, in the Tenth Arrondissement. He worked his cell phone almost constantly during my visit, lining up musicians for the concert, arranging for the food and refreshments, and so on.

It was clear from his conversation that holding a concert in response to a political crisis or event that touched many lives was consistent with deeply rooted traditions of Cameroon. He described a culture very focused on remembering and honoring ancestors, for example, with animal sacrifices and gifts of food. Music, he explained,

was a part of any ritual or ceremony:

> Music is a work of the spirit, then. We simply make music. In our home music is very preponderant because when there is mourning or when there is unhappiness, it is music that helps us to forget. When someone is sad because he has lost someone very dear, we are going to sing for him.[54]

He explained that, in contrast to written music, "It is really in playing it that it becomes something truly living and that it becomes still more creative." During the second interview I had with Nya Soleil (at the apartment to which he had moved in the Nineteenth Arrondissement near the Parc de la Villette), he described the ethnographic research he had done on the music of Western Cameroon. The music, he said, needed to be understood in relation to the culture that produced it.[55]

Nya explained that the benefit concerts he had been organizing were efforts to raise funds for those in need in African countries as well as such Africans in France as the *sans-papiers*. The December 1996 concert he organized at the well-established club New Morning was a good example of this combination. Having its impetus in the August 1996 expulsion of the occupants of Saint-Bernard, by the time it took place it was billed as "Christmas for the Children of Rwanda." Participants included Geoffrey Oryema, Lokua Kanza, and Ray Lema. Nya Soleil also organized concerts to rally support for the cause of the condemned Pennsylvania death row prisoner Mumia Abu Jamal, and, relatedly, to denounce the persistence of the death penalty— abhorrent to countries of the European Union—in the United States. In 1997 he put together a memorial concert for the celebrated Nigerian singer Fela Kuti, whose death had shaken his worldwide fan base. The concert took place just after the death of Nya's father, with whom he was extremely close. The two deaths became closely associated in his mind.

He described the planning of the concert for Fela in some detail:

> When I announced "Homage to Fela" people were already surprised, but then the African media received this idea very well. And then, I rounded up some artists, such as Tony Allen, who was Fela's drummer—who had participated with Fela in the creation of "Afro Beat" from his youth—and then many others. Wassy Brice, Cheikh Tidjane Fall, and others . . . And for this occasion we offered gastronomy for the public, free for that matter. And we wanted the concert to happen the way funerals happen in Africa: that people should eat, drink, dance, and be free. And that was the case, and a lot of people keep memories of it. And since I have organized several concerts, each time there is a concert, artists respond, "Yes."

In his political as well as musical sensibilities, Nya remained as attuned to French as to African culture. His response to the 1998 World Cup victory by the French *black/blanc/beur* team was to seize the opportunity to take advantage of the seeming sympathy being shown minority cultures in France. He did this, most characteristically, by organizing another concert, once again at the club New Morning, meant to profile African music and culture. He was operating in the mold of a Mamadou Konté.

By the turn of the century, Nya Soleil had begun to coordinate the work of Soleil Pour Tous with Aide et Action, the French nongovernmental organization founded in

1981 to support education in developing countries. He was especially interested in the programs that assisted children orphaned by the AIDS epidemic. He said he had been in frequent contact with Madjiguène Cissé, the former leader of the *sans-papiers* movement who had been expelled from France in July 2000. When I spoke to Nya in late 2000, he said he felt real tension existed between the humanitarian causes that interested him and the music business. "It isn't easy to line up artists for benefit concerts," he said, "but it is worth the effort." He was busy with work on his first album called *Soleil Pour Tous*. It was released finally in 2002.

Nya Soleil has remained in a precarious position—perhaps not unrelated to his political activism—with regard to his status in France. He has attempted to acquire French citizenship, but has been denied. The authorities have refused to recognize his marriage to a Frenchwoman—with whom he has two children—as legitimate. "They think that perhaps I made a *mariage blanc*," Nya said, "But there are all the reasons that prove that I lived seven years with this person and that it has not been a *mariage blanc*."[56] So he has remained stuck ("trapped" is his word),[57] without the ability to get more than a temporary residence permit. At one point he even endured brief imprisonment over this issue.[58] His case would seem to illustrate what Catherine de Wenden has called one of the "judicial absurdities" of the Chevènement Law, whereby a group of people have been created who can be neither regularized nor expelled. One factor, she explained, is paternity, that is, the state cannot separate someone from his minor children in France.[59] This would seem to apply to Nya's situation.

As often seems to be the case with African residents of France, Nya Soleil's relationship to France is conditioned and affected by his identification with his original country and vice versa. He came by his Francophilia through his family background and upbringing in Cameroon. When I asked him why he had immigrated in the first place, he said that "The first reason was the fact that we received a French culture, and later on, we had a certain idea of Europe by relation to our parents." His parents, he said, always "spoke of France with much dignity." Once he came to France, he was able to see its flaws, but he still retained that hope for the France of his father's nostalgic longing. It is an inescapable fact, however, that France, as he put it, "has taken much from Africa, and still takes."[60] He wants to be in France, needs to be for the career he has chosen, but recognizes that the country he wants to call home has been "much fed" by the African resources it has plundered.

His life in Paris is as French as anyone's. I have met him in cafés, and on two occasions by the fountain in front of the Cité de la Musique in the Parc de la Villette. In my memories I can see him striding toward me in the fine afternoon mist of a December day, his broad smile lighting up his face under a cap pulled down low, his hands thrust in the pockets of a leather jacket. The first time I met him he was dressed in a *boubou*, but each time thereafter his attire has been thoroughly Western. In other words, the more I have seen him, the more French he has seemed to me, but one must understand the word French in an expanded sense. His outlook is global, attuned especially to the Francophone world and the African diaspora within it. In late 2004 he busied himself with organizing a concert to raise funds for relief to be sent to the victims of Hurricane Joan, which had brought widespread death and destruction to Haiti.[61] The concert, sponsored by Soleil Pour Tous, was to be held on November 4, 2004, at "Triptyque" in the rue Montmartre in central Paris.

It included Nya and his band, along with gospel singers, reggae musicians, and a variety of others.[62]

The next person whose experience of Paris I will describe has been able to enjoy the advantages of the kind of citizenship that Nya Soleil has been denied. While it is clear that Senegalese musicians of the 1990s and later no longer assumed the need to base themselves in Paris for career purposes, this does not mean that everyone stayed in Dakar. I continued to meet Senegalese immigrants in Paris, some of whom—especially after having acquired French citizenship—divided their time between the two countries. Seydou Guèye (1963–), a music promoter and organizer of festivals whom I met in August 2001 in Paris, provided an example of such a migratory pattern. After studying architecture and design in France and working as an illustrator and operator of a 3D studio in Paris, he turned finally to music production, which actually had been his sideline since 1994. That was the year he cofounded the association Penc-Mi to organize concerts, festivals, and tours for African musicians.[63] I interviewed Seydou Guèye at the popular Senegalese restaurant Au Village (see chapter seven), and he described some of his many activities to me.

He told me that he had been in France since 1985, and now enjoyed the advantage of dual citizenship as a result of being married to a Frenchwoman. He traveled regularly to Dakar, of necessity for his career, but also

> to catch some energy because it is very difficult to live here the whole year. And then to see what is happening musically and artistically in general, because when we work here, it is a labor of discovery most of the time. We work essentially with developing artists who are not yet well known.[64]

This, he explained, requires follow-up visits to work with the musicians in Dakar to get them ready for their tours.

Like Senegalese immigrants of an earlier generation, Seydou Guèye was much involved in assisting with projects back home. To this end, in 1994 he had helped to found an organization called Solidarité Ndem especially to carry out educational and cultural projects. This, combined with his current work to promote African music and culture for European audiences, reminded me of the example of Mamadou Konté, and I said so. Guèye was pleased with the comparison, and said that Konté, with whom he had collaborated at one point, was someone he "respected very much." He also said that comparison had been suggested the previous month, when he had helped to present the festival of traditional acoustic music called "Africa Folk You," which received favorable comment in the French press.[65]

Guèye described his work as being almost equally divided between Paris and Dakar. His life was a continual shuttling back and forth between continents and between cultures, and he seemed energized by it. Travel was his major activity, he said. He made it very clear, however, that he considered Paris the "hub" of the African music world, no matter how much vitality one found in Dakar. Even today, I asked?

> Even today, even today! Because there was a moment, it is true, when there was a decline. But the number of African artists in Paris is unimaginable. It is enormous. It is true that even today artists come here because Paris is the hub. And then there are the

infrastructures that you have to have: there are studios, accompanying musicians, studio musicians, there are all the great movements, the great groups who have marked our modern musical history. They are here in Paris.

This was a veritable hymn to Parisian modernity. Guèye certainly acknowledged the great difficulties posed by restrictive immigration laws, and said that he found French responses to African immigrants to be highly contradictory. "They both welcome and exclude you," he said, adding that artists tended to have an easier time of it. The future might see a shift toward the United States for African musicians, but Paris was still the place to be, as far as he was concerned. Perhaps the best way to understand this is to recognize that people tend to generalize from their own situations in order to justify the personal decisions they have made. In any case, Seydou Guèye seemed every bit the dual citizen.

Global, Plural

In an essay that has been influential within postcolonial theoretical circles, Stuart Hall offered the phrase "diaspora identities" to designate those who refuse to be located within any one national or cultural category, suggesting that their identities remain in continual transformation.[66] This may be somewhat useful in considering Seydou Guèye and the African musicians in Paris (which Robert Aldrich has described as "the capital of diasporic cultures")[67] who embrace French life without relinquishing their native cultures, and one may find additional models from post-colonial theory that seem appropriate. Paul Gilroy's work has helped to question reliance on absolute categories such as "African" or "European," again reminding us that modernity increasingly has produced hybrid forms of cultural identity.[68] Long ago, Edward Said, whose work inspired much of the field of postcolonial theory, suggested the paired terms filiation and affiliation to refer to the cultural ties one inherits versus those one takes on deliberately.[69] In many ways these terms appear applicable to African musicians in Paris. In their book *Post-Colonial Cultures in France*, Alec Hargreaves and Mark McKinney argue that minorities from former French colonies who reside in France illustrate what Homi Bhabha called a "third space" that gets beyond the opposition between "insider" and "outsider" in terms of culture.[70] But Hargreaves and McKinney also remind us that postcolonial theory, however useful, must be applied in a careful, qualified way to contemporary French culture, pointing out as others have that postcolonial theory often reinforces the very binary oppositions it seeks to challenge.[71] Certainly in the case of African musicians living in Paris, it would be foolish to assert that all of their cultural activities have been motivated by the desire to address the legacy of colonialism.

Like their fellow immigrants who pursued other occupations, many of these musicians have remained in Paris, while many others have been forced through a variety of circumstances to return to their countries of origin. But even those in the latter category participated in contributing contemporary African influences to French culture, and in exhibiting mobility and a more complicated sense of citizenship, one

that has everything to do with an expanded notion of national identity in a more broadly defined Francophone world. Like immigrants before them, recent African musicians living in Paris make regular return trips to their home continent, except when their residency status makes that a risky practice. Those who have become successful touring musicians regularly cross national boundaries, and come to view themselves as global citizens. In nearly all cases, in their cosmopolitanism and enthusiasm for musical influences coming at them from all corners of the earth, the African musicians who have called Paris home in recent decades exemplify a new kind of mobile, multiple citizenship, characterized by a contemporary anthropologist as "flexible citizenship."[72] As many of them have become more French, they have made Paris a little more African. In some cases, especially as recent governments have taken steps to limit their mobility, their music at least has remained welcome even when they themselves have not. When a passenger on an Air France flight selects the African music channel on the audio headset, it is a reminder of the African flavor in contemporary French musical tastes.

A traveler experiencing such a moment almost seems like someone stepping from the pages of Jean-François Lyotard's *La Condition postmoderne* (1979), the book in which he characterized and celebrated as "postmodern" the ability of contemporary people to experience a global array of cultural styles and commodities in everyday life.[73] But of course the problem with much of postmodern theory is that it has dealt far more with surface representations than with the lived experience of flesh and blood historical actors. Postcolonial theory, which has had much to say about the cultural mixing of previously isolated groups (including the formerly colonized with the inhabitants of the colonizing country), is, as noted earlier, of some usefulness but must be applied carefully to such a topic as that of African musicians living in France. Terry Eagleton has pointed out that the emphasis on ethnicity and culture at the heart of postcolonial theory comes at the expense of class and nation, and is itself a symptom of the failure of revolutionary nationalist movements.[74] As an interpretive or explanatory approach, postcolonialism may leave out as much or more than it includes.

Discussions of postcolonial culture have been closely associated with the growing preoccupation with globalization. Clearly, the subjects of immigration and the transmission of immigrant cultural forms to the countries that receive them are part of the collection of phenomena and developments we have come to call globalization. Robert Holton, assessing globalization's "cultural consequences," presented three different theses, or models, found in writings about the phenomenon of globalization. He labeled them "homogenization," "polarization," and "hybridization." The last of three, said Holton, "centers on intercultural exchange and the incorporation of cultural elements from a variety of sources within particular practices." Hybridization, he argued, was particularly applicable to music, especially world music.[75]

Others have considered the topic in relation to cuisine. Catherine Palmer calls food one of the "flags of identity" for immigrant culture. As with clothing, the choice to consume one's native food is a statement, she argues, of "national belonging."[76] By the terms of her argument, a Senegalese immigrant in Paris dining on *mafé* (a rich beef or chicken dish cooked in a heavy peanut sauce) is affirming his Senegalese identity. And yet, other people acquire the taste for Senegalese food, and, for that

matter, immigrants consume other types of cuisine. Interviews with such prominent African musicians as Manu Dibango and Sally Nyolo have touched upon food preferences. The former expressed an appreciation for French cuisine but declared his strong preference for spicy dishes.[77] Nyolo said she did not care for *choucroute garni*, but was fond of *confit de canard*.[78] Those two dishes have strong regional associations in France, and perhaps prove the point argued by Sidney Mintz that there are no "national" cuisines, only regional dishes.[79]

Musical and culinary tastes that migrate along with immigrants provide more grist for the mill of the globalization theorists. Ulf Hannerz traces global patterns of "creolization," with influences beginning on the periphery and moving toward the center of former empires to shape the culture of such world cities (offering world music and a global array of culinary choices) as London, Paris, and New York.[80] In this post-whatever we decide to call it next world, it seems that everything is "creole." Indeed, this seems to be the interpretation found in many of the best studies of music from around the globe, such as Dick Hebdige's *Cut 'n' Mix*, which explores hybrid forms of Caribbean music in relation to such urban cultural settings as London.[81] The title of his book, referring to studio recording technology, implies the continually reshuffled deck of cards that we play with in our global culture.

Veit Erlmann, drawing upon such theorists of postmodernism as Fredric Jameson, elevates world music to an even more central role in the globalization of culture. It is, he writes, "more than a new style, more than a new category for racks in the record stores." He sees it as "an emergent way of capturing the present historical moment and the total reconfiguration of space and cultural identity characterizing societies around the globe." So-called world music is, in his words, "a new aesthetic form of the global imagination."[82] In stark opposition to this appealing claim, Gérald Arnaud argues that "la world music,"

> Far from participating in an effort of global integration, becomes an immense ghetto regrouping the music of "others."[83]

Whereas Erlmann considers music's global impact, Christian Mousset, director of Musiques métisses d'Angoulême, focuses on the African music and musicians that interest him, especially those who located in Paris in the 1970s and later. He points out, correctly, that Africa is the source of all contemporary pop music. Music, he insists, "has played and continues to play a very important role in the history of relations between France and Africa."[84] He declares that France has become a "multicultural" (he uses the dreaded American-style term in lieu of the term most French people have preferred—*pluriculturel*) society, and that African musicians working in contemporary popular music have played a "considerable" role in that regard.[85]

"Postmodern," "Postcolonial," "Globalization"—we keep coming up with terms that increasingly seem like ephemeral signs of our futile attempts to assign some kind of meaning to an ever-changing cultural situation in which all bets are off. All such terms seem feeble and unsatisfying, to be applied only until better ones emerge. Soon, let us hope! One of the few things all interpreters seems to agree on is that the emergent reality is one in which cultural heterogeneity will be the norm. This is presented as something new and unprecedented. But is that true? To return to the

arguments introduced in the early work of Gérard Noiriel (see chapter one), it may be impossible to trace our way back to some pure essence of French culture prior to the influx of new arrivals from elsewhere. This might be recommended as an insight that should be expanded to apply to all world cultures, that is, there is no "pure" culture, no essential or truly isolated culture. Cross-cultural communication may have been taking place for most of recorded history, in one way or another. Obviously, the ability to record music and have it circulate greatly accelerates the process.

Whatever the degree of *métissage* or hybridization actually existing in Paris and France in general, much of the discussion has continued to center on *communautés*, "communities," the highly charged word that to many French minds suggests the indigestible ingredients in *le creuset français*. Caroline Bourgine, in an article on African musicians in the Paris region, argues that we should speak instead of "communitarian networks" that are not all that easy to map. In an interesting image, she compares them to partially submerged icebergs, and says that they have no central point of visibility. The one exception to this, Bourgine claims, is the regular gathering of Malians at the Africolor Festival in Saint-Denis.[86] Her argument indeed conforms to my experience of seeking out musicians from such countries as Senegal, Côte d'Ivoire, or Cameroon in Paris.

In the debates that swirl in France around questions of citizenship and ethnic identity, the emphasis on particular communities, supposedly at the expense of *la patrie*, regularly comes under fire. But it may well be that the values called "republican," meaning among other things the dignity of the individual realized through collective association, were learned by African immigrants through their particular communities, including the native villages whose structures and ambience they have often sought to replicate in their adopted country. And it seems that African immigrants are attempting to change the terms of the debate. They ask to be accepted as citizens, but not as undifferentiated ones. They demand respect for their difference.[87] They do not dispute so-called republican values, but do not see the need to abandon cultural specificity in order to affirm them. However much they may seem to exemplify Anderson's "imagined communities,"[88] they seldom cling to one exclusive national identity. Most simply want to be accepted as French without renouncing their previous identities.

This seems particularly true of sub-Saharan immigrants. In an exhaustive study of French immigration directed by Michèle Tribalat and published in 1996, she paints a complicated picture of a population arguably more identified than any other immigrant group with their native countries, yet prone to seek French citizenship (often hastened through marriage to French nationals). Distance, cost, and, in many cases, the need for political asylum can make return visits to Africa quite difficult to manage. Yet they remain as African as possible. She calls them "pragmatic" above all, taking French citizenship when possible but not inclined to reduce their contact with their countries of origin. They do not concern themselves with any apparent conflict between their African and French identities. If they are able to acquire French nationality, it is something to count as a "plus," as Tribalat puts it.[89] They become French, yet, through their contact with their former countries, they practice what Benedict Anderson has called "long-distance nationalism."[90] I find Anderson's arguments make sense up to a point, but I prefer Tribalat's way of describing things. Her analysis leaves room for more of an emphasis on a fluid, flexible kind of citizenship.

Aihwa Ong's concept of "flexible" citizenship seems, then, another way of addressing Tribalat's description of Africans in France, and yet again another way of expressing Stuart Hall's "diaspora identity." Other observers of the recent French experience of immigration and attendant debates over identity and citizenship have offered additional terms and phrases for the same kind of phenomenon. Riva Kastoryano, in a comparative study of immigrant identities in France and Germany, speaks of "post-national citizenship,"[91] and Isabelle Taboada-Leonetti argues that her research demonstrates the emergence in France of what she describes as "le citoyen pluri-culturel."[92] In her view, immigrants in contemporary France develop various "strategies of belonging."

Meanwhile, the African influence on contemporary Parisian culture is more or less given, even when (and maybe even more profoundly) it is not acknowledged directly. Édouard Glissant, the influential writer from Martinique, has made this point in a recent interview. "Even if people are not aware of it, they are changing," he said, adding for emphasis, "Even people who are racist and fascist are being changed by the conditions of expression of the immigration in European countries."[93]

In late March 2004 I attended a solo piano concert Ray Lema gave at the Café de la Danse, a club with excellent acoustics, just off the Rue de Lappe on the Passage Louis-Philippe (very near the Place de la Bastille). He had just released his solo piano album *Mizila: Piano Solo*.[94] In an interview, Lema revealed that the album was named after his late mother.[95] A standing-room only crowd turned out to hear the performance (and I was among the standees). In a nearly pitch-dark room, Ray Lema sat at a piano, his shaved head glistening in the spotlight that illuminated the stage. Most of the music he played came from the new album: jaunty, playful, whimsical tunes. The audience thundered in applause after each selection. Near the end of the concert, Lema called his good friend and fellow African music star Manu Dibango to the stage. He called him "my brother," and they embraced. The crowd exploded with delight at the familiar sight of Manu. He stood off to the side of the stage, working his tenor saxophone in accompaniment. During the encore, which included some vocal numbers, Lema called some friends to the stage to sing with him. They all seemed delighted to be with him, and the concert ended in a party atmosphere. Among the singers, I recognized Isabelle Lemann, who had helped me arrange an interview with Lokua Kanza.

The Ray Lema concert served as a reminder that African music continued to have an enthusiastic audience in Paris, at least in the case of the more celebrated performers. It also illustrated the point, sometimes forgotten in the heavy emphasis placed over the years on music festivals and large public concerts, that African musicians increase their appeal to the Parisian public one performance at a time, usually in small clubs, in events typically publicized the same day through articles in *Libération*. More venues seemed to feature African music now than in its supposed heyday. New Morning no longer seemed the default choice, although it retained its prominence.

It was at New Morning in early December 2000 that I stumbled into one of my most important encounters in the course of the research for this book. My son Jacob had come to visit me in Paris, and we decided to go to New Morning to hear a concert by the incendiary Cameroonian band Les Têtes Brulées. Well into their set, we were enjoying the show and standing back near the bar. I recognized Manu Dibango,

who had just entered. For five years, I had tried unsuccessfully to arrange an interview with him. I had come close once or twice, as, for example, when I received a call informing me I could meet him the following day. Unfortunately, I was about to leave for the airport for a flight back to the United States at that very moment. Needless to say, all neurons were firing as I thought about my proximity to him in the club. I turned back to watch the band and to think about looking for my chance to approach him. Just then, Jacob leaned toward me and said, "Dad, I think that guy is trying to speak to you." In fact, he was just being Manu, caught up in *l'esprit du zinc*, working the crowd in his convivial way, but Jacob's remark spurred me to make my move. I introduced myself, shaking his hand, and explaining my research interests. Within moments, he was writing down his telephone number for me, expressing his willingness to be interviewed. The next day I called and arranged for the interview described in chapter one.

It was the kind of happy accident that tells the real story of what happens in any kind of research project, no matter what one has planned. If life is what happens to you while you're making other plans, then certainly that is true of historical research and writing. Happy, accidental encounters, such as the first time you hear a recording by an African musician that excites you in a way you haven't felt before, and you notice that it was recorded in Paris. Then you want to know more.

Notes

1. Christophe Alix, "Dakar-la Goutte d'Or, en voisins: Vis@Vis permet aux Sénégalais de Paris de voir et d'être vus de deur famille," *Libération* (November 27, 2001): 10.
2. Allassane Cissé, "Cybercafés à Dakar: voyager assis," *Africultures* 23 (December 1999): 41.
3. Hélène Lee, author interview, Clichy, September 26, 2003.
4. Adrien de Tricorre, "Le Griot de l'*Euro*," *Le Monde* (December 16–17, 2001): 12.
5. Élisabeth Badinter, "Ces millions de Français invisibles," *Libération* (May 29, 2002).
6. Sylvain Siclier, "Les voix et les joies de l'Afrique au festival Musiques métisses," *LeMonde* (May 19–20, 2002): 33.
7. Marie-Claude Fisc, "Les sans-papiers de l'Essonne soutenus par les paroissiens," *La Croix* (July 8, 2002): 9.
8. Isabelle Monnin, "Sans-Papiers: Génération 2002," *Le Nouvel observateur* (September 12–18, 2002): 12–15.
9. Isabelle Monnin, "Depuis cinq ans, on a laissé pourrir la situation," *Le Nouvel observateur* (September 12–18, 2002): 13.
10. Monnin, "Sans-Papiers: Génération 2002": 15.
11. Thierry Njomgang, "Africagora au Coeur des decisions . . . : Grioo a rencontré Dogad Dogoui, Président d'Africagora," *Grioo.com:* http://www.grioo.com/pinfo973.html.
12. Charlotte Rotman, Belles idées noires: La communauté black tente de s'organiser," *Libération* (August 20, 2002): 16–17.
13. John Tagliabue, "Working to Put Blacks on France's Agenda: Businessman Presses For Changes in Politics," *The New York Times* (October 15, 2002): A3.
14. Njomgang, "Africagora au Coeur des decisions . . ."
15. Tagliabue, "Working to Put Blacks on France's Agenda."
16. Bertrand Bissuel, "En Île-de-France, plus de 5000 personnes vivent dans les squats," *Le Monde* (October 2, 2002).

17. Solenn de Royer, "Ce que Raffarin prépare pour l'intégration," *La Croix* (October 18, 2002): 12.
18. Jean-Baptiste de Montvalon, "M. Raffarin préfère la naturalization au droit de vote des étrangers," *Le Monde* (October 26, 2002).
19. Solenn de Royer, "Peu de Maliens veulent rentrer au pays," *La Croix* (March 4, 2003).
20. Co. C., "Progression de l'immigration des Africains et des Asiatiques," *Le Figaro* (December 10, 2002): 19.
21. Solenn de Royer, "Le gouvernement fait un geste pour les sans-papiers," *La Croix* (November 28, 2002).
22. Marie-Christine Tabet, "Sans-papiers: Ce que dit la circulaire Sarkozy," *Le Figaro* (December 9, 2002).
23. Nathalie Ferré, "Nicolas Sarkozy et les sans-papiers: faire peur et tromper," *Le Monde* (January 24, 2003).
24. Christine Holzbauer, "Sarkozy veut négocier le retour des Maliens," *La Croix* (February 7, 2003).
25. "Accord franco-sénégalais sur les clandestins refoulés," *Le Figaro* (April 17, 2003): 5.
26. "Nicolas Sarkozy réagit: Nous ne sommes pas sous Vichy," *Le Nouvel observateur* (February 6–12, 2003).
27. Cécile Calla, "Réforme du droit d'asile: l'Ofpra traitera toutes les demandes," *Le Figaro* (April 17, 2003): 5.
28. Isabelle Monnin, "Droit d'asile: le tour de vis," *Le Nouvel observateur* (April 17, 2003): 6.
29. Ibid.: 7.
30. "L'éditorial du Monde: Besoin d'étrangers," *Le Monde.fr* (November 8, 2003): http://www.lemonde.fr/web/_article/0,1-0@2-3208,36-341099, 0.html.
31. Sylvia Zappi, "Un concert contre la double peine a attiré près de 15 000 personnes à Paris," *Le Monde* (May 13, 2003).
32. Véronique Mortaigne, "De l'apartheid à l'intégration, les luttes musicales du festival," *Le Monde* (June 6, 2003): 20.
33. Patrick Labesse and Véronique Mortaigne, "Les eaux chantantes des musiques métisses," *Le Monde* (June 6, 2003): 19.
34. David Cadasse, "L'Afrique est un véritable continent musical: Christian Mousset, fondateur du Festival Musiques métisses d'Angoulême," *afrik.com*: http://www.afrik.com/article8442.html.
35. Gérald Arnaud, "Un pays fou de musiques," *Africultures* 56 (July–September 2003): 118–119.
36. Hélène Lee, author interview, Clichy, September 26, 2003.
37. Eliane Azoulay, "Barbès, quartier show," *Télérama* (June 11, 2003): 18–19.
38. Marie Treps, "Le français, langue d'accueil," *Le Monde* (July 31, 2003): 26.
39. Gérald Arnaud, "Bon Manuversaire, Manu Dibango!" *Africultures* 57 (October–December 2003): 197.
40. Patrick Labesse, "Manu Dibango, musique de fête et dossiers chauds."
41. "Convicted Papa Wemba Walks Free," *Expatica: News and Information for Expats in France* (November 16, 1994): http://www.expatica.com/source/site_article.asp?subchannel_id=58&.
42. Thierry Leveque, "Singer Papa Wemba Convicted," *SwissInfo: Switzerland's News and Information Platform* (November 16, 2004): http://www.swissinfo.org/sen/swissinfo.html?siteSect=41&sid=5344609.
43. "Papa Wemba poursuivi pour aide à l'immigration clandestine," *Libération.fr* (February 20, 2004): http://www.liberation.com/page.php?Article=90154.
44. "Papa Wemba condamné à 4 mois de prison ferme pour aide au séjour d'étrangers," *Le Monde.fr* (November 16, 2004): http://www.lemonde.fr/web/dh/0,14-0@14-0@2-3246,39-23960539.

45. "Convicted Papa Wemba Walks Free."
46. "Papa Wemba condamné à 4 mois de prison ferme . . ."
47. "Convicted Papa Wemba Walks Free."
48. "Papa Wemba condamné à 4 mois de prison ferme . . ."
49. Leveque, "Singer Papa Wemba Convicted."
50. Brice Wassy, author interview, Montreuil, France, December 1, 2000. Unless otherwise indicated, all information on Brice Wassy is based on this interview.
51. "Brice Wassy," http://brice.wassy.free.fr.
52. Nya Soleil, author interview, Paris, May 12, 1998. Unless otherwise indicated, all information on Nya Soleil comes from this or other interviews with him.
53. Nya Soleil, author interview, Paris, December 1, 2000.
54. Nya Soleil, author interview, Paris, May 12, 1998.
55. Nya Soleil, author interview, Paris, December 1, 2000.
56. Nya Soleil, author interview, Paris, May 12, 1998.
57. Nya Soleil, author interview, Paris, December 1, 2000.
58. Nya Soleil, author interview, Paris, September 30, 2003.
59. Isabelle Monnin, "Depuis cinq ans, on a laissé pourrir la situation": 13.
60. Nya Soleil, author interview, Paris, May 12, 1998.
61. E-mail communication with the author, October 2004.
62. Ibid.
63. "Seydou Guèye: Communication," http://www.quichotte.com/docs/cv/seydou_gueye.html.
64. Seydou Guèye, author interview, Paris, August 4, 2001. Unless otherwise indicated, all information on Seydou Guèye is based on this interview.
65. Hélène Lee, "Buru carbure," *Libération* (July 19, 2001).
66. Stuart Hall, "Cultural Identity and Diaspora," in *Colonial Discourse and Post-Colonial Theory: A Reader*, ed. Patrick Williams and Laura Chrisman (New York, 1994): 402.
67. Robert Aldrich, *Vestiges of the Colonial Empire in France: Monuments, Museums, and Colonial Memories* (Houndmills, UK, 2005): 5.
68. Paul Gilroy, *The Black Atlantic: Modernity and Double Consciousness* (Cambridge, MA, 1993).
69. Edward W. Said, "Introduction: Secular Criticism," *The World, the Text, and the Critic* (Cambridge, MA, 1983): 1–30.
70. Alec G. Hargreaves and Mark McKinney, "Introduction: The Post-Colonial Problematic in Contemporary France," in *Post-Colonial Cultures in France*, ed. Alec G. Hargreaves and Mark McKinney (London, 1997): 4.
71. Ibid.: 14.
72. Among the many studies of new hybrid forms of citizenship and pluralistic senses of national identity, one of the most interesting is that of a student of the contemporary Chinese diaspora. The author is Aihwa Ong, and her book is *Flexible Citizenship: The Cultural Logics of Transnationality* (Durham, NC, 1999). Other works that explore such themes in the French or wider European context include Miriam Feldblum, *Reconstructing Citizenship: The Politics of Nationality Reform and Immigration in Contemporary France* (Albany, 1999); Gamé Guilao, *La France, terre d'accueil, terre de rejet: L'impossible intégration* (Paris, 1994); Maxim Silverman, *Deconstructing the Nation: Immigration, Racism and Citizenship in Modern France* (London, 1992); Rogers Brubaker, *Citizenship and Nationhood in France and Germany* (Cambridge, 1992); Riva Kastoryano, *Negotiating Identities: States and Immigrants in France and Germany* (Princeton, 2002); Robert Holton, "Globalization's Cultural Consequences," *Annals of the American Academy of Political and Social Science* (2000): 140–152; and Ulf Hannerz, *Transnational Connections: Culture, People, Places* (London, 1996).

73. Jean-François Lyotard, *La Condition postmoderne: rapport sur le savoir* (Paris, 1979).

74. Terry Eagleton, *After Theory* (New York, 2004): 9–10.

75. Robert Holton, "Globalization's Cultural Consequences," *Annals, AAPSS* 570 (July 2000): 148–149.

76. Catherine Palmer, "From Theory to Practice: Experiencing the Nation in Everyday Life," *Journal of Material Culture* 3:2 (1998): 175.

77. Laurent Gervereau, Pierre Milza, and Émile Termine, eds., *Toute la France: histoire de l'immigration en France au XXe siècle* (Paris, 1998): 175.

78. Ibid.: 184.

79. Sidney W. Mintz, *Tasting Food, Tasting Freedom: Excursions into Eating, Culture, and the Past* (Boston, 1996): 104.

80. Ulf Hannerz, *Transnational Connections: Culture, People, Places* (London, 1996): 65–78.

81. Dick Hebdige, *Cut 'n' Mix: Cculture, Identity, and Caribbean Music* (London, 1987).

82. Veit Erlmann, "The Aesthetics of the Global Imagination: Reflections on World Music in the 1990s," *Public Culture* 8 (1996): 468.

83. Arnauld, "Toute musique est métisse—bien sûr!": 88 (my translation).

84. Christian Mousset, "La Musique africaine et la France," in *Étudiants africains et la France 1951–2001: Cinquante ans de relations France–Afrique: Quel avenir?*, ed. Michel Sot (Paris, 2002): 163–167 (my translation).

85. Ibid.: 167.

86. Caroline Bourgine, "Les réseaux communautaires," in *Les Musiques du monde en question*, ed. Sabine Wespieser and Hubert Nyssen (Paris, 1999): 103–108.

87. Jean-Loup Amselle, *Vers un multiculturalisme français: L'empire de la coutume* (Paris, 2001): 179.

88. Benedict Anderson *Imagined Communities: Reflections on the Origin and Spread of Nationalism*, Revised Ed. (London, 1991).

89. Michèle Tribalat, *De l'immigration à l'assimilation: Enquête sur les populations d'origine étrangère en Franc*, avec la participation de Patrick Simon et Benoît Rianley (Paris, 1996): 185. For a description of the ways in which recent Senegalese and Malian immigrants continue the tradition of supporting (and developing) the economies of their countries through their earnings and savings, see Reynald Blion and Sandrine Witeska, "Revenus, épargne et transferts d'économies des immigrés maliens et sénégalais en France," *Hommes & migrations* 1214 (July–August 1998): 38–46.

90. Benedict Anderson, "Exodus," *Critical Inquiry* 20:2 (winter 1994): 326.

91. Riva Kastoryano, *Negotiating Identities: States and Immigrants in France and Germany*, trans. Barbara Harshav (Princeton, NJ, 2002): 175.

92. Isabelle Taboada-Leonetti, "Citoyenneté, nationalité et strategies d'appartenance," in *Pluralité des cultures et dynamiques identitaires: Hommage à Carmel Camilleri*, ed. Jacqueline Costa-Lascoux, Marue-Antoinette Hily, and Geneviève Vermes (Paris, 2000): 116.

93. Landry-Wilfrid Miampika, "Migrations et mondialité: entretien avec Édouard Glissant," *Africultures* 54 (January–March 2003): 12 (my translation).

94. Ray Lema, *Mizila: Piano Solo* (One Drop, 2004).

95. Patrick Labesse, "Ray Lema Solo: All about My Mother," rfimusique.com (March 29, 2004): http://194.117.210.41/steeen/article_7261.asp.

Index